Neoclassic to
Post-Impressionist Painters

THE LIVES OF THE PAINTERS
by John Canaday

THE LIVES OF THE PAINTERS, III

Neoclassic to Post-Impressionist Painters

JOHN CANADAY

The Norton Library
W · W · NORTON & COMPANY · INC ·
NEW YORK

Books That Live
The Norton imprint on a book means that in the publisher's
estimation it is a book not for a single season but for the years.
W. W. Norton & Company, Inc.

ISBN 0 393 00666 2

PRINTED IN THE UNITED STATES OF AMERICA
1 2 3 4 5 6 7 8 9 0

Contents

Contents

Preface to
The Lives of the Painters

This book is a history of painting from the end of the Middle Ages to the eve of the twentieth century—from Giotto's revolution to Cézanne's—told in the form of several hundred biographies strung together on a historical cord. By way of its index it can also double as a reference encyclopedia, since each biography is self-contained, whether within a brief paragraph or a long essay.

If the book is an acceptable history, I am glad. If it is a helpful encyclopedia, so much to the good. But what I most hope is that these biographies will enlarge the reader's enjoyment of painting, and I like to think that this is a book that can be picked up and opened anywhere for a bit of pleasurable reading from time to time. It was written in somewhat that way: the biographies were composed not in chronological sequence, but according to my interest from day to day and were collated en route.

The question may be asked why a history of painting should be told in the form of linked biographies. There are good arguments to support the contention that knowledge of a painter's life and personality should not be allowed to intrude upon our response to his paintings, since paintings are objects with independent existences. This is a principle upon which I used to insist and with which I still agree in the cases of living artists. We have our own firsthand experience of our times as a basis for putting the work of our contemporaries in context. But even the greatest art of the past can be fully understood only if we can see it in the context of the society in which it was conceived as well as in its timelessness.

Preface

If we accept the truism that art is not produced in a vacuum (and we must), it follows that artists' lives tell us about the air they breathed, how it differed from one part of the world to another, and how it changed from one century to another —all of which explains the changing forms that in their succession make up the history of art.

Some of these biographies may seem too long or too short as measures of the painters' worth. No such proportion has been observed. A minor painter may have had an interesting life or a life that, as in the case of one very dull Spaniard, Francisco Pacheco, affords the best opportunity for describing the climate in which painters better than he were working. In an instance or two I have included artists not because they were important but simply because I like them. This personal indulgence accounts for the presence of, for one, the minor Florentine mannerist Bernardo Buontalenti. I hope there are no omissions except those explicable by the truth that a book can't go on forever.

Cézanne's birth year, which was 1839, has been adopted, with a few self-explanatory exceptions, as the boundary date for artists included in this story. The story ends with the triumph of impressionism—shared by Cézanne—and the rift between nineteenth- and twentieth-century painting, which Cézanne initiated. Cézanne's fellow post-impressionists, as they have come to be called (Vincent van Gogh, Seurat, and Gauguin) were all younger than he and thus are ruled out by date. In any case their biographies would have had to begin yet another volume in this already very long book, and we would have had to go on to a shift in fundamental premises corresponding to the radical change in the concept of creative art represented by Cézanne's descendants, Picasso among them.

The list of acknowledgements that usually concludes an author's preface would in this book have to include the

hundreds of museums and private collections in Europe and America that have given me for many years the opportunity to see paintings, and then the hundreds of historians whose work over the centuries has supplied the factual material that has been given yet another winnowing here. Some special debts to other winnowers, and researchers, are acknowledged in the course of the text. The general debt, shared by every art historian who has followed him, goes back to Giorgio Vasari, the father of us all, whose biography appears on pages 284-86. But I should mention that Rudolf and Margot Wittkower's book on the character and conduct of artists, "Born Under Saturn," was particularly helpful not only as a guide through Vasari but as a summary of references to other early histories.

Inevitably, a major source was the work of that great and delightful man, the late Erwin Panofsky, and I want to say here that I treasure our friendship of more than twenty-five years. He was wonderfully generous and patient with me as a writer who could not aspire to his kind of scholarship; on my part, as a writer, I once complained to him that he was a difficult scholar to crib from because he expressed everything so perfectly that to rephrase anything he had written was to butcher it.

Essays on several of the artists have appeared in somewhat different form in *Horizon* magazine. Permission for the use of this material is gratefully acknowledged.

I cannot conclude without thanking Robert E. Farlow, who wanted this book written and gave me the chance to write it.

JOHN CANADAY

New York

23

EARLY NINETEENTH-CENTURY ROMANTICS OUTSIDE FRANCE

When Jacques Louis David completed *The Oath of the Horatii* in 1784, he had formulated a standard for the emulation of the antique that became, under his dictatorship, the nominal standard for French painting when the nineteenth century opened. But the standard was only nominal. The chilly forms of the Davidian neoclassical ideal were inappropriate at a time when the French Revolution and the American War of Independence had shown that blood runs equally warm in all men. And there was a fundamental opposition between the classical generalizations and the recognition that every individual is unique and possessed of inalienable rights. Romanticism—in the sense of individualism, revolt, emotional release, exploration, color, and adventure—was the spirit of the time, and David, in spite of his many protégés and an army of painters who imitated him, actually found no follower in spirit. French classicism came to be little more

than an arbitrary loyalty to a mannered style; it had little
to do with any understanding of the ideals of antiquity. Cos-
tumed in their togas, the best of the so-called French classical
painters gave romantic performances.

In England the classical ideal had never been defined
with the arbitrary precision attempted by David, and the
romantic spirit permeated nominal classicism from the begin-
ning. Romanticism did not have to declare itself in revolt in
English painting; there was never a pitched battle like the
acrimonious and vindictive one that took place in France
between the opposing schools, simply, no doubt, because the
English attached so much less importance to painting than
did the French. As the century went on, the French fought
their aesthetic wars with such vehemence that they created
the type of the artist-as-martyred-leader, from Delacroix to
Cézanne. But the first martyrs in a confused century have re-
mained largely unsung. They were martyrs to circumstance,
and they were Americans.

But theirs was an unacknowledged romanticism. Roman-
ticism as an aesthetic and art-political rebellion against the
pseudo-classical restrictions of the French Academy found its
great protagonist in Delacroix, who was following Géricault's
early lead. Delacroix, however, was preceded in America,
Germany, England, and at home in France by artists who
worked in the romantic spirit a generation before him.

Washington Allston in America, Caspar David Friedrich
in Germany, Turner in England, and A. J. Gros in France—
all were born during the 1770's, while Delacroix was born
in 1798. For the French, romanticism was legitimized as a
studio war and a bohemian way of life after a series of ille-
gitimate births from the classical womb. But before that
time, the Americans had yielded to the romantic spirit with-
out quite identifying it; the Germans had formulated a
romantic philosophy and had set it down in writing and

painting; and the Englishman's response to nature had produced, among other artists, Turner—quite possibly the great romantic genius of them all.

The thing to do here is to begin with the Americans, continue with the Germans, and then consider the English before (in the next chapter) tackling the French, who thereafter chart the course for painting on into the twentieth century. The difficulty, a usual one in art history, is that the sequence page by page suggests a progressive sequence in time, where, in fact, everything was happening at once.

The early nineteenth century in America produced a group of painters who, if they had had a Gertrude Stein to coin the phrase for them, might have called themselves a lost generation. Biologically they belonged to two generations, since we can include John Trumbull, born in 1756, and Samuel F. B. Morse, born in 1791, with Washington Allston and John Vanderlyn in between. The misfortune of these men was that their imaginations and ambitions, stimulated by contact with French and English painting, exceeded anything that America was ready to satisfy.

The Americans who had preceded them in England and on the Continent had either remained in London, like West and Copley, or, like Charles Willson Peale and even Gilbert Stuart, had been content to occupy themselves with turning out portraits when they came home. America offered a painter virtually no opportunity to earn a living except by portraiture and, for that matter, hardly offered even a spectator audience for any other kind of painting. The most tragic victim of this cultural lag was John Vanderlyn, who was both the most talented and the most vulnerable of the Americans whose appearance was so unhappily timed. The talent was apparent in his early work, at least; it died of frus-

tration later on. His vulnerability was particularly acute because he was the first American artist who returned from training in France, where painters were both aesthetically and ideologically more advanced than in England.

Vanderlyn was born in Kingston, New York, in 1775, the grandson of a Colonial painter named Pieter Vanderlyn, who helped establish an American portrait tradition but failed to accumulate an estate. As a starveling youth, John Vanderlyn went to Philadelphia, where he clerked in a shop to support himself while studying with Gilbert Stuart. Stuart allowed him to help with copies, including copies of his celebrated portraits of Washington, which were in demand by the dozen. When money became so short that Vanderlyn had to leave the studio, he found a colorful patron in Aaron Burr, who had decided that Vanderlyn was a genius. Burr supplied funds to keep the youth under Stuart's instruction—living in Stuart's house—and then in 1796, when Vanderlyn was twenty-one, sent him to Paris to study. Vanderlyn remained there for five years.

He entered the studio of a sound neoclassical follower of Jacques Louis David named Vincent, and became once and for all dedicated to the Davidian concept of art as a combination of moral statement and political affirmation, an intellectual-aesthetic expression of the noblest ideals ever held by man—by which David meant, of course, the ideals of antiquity as revived in France. After this indoctrination, Vanderlyn returned to America in 1801, but he did not stay long. In 1803 he returned to Europe, and this time he stayed twelve years.

The first two he spent in Paris. In 1805 he went to Rome, where he stayed three years, and there he painted a neoclassical pastiche entitled *Marius on the Ruins of Carthage* (San Francisco, De Young Memorial Museum) that was a great success in Paris in the Salon of 1808. Napoleon awarded

him a gold medal. In Rome, Vanderlyn met another American, Washington Allston, who, like him, was experiencing a period of delight and was equally unsuspecting that it would give way to years of disappointment at home.

From 1808 to 1815 Vanderlyn was in London and Paris, and in the latter city he was able, in lion-and-mouse fashion, to help his erstwhile patron, Aaron Burr, whose schemes had brought him into disgrace in America. He also painted, among other pictures, one of the most beautiful works by an American in the first half of his century, a reclining nude called *Ariadne Asleep on the Island of Naxos,* which was exhibited in the Salon of 1812 and is now in the Pennsylvania Academy of the Fine Arts.

When Vanderlyn returned to America in 1815 he was forty years old and had spent most of the last twenty years in Europe. He was not only the first American to have studied in Paris rather than London; he had also met French painters on their own ground, which meant facing the roughest competition the art world then offered, and had come out a winner. His compatriots were impressed by this record, but they were not ready for the kind of painting that accounted for it. *Ariadne,* supine, naked, and glowing, shocked a provincial audience. American buildings, although designed on classical patterns, were too small and too domesticated to support the huge decorative historical pictures that Vanderlyn would have liked to supply in the French manner as an American David. For that matter, there was a basic incompatibility between the Napoleonic manner and the American democratic ideal. Vanderlyn's tragedy was not so much that he was unappreciated as that he was simply out of place.

Even in portraiture he was a failure. He worked too slowly for the convenience of a clientele that was accustomed to getting their part of the business done with in a couple of sittings, and also too slowly to produce an income that he

could live on. In New York he tried to adapt art to a form of public entertainment by constructing a rotunda for the exhibition of cycloramas where the observer, standing in the center, was surrounded by a panorama of, for instance, the palace and gardens of Versailles. The panoramas, including scenes from American history, could have been changed regularly, but the public did not respond. The project failed and in 1830 was taken over by the city. In the meanwhile, the one monumental project that might have given play to Vanderlyn's talents and training, the murals in the national Capitol, had been awarded to Trumbull by influential politician friends.

Embittered, Vanderlyn returned to his birthplace, Kingston. In 1842, when he was sixty-seven, Congress commissioned a mural, *The Landing of Columbus,* and Vanderlyn went to Paris to carry it out. Thus his career should have ended with an affirmation of his principles—but it was too late. His talent had withered in defeat. His drawings for the project are painfully studied and often incredibly inept for a man who had once met the exacting standards of Davidian draftsmanship. The mural itself, which was put in place in the Capitol, was executed by French assistants.

Vanderlyn died in 1852, seventy-seven years old and destitute.

Washington Allston, the first American landscapist of distinction, was also one of the earliest painters of the romantic movement, American or European. If he had done his early work in France, he might now be recognized as a pioneer in the great romantic revolution, being twelve years older than Géricault and nearly twenty years older than Delacroix. But, allied to England rather than France, he was part of the earlier, quieter, and even more significant rise of the

romantic spirit as an intuitive phenomenon—a rise exemplified in English painting by Constable and Turner, the one three, and the other four, years older than he, and in poetry by Samuel Taylor Coleridge, his senior by seven years, his mentor-companion in discovery, and his lifelong friend.

Allston was born in Georgetown, South Carolina, in 1779, but got transplanted to New England early. He went to school in Newport and then to Harvard, and upon graduation returned to Charleston to try to convince his parents that he should become a painter. They objected, and Allston sold his portion of the family estate and set off for London. It was May, 1801, and he was five months short of his twenty-second birthday. Like all good American students, he headed directly for the studio of Benjamin West, who at sixty-three had been president of the Royal Academy for nine years and was full of honors, but still kept open house for his hopeful and ambitious young countrymen.

After two years with West at the Academy, Allston went to Paris, where he was able to see the museum of the Louvre newly enriched with Napoleonic plunder. Early in 1804 he set off for Italy, going through Switzerland. He stopped in Siena with the idea of learning Italian, then by November, just turned twenty-five, he reached Rome, where he stayed, with interruptions for excursions elsewhere in Italy, for four years.

It was a wonderfully happy time. He met Coleridge (who was not yet a great name). They became friends immediately, they walked, talked, philosophized, and learned the city as a great living book. Washington Irving was another friend; so was the archclassicist among sculptors in the foreign colony, Bertel Thorwaldsen.

During all these years, Allston's fiancée, a Miss Anne Channing, had been patiently waiting at home. In 1808, or perhaps 1809, Allston arrived in Boston. He was thirty when

he married Anne in 1809. But Boston seemed dull after London and Rome. He fretted for the companionship of other artists and writers. Painting in Boston meant painting portraits, and in Rome he had been irretrievably seduced by the landscapes of Claude Lorrain and Salvator Rosa. He tried his hand at poetry, his most ambitious effort being "The Sylphs of the Seasons," an extended exercise in which the four seasons appear to a poet in a dream as four damsels who vie with one another for the position of queen of the year, extolling for the poet their contrasting charms.

In this poem Allston made a typically romantic identification between the moods of nature and the moods of man, with emphasis on melancholy reverie, stormy terror, and fearful joy. It is an amateurish poem, but it is an interesting reflection of Allston's philosophical fellowship with Coleridge. If today it can only be blushed for as poetry, it represented at the time, in America, an innovational expression of the intellectual energy that was inspiring the first great literary movement in this country. "The Sylphs of the Seasons" was probably the poem that Allston read at a meeting of the Phi Beta Kappa Society of Harvard in 1810, reported by a Reverend Dr. John Pierce. The reading took fifty-five minutes by Dr. Pierce's watch, and he found it a bit wearing, especially since Allston "spoke very low, & I was in a lateral position," so that he heard very little. But he conceded that the poem "was received with great emotion of pleasure by those who heard it." Three years later (1813) "The Sylphs of the Seasons, with Other Poems" was published, first in London and then in Boston.

By this time Allston had returned to London. A scant three years in Boston had seemed very long, and in July, 1811, he sailed from New York with his wife and a student— Samuel F. B. Morse. He stayed seven years, the last really productive ones—in painting—of a life that dragged on much

longer. During this second London sojourn Anne Channing Allston died (1815): her eight years of waiting had been rewarded with six years of marriage, which perhaps was fair enough.

Allston himself had nearly died two years earlier (1813), and he never entirely recovered from the illness. The double trauma of his brush with death and death's victory over his wife induced a state of exaggerated piety that colored the rest of his life.

Allston was always a man torn between conflicting sentiments and convictions. If Boston had seemed provincial, he was afflicted by homesickness in London. He returned to America in October, 1818—he had just entered his fortieth year—and was so stirred by the sight of Boston Harbor when he arrived, on a clear evening, that, as he later wrote to a friend, "the moon looked down on us like a living thing, as if to bid us welcome, and . . . she broke her image on the water to make partners for a dance of fireflies." Patriotically, he remembered that he was "in the very waters, which the gallant Constitution had first broken, whose building I saw when at College."

Allston lived another short quarter-century in Boston and Cambridgeport, dying in July, 1843, not quite sixty-four years old. He was constantly plagued by money troubles during these years. In 1830, aged fifty-one, he married a forty-six-year-old cousin of his first wife, Martha Remington Dana. He was a divided man, feeling again out of contact with Europe and yet not sharing the growing creative spirit of the younger men in America. These men found in Allston a symbol of the artist's dilemma in the new country and a declaration of the high position that an artist should hold. Painters had been considered craftsmen, but Allston, writing and lecturing, was a participant at the center of American intellectualism. With the cachet of English and Continental experience as the

guarantee of his good judgment, he was able to induce influential men like Charles Sumner and Daniel Webster to give commissions to young sculptors such as Horatio Greenough and Thomas Crawford for the beautification of government buildings in Washington. Allston could have painted murals for these buildings, but he refused to identify his art with politics.

He occupied himself with a series of essays called "Lectures in Art" (which, published after his death, caused hardly a ripple) that reveal him as an intuitive romantic who, contradictorily, was a methodical thinker in the classical fashion. His studio was full of casts of classical sculpture and, although his romantic expressions are his finest, he was really a hybrid, fascinated by the stormy, mysterious moods of nature and yet visualizing a harmonious understandable universe in the tradition of Neoplatonism. He struggled in his painting for effects of luminosity and atmosphere; his great discovery was that the texture and color of a painting, entirely aside from the subject, could be expressive. He learned this from the Venetians that he saw in Italy—Titian, Tintoretto, and Veronese—and in his last writings he anticipated twentieth-century theories of expression through form and color alone.

In his own work, Allston rose to his intellectual perceptions only occasionally and incompletely. Something just a touch naïve and awkward usually flavors even his best paintings and ties them to American provincialism. And yet his landscapes can so evoke the emotional forces he read into trees, hills, and skies, that Coleridge's hyperbolic tribute can be accepted as inherently just: in a letter of condolence after the death of Allston's first wife, Coleridge wrote him, ". . . to you alone of all contemporary painters does it seem to have been given to know what nature is—not the dead shapes, the outward *Letter* but the life of nature revealing itself to the Phaenomenon, or rather attempting to reveal itself. . . . The

great artist does what nature would do, if only the disturbing forces were abstracted."

For Allston the disturbing forces were not always abstracted, especially as he grew older and was increasingly torn between classical rationalism and mystical emotion. But in the best of his landscapes he can stand with any nature-romanticist. In an uncompleted painting called *Belshazzar's Feast* (Boston, Museum of Fine Arts), he struggled impotently for twenty-three years (he was still painting on it the day he died) to combine the monumental logic of classical composition with the romantic warmth of his first conception of the subject. He was totally defeated here. But in another huge studio picture, painted in London and successfully exhibited there, a scene of miracle, *The Dead Man Restored to Life by Touching the Bones of Elisha* (Pennsylvania Academy of the Fine Arts), he achieved in the figure of the dead man rising to life a synthesis of classical form and romantic impact unsurpassed by any painter of his generation anywhere.

Samuel Finley Breese Morse (1791-1872), as the records show, lived for eighty-one years. But he died as a painter during his forties, when he gave himself over to the invention of the telegraph—or his version of it. The Morse code bears his name, but like his telegraph it is a variation rather than a completely original invention. Nevertheless, Morse was internationally famous for this scientific achievement, and was the hero of a dramatic moment in American history when he proved to Congress, in 1844, that his instrument would work. He transmitted the message "What God hath wrought" from Washington to Baltimore.

As an artist, Morse went with Washington Allston to London, as Allston's student, at the age of twenty. There he met Turner, Coleridge, and Wordsworth. Before the trip he

had been graduated from Yale, where his interest in electricity had been aroused. Allston trained him as a colorist, but Morse somehow never managed to find himself as an artist. He might have been a first-rate romantic realist if he had followed a natural bent, but he was convinced that only the most grandiose compositions were worthy of an artist. Since there was no demand for this kind of painting in America, he fretted and marked time with portrait commissions, settling in New York after some travels following his return in 1815. Some of the portraits are delightfully fresh; here, too, Morse might have been at the top of the heap if he had not wanted so much more. During a return visit to Europe in 1829-32, he gave further indication of unrealized talent in some scenes cast in Allston's romantic vein. But after three more years at home, he stopped painting altogether.

His best picture is probably *The Old House of Representatives* (1822; Washington, Corcoran Gallery), a large affair documenting an architectural interior during a legislative session. Morse was a founder of the National Academy of Design, an institution that has done him little credit. And, in a more rewarding connection, he was one of the league who opposed that symbol of dry rot in art, the aged Trumbull.

John Trumbull is a hard man to like, although he began appealingly as a youth. Eighteen years younger than Copley and West, he can still be thought of as one of those American boys whose determination to realize themselves as artists was the manifestation of a creative impulse inexplicable in terms of the environment that produced them. He was wellborn, and had to go against the will of his father, Jonathan Trumbull, governor of Connecticut, to enter a not very respectable profession. But unfortunately Trumbull's eighty-seven years (from 1756 to 1843) allowed him more than a quarter of a

century to establish his record as a cantankerous, vindictive, grasping, hidebound old curmudgeon, a character that fell upon him in late middle age. Nor, by this time, was he much of an artist, although among artists he was a power.

Trumbull was graduated from Harvard in 1773 when he was seventeen—not, at that time, any indication that he was a prodigy, although he was a bright boy. He was twenty when the Revolution broke out, and in its first year he served as an aide to Washington. Although he achieved the rank of colonel, he resigned from the army in 1777 in what sounds like a huff over technicalities regarding his commission, and, in the middle of the war, devoted himself to painting.

In 1780 he decided to go to London to study with Benjamin West. He got to London but was imprisoned for eight months as a spy, and was then deported.

At twenty-eight, in 1784, he went back to London and this time succeeded in allying himself with West. During the next five years he did his best painting, combining a grasp of classical composition, gained from West, with a natural facility that was enriched by his admiration for Rubens, an artist whose lush vigor was taboo according to the congealing restrictions of the neoclassical ideal.

At West's suggestion and with Thomas Jefferson's encouragement (Trumbull's biography, in detail, is a succession of contacts with important men), Trumbull now set himself an assignment that would have been a lifework if completed and did produce in its early stages his best painting. He decided to do a series of twelve enormous narrative pictures on the history of the American Revolution. He knew personally most of the important American leaders and many of the English and French ones, and the program called for portraits of them all, in action. He produced numerous sketches for these portraits and eight preliminary studies for the compositions.

When he returned to America in 1789, Trumbull of-

fered engraved versions of the subjects for sale. Under any-
thing like favorable conditions the project should have been
a great success, but after a lively beginning, it failed. The
country was too tired and too shaky financially to support it.
Trumbull abandoned the whole thing and decided to give
up art entirely. At this point he can be understood as an
artist of defeated potential. If the country had been ready, he
might have become an American Jacques Louis David. He
was a good painter then (although he was never to be a good
one again) and, to continue the parallel, he also had David's
political adaptability.

After his return to America, Trumbull had combined
his art project with the more dependably lucrative position
of secretary to the politician and statesman John Jay. Now,
in 1794, nearing forty, he went to London with Jay in a
diplomatic capacity having to do with the Jay Treaty, which
regulated commerce and navigation in settlement of viola-
tions of the Treaty of Paris of 1783. The Jay Treaty was
concluded the year of Trumbull's and Jay's arrival, but
Trumbull stayed on in London, going back to his painting
and pursuing an unsuccessful career as a fashionable por-
traitist for another nine years.

Back in New York in 1804 he opened a studio. But he
was dead as a creative painter. His style—cold, dark, and un-
utterably dull—understandably failed to catch on. He was
pushing fifty. After four years he tried London again, stayed
for eight years, and at the age of sixty returned to America
for good.

In a way, he returned to honors. The next year (1817)
Congress, inspired by Trumbull's influential friends, com-
missioned four of his Revolutionary subjects for the rotunda
of the new Capitol in Washington (to the distress of a better
artist, John Vanderlyn, for whom the failure to get the assign-
ment was the final blow). The paintings turned out to be
heroic in size only. It was too late. Everything that was mean,

tight, and small-minded about Trumbull had triumphed over the vigor of youth. That same year, he became head of the American Academy of Design. He used his position as an instrument for personal profit, selling his work for high prices under the Academy's hallmark while letting the Academy's own financial situation deteriorate. He was shameless in his use of influential connections and did everything he could to demolish any young artist whose career was a threat to his own. He originated in this country the type of aesthetically ossified art director that became the international villain in the story of nineteenth-century art.

In the 1830's he founded the Trumbull Gallery at Yale, one of the earliest museums in this country, where he deposited—in return for a pension—his sketches for the long-since-defeated project of the pictorial history of the American Revolution. In 1837 he retired to New Haven, where he lived for six more unpleasant years.

Early German romantic painters are remarkable for being all but unknown in comparison with their literary counterparts. Thus Philipp Otto Runge, who died at the age of thirty-three, missed by a wide margin (but still only by a margin) an achievement that would have put his name alongside that of Géricault, who also died young but exerted an influence so revolutionary that he stands as a dividing line between major periods in the history of painting. Runge's name is frequently omitted even from encyclopedias and lengthy art histories; yet he might have been, under different circumstances, a major historical figure instead of an interesting neglected one. If he had somehow found a French audience, or even an English one, he might have been conspicuous enough as a rebel to find martyrdom or a following—in either case serving as a fuse for the romantic bomb.

But Runge worked in Dresden and Hamburg. German

romanticism was largely a self-contained movement, and a painter was closely held within its boundaries. Philosophical dissertations and books of poetry might travel, but paintings did not. Runge's audience was small and, in effect, provincial.

Runge was born in 1777 in Wolgast, on the Baltic coast, to a family of shippers and builders. From the first he was conditioned to religious reflection. The family, Lutherans, were extremely devout, and Runge's first tutor was a Reverend Kosegarten, a follower of the seventeenth-century mystic Jacob Boehm, who saw God as the universal harmony of man and nature and the source of all creative will—including, of course, the making of paintings.

In writings of agonized tortuosity interspersed with rapturous visions ("When every leaf and every blade of grass teems with life, when the earth is alive and stirs beneath me, when everything is resolved in harmony, then my soul shouts with gladness and soars in the immeasurable space around me . . ."), Runge tried to formulate a philosophical assignment for the artist. But as an artist he had no great natural facility, and what he did have was not cultivated until late: he took his first drawing lessons when he was twenty years old.

At twenty-two he went to Copenhagen to study at the Academy—just missing Caspar David Friedrich, who, three years older than Runge, had left the year before. But in 1801, when Runge came to study in Dresden, the two young men met. The twenty-four-year-old Runge introduced the twenty-seven-year-old Friedrich to the poets and philosophers of the romantic circle. It is not always easy to determine the authorship of the ideas that Runge and Friedrich both propounded, but as an artist Friedrich was much the more successful in applying the idea that nature observed by man could be the revelation of God, and hence that landscape was the noblest form of painting.

In 1803 or 1804 Runge went to Hamburg. He worked

on a series of symbolical pictures of the hours of the day (Friedrich had already tackled the same subject), which were to incorporate his complicated theories of symbolical color in relation to mathematics and music. Goethe later developed these theories in part. But the immensity of the all-inclusive philosophical program that Runge had set himself was more than he could cope with, and his death in 1810 is often attributed to his having exhausted himself with study.

Three of Runge's paintings were destroyed in the Munich Glaspalast fire of 1931. The remaining fragments of his work include some charming portraits with a faintly primitive cast and—probably his best works—two versions of the morning episode of his hours-of-the-day cycle and an uncompleted *Rest on the Flight into Egypt*—all three in the Kunsthalle, Hamburg. Runge's symbol of morning is unforgettably curious, a naked babe lying on its back in a meadow, struck with wonder at the glory of the world. A similar infant, this time specifically the Christ child, is equally bemused in a world of evening light in *Rest on the Flight*. There are strong echoes of William Blake here, as in much of Runge's work. Like Blake, he theorized about innocence, but where Blake was a natural and incurable innocent, Runge was an intellectual who set himself the impossible task of arriving at innocence by coming full circle through philosophical terrain. Perhaps, in spite of the potential we can imagine in his handful of paintings, it was inevitable that his execution should fall short of his conception.

Caspar David Friedrich, the son of a soap boiler and chandler, was born in 1774 at Greifswald on the Baltic Sea, and the great spaces of the landscape he first knew must have been a determinative introduction to nature for an artist who during a life-span of sixty-six years saw nature as a revelation

of God. A second experience of his boyhood reinforced his natural bent to melancholy: his brother died trying to rescue him from drowning. The early death of his friend and mentor, the painter Philipp Otto Runge, confirmed Friedrich's romantic conviction that life on earth is an interlude during which man, beset by mortality, can sustain himself not by making the most of the moment—a Renaissance idea —but by reflecting upon the spiritual harmonies that rule the universe in spite of his fatal propensity to degrade and confuse himself. With other German romantics, Friedrich did not exactly return to the medieval idea that life on earth is only a time for earning one's way into paradise, but he did believe that life is largely a matter of death and despair, with resurrection as the only hope, and harmonization of the soul with nature as some kind of means toward that end.

In his life as a painter, however, Friedrich must have found his consolations. He first studied in Greifswald under a J. G. Quistorp, and when he was twenty his parents, who always did their best to give him what he wanted, sent him to Copenhagen, where he studied for four years at the Academy. He received a sound training under N. A. Abildgaard (1743-1809), a reigning classicist. As a student of architectural drawing, he helped support himself by doing views of tourist spots to sell in the pre-postcard era.

In 1798, when he was twenty-four, he went to Dresden, the most important center of painting in Germany just then, and settled there. He met Runge, who among painters was the spokesman of romantic theory, and through Runge met the other painters, poets, writers, and *amateurs* who held to the general idea of the philosopher Schelling, that mind and nature are essentially one and that this oneness is expressed by the creative impulse called art. One of Friedrich's early projects, done first in gouache and later repeated in oil, was a romantic variation on the old theme in which the hours of

the day, the seasons of the year, and the life cycle of man are identified with one another.

In spite of inevitable opposition from the classicists, Friedrich had the satisfaction of applause from fellow artists and intellectuals, including Goethe. In 1808, when he was thirty-four, his position was established with an altarpiece, *The Cross in the Mountains* (now in Dresden), in which the vast rocks of the landscape are united to the evening sky by a tiny cross, the symbol of faith as the light of the world. In 1810 (the year he met Goethe and the year Runge died), Friedrich was elected to the Berlin Academy, and in 1816 to the Dresden Academy, where he became a professor in 1824. He was paralyzed by a stroke in 1835, and died five years later, in 1840. It was a miserable end. He was forgotten during these last years and died in poverty.

The typifying, and greatest, German romantic painter, Friedrich was a didactic mystic, a contradiction reflected in the meticulously detailed, unequivocally defined, and impersonally presented natural forms of paintings that, nevertheless, are conceived in moods of transcendental melancholy. In contrast with Turner, his exact contemporary, who in his late work reduced nature to an abstraction of color in movement, Friedrich was, detail by detail, a realist who stuck by the classical tenets of drawing. He painted the ruins of the Cistercian Abbey of Eldena, near Greifswald, a crumbling Gothic relic, with the clarity of an architectural study, but painted them desolate in a snowscape in chilly evening light, with a funeral procession of monks winding beneath barren, broken trees—the whole scene so beautifully staged that the implacable definitions are transmuted into expressive symbols of mortality. (The painting, formerly in Berlin, is now lost.)

Dusk, sunset, moonlit night, and pale dawn were Friedrich's hours. In these lights, a figure stands on a beach or

against a valley, with his back to us, a proxy for ourselves, who are thus taken into the picture and may contemplate the mystery of God in nature. Sometimes a little naïve, but never suggesting mere painterly artifice or romantic posing, Friedrich is a fascinating artist and, potentially, an artist of wide appeal. But he is little known outside Germany, since his paintings can hardly be seen elsewhere, and even in Germany he has suffered badly from the loss of works in the Munich Glaspalast fire of 1931 and the destructions of World War II.

Friedrich (along with his circle) was almost chauvinistically and often confusedly German, thinking of Gothic architecture as an original Germanic expression, and believing that in his use of realistic detail he was loyal to a tradition established by Dürer—whose yearning toward God he shared, but whose humanistic intellectualism escaped him. In his writings, Friedrich summed up the basic romantic conviction: "The artist's feeling is his law"; but unlike many romantics, he did not regard this principle as a *laissez-passer* to personal indulgences and aesthetic violations.

Early German romantic painting, after Runge and Friedrich had shown how great a school it might have become, failed its promise when a group of artists called the Nazarenes got lost in a bypass under the leadership of Johann Friedrich Overbeck.

Overbeck was born in 1789, and at seventeen entered the Vienna Academy of Fine Arts, but was expelled for his opposition to its classical standards. As he wrote his father, the standards that the Academy revered were without "heart, soul, and feeling." In 1809, when he was twenty, he founded, with five other youngsters, the Lukasbund, or Guild of St. Luke (the patron saint of artists), with the notion of bringing painting back to the pure ideals of the masters of the

early Italian Renaissance. Sincerely religious himself, Overbeck confused a historical style with a state of soul, mistaking the broad, clear definition of the early painters for a direct reflection of pure, simple Christian faith.

At the Academy, Overbeck rejected an eclecticism based on Michelangelo's drawing and Titian's color—only to devise a disastrous hodgepodge of his own. Borrowing indiscriminately from a mixture of fifteenth-century artists, he became an eclectic to such an extent that he is an almost farcical definition of the type. He was, however, a very sincere artist, as many bad artists, indeed, have always been. Determined to combine a revival of truly Christian art with a truly Christian way of life, he went to Rome (in 1809) with another member of the Lukasbund, Franz Pforr (1788-1812), and shortly thereafter moved into the deserted monastery of San Isidoro, which he envisioned as a center where painters committed to his dual interest in art and religion might live communally on a near-monastic pattern.

In 1810 Overbeck and Pforr were joined by two other members of the Lukasbund, Georg Ludwig Vogel (1788-1879) and Johann Konrad Hottinger (1788-1828), both twenty-two years old and still in the full flush of youthful romantic idealism. The flush subsided for them by 1813 and they left, along with a fifth member of the bund, Josef Wintergast (1783-1867), who had arrived in 1811. The sixth member of the original group, Joseph Sutter (1781-1866), perhaps because he was already nearly thirty when the bund was formed, had never been quite as starry-eyed as his colleagues and did not take part in the monastic experiment, although he moved to Rome at the age of thirty-five and stayed there twelve years.

The members of the Lukasbund became better known as the Nazarenes, a nickname that stuck, although it was originally a half-chiding reference to the beards and long hair affected by the group. Over the years "Nazarene" came to

identify a more loosely formed school of German painters who followed Overbeck in his eclectic preferences and often in his religious subject matter even when they were less tenacious in their idealism. Passing in and out of Rome, usually as youths, they joined Overbeck in the execution of mural projects, and returned to create similar, usually painfully dull, cycles at home.

Overbeck himself was a plodder who completed very few paintings—less, however, because he worked so slowly than because he shared the general romantic conviction that inspiration comes directly from the soul. He believed that if he worked too long on a painting he would obliterate expressions of the original emotional power. In front of his work today, with its elementary color, its line both dry and flaccid, one wonders what evidence of that power he imagined he saw. He died at the age of eighty in 1869, respected for an idealism whose expression, puerile as it often seems to us, did not seem so to his contemporaries. He had exerted a wide and strong if unfortunate influence on German painting, and had anticipated a major school of English painting, the Pre-Raphaelites.

The most highly regarded of the Nazarenes was not Overbeck, the founder, but Peter von Cornelius (1783-1867), who managed to reap the practical awards of the movement during his lifetime. Not an original member of the group, which he joined only temporarily and peripherally, he maintained an independent position as a skillful portraitist and history painter. After a stint as director in Düsseldorf, he was appointed director of the Munich Academy in 1825. In 1841 he moved on to Berlin. Like the other Nazarenes, he was drawn to Rome, and his whole career is punctuated with trips to Italy. When he was seventy-two, and already much honored, he was one of the three foreigners awarded gold medals in the Paris Salon of 1855, which was conceived as an inter-

national art event in connection with the Exposition Universelle. (The other foreign winners were Sir Edwin Landseer of England and Hendrik Leys of Belgium. Ingres and Delacroix were the French stars.)

If England has produced a single genius among her many painters of talent, intelligence, and originality, that genius is Joseph Mallord William Turner. Alone among English painters—and we are not forgetting the visionary Blake—Turner had "exceptional natural capacity for creative and original conceptions"—a dictionary definition of genius—to a degree that is inexplicable and must be accepted as an independent phenomenon, self-generated and self-sustaining.

Turner's originality was so great and of such breadth that it has been revealed only gradually over more than a hundred years by the series of aesthetic revolutions that have transformed our way of looking at art since his death in 1851. His history as an artist, which during a long lifetime carried him from realistic beginnings to an abstract conclusion, is also the history of modern art. The impressionists were the first painters to discover that Turner had anticipated them; his watercolors, since then, have been compared with Cézanne's; the cubists, it must be admitted, have been unable to tie their art to his, but the abstract expressionists and action painters of the 1950's and the new colorists of the 1960's have claimed him not only as an ancestor but even more enthusiastically as a colleague.

And yet, during the second half of the nineteenth century and the first part of this one, Turner's art had very little direct influence on the various painters or schools apparently descended from him. His work did not serve as a point of departure for revolution; it was recognized as revolutionary after the revolution had been accomplished. The late sketches

in which his originality seems most emphatically declared were not exhibited at all until 1906, and not in any quantity until 1938. Turner's official canonization had to wait another twenty-eight years, until the Museum of Modern Art in New York exhibited him in 1966, not, in effect, as a nineteenth-century romantic, which he was, but as a twentieth-century abstractionist, which he can be made to seem by selecting certain bits and pieces of his work, reducing the tremendous field of his art to the dimensions of a studio exercise.

His field was the universe, and his discovery of it reversed the biblical process of its creation. As a youth he saw the world as the comfortably inhabited landscape of England, but as an old man he painted the cosmos as a spectacle of the elements in chaos—with air, fire, and water fusing and spinning in a vortex that might be the primordial womb from which the solid forms of earth were brought forth.

An understanding of theory—or, more accurately, the application of it—was a negligible factor in Turner's achievement of his ultimate expression. For every passage in his work that seems to conform to theory there are hundreds that contradict it. Creatively he was an empiricist who fulfilled his genius by degrees over a lengthy route that by the grace of God he lived long enough to cover, inch by experimental inch, to its end.

Turner was a competent artist in his early teens, a successful one in his twenties, a great one during middle age, and then a very great one until a brief decline just before his death at the age of seventy-six. We have become so accustomed to thinking of him in terms of modernism that it is always surprising to remember that he grew up in the eighteenth century: he was born in 1775, in Maiden Lane, in the Covent Garden district of London, where his father was a barber and wigmaker. If he was not born holding a pencil, he must have learned how to hold one soon. By the time he was twelve he was already sufficiently conscious of his identity as an artist

to be signing and dating some not very impressive topographical drawings (probably copies, although they were done in the country, where his parents had sent him, at the age of ten, to live with an uncle).

This signing and dating at such an early age can be recognized, without too much romanticizing, as the germ of Turner's feeling, in maturity, that his total work was a unit. If he consented to separate some of it from the rest to make money, which he loved, he refused to part at any price with the paintings he considered his best, and when he died he left the contents of his studio—some 350 paintings (more than half of them unfinished) and 19,000 drawings—to the nation. Anyone who has visited the Turner rooms in the London museums knows that Turner was right. Whatever the beauty and power and variety of his individual paintings, the spectacle they present en masse can be an overwhelming revelation, whereas a similar display by most artists, even great ones, would be only encyclopedic and exhausting.

At fourteen Turner was admitted, on probation, as a student in the Royal Academy schools, and returned to live with his parents in London. At about the same time he received some instruction from one Thomas Malton, a topographical watercolorist, who distinguished himself by advising Turner's father to teach the unpromising boy some useful trade, such as that of tinker or cobbler. At fifteen Turner had a watercolor in the Royal Academy exhibition, and for the next sixty years he was always represented there except when, occasionally, he chose not to submit. At seventeen he was supporting himself by coloring prints for engravers. In 1794, at nineteen, he was still working at copying drawings—those of the popular J. R. Cozens, done for Dr. Monro*—but in

* Dr. Thomas Monro was a specialist in mental diseases who had treated J. R. Cozens (as well as George III). An amateur artist and collector, he enjoyed entertaining young artists at his mansion in Adelphi Terrace. He often gave them copying to do for no other reason than to supply them with a little income.

the same year one of his own was published as an engraving, which meant that he had been accepted in a field that could be a source of major income for an artist—and was one for Turner, for the rest of his life.

By the time he was twenty, Turner was well established among printsellers, was making money, and was conspicuous enough to be mentioned for the first time (of many) in the gossipy diary of Joseph Farington (1747-1821), a landscape painter whose daily jottings are a standard chronicle of the London art scene of the period. When he was twenty-one, Turner exhibited his first oil at the Royal Academy, and in the last year of the century, when he was twenty-four, he was elected to the Academy as an associate member—at the earliest permitted age.

In 1800, then, he was twenty-five and an established artist. By hindsight we can recognize that the Turner-to-be was nascent in the early oils he exhibited at the Academy. On the surface these followed closely enough the subject matter that was popular and salable for a landscape painter—scenic spots, frequently with the medieval ruins that were so romantically appealing to tourists. But a picture of Dunstanburgh Castle (Melbourne, National Gallery of Victoria) is subtitled *Sunrise After a Squally Night,* and that is the real subject. A view of Millbank (London, Tate Gallery) is only secondarily topographical: the scene is one huge receptacle for moonlight. *Morning Amongst the Coniston Fells* (London, Tate Gallery) was accompanied in the Academy catalogue by lines from Milton's "Paradise Lost" beginning "Ye mists and exhalations," and these rise in the distance, an effect of nature that one day would engulf entire canvases in chromatic fantasies and lead Constable to say, half ridiculing and half admiring, that Turner painted with tinted steam.

The most revealing of the quotations that Turner chose for the catalogues at this time accompanied a painting of

Buttermere Lake (London, Tate Gallery) in the exhibition
of 1798:

> Till in the western sky the downward sun
> Looks out effulgent—the rapid radiance
> instantaneous strikes
> Th' illumin'd mountain—in a yellow mist
> Bestriding earth—the grand ethereal bow
> Shoots up immense, and every hue unfolds.

"And every hue unfolds" is a prophecy of Turner's de-
velopment, and the "yellow mist" forecasts a passion for that
color so great that when Turner was an old man he was cari-
catured (a short fellow, almost squat, his oversize head bear-
ing a great handsome beak of a nose) with a bucket of yellow
paint and a mop, swabbing away at a large canvas. Turner
had borrowed the lines accompanying *Buttermere Lake* from
James Thomson's "The Seasons" ("Spring") seventy years
after they were written. But as a description of a Turner
painting they might have been even more appropriate in
another forty years, when Turner had discovered the miracle
of Mediterranean light and the technical means of translat-
ing it into paint. Light, by then, had become for him the
ultimate dynamic force, the manifestation of the dynamism
that for Thomson was evidence that God existed at the heart
of nature.

About 1798, the year *Buttermere Lake* was exhibited,
Turner met Sarah Danby, the widow of a composer and or-
ganist. He began an affair with her that lasted at least ten
years and produced two daughters to add to the three Sarah
had already borne her husband. Maddeningly little is known
about Sarah Danby, but since one of her legitimate daughters
married a composer and organist of respectable standing, and
since one of Turner's daughters, Evelina, married a respect-
able consular official, Sarah must be imagined as a woman

who maintained a respectable position of her own. Any re-constructions of the relationship between this presumably cultivated woman and the youthful Turner must be made on shaky foundations, but they keep suggesting themselves all the same. Turner must have been Sarah's protégé as well as her lover, and one imagines that she was his early literary mentor.

The picture of this ill-educated young man poring over Milton and Thomson (and, as it turned out, making his own efforts at versification), possessed of a superior mistress, and having brought himself by the age of twenty-five to a position of prominence on his own terms against the grain of the snobbish, competitive art world, is an impressive one and a happy one. But it is given a different cast by a fact of Turner's life that must be remembered as of central importance in any re-creation of him as a personality, at that time and until he died. His election to the Royal Academy, a professional triumph, coincided with a personal tragedy, his mother's final reduction to hopeless insanity.

In 1800 she was admitted to Bethlehem Hospital, and when she was discharged as incurable the following year, she was put into a private asylum, where she died three years later. Turner left virtually no autobiographical comments, and the inadequate records left by his contemporaries reveal no awareness of his mother's madness. But certainly it was not something that Turner accepted easily. Rather, it might explain why, in spite of his strong sexuality, he never married; why, in spite of his success, he felt a basic insecurity that led him to grasp sources of income that he did not need, and to hoard money; why, in spite of a few close friendships, he remained a loner in a society where he could have been a lion.

Critics who could not understand Turner's late work, with its violence and what seemed to them its incoherence,

frequently called him a madman, as a figure of speech. Even Constable once said as much. Probably these men were unaware of how painful the word was to Turner. If aware, their use of it was either lamentably careless or despicably cruel. It is reported that Turner sometimes read adverse criticisms with tears in his eyes: the explanation might lie in these unmeaning accusations of madness.

When Turner's mother was committed to Bethlehem, his father closed the barbershop and moved in with his son as a general handyman. Turner was utterly without social ambitions; he and his father lived simply, almost roughly, uninterested in the luxurious appurtenances of the successful Londoner—the fine furniture, the silver, the servants, and the parties. Whatever else united them, the father and son shared a love of money for its own sake, which is usual enough among poor people who have begun to earn large sums. The two Turners developed a reputation as misers, and there were stories about the shabbiness and squalor in which they lived. But this tolerance of primitive domestic conditions is explicable as a natural indifference on Turner's part to vanities that would only complicate his life by taking more time (and, always, more money) than they were worth. Turner was simply too busy to bother. He had no wife who had to be pleased, and the old man was little more than a peasant who must have thought of his new mode of life as rather an opulent one.

When he was twenty-seven, Turner was elected to full membership in the Royal Academy. He could sell anything he wanted to, and in 1804, seeing no point in working through intermediaries, he opened his own gallery in Harley Street, where he kept twenty to thirty works on exhibition. He also moved into a better house, although not a better-kept one, in Upper Mall, Hammersmith. A few years later—in 1810—he took a large house in Queen Anne Street, which he eventually remodeled to include his gallery-salesroom.

He was continuously busy and continuously successful, but all the while he was conscious that something was eluding him as an artist. He traveled incessantly hunting for it, seeming not to know quite what it was, except that the peaceful English countryside did not offer it to him. He could and often did paint landscapes of great serenity, but the closed horizons and the intimate comforts of the countryside that so delighted Constable were cramping to Turner. He traveled through England, Wales, and Scotland. In 1802, when the Treaty of Amiens was signed and the restrictions on visits to the Continent were lifted, he headed straight for the Alps, letting Paris and the Louvre wait for a visit on his way home. On a German trip he discovered that the Rhine was his river, with its turbulent falls, its forested banks, and its castled crags, just as the peaceful Stour was Constable's.

He reflected all these experiences in his paintings. He had seen avalanches, and storms at sea, and he alternated paintings of the destructive forces of nature with others of idyllic visions in which rural England was adapted to the combination of romanticism and formality that had kept Claude Lorrain a deity of the Academy. Turner never hesitated to challenge comparison with the old masters, and he challenged Claude on his own ground not only with Claudian adaptations of local subjects but with history pictures on an operatic scale, such as the famous *Dido Building Carthage* of 1815, now in London's National Gallery.

But the catalyst was somehow missing. By his early forties Turner had been a professional artist for a full quarter of a century, and his preoccupation with the quality of light had been continuous. The catalyst—or the fuse that lit the explosion—was his first trip to Italy, in 1819, when he was forty-four. He stayed five months.

Turner was far beyond the stage when the Vatican's Raphaels and Michelangelos, and the other shrines of Renais-

sance art, could mean much to him. He made the Italian trip to see the sights, the ruins of antiquity, and perhaps out of a general curiosity and the restlessness that made him a traveler all his life. What he discovered in this southern country was that there existed a kind of light that belonged to him and his painting. He had conceived of the elements in storm—water in flood, earth in avalanche, air in hurricane —and now he saw that there could be a storm of light. He saw that solid objects might be consumed in a sparkle of brilliant, shadowless radiance in a way altogether different from their soft dissolving in the cool "mists and exhalations" of the North. As if to make the revelation complete, Vesuvius erupted and Turner hurried down to Naples with his water-color box to make firsthand acquaintance with primeval fire as a destructive natural force.

Back in London he remodeled and enlarged his Queen Anne Street house to include his sales gallery. His work from now on, increasingly revolutionary in its rough surface of pure color, its sacrifice of solid form to immaterial substances, its cataclysmic subjects, increasingly puzzled and offended the critics. But Turner was invulnerable. He had already made a fortune. If nobody had bought the new pictures, it would not have made much difference, but in spite of the critics there were assiduous Turner collectors. Nor was Turner too badly wounded in his self-esteem. In his pictures for the Academy he had frequently made concessions to popular taste; now and then he still did, and he was not above re-peating an old success for a ready sale. But he painted more and more for himself, secure in his renown and conscious that he was achieving what he was after—including, no doubt, a position in the mainstream of the history of art. When he was irritated he could demolish a critic or a poor foolish questioner among his clients with a murderously con-temptuous phrase, but ordinarily he did not bother.

What kind of man was Turner by this time, fifty years old and at the height of his success? By a portion of the evidence it would be easy to picture him as a misanthropic solitary, and certainly it would be wrong to deduce any character in which there was not a strong element of pessimism. His use of figures that have the look of puny victims of cosmic cataclysms is frequently interpreted as a comment on human frailty, on the indifference of the gods, or of nature, to man's fate. But Turner's comment is never much more than a postscript, and the figures themselves, usually ill-drawn, are like postscripts to the rest of the painting, and rather obtrusive in their small way. As often as not, the figures, with whatever philosophical comment they carry, seem to have been introduced as concessions to the nineteenth-century public's feeling of unease when confronted by a picture offering no kind of human or narrative interest to cling to.

Occasionally Turner adopted moralistic themes, but when he did so there was always a special reason. *Dido Building Carthage* and the companion *The Decline of the Carthaginian Empire* (London, Tate Gallery), taking their themes from Thomson's long poem "Liberty," warned by historical example that a nation in its greatness must preserve the virtues that built it, or must fall. But this high-minded declaration was incidental to Turner's deliberate intention to paint two pictures that could stand comparison with the masters of the past—especially Claude—and in spite of their themes, the pair are notable solely (and splendidly) as pictures. Their philosophical content is altogether dependent upon accompanying literary exposition.

This was always true of Turner's work. He was emotionally committed only to nature as his subject and paint as his medium, no matter what sops he threw to the public (and perhaps to himself) by tying literary or topical references to exhibited pictures. Around 1804, before he was thirty, he

began composing verses of his own for this purpose, and in 1812 there appeared the first quotation from a poem with the cheerless title "Fallacies of Hope"—supposedly a work of epic length that Turner was working on over the years, but a work that was never seen. The quoted lines were probably produced for each occasion, and are quite embarrassingly ill-written. Turner's education was, to say the least, limited. His thin acquaintance with humanistic learning has been regarded as a disadvantage accounting for the feeble classicism of his mythological subjects, but more perceptively it has been recognized as an advantage that gave his originality full play.

But none of this tells us enough about Turner's personality. And for a man so famous, he managed to keep his private life private to a degree that has left him indecipherable. He wrote almost no letters and never went out in society. Did he have friends among the sailors and fishermen and the women of the ports where he went to sketch? He used to hire small fishing boats to take him out in rough weather and once had himself lashed to the mast for four hours to observe the natural effects of a snowstorm, wondering all the while, he said later, whether he would survive the experience.

The friends he is known to have had respected his privacy. By the time he was thirty-five—and perhaps much earlier—he was making annual visits to his friend Walter Fawkes of Farnley Hall, Yorkshire, visits that continued until Fawkes died in 1825. Turner had also formed a friendship with the Earl of Egremont and had been a guest at his seat, Petworth. From September, 1829, when Turner's father died and he was fifty-four, he visited Petworth regularly, until the death of Lord Egremont eight years later, in 1837.

It is significant that the most intensely personal expression of Turner's genius coincided with the death of his father

and the beginning of his Petworth experience. The rough old man had been his steady companion for thirty years. Whatever he had supplied in the way of an emotional center for his son's life must somehow have been transposed to the unexpected quarter of Petworth, whose master was a connoisseur and collector.

The paintings and sketches Turner did there—most of them never exhibited during his lifetime and unknown even to the collectors most interested in his work—are at once the most evocative and the most maddeningly unspecific records of his oddly complex and hidden spirit. These pictures represent his first complete release into color as a field of light and his approximation of abstraction by the treatment of paint simply as paint. But in every other way the Petworth pictures contrast with the rest of his work. They are interiors, for one thing—great halls or intimate corners of bedrooms sometimes recognizable as rooms at Petworth but, often too, as fantasies derived from them. The mood is warm and vibrant rather than violent, and—something exceptional in Turner's work—the scenes are dominated by the presence of human life. The human figures, it is true, dissolve into light along with architectural motifs and furniture. Like these, they glow yellow, orange, and vermilion—live coals without the violence of fire—but they are at home. Frequently the rooms are empty, but the human presence impregnates them. One of the most beautiful of the Petworth series, a watercolor (or gouache of some kind) only 5½ by 7½ inches (British Museum), shows the rumpled white sheets of an alcoved bed hung with orange curtains, a gilded chair alongside, and a bit of shadowy room and suggestion of a window beyond that. It was painted soon after Turner's preoccupation with Petworth began—about 1830.

Eighteen thirty is also the approximate date of a sketchbook of erotic scenes unconnectible in style or content with

anything else Turner ever did. The tiny sketches, somber in tone, at first seem to be hardly more than blots and scrubs. But from their darkness the figures of lovers appear, naked and coupled in curious embraces; the atmosphere is secret, hallucinatory, and threatening, the mood not so much one of sexual ecstasy as of nameless foreboding.

Egremont's death in 1837, when Turner was sixty-two, marked the end of what must have been the happiest period of his life. The last painting of the series, *Interior at Petworth* (London, Tate Gallery), is of a vast imaginary hall, shattered and melting in golden light and filled with the breath of phantoms—a final realization and a farewell.

In 1828 Turner had made a second Italian visit; later ones included at least three to Venice. His big house and gallery on Queen Anne Street had acquired a housekeeper named Hannah Danby, a niece of Sarah's. (One is left wondering whether, or how, or when, Turner saw his daughters, or anyone else connected with his early affair with Sarah Danby.) Hannah, a woman of notoriously repellent aspect, succeeded Turner's father as general factotum in the increasingly neglected house, and frequently made it difficult for visitors to gain admission to the gallery. Turner dispensed even with those amenities he and his father had enjoyed. Two years after the death of Egremont, he took a cottage at the corner of Cremorne Road and Cheyne Walk in Chelsea, where he spent most of his time, incognito. When he died there on December 19, 1851, at the age of seventy-six, the neighbors still knew him only as Admiral Booth, a retired naval officer who had taken to drink; the woman he lived with was known as Mrs. Booth.

Turner seems, indeed, to have taken to drink, but only at the very end of his life. The years after 1840 include some of his consummate expressions, although toward the last he became, for the first time in his fifty years as a prominent

artist, a dull and heavy-handed one. He exhibited four pictures at the Academy the year before he died, and even in the year of his death he managed to attend the varnishing day—often, in the past, the occasion for completing his canvases as they hung on the wall.

Turner left an estate of 140,000 pounds, which would be something more than three million dollars today. Although during his life he had never given much sign of interest in the welfare of his colleagues, he left funds to establish a foundation that would care for indigent artists. It died in the courts, but his daughters, after some legal complications, came out well. He was buried in St. Paul's.

The only critic who, during Turner's lifetime, had anything like a really clear idea of what Turner was about was John Ruskin, forty-four years younger than he, who had begun his major book, "Modern Painters," as a defense of Turner in 1843. But if Turner's contemporaries failed to recognize what was novel in his work, modern critics have more than made up the deficiency by a tendency to exaggerate his modernism. Perhaps that is not quite the right way to put it: the modern critic tends, rather, to concentrate on Turner's innovations at the expense of neglecting the expressive ends these innovations served.

As a proto-impressionist, Turner worked with gobbets of color, if you wish, but he held to no theories of broken color nor did he share the impressionist distrust of the heroic and grandiose. His goal was always epic, never intimate (with an exception of sorts in the Petworth interiors—but even these are epic abstractions in comparison with the comfortable domesticity of the impressionists). He was interested in Goethe's color theories, and worked out charts to analyze them, but in the end it was Goethe's ideas on the emotional associations of colors, and not on their physical characteristics, that affected him. Turner's closest connection with the im-

pressionist technical revolution was his method of creating luminous effects by painting entirely in light tones rather than by contrasting deep shadow and bright color. He thus identified light with pigment—the general goal of impressionist technique—but whether he was or was not a major influence on Monet, who saw Turners in London in 1870, is a question that has two answers, depending, usually, on whether you are reading a French historian or an English one.

Turner's approach was empirical no matter what his preliminary theories. The diarist Farington was saying something of the kind when he wrote, "Turner has no settled process but drives the colour about till he has expressed the idea in his mind." Turner probably wouldn't have put it quite that way himself, but the business of "driving the colour about" has been quoted to establish him as a distinguished grandparent of abstract expressionism, particularly the branch of it called action painting. There is a healthy germ of a relationship here: the late Turner paintings of storms, where the paint swirls in a great vortex, need only the slightest push to become abstract. Nature, however, is still recognizable—the elements are still discernible in their cosmic majesty—and that makes all the difference. At his most abstract, Turner is still employing pattern and color as a means to a specific and defined expressive end. He is not dealing with an aesthetic problem in which the means itself becomes the end—which is the exciting convenience, and the great tragedy, of contemporary art.

A curious figure, John Martin (1789-1854), is introduced here partly because he does not fit exactly anywhere. He was fourteen years younger than Turner and a long generation younger than Blake and Fuseli, who were still alive when Martin was in his thirties. He learned from all of them—the

"sublime" from Turner, the fantastic from Blake and Fuseli
—and can be called the last representative of visionary (in
the sense of hallucinatory) romanticism in England.

Sometimes awarded the sobriquet "Mad," Martin was
born in Northumberland of a mentally unstable family. (It
was one of his brothers, Jonathan, who set off the fire in
York Minster in 1829.) After some study with an Italian
painter named Bonifazio Musso, he came to London at the
age of seventeen and made his living enameling glass. By
twenty-two he was exhibiting at the Academy, and five years
later he made a sensation and became famous with his *Joshua
Commanding the Sun to Stand Still.* With other pictures on
heroic and fantastic subjects, some biblical, others semihis-
torical (*Destruction of Herculaneum*, 1822; Manchester), but
all violent in theme and in color—pictures where tiny human
beings bow to cosmic forces, usually wrathful, and a gran-
diose architecture soars in planetary landscapes—Martin be-
came part artist and part showman, staging his own spectacu-
lar exhibitions.

The public eventually tired of being stunned by his
colossal and ingenious horrors, but he retrieved his position
with a picture of the coronation of Queen Victoria. Among
the literary sources of his romantic melodramas were Byron,
Persian legends, and "Paradise Lost," for which he did a set
of illustrations. The fantastic architecture in his paintings is
convincingly structural, perhaps owing to his experience as
an engineer (he designed a scheme for improving London's
water supply). After a period of obscurity, not entirely unde-
served, Martin is at present the subject of a mild revival.

Thomas Girtin was Turner's exact contemporary by
year of birth, 1775 (and a year older than Constable). But
where Turner managed to live past the nineteenth century's

halfway mark, dying in 1851, Girtin barely managed to sur-
vive the end of the eighteenth. He died in 1802, at the age
of twenty-seven. He had been allowed barely five years of
work after he had discovered his own style. It was a style that,
forecasting the path followed by the English watercolorists of
the romantic school, made him, at least in spirit, an artist
of the nineteenth century.

Girtin was born in the London borough of Southwark,
the son of a brushmaker. His older brother was an engraver
—practicing as an artisan, however, not as an artist. When
he was fourteen, Thomas was apprenticed to Edward Dayes,
a topographical draftsman who turned out salable views of
the countryside, sometimes spotted with castles. After two
years with Dayes, Girtin was a good craftsman in this unam-
bitious genre.

When he was about eighteen, he met a man named
James Moore, a merchant who was also an antiquarian and
amateur draftsman. Moore was at work on a series of illustra-
tions to be published under the title "Monastic Remains and
Ancient Castles in England and Wales," and another collec-
tion of views of Scotland. He employed Girtin and Dayes to
polish up these illustrations from his original sketches, and
perhaps took young Girtin for a tour of the sites.

Nearing twenty in 1794, Girtin met the pioneer alienist,
Dr. Thomas Monro, who had already attached a young fel-
low named James Mallord William Turner to his circle.
Turner and Girtin became close friends and probably took
sketching trips together. At Dr. Monro's house they copied
drawings by one of his disturbed patients, J. R. Cozens. But
Girtin, so far, had not given much hint of an original talent.

This changed in 1796—he was twenty-one—when he set
out on a sketching tour of northern England. Like Turner,
he discovered a new grandeur in landscape. His topograph-
ical views now went beyond the delineation of hills, valleys,

and castles to become romantic responses to such vistas. Within a few years he was his own man, working independently.

But he was not a healthy man. He had begun to suffer from asthma, or some lung complaint that was called asthma. In 1801, twenty-six years old, he went to Paris, apparently in search of treatment for his ailment rather than for any reasons having to do with art, and he stayed there until May, 1802. Back in London he exhibited his *Eidometropolis*, a panorama of London on two thousand square feet of canvas, a most un-Girtinlike project in its large scale, of which not a scrap remains. He died six months after his return, in November. Edward Dayes attributed his one-time student's death to his "suffering the passions to overpower reason," a widespread romantic failing.

Historically Girtin is the painter who introduced into watercolor painting an emotive response to landscape fully developed later on by Constable and Turner—not necessarily under Girtin's inspiration. Because Constable and Turner lived to go far beyond Girtin, his work is difficult to recognize in its full originality. Yet he not only established an emotional rapport between the artist and a topographical scene, but, beyond that, developed a style of watercolor painting—free, spontaneous, sketchy—appropriate to its expression. Watercolor, before Girtin, had been a medium for tinting drawings. He made it a medium for direct painting, like oil. Some critics today recognize Girtin's originality but deplore as sloppy the watercolor tradition that he began. Others see him as the man who freed watercolor into areas of significant statement. Either point of view can be supported by good or bad watercolorists who have worked since Girtin's death.

John Crome, sometimes called "Old Crome" to distinguish him from his sons and followers John Bernay Crome and W. H. Crome, is an engaging personality and a moderately engaging painter among English romantic landscapists. He was born in 1768, the son of a weaver, in Norwich. In that city, where he lived and died, making only a few trips to London and one to Paris, he became the founding patriarch of a group of artists, few of much consequence, called the Norwich school.

After a brief career as an errand boy for a doctor, which is worth mentioning only because he later recounted, chuckling, that he used to change the labels on the medicine bottles for sport, he was apprenticed at the age of fifteen to a coach and sign painter. Over a period of seven years he thus learned painting of a somewhat crude sort. For the rest, he remained largely self-taught, although he did receive some help from Thomas Harvey, an *amateur* and collector who was attracted by some of the youth's early efforts to go beyond the coach and sign level.

Harvey allowed Crome to copy Gainsborough, Richard Wilson, Hobbema, and Cuyp in his collection, and also saw to it that his friends, William Beechey (1753-1839) and John Opie (1761-1807), successful portrait painters, gave the youngster help. Beechey set down a recollection of the eighteen-year-old Crome as an "awkward, uninformed country lad" who managed to make some shrewd remarks on art in spite of his difficulties with language.

In 1792, when he was twenty-four, Crome married Phoebe Bernay, who was pregnant, and the presumption is that they were quite happy together. He supported himself with a few sales of pictures and much teaching, especially of young ladies of good family, including one group of six sisters who, by the evidence of a diary kept by one of them, were much smitten with their instructor's charms. In 1801

he opened an art school in his own house, from which he and his students made excursions into the countryside, where innocent pastoral yearnings competed with painting lessons. He was also drawing master at the Norwich Grammar School.

In 1803 Crome organized the Norwich Society of Artists, a club with the purpose of selling pictures through exhibitions, and thus he became the founder of a minor school of English landscape painting. The only exotic adventure of his life took place in 1814, when, forty-six years old, he could afford a trip to Paris, with two men friends, to see Napoleon's art collection. (The looted treasures were on final exhibition before being returned to their rightful owners.) There exists a charming letter, that of a wide-eyed countryman in cosmopolitan surroundings, to his wife: "You may imagine how everything struck us with surprise; people of all nations going to and fro—Turks, Jews, etc. . . . We have seen three palaces. . . . I believe the English may boast of having the start of these foreigners, but a happier race of people there cannot be. I shall make this journey pay. I shall be very careful how I lay out my money"; and he signed himself: "I am, etc., yours till death, John Crome."

But his last words, before he died at the age of fifty-three, in 1821, were not to his wife but to another artist long dead: "Oh, my Hobbema, how I have loved you!" So, at any rate, goes the legend. Unfortunately Crome had little of Hobbema's power of organization or of any other kind. He was a painter whose response to landscape is apparent, but whose appeal comes largely from a limitation: he remained "an awkward, uninformed country lad" to the end.

John Sell Cotman is recognized today as the most distinguished of John Crome's colleagues in his Norwich Society of Artists. Unlike Crome, who began life poor and remained

simple and incorruptibly sane, Cotman started out in easy circumstances and was burdened with a neurotic flaw.

He was born in 1782, the son of a well-to-do draper and silk merchant who had been a hairdresser. At sixteen his parents sent him to London to study. He augmented a satisfactory allowance by working for Rudolph Ackermann, the printseller. As one of the youngsters accepted at the house of Dr. Monro, he copied drawings by Girtin and Turner, who were his elders by seven years, and probably met them both. By 1802, the year of Girtin's death, Cotman was a leading member of the Drawing Society—an informal club that Girtin had founded as a discussion group.

During these years, and for some years more, Cotman led a life that should have been most pleasant. He went on tours around England and Wales to make topographical drawings that, in his continuing prosperity, he had no urgent need to sell. He was exhibiting regularly at the Royal Academy. But in 1806 he seems to have had his first serious access of melancholia—he was also subject to sudden wild fits of gaiety—and decided to give up London entirely. He returned to Norwich, joined the Norwich Society (very small potatoes after London), married Ann Miles, a farmer's daughter, and kept busy with pupils, portraits, landscape drawing, and a circulating library of drawings that could be rented, for copying, by subscribers.

In 1812 he moved to Yarmouth; in 1822 he published, in partnership with a patron, Dawson Turner, a book on architectural antiquities of Normandy. In 1823 he was in Norwich again, and set up a drawing school. But his work had never come into popularity, and his private funds had been drained away by a large family. Stories of the hardships of his late days are usually exaggerated, but he was in financial difficulties, which must have increased the frequency and intensity of his melancholy periods. From letters to

friends one gathers that he despaired of life, of himself, of his art. He was fifty-two when Dawson Turner helped get him an appointment as drawing master at King's College, London (where Dante Gabriel Rossetti was one of his pupils), and he remained in that post until his death in 1842.

Cotman, never well known during his lifetime, was very nearly forgotten after his death. He is one of those artists who have been rediscovered by the twentieth century because he seems to have anticipated some aspects of the modern revolution. Much of his work must be discounted. Extremely uneven, he was frequently no more than a skilled and objectively respectful delineator of scenes and architecture; and sometimes, imitating J. M. W. Turner in the hope of sales, he produced pictures that are only thin, strident, and disagreeable. But at his best and most personal he gave to ordinary subjects a serene gravity, a reticent dignity, in which it is possible to imagine a spiritual kinship with Cézanne.

James Ward, a prodigiously productive engraver, lithographer, and painter who is remembered for a few successful pictures and one spectacular failure, could serve very well as the model for a type of artist who is lucky to be remembered at all—the man whose admirable ambitions are frustrated by a talent too modest to support them. Ward was the very model of the second-rater who confuses high intention with full achievement, and tries to reconcile himself to life on a basis of envy and resentment because the public, and his colleagues, have not found him up to his own measure.

Nevertheless, Ward qualifies as an interesting early English romantic and as a perfectly satisfactory if uninspired painter of animals. Awarded membership in the Royal Acad-

emy fairly early in his very long life (he was voted a full member in 1811, when he was forty-two), he was in demand for the kind of work he did best, the conventionally placid rendition of prize animals—not only horses, but also cattle, sheep, and pigs, which he immortalized for their breeders. But he failed to profit from the example of the great George Stubbs, a generation older than he, who had demonstrated that animal records could be elevated to the level of fine art.

Ward was born in 1769, the son of a London fruit salesman. He was doubly brother-in-law to George Morland (1763-1804), a carousing painter who equated rags with picturesqueness in scenes of peasant life. He married Morland's sister and Morland married his. Until he was about thirty, Ward was content to work in his brother-in-law's modest and rather sentimental style. In 1794, when he was only twenty-five, he was appointed Engraver in Mezzotint to the Prince of Wales. He was in his early thirties when he began those excursions into the romantic mode upon which his reputation still rests, whatever our reservations about them.

Ward must have known the series of romantically conceived paintings, a secondary aspect of Stubbs's art, that show a horse stalked and killed by a lion. But Ward's eyes were on the recognized giants, and he turned to Rubens and Paul Potter (then more of a giant than he is now) for inspiration. Combining the two, he drew upon Rubens's *Landscape with the Château de Steen* (London, National Gallery) for a sweeping backdrop for the battle of two bulls, these a direct challenge to Potter, and produced the painting that first comes to mind nowadays when his name is mentioned, *Bulls Fighting, with a View of St. Donat's Castle in the Background* (London, Victoria and Albert Museum).

Ward had all the makings of a great romantic painter except the last magical thing, whatever it is, by which emo-

tion is transformed into powerful emotive images. What he does is always done a little too obviously; he belabors rather than develops his ideas. And he was always picking up gauntlets. Because a connoisseur named Sir George Beaumont had said that Gordale Scar, a chasm between limestone cliffs in Yorkshire, was unpaintable, Ward set out to prove him wrong. His largest painting of it, along with several studies, is now in the Tate Gallery, London; smaller versions are in the Bradford (England) Art Gallery and in Temple Newsam, Leeds. All were made between 1811 and 1815, and proved, at least for the time being, that Sir George was right. The gorge's sinister character is mentioned by Gray, who says in a letter that he could not look upon it without shuddering, and by Wordsworth, who found it " . . . terrific as the lair where the young lions crouch." Ward tells us that the chasm is big (he greatly exaggerated its scale) and that he intends to show us its threat and its violence; but somehow he does not touch us. Like a cook intent upon combining the virtues of many dishes in a single one, he added a dash of symbolism and a scrap of historical reference, introducing a bull as the incarnation of strength, and a deer in allusion to the deer forest that existed there in the Middle Ages. He also confused mere record with emotional expression, supplying careful studies of local flora in the fashion of a botanical guidebook. As incidentals, none of these accessories need have been bothersome; the trouble is that they are symptoms of what was wrong with Ward as a true romantic: he tried to make up through process and program what he lacked in (to use the appropriate romantic term) divine fire.

His supreme effort was a supreme demonstration of these faults, a picture with a title so long that it constitutes its description: *The Genius of Wellington on the Car of War, supported by Britannia and attended by the Seven Cardinal*

Virtues, commanding away the Demons, Anarchy, Rebellion and Discord, with the Horrors of War.

Ward was forty-six years old. Elected a few years before to the Academy, he was at the height of his success when he received a prize of one thousand guineas for a preliminary sketch of the *Triumph of Wellington,* as it is called for convenience. He was commissioned to execute the subject for the new Chelsea Hospital and six years later he completed it at over double the requested size. (He increased it from 12 by 14 feet to 21 by 35 feet.) The picture was a resounding failure. No one liked it, including the hospital, which later returned it to the artist's family. It is now again in the Royal Hospital, Chelsea.

Ward was bitter in defeat, and complained that he was once more reduced to becoming "a mere Morland." Having come full circle, he set about doing a series of lithographs of famous horses, which are highly esteemed examples of their kind.

When Ward died in 1859 he was ninety years old. For thirty years he had virtually withdrawn from the London art world, where his reputation had steadily declined after the fiasco of the *Wellington.* He was an odd man, whose life and opinions give indications of the mystical quality that somehow never came through fully in his paintings. Religiously he was a follower of the apocalyptic cult led by Edward Irving. He was a firm believer in pure revelation as the artist's guiding star, and revelation is what he prayed for in his studio. He was among the minority who recognized Blake's genius, but with typical exaggeration he regarded Blake as a man possessed. He was unstable and given to petty rages: when one of a group of his paintings was rejected for exhibition at the Royal Academy, he withdrew the lot and held his own one-man show rather than permit any reservation as to the totality of his excellence. It was not so much in his art as in

his attitude toward it that James Ward showed himself a true romantic.

Samuel Palmer, usually referred to, but not quite accurately, as William Blake's most important follower, is the only member of the group of young artists self-christened "The Ancients" who can hold our attention today. Palmer was born in 1805 and died in 1881, thus attaining the age of seventy-six. After his death, his son wrote that the last forty years (or so) of his father's life had been "a dreadful tragedy," and this was certainly true of Samuel Palmer as an artist.

At fourteen (in 1819), Samuel Palmer was a child prodigy who exhibited three landscape drawings at the Royal Academy. From about the age of twenty until he was in his early thirties he produced a series of paintings—landscapes and small compositions involving landscape, architecture, and figures—based directly on nature but mystical in spirit. On the strength of these, he holds a firm, if rigidly circumscribed, position in the romantic movement. As he entered his thirties, Palmer left behind him a decade during which he had given signs of genius (or so it seems to us in retrospect), but by his mid-thirties he had turned into a painter of pretty, bright-colored scenes so obvious, so shallow, that even parasitic association with the early pictures cannot lend them an illusion of poetic expression or, indeed, much expression of any kind.

Palmer's father was a bookseller and a strict Baptist. The atmosphere of the home was both literary and religious, and the child was a precocious reader of poetry. From the first he was attracted to landscape as a mystical revelation; he seems to have had a spontaneous response to the cloisters-and-landscape union before it became a standard romantic theme. As he grew up and was given lessons, he was subjected to the

inevitable ideal of sentimental neoclassicism and drew from the antique. Antiquity left its impression on his work, but it is a surface impression only. In his fascination with soul-searching Palmer was anticlassical.

Palmer was a great landscapist, but in spite of some very English qualities he had virtually no connection, technical or spiritual, with the tradition of English landscape that reached its climax during his lifetime in the art of Constable. He was, instead, drawn toward an essentially Germanic mysticism. Although he based his art on the natural appearance of the countryside, he did not, like Constable, love this countryside as the habitat and friend of man. "I will, God help me, never be a naturalist by profession," he once wrote. He loved nature best when it was transfigured by moonlight or by the "raving-mad splendor of orange twilight glow." Such conditions best facilitated the communion of the soul with the universe.

"Vision" in all senses except clairvoyance is probably the word that comes closest to defining Palmer's art. Vision as an optical experience and vision as a mystical experience have never been more harmoniously fused in the art of a single painter, and when he spoke of his "Valley of Vision," referring specifically to the locale he liked best to paint, he referred secondarily to the spiritual ambience that produced his great paintings and then so mysteriously evaporated.

In 1824, when he was nineteen, Palmer met Blake through John Linnell. If he became "Blake's most important follower" it was in truth only because Blake had no followers, and Palmer became the finest artist among the group of young men who brought Blake a little welcome appreciation during the last years of his life. Palmer's notebooks indicate that he found a stimulation in Blake's company, and in his ideas, that he found nowhere else; there was something like a meeting of spirits between this youngster who could talk

of "receiving nature into his soul" and the old man who off and on during his lifetime held chummy conversations with celestial apparitions. But there was not a meeting of artists. Palmer's mysteriously shadowed and, literally, moony art had nothing in common technically with Blake's obsessively clean-edged forms. And in their attitude toward nature the two mystics were wide apart. For Blake, nature was the "vegetable" world and beneath notice; for Palmer nature was the manifestation of Christian mysteries, even when he saw it as the topography of Vergilian idealism. (Palmer not only illustrated Vergil's "Eclogues," but made a respectable translation of them.)

In 1827, now twenty-two years old and (as things turned out) just reaching the height of his powers, Palmer left London to settle in the Kentish village of Shoreham, where he found his "Valley of Vision." His decision was determined by the coincidence of ill-health and a well-timed bequest; together they justified his retirement to a place where his longing to commune with nature and paint landscape could be gratified. Shoreham must become, he decided, an ideal community in which he and his friends could create a new golden age. "The Ancients"—the name does not allude to the ancient world of Greece and Rome but reflects the group's ideal of primal simplicities in art and living—for a period of about seven years did manage to maintain an inspirational atmosphere in which Palmer did his best work.

After leaving Shoreham, Palmer traveled in Wales and then returned to London, where he married the eldest daughter of John Linnell in 1838. The two went to Italy, and whether because of marital trauma or increased contact with the tradition of Claude Lorrain, Palmer's art (not to be confused with his career) tobogganed. Suddenly he was no longer the young man who could write, "Sometimes the rising moon seems to stand tiptoe on a green hilltop," or could

see in moonlight the "mystic glimmer like that which lights our dreams," and who in his paintings could revivify the trite old simile of boughs arched like the ribs of a Gothic vault with an identification between nature and God in the harmonious paradox of a Christian pantheism.

Samuel Palmer's closest friend in the days when the idealistic "Ancients" worked in Shoreham, and the only other member of the group worth much attention, was Edward Calvert (1799-1883). To the quiet and bookish Palmer, Calvert must have been a romantic and adventurous personality. When they met in 1826, Calvert was a husky twenty-seven to Palmer's frail twenty-one, and already had adventures behind him. The son of a prosperous family, he entered on a naval career, and at fifteen was a midshipman. His ship saw service in the Mediterranean, bombing Algiers and cruising in the Aegean Islands. But Calvert the seaman went through some contradictory adolescent symptoms: in his cabin he wrote poetry, practiced drawing, and read Vergil. After six years he retired from the navy (at the age of twenty-one) and studied in Plymouth under A. B. Johns, a painter of ideal landscapes. As a student at the Royal Academy he met Fuseli and thus Blake and then Palmer.

During the Shoreham years, Calvert produced some exquisite wood engravings of immaculate precision and true poetic spirit, as well as some pantheistic and symbolical watercolors. Just as Palmer said that hills "should give us promise that the country beyond them is paradise," Calvert said, "I have a fondness for the earth and a rather Phrygian mood of regarding it. I feel a yearning to see the glades and the nooks receding like vistas into the gardens of Heaven."

But these vistas receded for him, instead, into sugary forms of classical idealism. The inspiration of Shoreham and

of Blake faded quickly after 1833. Palmer himself left Shoreham to move back to London, in part, at least, to be near Calvert. Calvert—who lived to the age of eighty-four—had always maintained a precarious peace between neoclassic reflections of the Platonic ideal and his Gothic-flavored Christian mysticism. He spent the last fifty years of his life as a pseudo-Hellene who kept an altar to Pan in the back garden of his London house and talked a great deal of nostalgic nonsense about the lost glories of Greece. He was a long way from the Calvert who in 1827 had published his first wood engraving, *The Ploughman, or the Christian Ploughing the Last Furrow of Life,* and distributed it to his friends with the accompanying legend "Seen in the Kingdom of Heaven by vision through Jesus Christ Our Saviour."

Alongside Samuel Palmer and Edward Calvert who were, if too briefly, true artists, we should mention a third member of "The Ancients," George Richmond (1809-1896). As the junior member of the group (he was four years younger than Palmer), Richmond was so wide-eyed at the age of sixteen that upon his first sight of William Blake he said he had met "the prophet Isaiah." Yet he borrowed freely from Blake's manner without ever giving any indication that he had the first inkling of what Blake was all about. He progressed, if that is the word, from borrowing from Blake to borrowing from Fuseli (on Blake's one hand) and Michelangelo (on Blake's other). But Blake's presence seemed to be the one thing that kept Richmond holding to the mistaken idea that he might be an artist capable of poetic expression. He went to Paris briefly after Blake's death and returned to London to make a success in the field where his talent really lay—fashionable portraiture.

Richard Parkes Bonington occupies a unique position as a liaison between romantic painters in England and France. He was English by birth but spent most of his maturity in France—such maturity, at least, as was granted him, for he died at the age of twenty-six or twenty-seven. He mastered a typically English style of watercolor painting under the teaching of Louis Francia, a Frenchman who had learned it in England. He worked with Delacroix at the time when the great French romantic was most interested in English painting, and learned from Delacroix just as Delacroix learned from him. He was popular on both sides of the Channel, and still is. With a consummate mastery of an English approach to landscape painting, he became a prophet of French impressionism.

Bonington was born in 1802, or perhaps in 1801, in Arnold, near Nottingham. His mother kept a school and his father was apparently versatile: although a drawing master and portrait painter of sorts, he was also governor of Nottingham Gaol, and when some irregularities in the administration of that institution were uncovered, he emigrated to France with his family, setting himself up in the lacemaking business in Calais. Bonington was about fifteen years old at the time of this move, 1817. Louis Francia (1772-1839), a native of Calais, had just returned there after twenty years in England, where he had been part of the heavy traffic of young artists who passed through Dr. Monro's house in Adelphi Terrace, and had learned watercolor technique from Thomas Girtin. This he taught to Bonington, as well as the technique of lithography.

Just when Bonington began to be able to sell his work is not certain, but he began early, perhaps not long after 1818, when he settled in Paris. He entered first the Ecole des Beaux-Arts and then, in 1820, the studio of Baron Gros—the true, if reluctant, father of romantic painting in France. As

part of his study, Bonington made watercolor copies of Dutch and Flemish landscapes in the Louvre, and it was there that Delacroix first spotted him, "a tall adolescent in a short jacket."

At twenty or twenty-one, Bonington made his debut at the Salon. This was the same year, 1822, that the twenty-four-year-old Delacroix made his first sensation with *Dante and Vergil,* a painting that Gros, a member of the jury that year, admired so much that he had it framed at his own expense. In the Salon two years later, Bonington received a Gold Medal (as did Constable for *The Hay Wain*), and Delacroix made his second and greater sensation with *The Massacre at Chios.* Whatever the closeness of their friendship before 1825, it was strengthened in that year when they both visited England, and it stood the test, in Paris, of a shared studio. They seem to have been generous on occasion, also, in sharing with one another their conquests in the demimonde. They must have been a fetching pair of young men—handsome, talented, socially adept, and with that special allure that invests creative people on the way up.

There was such interdependence between Delacroix and Bonington that it really cannot be said who influenced whom. They stimulated in one another a common interest in medievalism. Bonington, certainly, fed Delacroix's interest in English literature, particularly the novels of Sir Walter Scott as subject matter for romantic history pictures, but it was his fresh, quick touch in oil painting that Delacroix most admired—that he began, in fact, by envying. Later he changed his mind, over the years referring in his journal variously to Bonington's "coquettish touch" and "unhappy facility" and to his being "carried away by his own skill."

But Bonington was not carried away by his own skill. Dead at twenty-six, or at most twenty-seven, he was given no opportunity to prove himself as anything more than a su-

premely talented artist who, having mastered his craft, was ready to begin employing it in the fulfillment of whatever deep expressive potential he had. Bonington died in London, where he had gone for a visit, in 1828. He may have contracted the tuberculosis that killed him when he made a trip to Italy in 1826 to see Venetian painting.

However incomplete his achievement, and in spite of the confusion caused by quantities of forgeries and false attributions, Bonington remains unsurpassed except, possibly, by the impressionists in his use of oil to create sparkling effects of the transient aspects of nature.

24

THE
CLASSIC-ROMANTIC
SCHISM IN FRANCE

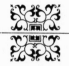

French artists born around 1770 were, perforce, hybrids, the products of a cross breeding of the classicism dictated as an official style by Jacques Louis David with the fervid romanticism of a defiant society. When this generation of young men were ready to study, the Davidian ideal was unchallenged in the studios, so the Davidian ideal was what they learned, by rote. When they came to make their careers, the Davidian grip on patronage was a monopoly, so what they had learned was what they practiced—as technicians. And yet all this time, Revolutionary and Napoleonic France had been conditioning these same young men in a school where turbulence, violence, and the wildest ups and downs of public emotionalism (hysterical reactions always—to glorious victories or ghastly defeats) denied every Davidian tenet of control, order, and rational creation.

As a result, French painting in the first half of the nine-

teenth century was split between ideals. A nominal classicism was enforced by the Academy even after romanticism had won the day. The division was often manifested not only between painters in opposing aesthetic camps, but sometimes, also, within the creative spirit of a single artist, where the conflict could be extremely painful.

David himself once said that the style he had introduced was too severe to please for very long in France. A painter only ten years younger than he, Pierre Paul Prud'hon, exemplified the kind of romantic swooning that flourished even during the nominally rational eighteenth century, and he will serve us here as an introduction to the group of romantic-classicists born around 1770, and to Géricault and Delacroix, who declared open warfare against the last-ditch classicism epitomized by one of France's greatest painters, Ingres. But it should become apparent that conflicting ideals were less under fire from one another than were the attendant means of expression—color, texture, and the like. The old battle between the Rubenists and the Poussinists had simply expanded into a new (and more confused) phase.

Pierre Paul Prud'hon was born in 1758 while Louis XV was in full flower on the throne. Before Prud'hon died in 1823, France had guillotined Louis XVI, had seen the rise and fall of the Revolution, the rise and fall of Napoleon, and the unimpressive rise, from this triple pile of ashes, of the restored Bourbons. During these sixty-five years of his life, Prud'hon must frequently have wished he were dead.

Although he is most easily pigeonholed as a neoclassical painter, and although he was ten years junior to David, Prud'hon really belongs more to the eighteenth-century tradition of erotic sensibility than to the Davidian tradition of classical discipline. Even David, who befriended him, called

Prud'hon the Boucher of his day. He was frequently a rather squashy painter: his languishing nudes, male or female, but usually female, are the too-lovely sculptured creatures of Canova seen through mists that Prud'hon borrowed from Leonardo da Vinci and Correggio. His art is one long sexual reverie in which the pleasure of yearning without any prospect, or any real need, of consummation identifies him as one type of romantic.

Prud'hon was the son of a stonecutter in Cluny, and one imagines him—unfairly, on the basis of his painting—as a sensitive, rather soft and pretty boy. As a youth in the provinces he found his first patron in the Bishop of Mâcon, who sent him, when he was sixteen, to the academy in Dijon. There he won first prize in painting and botched his life with a union of the kind sometimes called a marriage of honor but often, too, called a shotgun marriage. There was no love between him and the girl, named Jeanne Pennet, who was of low origin and unstable temperament. Prud'hon was nineteen at the time. He was forty-five before he was relieved of his burden.

He was twenty-two years old in 1780 when he went to Paris under the patronage of the Baron de Joursanvault and entered the Ecole des Beaux-Arts, supplementing his income by working for engravers (as he continued to do over the years). He was in Paris for three years and then returned to Dijon, where in 1784 he won the Prix de Rome—not the big Prix de Rome but a little one offered by the state of Burgundy. For four years, not working too hard, he basked in Italy, where he knew Canova.

In 1788, the eve of the Revolution, Prud'hon was back in Paris, scraping by with hack work. He exhibited in the Salon of 1791, but life was hard and he returned to Burgundy. For the most part he marked time; his only commissions of much importance during the next seven years were sets of

illustrations for Ovid's "Art of Love," Bernardin de Saint-Pierre's "Paul et Virginie," and Rousseau's "La Nouvelle Héloïse." In 1796, aged thirty-eight, he went back to Paris—it proved to be a permanent move this time—and shortly found himself a great success.

He knew very few painters, but he did have David's approval, and he became drawing master first to Napoleon's Josephine and, later, to his Marie Louise. He went about in Napoleonic society, and commissions came to him in quantity, not only for paintings but for decorations. He designed Marie Louise's bridal suite, including all the furniture, and the cradle for her poor little King of Rome. In 1803 he was able to obtain a legal separation from Jeanne. She had taken to forcing her way into the presence of his lady patrons, and her dramatically vulgar accusations against her husband became so embarrassing that she was committed to an asylum.

Now, for eleven years, until the defeat of Napoleon, Prud'hon's personal and professional lives were coincidentally rewarding. He established a liaison with his favorite disciple, Constance Mayer (1775-1821), twenty-eight years old and seventeen years younger than he, a talented painter and a woman of sensitivity as well as independent income. *Justice and Vengeance Pursuing Crime* (Louvre), his most ambitious painting and a most admirable one, commissioned in 1804, made his reputation in the Salon of 1808. He was offered more portrait commissions than he could accept. Among those he accepted was one to paint Napoleon's promiscuous sister, Pauline Borghèse, in the nude.

During these rich years, Prud'hon remained apart from his fellow painters and was repeatedly blackballed from membership in the Academy. He was finally admitted in 1816, when he was fifty-eight years old, but by then it was already apparent that he was not going to survive the Napoleonic debacle. After Waterloo his patrons fell away. His relationship with Constance also deteriorated. One day in 1821 she

stood in front of a mirror and cut her throat with his razor. Prud'hon never recovered from the shock. He died two years later and was buried in her grave.

In spite of his mawkish sexuality, Prud'hon was frequently a really beautiful painter. His portrait of Josephine in the woods at Fontainebleau (Louvre) is a romantic masterpiece, for all its artificiality and sentimental cast. Delacroix, born forty years after Prud'hon, admired him tremendously, which comes as a surprise from a painter who set such store by vigor. Delacroix wrote about Prud'hon as an artist who "allied the nobility of the antique with the grace of men like Leonardo and Correggio." The components—the antique and the two Renaissance masters—are recognizable, but today Prud'hon seems to have passed up the nobility in favor of Canova's pseudo-antique vanilla-flavored loveliness, and to have confused grace with insipidity in echoing the disturbingly softened androgynous forms of Leonardo's late paintings at their worst.

Still, Prud'hon could achieve wonderfully sensuous effects with a luminosity that did not totally sacrifice classical definition. This virtue is more apparent today in some of his drawings than in most of his paintings, since in the latter he employed the then-new bituminous pigments, which yielded wonderful velvety darks—and then cracked and blistered so badly that whole passages of Prud'hon's finest works, including *Justice and Vengeance Pursuing Crime,* are illegible. This means that Prud'hon at his best is lost to us. On the basis of what we can see, he is at first acquaintance an interesting but, in the long run, a disappointingly spineless artist.

Anne Louis Girodet-Trioson* (1767-1824) was a student of David's who managed to violate all the Davidian com-

* His name originally was Girodet de Roussy (or Roucy). Trioson was the name of his adoptive father.

mandments except the one for tight drawing and polished surface. His pictures are early catalogues of nearly every French romantic ideal except that of emotional vigor translated into rich pigment richly applied. And in a few sketches, Girodet approached even this painterly standard.

But even as a pictorial artist, Girodet was at heart a litterateur. In 1812, when he was forty-five, he celebrated the inheritance of a fortune by giving up painting altogether. With the shutters of his house closed against the daylight (romantic enough) he spent his time translating Greek and Latin poets and writing treatises on aesthetics (some of them in poetry) which are never read today and surely must never have been found readable except by their admiring author.

Girodet was born in 1767, and became a pupil of David's in 1785. He was eighteen. He is one of several painters described as David's favorite—all, it seems, with reason, since David kept changing his favorites as they failed, one by one, to meet his standards of loyal performance. Still a favorite at the age of twenty-two in 1789, Girodet won the Prix de Rome, and went to that city, where he spent four years. He wrote home that the Academy's Roman branch was a "royal sheepfold" where the fellows, sheeplike, were herded into conformity in a way not compatible with "men of genius and original work."

The sheepfold ceased to be royal with the consummation of the Revolution. The end of Girodet's stay coincided, in 1793, with David's order to take down the royal arms and put up those of the Republic. An anti-French riot ensued, in which the Academy's building was pillaged and its superintendent murdered. Girodet escaped to Naples, and then, by way of Genoa, reached France after some hardships in flight, hardships of a kind more enjoyable in romantic novels than in experience.

Once home, things went well for him. He was not only

a protégé of David's, but, as well, a socially well-connected young gentleman eligible for inclusion in fashionable intellectual circles and able to afford them. In 1801, the architect Fontaine commissioned him to do a ceiling for Napoleon's Malmaison, and the next year he completed it, producing one of the most curious pictures in the history of French painting: *The Shades of the French Warriors Led by Victory to the Palace of Odin, and Received by the Homer of the North and the Phantoms of Fingal and His Kin,* a title usually shortened to *Ossian Receiving Napoleon's Generals.**

Ossian ("the Homer of the North") was internationally fashionable and in France a fashion that had become a cult. But the idea of celebrating the Continental Peace of 1801 by showing the ghosts of Napoleon's generals (Kléber, Marceau, Hoche, Desaix, Dugommier, Joubert, all in careful portraits) being received into a romantic heaven by a Gaelic bard, rather than into a classical pantheon by Olympian Zeus, was a concept not calculated to please David—nor did it. Since David disapproved, the picture had a bad reception at the Salon, but Napoleon, an Ossian enthusiast, was delighted with it, so the day was saved.

With its bizarre mixture of Northern legend, current history, neoclassical draftsmanship and protoromantic drama, *Ossian Receiving Napoleon's Generals* is more interesting as a literary charade than as a work of art. But in another picture taken directly from a literary source, Girodet summarized consummately the rather precious sensibilities that flourished in literature as a romantic revolt while painting was still struggling for release.

* Ossian, or Oisin, was the legendary bard of traditional tales of third-century valor preserved in Ireland and Scotland. Like his classical counterpart, Homer, he was represented as blind and ancient. Ossianism, as a phenomenon of late-eighteenth- and early-nineteenth-century intellectual byplay, was generated by the Scotch writer James Macpherson, who in 1765 published, as translations of Ossian, a series of grandiose and moody poems of his own.

The picture is *The Entombment of Atala* (Louvre), il-
lustrating the final episode from Chateaubriand's short novel
"Atala." Atala, a beautiful half-breed girl of the American
wilderness, converted to Christianity, chose to die rather than
sacrifice the virginity to which her mother, with little fore-
sight, had pledged her, and she is shown—a lovely corpse—
supported by a monk (missionary in the wilderness) while
her Indian sweetheart, Choctas, clasping her knees in grief,
is depicted as a nude Roman gladiator in dark make-up.
Atala herself seems less a half-breed girl than a Greek goddess
in a gauzy classical robe. Ridiculous as all this sounds, the
scene, with its mysterious light and luminous shadow, is
poetically effective in spite of its extreme artificiality.

Chateaubriand's novel was originally planned as a sec-
tion of his "Génie du Christianisme," which, with Napoleon's
re-establishment of the Church after the Revolution, had
made Christianity fashionable in France. *The Entombment
of Atala,* along with *Ossian Receiving Napoleon's Generals,*
completed the list of Girodet's romantic loyalties. Christian-
ity, which is irrational, concerned with the supernatural, is
opposed to classical reason. Exotic and faraway places—a
never-never America, a Gaelic Valhalla—offer imaginative
release; the allure of the strange, the unexpected, and the vio-
lent replaces the security of classical rule and regulation. The
savage is ennobled in his simplicity—*for* his simplicity, in the
belief that nature in the raw is more profound than nature
reduced to order by the intellect. One recognizes, of course,
that all of these romantic hypotheses are belied by the hyper-
civilized and even chic manner of their statement. But within
his graceful and effete limits, Girodet stated the faith.

François Pascal Simon Gérard began life in Rome in
1770 as the son of a French father and an Italian mother,

both servants, and by the age of forty-four had acquired the title of baron at the French court. He owed his career to talent, luck, opportunism, and personal attraction, a familiar combination in success stories. The success, in historical retrospect, was so out of proportion to his contribution as an artist that it is difficult, today, to find anyone who will say a good word for Gérard either as a man or as a painter. But he was not all bad on either score.

Gérard had some early training under the sculptor Augustin Pajou (1730-1809), but his luck began when, sixteen years old in 1786, he attracted David's attention. David had made his epochal success with *The Oath of the Horatii* only the year before. Gérard became his pupil and for the rest of his life was David's closest follower in the rigorously disciplined style that no painter, in truth, managed to follow more than superficially. He combined the impersonal, meticulous Davidian technique with forms that were even less truly classical than David's own. His portraits are extremely graceful. Like David's they are sharply defined, but unlike David's they never reveal a personality beneath the immaculately and charmingly rendered mask.

As a youngster in David's studio, Gérard helped support himself by working for engravers. He was not quite twenty when the Revolution broke. During the following terrible years he avoided military conscription by serving as a judge on the Revolutionary tribunal—David, of course, having found this spot for him. By his record as a member of this body, Gérard would seem to have been an invalid. Actually he was feigning illness to bypass the responsibility of sending his fellow citizens to the guillotine.

By 1795 (he was twenty-five years old), Gérard had made his reputation as a portraitist, and during the Directoire years he became a great favorite. He remains the perfect Directoire painter when painting is thought of as an accessory to interior

decoration. By the time Napoleon established the Empire, Gérard rivaled David. And finally he excelled his master— not as a painter, but in political foresight—when he turned the Bourbon side of his coat outward in the most agile way. The friendship with David had cooled long since; David regarded Gérard's concentration on portraiture as a debasement of the classical tradition.

Talleyrand introduced Gérard to Louis XVIII, who made him court painter and then a baron during the first year of his reign, 1814, while David, perhaps, was still in a state of shock over the Napoleonic debacle. After David erred in mistaking Napoleon's brief return in 1815 for a permanent resurrection and was exiled in 1816, Gérard was left with no rivals. He maintained a large studio where assistants helped him turn out his glossy product, and lived as Baron Gérard for twenty-three years, dying in 1837 at the age of sixty-seven, having survived the Bourbons to become the reigning portraitist at the court of Louis Philippe.

In spite of his dedication to Davidian rules, Gérard was not a pedant. He was one of the first established painters to recognize the merits of the young Delacroix. "A painter has just been revealed to us," he said, and called Delacroix "a man who runs along the roof tops," referring either to *The Massacre at Chios* in the Salon of 1824 at the time that his colleagues were making a scandal of it, or to *Dante and Vergil* two years earlier. Baudelaire, in reporting the comment in 1846, is not sure which. He adds, "To run along the roof tops you need a firm step and an eye illumined by an interior light," and "Let glory and justice be accorded . . . M. Gérard." Delacroix wrote in his journal on August 19, 1824, "Saw M. Gérard at the museum. The most flattering praises," and Gérard asked him to dine in the country the next day. Many years later—1857, with Gérard dead twenty years—Delacroix wrote that he still found Gérard's work

"finely ordered" but lacking, like all Davidian painting, the warmth that comes from the mark of the painter's hand in the execution.

Even as a dedicated classicist, however, Gérard was not immune to romantic infection. In the Salon of 1822 (Delacroix's year as a debutant with *Dante and Vergil*), he made a sensation with *Corinne at Miseno,* a subject from Mme de Staël's novel, where wild emotionalism is indulged (and seems understood) as a romantic concept although not allowed to crack the mold of classical form. Commissioned in 1819 by Prince Augustus of Prussia, the picture was a sensation when it reached Germany, where it was copied several times and thus disseminated as an influence on German romantic painters. Augustus presented the original to Mme Récamier (who had suggested its commission in the first place). She hung it in her drawing room where, for a quarter of a century, it was greatly admired by French romantic litterateurs. In 1849 she gave it to the Musée des Beaux-Arts, Lyons, where it still hangs.

On June 25, 1835, the body of Baron Antoine Jean Gros, who had recently celebrated his sixty-fourth birthday, was found in about three feet of water in a tributary to the Seine below Meudon, near Paris. There has never been any question but that he had managed to drown himself. His suicide is usually explained as a result of his inability to reconcile the spontaneous emotional responses of a born romantic, which he was, with the inculcated intellectual loyalties of a trained classical painter, which he also was. Declining prestige and an unhappy marriage could have been additional reasons, but the conflict between his natural bent and the theories he held was a major reason all the same. It is conceivable that at any time in the history of art a painter

might have killed himself in despair over the quality of his work or the ruin of his career, but only in the first part of the nineteenth century, surely, was it conceivable that an artist should kill himself as the only way out of such a dilemma as Gros's—the incompatibility of theory and practice that split his loyalty between two opposed schools of painting. Schools had been opposed many times in the past, but not until the nineteenth century had aesthetic loyalties been propounded as aspects of personal morality and social responsibility. Gros was the victim of an inner struggle that concentrated within one poor soul the ferment of the classic-romantic battle that other artists fought happily as single-hearted partisans of one side or the other.

Gros was born in 1771. Both of his parents were practicing artists, and he had his first lessons from his father, a miniaturist. When he was fourteen he entered the studio of Jacques Louis David, and at this impressionable age was taught the classical disciplines. When he was twenty-one he tried for the Prix de Rome, but failed. The next year, 1793, he left France. He had attracted Bonaparte's attention and accompanied his army in a minor capacity as "an inspector at reviews."

His career opened in earnest in 1796 when, in Genoa, he met Josephine Bonaparte, who found him attractive and sponsored him socially. She even managed to get Napoleon to sit for his portrait—which he had always refused to do, except, once, for David—by the direct method of holding him on her lap while Gros made a study for a picture where the great man is shown under more heroic circumstances, the Louvre's *Napoleon at Arcola*. (Delacroix attests to the authenticity of this story in his journal.) Napoleon apparently did not resent the indignity, since he commissioned Gros to select from the spoils of war the works of art that should go to the Louvre.

In 1800, twenty-nine years old, Gros returned to Paris and over the following decade did his best paintings. Repeatedly he made sensations in the Salon, deifying Napoleon in large pictorial records of events from the campaigns. In the full flood of his creative powers and at the height of his public success he seems not to have cared—or not to have realized—that he was violating every Davidian principle. His color was warm and sensuous, his paint rich and fluid, his pictorial schemes dynamic. He represented events as he had seen them or as they had been reported, with emotional bias it is true, and taking romantic liberties, but never in allegory or other classical translation. Romantically he transmuted the horror, the suffering, the violence and the sordidness of war into a form of exaltation. In his hero-worship he created a dramatic Napoleonic legend that exposed David's classical machinery as a studio exercise, and by doing so he indicated the direction that painting was to follow under the romantic leadership of Géricault and Delacroix.

But Gros himself rejected the course he had set, turning backward on it after the fall of Napoleon. He tried to adapt his art to the glorification of the restored Bourbons, a notably colorless group of substitutes for his deposed god-idol, and he tried also to live up to a position he had now officially inherited as the head of the classical school. He took over David's studio in 1816 with the blessing of that master, who from exile exhorted him to train the pupils just as he, David, would have trained them. David also chided Gros with having painted no real history pictures. That is, he had dealt only with topical events; he had not gone to the ancient world for more transcendent subject matter.

In the service of the hardly transcendent Bourbons and classical subjects that he could approach only as an embalmer, Gros annihilated himself as an artist. In 1824 he completed the paintings for the dome of the Pantheon that,

projected ten years earlier as the consummate tribute to Napoleon, had been shifted to a narrative of French history creditable to the Bourbons. The decorations were just as uninteresting as might have been expected, but Charles X invested Gros with a baronage in appreciation of the transferred tribute. Gros was fifty-three years old.

Six years later, Victor Hugo's "Hernani" was performed, and partisans within the romantic-classical dispute came literally to blows. Thereafter the painter who should have been the great romantic of them all tried more desperately than ever to freeze himself into the classical mold. His paintings began to be laughed at in the Salon. In 1835 he exhibited *Hercules and Diomedes* (now in the Musée des Beaux-Arts, Toulouse), a painting of two grotesquely muscled giants intertwined. As an intentional parody of neoclassicism it would have been hilarious enough; the public and the critics found it even more hilarious as an unintentional one. Gros's last students left him and he went, alone, to the river.

Gros's tragic end makes him, among painters of the protoromantic generation, the antipode of Pierre Narcisse Guérin (1774-1833). Guérin was Gros's contemporary almost to the exact years of birth and death and, like him, was an avowed classicist whose name is important in the genesis of French romantic painting. But unlike Gros, Guérin was not much of a painter. He was a great success, one of those men who somehow find all good things falling into their laps. He had not been much interested in becoming a painter and was a lazy student, but he won the most coveted of student prizes, the Prix de Rome. Then in 1799, when he was twenty-five, he exhibited in the Salon a history subject carried through in the approved classical-academic manner, *Marcus Sextus Returned from Exile,* now in the Louvre. By lucky coinci-

dence, the picture seemed to have been conceived as a symbolical celebration of the return to France of the émigrés who had fled the Revolution. Thus interpreted, *Marcus Sextus* made a leading painter of Guérin, and he never lost that position. Later he painted Napoleonic propaganda pictures and, in what amounted almost to a divorced manner, scenes from classical dramas or legends in the style of their presentation by the Comédie Francaise—sets, costumes, and stage gestures included. Although he adopted Davidian principles in his easygoing way, Guérin was a student of David's only at second hand, by observation. His teacher had been Jean Baptiste Regnault (1754-1829), an early rival of David's who, as a classicist, continued the eighteenth-century tradition of sensuous grace that David had rejected.

Guérin's final honor was a coveted plum, the appointment, in 1822, to the directorship of the French Academy in Rome, that idyllic spot. But his greatest stroke of luck, as far as the perpetuation of his name in the history books is concerned, came through his students. In spite of its nominal dedication to Davidian principles, his studio was a hatching ground of French romanticism because both Géricault and Delacroix studied there. There is no indication that he understood their originality; he even advised Delacroix not to exhibit *Dante and Vergil,* which (exhibited despite this advice) was a sensation and became a historical landmark. But no matter. On the record, Guérin taught Géricault and Delacroix.

When Théodore Géricault died in 1824 shortly after his thirty-second birthday, he was an artist of sensational prominence although he had exhibited only three paintings. He cannot quite be compared to Masaccio in the fifteenth century, or to Giorgione in the sixteenth, who died at the ages

of perhaps not quite yet twenty-seven and thirty-two respectively but set courses that painting followed for a hundred years, or to Caravaggio in the seventeenth and Watteau in the eighteenth, who also veered painting in new directions but were granted a few more years to do so before deaths at thirty-seven. And yet Géricault can be called the first artist to work fully within the history of the nineteenth century as a generating force of its multi-faceted spirit.

He holds this position on several scores today, but could hold it on the strength of a single painting and very nearly did just that in his lifetime. The picture that made him famous, *The Raft of the Medusa,* became, within a few years of Géricault's death, a seminal work for two nominally opposed schools of nineteenth-century painting—romanticism and realism—and at the same time it was admired by neoclassical conformists, opposed to both these schools, as an example of picturemaking by the rules. But during Géricault's lifetime, to his distress, *The Raft of the Medusa* was more famous as the sensational document of a melodramatic scandal than for its merits as a work of art. These merits do, indeed, combine the usually incompatible elements of romantic passion, realistic observation, and classical rule.

Géricault was a young man with an exceptional appreciation of the dramatic flavor of violence. The sinking of the frigate Medusa in 1818 supplied him with a subject that involved storm, disaster, madness, and perhaps cannibalism among various other forms of physical and emotional pain and derangement. The Medusa sank off the coast of Africa with great loss of life. One hundred and forty-nine survivors were crowded onto a raft, improvised during the hours when the ship was *in extremis,* that was towed, briefly, by lifeboats. The cable either broke or, by a more dramatic accusation, was cut, and for twelve days the raft drifted while 134 of the 149 men died from thirst, starvation, exposure, suicide, and

murder. Géricault's picture shows the fifteen still alive, with a few dead and dying who have not yet been cast overboard, at the moment when despair turns into a frenzy of hope as a ship is sighted on the horizon. The struggling figures are interlaced in a spiraling rush of forms building to the triumphant climax of the one of their number whom they lift high. He waves his shirt at the ship miles and miles away.

When *The Raft of the Medusa* is freed from its topical reference, it can be (and has been) interpreted as an expression of the power of the human spirit, its will to survive, the triumph of moral energy over evil force. But for the public in 1819 it could be only a declamation on a disaster that had become a scandal. The Medusa was a government ship; its captain, a totally unqualified old émigré, had received his post as a political favor from the restored Bourbon regime. Géricault was opposed to this regime, but any political reference in *The Raft of the Medusa* is present only by association. Géricault's imagination had been electrified by the first newspaper account he read of the rescue, and he set about creating his monumental picture (it was unheard of to give this kind of attention to a current news event, except, of course, for the glorification of battles or the like) with the combined enthusiasm of an artist and a journalist. He worked for a year and a half, finishing at the end of August, 1819. (He was just short of his twenty-eighth birthday.) He had made countless preliminary studies, had interviewed the survivors, had built a model of the raft with the help of the ship's carpenter, and had visited hospitals to watch men die and to study their appearance in death—not as the anatomical specimens familiar to artists for centuries, but as case histories in a psychological study of death—and had bound everything into a formal scheme of classical balances and counterbalances. *The Raft of the Medusa* is almost 17 feet high and more than 23 feet wide. Now in the Louvre, which

purchased it after Géricault's death, it is rather badly darkened, but as a display piece in the Salon tradition it is still impressive in spite of a not inappropriate murk that partially obscures some of its most brilliantly executed passages. And as a pure work of art, it gives epic stature to what could have been only the record of a sensational bit of ephemera.

Speculation as to what Géricault might have done if he had lived a normal span is as inevitable as it is futile. He was an artist of tremendous strength and of a creative imagination that had only begun to unfold. He had been a strapping man and a great horseman (preferring stallions, and accused of overriding them in perverse pleasure), and he died miserably of complications following a riding accident. At the end of December, 1823, a month or so before Géricault died on January 26, 1824, the young Delacroix visited him and then wrote in his journal, "His emaciation is horrible. His thighs are as big as my arms. . . . And to die amid all that one has created in all the vigor and passion of youth, when one cannot move an inch in bed without the help of others!" Géricault had enjoyed a generous allotment of the vigor and passion of youth, both physical and intellectual, and until the last dreadful weeks he had had his choice of the good things of the world.

He was born in Rouen on September 26, 1791, and while he was still a child his father, a well-to-do lawyer, moved the family to Paris. When he was sixteen, Théodore entered the studio of Carle Vernet, famous for his painting of horses, but later the butt of Géricault's remark that one of his, Géricault's, horses could devour half a dozen of Vernet's, which was true enough.

When he was eighteen, Géricault changed masters and went to study under the easy-going Davidian disciple, Guérin. (Although Géricault did so much to birth the revolution that discredited the Davidian tradition, he admired the icy David

all his life.) In 1812, only twenty-one years old, he made
a Salon success with his first publicly exhibited picture,
Mounted Officer of the Imperial Guard (Louvre). It is a
rousing painting, a bravura performance that in its dyna-
mism denied all classical reserve. His teacher by example was
Gros, although he also received a bit of tutoring on how to
draw a rearing horse by reference to Raphael. In the Salon
two years later his *Wounded Cuirassier* (which, although in
the Louvre and habitually admired today, is a lamentable
piece of drawing) was not well received. Nevertheless, he won
the most coveted of all awards, the Prix de Rome, and set off
for the Academy's Roman branch in 1816.

He fretted in this Elysium of talent because, as he wrote
to a friend, "The five years granted to the students at the
Academy are more harmful than beneficial, since it prolongs
their studies at a time when they would be better off doing
their own work. They thus become accustomed to living on
government money, and they spend the best years of their
lives in tranquillity and security." He stayed in Rome long
enough to discover a new master in Michelangelo's Sistine
frescoes, and returned to Paris in 1817. Shortly after that, he
began work on *The Raft of the Medusa.*

The picture made such a sensation in the Salon of 1819
that Géricault expected that the government would acquire
it. Purchases of Salon successes were one form of subsidiza-
tion of the arts. But *The Raft* was not purchased, for the
obvious reason that it had been interpreted as political criti-
cism (although exhibited with the innocent title of, merely,
A Shipwreck). Also, a timorous Academy was still question-
ing the picture's lunging compositional scheme, although
later this was much admired. Géricault left for England,
taking *The Raft* with him, and exhibited it there for a fee
and made a comfortable sum. He developed a great admira-
tion for the English animal painters, and devoted himself to

enlivening his palette, with Constable as one of his preceptors.

He returned to France in 1821, and now, in the time left to him, less than three years, he painted ten pictures (of which five survive) that would have established him, in retrospect, as an interesting painter even if he had never painted *The Raft*. His friends included a Dr. Georget, who, as a pioneer psychiatrist, interested him in insanity as a human problem. In a series of portraits of Georget's patients, Géricault painted the first studies of mental derangement as something more than a freakish phenomenon, which it had been to the artists of the Middle Ages and the Renaissance, or a matter for clinical description, which it had been for Hogarth in the final scene of *The Rake's Progress*. The portraits are accurate in their delineation of such symptoms as can be observed and recorded objectively. But, more importantly, they are efforts to understand the alienated world that the victims inhabit. As the first great French romantic, Géricault was reflecting an obsession with the irrational that was common enough in other romantics, but these portraits rise above the sentimentality and the mystical picturesqueness that infects the general run.

Géricault as a personality eludes definition—perhaps because when he died he was still so young (granting that he was one of those people who mature slowly) that he was incompletely formed. Delacroix is supposed to have known him well, and certainly knew him over a period of years. But Delacroix's comments, in his journal, only increase our bepuzzlement as to what sort of man Géricault was.

When Géricault returned from Rome he was twenty-six years old to Delacroix's nineteen, a large gap at that time of life that Géricault had filled with as much adventure as possible in the role of man about town. He painted his young friend's portrait (Rouen, Musée des Beaux-Arts), exaggerat-

ing a wild romantic darkness yet revealing an essential naïveté that is borne out by everything we know of Delacroix as he left his teens. He painted his young friend, too, as one of the survivors in *The Raft of the Medusa,* and seems to have adopted him as a companion, while Delacroix adopted Géricault as a mentor.

In May, 1823, six years after their meeting, Delacroix wrote in his journal, "Géricault came to see me Wednesday, the day before yesterday. I was upset by his coming: how absurd!" When Géricault was dying, Delacroix wrote, rather oddly, "I sincerely want him to live." When he received news of the death, he wrote, "Although he was not precisely my friend, this unhappiness pierces my heart." His lament seems to have been not for a personal loss but for the disappearance of a vital object he admired: "What a different destiny so much bodily strength, so much fire and imagination, seemed to promise!" But two months later, "I have seen the death mask of my poor Géricault. O revered monument! I was tempted to kiss it. His beard, his eyelashes. . . ."

But then, immediately, "And his sublime *Raft* . . . what a precious reminder of that extraordinary man."

Romanticism, by the broadest definition, is a point of view that trusts emotional impulse before rational analysis—natural responses before intellectual conclusions. But like all very broad definitions, this one applies wholly to only a few specific instances, and is refuted by many when we get down to particulars. It certainly does not apply to the instance of Eugène Delacroix, who became by acclamation (rather than by choice) the standard-bearer of romantic painting in France and has been accepted, ever since, as its international godhead. Delacroix was a man who never indulged an emotional impulse without first examining it, and he evolved the

aesthetic tenets of his romantic code by applying classical disciplines to the creative process.

Romanticism is also associated with a way of life that releases its converts from the conventions that bind most of us. Here, too, Delacroix was a contradiction. He lived in a nineteenth-century Paris that bred the romantic bohemian as a type—the bearded artist with the pretty little shopgirl mistress, the shabby genius in the cozy garret, the free-and-easy habitué of the cafés and the boulevards where the joys and sorrows and battles of the creative life were shared by an informal community of artists and poets who enjoyed shocking the good, solid citizens—a type that persists today with the forms of self-indulgence called beatnikism and hippie-ism among its recent historical manifestations.

In the nineteenth and very early twentieth century, the bohemian rebel was a legitimate manifestation of an aesthetic revolution that reflected liberal thought. But Delacroix, a revolutionary deity, was an aristocratic gentleman who held himself aloof from the vulgarities of the garret, the street, and all eccentricity. He bestowed his presence upon a few of the most distinguished salons where successful artists were lionized, and upon the more choice ones where the great figures of the demimonde and the arts admitted worthy socially eminent patrons to their company. He was bored or repulsed by the company of most painters; he had no patience with their ways of thinking and living, whether these ways reflected the typical successful artist's adherence to a stuffy pattern of bourgeois respectability, or the rebel's flouting of that respectability. Delacroix felt more at home with writers than with artists, and was a natural writer himself—much more a natural writer than a natural painter. His journal, begun in 1822 when he was twenty-four, and then, after interruptions, kept every year from 1849 through the last fifteen years of his life, is one of the great testaments in the

history of art, and in many ways is more satisfactory as a revelation of his temperament and his convictions than is his painting.

Painting for Delacroix was a form of aesthetic dissertation rather than a form of emotional expression. This is a bothersome paradox in a romantic painter, and it makes Delacroix an oddly unsatisfactory artist in spite of the elevated position he holds and the universal admiration that is professed for his achievement. He was fanatically conscientious and industrious in the research he did for his paintings of historical subjects—not a man who depended upon the fire of romantic inspiration. In everything except his quickest sketches (where he is, in truth, most appealing) he labored, fretted over, planned, analyzed and deliberated every point of form, color, and subject. In spite of this he produced more than a thousand paintings, two thousand watercolors and pastels, and at least nine thousand drawings. Within this mass there are splendid passages, but there are also great stretches of boredom where the best one can do is respect the artist's integrity (that most admirable but least sparkling of virtues). Often enough even Delacroix's integrity produced nothing that can be truly enjoyed except within the context of his godhood.

With the generalship of the romantic army imposed upon him, Delacroix pondered his position. If he was a romantic, he said, it was because he insisted upon "the free display of my personal impressions"—a romantic tenet, and yet he never used his canvas as a confessional. He recognized himself as a romantic in his "repugnance for the types invariably admired in the schools and for academic formulas," and yet this is a negative allegiance: it is not pro-romantic but merely anti-academic. Delacroix was not interested in establishing new values in the art of painting. On the contrary he wanted to re-establish values of the past that had

been lost or deformed by the Academy. And this is the first imperative if he is to be understood: remember that he was not a revolutionary but, at most, a reformer who recognized that the Academy misinterpreted the past whose ideals it professed to perpetuate. His eye was always on the past: his definition of the ideal romantic style was "a combination of Michelangelo and Goya."

Delacroix thought of himself as a true classicist, and said as much. In music (which was his passion, where painting was only his obsession) his great men were Mozart and Gluck and, among his contemporaries, Chopin, who was a close friend. Delacroix never understood the declamations of Berlioz, which were more closely allied to his own theories of painting than were Chopin's intimate, poignant, and brilliant reveries. Nor did he admire Victor Hugo, the literary figure to whom he was always compared. The reward he most coveted was recognition by the Academy whose weaknesses he constantly exposed. He applied for membership again and again—nine times in all—and was consistently blackballed by the votes of artists now forgotten until, old, sick, and discouraged, he was finally granted the meaningless kudos of election to this group dominated by nonentities.

In physical stature Delacroix was a little man. He had the kind of body—well-chested and narrow-waisted—that in a little man always recalls a bantam rooster. A bachelor all his life, he exercised his masculine force generously in numerous affairs, sometimes, in passing, with a model ("I took a bad chance of a disease with her," he notes in his journal, commenting on a postscriptual adventure after a session at the easel), or in affairs of long duration, such as that with his cousin Joséphine de Forget, an attachment that lasted, in one form or another, from 1834 until his death nearly thirty years later. If an average is struck, Delacroix's preference in women seems to have been about equally divided between

those of his own class who were already married and hence ineligible as prospects for the halter of matrimony, and those in the upper brackets of domestic service who would accept a relationship without hopes of marriage.

Atop his small body Delacroix had a large head made larger by a well-tossed mane of black hair. It was a good head. He held it high and painted it several times in full recognition of its individuality—its combinaton of a short, blunt nose and an aggressive jaw like a pugilist's with alert dark eyes beneath the noble brow of a poet and intellectual. The head is carried almost arrogantly in these self-portraits, too vigorously to give an impression of unqualified hauteur, yet still with an air of disdain for any little persons (of whatever physical stature) who might not recognize its distinction.

Delacroix was impatient with stupidity, which is natural enough, but he was also impatient with any lack of finesse or social aplomb. He was a bit of a snob in his choice of the houses he visited, but social position was not enough to make a hostess attractive to him. Within the fashionable world he was further selective on the basis of intellectual companionship. Everywhere he was much courted, for he had everything to offer—his looks, his elegant manner, his brilliance, his eminence as a painter (made even more interesting by its controversial nature), and a social position by right of a birth that had the added piquancy of having been almost certainly the consequence of a scandalous affair within the aristocratic preserve.

Delacroix was born to the good life as the putative son of Charles Delacroix, a diplomat whose career had begun with election to the Convention of the Revolution. Subsequently Charles Delacroix held a series of desirable posts, and was Foreign Minister at the time of Eugène's birth, which was registered on April 27, 1798. But there is very little chance that Charles Delacroix was Eugène's father and every

chance that a much more distinguished statesman, Charles Maurice de Talleyrand-Périgord, was.

Charles Delacroix, who was seventeen years his wife's senior, had not fathered a child since the birth, fourteen years before the birth of Eugène, of the last of his three children. It was well known that he had become the victim of a tumor of the testicles that made intercourse impossible, and to this unhappy situation he was apparently resigned. After so long a time, he subjected himself to an agonizing and hazardous operation for the tumor's removal, and then made a public declaration of regained potency. He had a pregnant wife to prove it. But the operation had been performed only seven months before the birth of a full-term baby, and two months after Talleyrand had shared living quarters with the Delacroix family in the Hôtel de Gallifet, exactly when Talleyrand was succeeding to Charles Delacroix's post as Foreign Minister, and Charles was beginning a stint as Ambassador to the Netherlands.

Although Charles's operation was of a kind ordinarily performed without fanfare, he gave a dinner party beforehand to celebrate his decision to submit to it—an odd thing to do. Odder still, the operation was publicized, after his declaration of potency, in a medical pamphlet that was under Talleyrand's indirect sponsorship. But if these gallant manipulations deceived anyone at the time, the boy himself eventually offered the most conclusive evidence of his true parentage. Eugène Delacroix grew up to look nothing at all like Charles Delacroix, and very much like Talleyrand.

This question of parentage would be of only anecdotal interest if Talleyrand had lost all interest in the boy, but apparently he did not, and the direction that his interest took had some effect on the history of nineteenth-century art, making possible, for Eugène Delacroix, certain achievements that otherwise would not have materialized—at least not in exactly the fashion they did.

Eugène Delacroix and Talleyrand perhaps met after the boy was grown, but no one knows exactly what Delacroix himself knew, suspected, or cared about his probable paternity. When he was a child the family, understandably, ceased relations with its erstwhile guest. But after Delacroix was grown, he received a series of awards and commissions through the state that are explicable only by the presence of a powerful influence behind the scenes—which Talleyrand was, and which the memory of Charles Delacroix's services to the state could hardly have been. When Eugène was only twenty-four the government purchased his *Dante and Vergil* from the Salon of 1822 at a generous price, although it was by a newcomer and had been as much attacked as praised. Ordinarily the official purchases went as awards to established reputations whose submissions to the Salon had been acclaimed by critics appended to the Academy. *Dante and Vergil,* now in the Louvre, was only the first of a series of purchases and commissions that went to Delacroix, to the impotent fury of the academic hacks. Impotent, that is, except that the hacks could still blackball him from the list of the officially elite.

Talleyrand's role as a protective parent from a distance can only be presumed. Delacroix once complained that the only man in an official position who had ever held out a hand to him was Adolphe Thiers, but he hardly needed a better hand than this politician's, even though Thiers went back and forth in and out of power several times during Delacroix's lifetime. Talleyrand lived until Delacroix was forty; Thiers was Delacroix's age plus only one year, and outlived him. Thiers was not greatly interested in art, and there is no reason to think that he kept a benevolent eye on Delacroix because he shared his theories of art or cared very much one way or another about the classic-romantic controversy. If anything, Thiers might more reasonably have been expected to support the Academicians as the government-sponsored

representatives of French culture. And yet, with Thiers' help, Delacroix became virtually a ward of the state. An assumption unsupported by any known facts might be risked—that Talleyrand was pulling the strings.

It would have appealed to Talleyrand to have a son of Delacroix's caliber. When the young Delacroix began attracting attention in the Salon, Talleyrand must have decided that this (from among the several children he had sired with equal informality) was a son worth sponsoring. For Talleyrand, unlike Thiers, was a man whose life, divided between two centuries, had brought him the cultivated tastes and interest in the arts typical of an eighteenth-century aristocrat.

Delacroix needed his income from the government, and much of the time he managed to survive only because of it. A great deal is always made of his financial difficulties, and it is true that he was never quite secure after he lost an inheritance in litigation.But insecurity for Delacroix meant that he could not live like an aristocrat. He was more at home in the world of eighteenth-century patronage than in the world of nineteenth-century commercial competition. He was never in want, but he lived simply—increasingly simply as he grew older. This, however, was apparently more from preference than from necessity.

When he died in 1863, at the age of sixty-five, Delacroix was a virtual recluse in the studio on the Place Furstemberg that is now his museum. There he was guarded by a loving dragon called Jenny Le Guillou. Jenny was a simple, uneducated woman—and, by the evidence of Delacroix's portrait of her (Louvre), a homely one in an earthy way—but she became not only the great man's housekeeper and watchdog, but his closest companion and best audience as well. Baudelaire, who of all Delacroix's contemporaries best understood what his art was all about and whose defenses in print were the major source of such public appreciation as developed

during Delacroix's lifetime, wrote that he had seen Delacroix touring the Louvre with Jenny and inducting her into the mysteries of Assyrian sculpture.

Delacroix's life during the last years was reduced to the simplest, almost to ascetic, terms that would allow him to work from seven in the morning to three in the afternoon whenever his health permitted it. But he was prematurely aged by illness and, although he managed to make his appearance at official functions, he socialized less and less. For the very young painters he became a symbol. He had never taken students, but had taught by example how to free color in ways that were contributing to nascent impressionism. The young men who were to be called impressionists, when that word was coined later, so venerated him that when the young Monet discovered a window in a neighboring building that afforded, now and then, a glimpse of Delacroix at an easel set up in the garden of his studio, it was as if he had found a rift in the clouds and caught a glimpse of some divine figure.

But it was not only Delacroix's technical contribution that made him such a figure. More than that, he had been vehemently and conspicuously the defender of the artist's right to paint as he pleases. That his own work was not really revolutionary at base does not reduce his importance as a defender of liberty. His battle was not against tradition but against the blindness that identified tradition with ossification. He was not interested in a revolution that discarded the past. He wanted to nourish a living growth from the past's living roots.

As a boy, Delacroix received the good education normal for a member of a family almost wealthy and of good position. In his early teens, he scribbled a few drawings that only in retrospect can be thought of as hinting at much more than a respectable talent, and when he first began studying with Guérin he seems not to have been ambitious to acquire more

than the proficiency of an *amateur*—in the French sense of that word as a cultivated hobbyist.

Guérin, an easy-going classicist who rode along successfully with the tide but had no very strong convictions one way or another, was hardly the person to stimulate the young man to a passion for art. The catalyst was another of Guérin's students—Géricault, who was seven years older than Delacroix. The two may have met in passing in the studio, but their friendship began in 1817 when Géricault returned from a Roman stay. During the next year Delacroix, now twenty, watched Géricault at work on *The Raft of the Medusa*, so antithetical, in its passion, its violence, and its realism, to Guérin's polite and sugary confections. Delacroix had of course been exposed to other less sugary artists—including Gros—but the direct contact with Géricault and then the excitement of the scandal that burst upon *The Raft of the Medusa* set him in the direction of dramatic statement and gave him an early faith in individual expression as opposed to the observance of conventional niceties.

Dante and Vergil, which Delacroix began painting shortly after the *Medusa* scandal, was the immediate expression of Géricault's influence, which had considerable buttressing from Michelangelo and Rubens, who, with the great Venetians, were Delacroix's mentors among the old masters all his life. Among living painters he shortly found another mentor by example in John Constable (who had already been discovered by Géricault during a visit to England). He was so impressed by Constable's *The Hay Wain* in the Salon of 1824 that he virtually repainted his own entry for that year, *The Massacre at Chios* (Louvre), in his excitement over the discovery of Constable's fresh color applied in juxtaposed strokes—the germ of the impressionist revolution.

Of all French painters, Delacroix probably owes the largest debt to England. His immediate technical debt was to

Constable, but he was inspired, too, by English literature. The romanticism that left him cold to Victor Hugo appealed to him in Sir Walter Scott, and where his conventional contemporaries in France drew their themes from the dramas of Corneille and Racine he drew his from Shakespeare. And although he was too cool, too rational, and too detached a spirit ever to have considered undertaking the kind of adventure that carried Byron to Greece (and to his death there), he so admired Byron that at times he seemed almost to regard him as an alter ego.

In 1825—the year after his discovery of Constable, and also the year after Byron's death—Delacroix went to England for three tightly packed months. He disliked the country at first, and never did respond to the English countryside; Delacroix was a Parisian first and always. The English trip increased his interest in English literature in its grandest or most grandiloquent forms, but English coziness appealed to him not at all. Nevertheless, when his good friend Bonington worried that his own pictures might be too small and intimate, Delacroix (always an acute critic) advised him to stick to the virtues peculiar to himself rather than to sacrifice them to ambitious schemes foreign to him. The advice has been proven sound: Bonington's fresh, poetical landscapes have endured, while his more ambitious history pictures are bores.

It seems to have been Bonington who introduced Delacroix to Aimée Dalton or, perhaps, turned her over to him. The subtlety, complexity, and seeming inconsistency of Delacroix's character is revealed in several facets of the affair that followed, not because it was an intense one, but rather because it was so casual, sometimes even appearing callous, that in spite of its continuation over fourteen years—from 1825 to 1839—"affair" is too strong a word for it. Delacroix, who in sudden sexual encounters had a quick, fierce lust, and who in an extended affair could be tenderly devoted, commented

that Aimée had "a good heart," and that an attachment with such a woman was "as good as any." An artist and critic of demanding standards and a proud man who was not an asker of favors, he nevertheless pulled a string or two with journalists when Aimée had paintings in the Salons. He felt no obligation of faithfulness to her; she was apparently just there, rather comfortably. When she had a chance to take a job as drawing teacher in Algiers, Delacroix bought her a ticket and shipped her off.

In 1832, Delacroix had made his own trip to North Africa, and it was probably the most decisive single experience of his life as an artist. He had had a literary acquaintance with exotic countries, and in paintings like the Louvre's huge *Death of Sardanapalus* of 1827—the subject having been taken from a play by Byron—he reflected the synthetic Orientalism popular with other romantic painters and writers. But now in Morocco he saw at first hand all the color, the violence, and the brilliant light that he had (so to speak) only talked about in his paintings.

He was attached to a mission organized under his friend, the Count de Mornay, who was charged with the duty of placating the Sultan of Morocco following France's conquest of his neighbor, Algeria. Delacroix had no duties; his presence was another example of his convenient rapport with the state—although the suggestion that he go along seems, this time, to have come from a delightful creature named Mlle Mars, a comedienne and courtesan who was currently Mornay's mistress.

During the trip Delacroix complained that he had no opportunity to make adequate sketches: if he had gone out alone he might have been stoned or shot. But during short official excursions or from the safety of the windows of the shelters where the mission was lodged he made brilliant sketched notations, sometimes in pen with quick dabs of

color, sometimes only with scribbled memoranda of colors. The pages of his journal during this time are electric, and the quick sketches and the sometimes almost frenzied jottings-down of impressions served him the rest of his life as pictorial sources. But he had no interest in exploiting the subjects as picturesque Orientalia. Using their high color, their drama, frequently their violence (and always their removal from mundane familiarity) as his point of departure, he transmuted the merely picturesque into generalized statements of human passion.

There is, however, hardly such a thing as the typical Delacroix, although there are numerous paintings that typify him in his variety, from the glowing, surging, and stormy paintings of Arab horsemen and the fluent notation of some of his best drawings, to the rather stuffy, overworked, and belabored late murals in the Church of St. Sulpice, or from the lovely flower pieces and the quick, sensitive portraits of friends to the frequently tiresome history paintings.

In 1855, when Delacroix was fifty-seven, he was given an exhibition to himself, consisting of forty-two paintings, in the huge Salon of that year. The honor was rather explicitly symbolical of his curious position as an artist of national eminence yet still denied official honor. The Salon was planned as a feature of the Exposition Universelle of that year and was intended to demonstrate the transcendent position of France in the arts, and yet Delacroix, starred in tandem with his arch opponent, the classicist Ingres, had yet to be elected to the Academy. This tardy recognition was given him two years later, in 1857. He was nearly sixty, much withdrawn from the world, and already in failing health. He must have received the hollow honor with a combination of amusement and bitterness.

Alexandre Gabriel Decamps (1803-1860) must be given postscriptual comment as a colleague of Delacroix's who, during their lifetimes, rivaled Delacroix in the opinion of many perceptive critics and far surpassed him in public favor. He was an Orientalist who frequently adapted this popular exoticism to biblical scenes, modifying Delacroix's manner with Rembrandtesque effects of deep shadow and yellow lights. He visited North Africa before Delacroix did.

Delacroix, five years older than Decamps, first met him when they were both young men. In their middle age (1847), Delacroix said, amazingly, of Decamps' *Samson Turning the Millstone,* "there is genius in it." Six years later he said that in a *Joshua* by Decamps "the distribution of the groups and of the light approaches the sublime." In 1855, Decamps had fifty paintings in the great international Salon, thus joining Delacroix and Ingres in official recognition as one of the three great painters of the nation.

But by 1860, the year of Decamps' death, Delacroix had come around to a point of view even harsher than ours today on Decamps' art. He wrote in his journal that he found the paintings in a new exhibition ". . . antiquated . . . stringy; he still has imagination, but no drawing whatever; nothing becomes so tiresome as that obstinate finish over that weak drawing." Decamps does not seem quite that weak today, although he is that bothersome thing, an apparently intelligent painter who somehow just doesn't come off as an artist. He was a political caricaturist of some wit, and occasionally a satirist; in one picture, now in the Metropolitan Museum, he represented art experts standing in front of a painting as a group of monkeys in tailcoats.

Jean Auguste Dominique Ingres, one of the greatest artists of a country that has produced so many, was the official

representative of neoclassicism in its struggle to the death—
its own death—with romanticism. As commanding general
of the forces bastioned in the Academy, Ingres was pitted
against a formidable opponent, Delacroix. But Delacroix,
even as a youngster (there was a difference of eighteen years
in their ages), admired Ingres. Ingres, less generously, refused
for years to shake Delacroix's hand, relenting only in his
old age.

Ingres's real opponent was neither Delacroix nor even
romanticism in general, but the Academy he swore by. Be-
fore Ingres came into its leadership, this increasingly hide-
bound institution and its satellites among critics had given
him an extremely rough time. He was attacked within his
own camp with a malevolence (and a stupidity) that the ro-
mantics never inflicted upon him. These younger men sensed
in Ingres's art qualities that he himself, as a rather pedantic
public figure, did not recognize for what they were. His
yearnings toward sensuousness, his tender responses to sym-
pathetic personalities, his love of exoticism with its strange
trappings and its promise of strange pleasures, usually sexual,
of kinds denied this honest, upright representative of the
bourgeoisie—these were aspects of personal sensitivities that,
expressed in his painting, separated it from the impersonal-
ized standards of the ideal he thought he followed. Although
he distilled experience (and yearnings for experience) by sub-
jecting it to processes of drawing and painting taught him by
David, his art was a deeply personal sublimation that he
thought of, with his special kind of lifelong intellectual inno-
cence, as an abstraction of the classical disciplines.

Ingres was of simple but respectable origin, and the
consciousness of this fact stayed with him always. The parents
of Gérard (who was ten years older than Ingres and his only
rival as successor to the authority of David) had been serv-
ants before the Revolution, but Gérard, a different sort of

man from Ingres, accepted his rise to the position of social lion, and his title of baron, with great élan. Perhaps some early rejections—as an artist and as a suitor—gave a permanent set to Ingres's youthful uncomfortable awareness of his modest social position. He remained, at any rate, a modest man, never really at home in high society even after his entree was undisputed.

Ingres was born in 1780 in Montauban. His father, barely describable as a sculptor, was a designer and carver of architectural ornaments, including garden sculpture, who also had some skill as a painter and amateur musician. The boy's formal education began at the age of six and ended four years later when he was taken out of a school run by the Brothers of the Christian Doctrine and, shortly thereafter, sent to Toulouse to enter the academy there. The disruptions of the Revolution might have accounted for this change. The provincial academies, at that time, were still training schools where one could learn an income-producing craft.

Ten years old when he left Montauban for Toulouse, Ingres studied drawing, painting, sculpture—and the violin. At thirteen he was partially self-supporting as second violinist in the local orchestra. He combined this profession with study in the academy, winning drawing prizes. In the month that he turned seventeen, he left for Paris to study with David. But the violin was not abandoned. As a student he continued to pick up money playing in theater orchestras, and throughout his life his violin remained a solace and companion. The phrase *"violon d'Ingres"* has entered the French language to designate a hobby that is more than a hobby—a hobby that is part of the heart.

By the time he was nineteen, Ingres was David's trusted assistant. But there was some kind of quarrel, or at least a cooling of trust and affection, and Ingres was relegated to David's considerable company of ex-favorite students. Part of

the reason could have been that Ingres found a rival mentor in the work of John Flaxman, the English draftsman and designer whose Gothicism was as strong as his more celebrated classicism. Even under David, Ingres had been developing a style less icy than the master's, more graceful in its contours, and adulterated by hints of the linear sinuosities that characterized the mature Ingres at his best. Still malleable at twenty, Ingres included within his other enthusiasms a reverence for Raphael that increased, eventually, to a form of idolatry—not always to Ingres's benefit.

Ingres entered the Academy's school, the Ecole des Beaux-Arts, in 1799, and after winning prize after prize for two years, won the grand prize, the Prix de Rome, in 1801 just a month after his twenty-first birthday. But the prospect of four years in Elysium (and close to Raphael) met with a hitch. The French treasury was so enfeebled that there were no funds for the fellowship. Ingres waited in Paris for five years before the funds came through.

They were productive years: from boyhood until death, Ingres was as industrious as an inspired ant. He exhibited in the Salon for the first time in 1802, found private and official portrait commissions, set himself up in a studio where he continued his studies under his own expert tutelage, made some serious friends among other artists, eschewed the bohemian life, and fell in love with a girl named Anne Marie Julie Forestier.

Julie Forestier was the only child of a prosperous family several social cuts above Ingres (her father was a judge). She was talented enough to exhibit, in the Salon of 1804, when she was twenty-two, a painting called *Minerva, Goddess of Wisdom and Fine Arts,* a fine subject for a young lady tinged with bluestockingism. Ingres's drawing of the Forestier family in that same year shows Julie standing with one hand touching the keys of a piano (another talent?) and receiving

the adulatory gaze of her father. She had, by Ingres's trustable reflection of it, a round, quiet face, neither plain nor pretty, with full, soft features.

Two years later, in the summer of 1806, Ingres and Julie became engaged, and at the same time his travel funds at last came through. But this good moment in his life was scotched by his first collision with the critics. In the September Salon he exhibited a group of portraits— among them one of himself (Chantilly, Musée Condé), one of Napoleon (Paris, Musée de l'Armée), and three of M. and Mme Rivière and their daughter (all now in the Louvre). The portrait of Mme Rivière, with its exquisitely convoluted lines flowing from more serene rhythms, like sudden ripples in a stream, or like drifting smoke in an unexpected current of air, remains one of Ingres's half dozen or so finest paintings. But along with the others in 1806 it was attacked as if the critics were blind. The linear complexities were called "Gothic," a term quite justifiable as one of praise. But since everything Gothic was reprehensible in its opposition to anything classical, the term was opprobrious. The paintings were also called "vulgar," a term possibly applicable to some of Ingres's later works, but not to these. Ingres's almost caressing tribute to the allure of a beautiful woman in the portrait of Mme Rivière was offensive to tastes that had been conditioned by the mincing refinements, often lascivious beneath their affectations, of the run of fashionable portraits at that moment.

Ironically, Ingres could never have won the Prix de Rome with these pictures, but simultaneously he picked up his delayed reward for the rather saccharine exercise (*The Envoys from Agamemnon*; Paris, Musée de l'Ecole des Beaux-Arts) that had brought the prize to him five years earlier. He left for Rome confused and wounded. But the city enchanted him at first sight. He sent Julie paintings and drawings of the Villa Medici where the French Academy was set up, and

of other favorite spots that combined for him the excitements of an adventure and the satisfactions of a spiritual homecoming. He wanted Julie to join him there. Her father said no, and considered Ingres's unwillingness to give up Rome for Paris an indication that he did not think enough of the girl to be worthy of her in marriage. Her suitor, after all, in the eyes of her father, should be making all the concessions, since he was a young man of no social consequence, with no money, with nothing but his talent and his promise, and these now questionable since the critics' reception of his latest work. There were arguments pro and con back and forth, in which Ingres's family joined him. Julie, exercising another talent, fictionalized the affair later in a novel, "Emma, ou la Fiancée." Not a literary monument, it had to wait until 1910 for publication as a document.

Less than a year after Ingres's arrival in Rome, the engagement to Julie was broken. Five years later he tried to fall in love again, without much conviction, and was briefly engaged to the daughter of a Danish archaeologist. He found a wife at the end of 1813, when he was thirty-three. His manner of discovery was eccentric, but the wife turned out perfectly.

Courted and proposed to by mail, without ever having met her suitor, Madeleine Chapelle, a carpenter's daughter who had entered her thirties—spinsterhood, in those days—was living with a married sister and supporting herself as a seamstress and milliner in the town of Guéret. Ingres met her, or rather started writing letters to her with marriage in mind from the first, at the suggestion of her cousin, Adelaide Nicaise de Lauréal. Adelaide and her husband, a functionary at the French court in Rome where Ingres was finding his patrons, were his good friends. He may or may not have been smitten with Adelaide. The story goes that he was, and that she first thought of Madeleine as a prospect because Made-

leine resembled her. If so, Adelaide was a woman of sweet and gentle appearance. Ingres drew his Madeleine many times. Her agreeable features were without dramatic distinction, but if love ever beautified a face from the inside, it beautified Madeleine's, not only in her regard for Ingres, but in his response as revealed in the drawings.

The fiancés met for the first time when Madeleine came to Rome late in 1813, with the marriage already arranged. The ceremony took place in December that year. In the second year of their marriage their only child was stillborn. But for another thirty-four years they enjoyed a marriage of perfect companionship. Madeleine died in 1849, sixty-seven years old to Ingres's sixty-nine.

By this time Ingres was full of honors, but his marriage with the Academy had not run smoothly. His departure from Paris had been almost in the nature of a flight, and instead of staying only the four years provided for by his Prix de Rome, Ingres stayed eighteen—from 1806 to 1820 in Rome, and then from 1820 to 1824 in Florence—sending paintings back to Paris for the Salons and receiving bad criticisms with the old curse, "Gothic," always dogging him. It dogged him through his most productive and his finest years as a creative artist. He shed the epithet only by de-individualizing his style. He worked out a manner that was a compromise between Davidian rigor without its force and Raphaelesque grace without its depth. When he managed to accomplish this, his work was well enough received in Paris to encourage him to come home, which he did, in 1824.

He brought with him a large, elaborately studied painting, *The Vow of Louis XIII* (it had been commissioned for the cathedral in his home city, Montauban, and is still there), a Raphaelesque pastiche so dull that even his most ardent admirers today can muster little more than glum respect in front of it. It was a tremendous success. The nonconformist

had reformed; the prodigal was welcomed back. *The Vow of Louis XIII* by the forty-four-year-old Ingres was the star of the Salon of 1824 while *The Massacre at Chios* by the twenty-six-year-old Delacroix was its scandal. The war between two great painters was thus declared by their respective supporters. Ingres was catapulted into official favor in part to fill a gap: David was in exile, Gros had lost his bearings, Gérard and Guérin were butterflies. In 1825, Ingres was awarded the Cross of the Legion of Honor by Charles X and elected to the Academy. In 1829 he was appointed professor at the Ecole des Beaux-Arts. In 1833 he became its vice-president, and in 1834 its president. He had been back in Paris, and in favor, for ten years.

But he had grown increasingly irascible, and when his painting *The Martyrdom of St. Symphorien* (Autun Cathedral), a major effort but a distressing production, was badly received, he left Paris again. He did not leave under a cloud: asking for the directorship of the French Academy in Rome, he received it, and went back to his paradise. He worked hard on the curriculum of the school but did not paint a great deal during the six years of this stay.

In 1841 he came back to Paris to remain. After Madeleine's death in 1849 he was profoundly depressed and seemed to be preparing for his own departure from life. He had abandoned a project that had occupied him for six years (two mural decorations, *The Golden Age* and *The Iron Age,* commissioned in 1839 for the château at Dampierre by the Duc de Luynes), cleared out his studio by giving fifty-one paintings to Montauban, and resigned, after twenty-eight years, as professor at the Ecole des Beaux-Arts.

His friends were worried and urged him to remarry. He did. At the age of seventy-one, not quite three years after Madeleine's death, he married Delphine Ramel, a forty-three-year-old spinster relative of his oldest and closest friend, Mar-

cotte d'Argenteuil. He lived for another fourteen and a half years while medals, presentations, political honors (he became a senator), and retrospective exhibitions piled up. When he died on January 14, 1867, he was eighty-six years old. His last drawing, done six days before, was a tracing from a print of Giotto's *Entombment*.

It is regrettably true that in his authoritarian role Ingres could be as merciless to painters who stepped out of line as the critics had been merciless to him early in his career. But it is usually forgotten that he refused to use the Salon as a weapon. He loathed the Salon, and for twenty years, from 1835 to 1855, refused to exhibit in it. We must admit that he sometimes indulged personal spites, but as a member of the Commission of Fine Arts in 1848, he tried, though unsuccessfully, to make the Salon an open, non-juried exhibition. If he had had his way, the Salons would never have become the life-and-death affairs that they were when the impressionists had to fight them.

During his first eighteen years in Rome, Ingres found his most dependable source of income in small portraits of visitors to the city who usually came to him through friends, consulates, or what must be called satisfied customers. He did these drawings by the hundreds, but never as hack work. In their adroitness, their certainty, their strength and delicacy, their sheer technical miraculousness, they are astounding. But they are great drawings for a deeper reason. Ingres was acutely sensitive to personalities, and he revealed them by means so subtle that he could expose the vanities of a fop, a silly woman, or a windbag, in drawings that delighted them. But he was not a cruel man, nor a witty one. His finest drawings are his most tender ones: his portraits of his friends with their wives, of women with their children, of Madeleine, or often of a visitor who, appearing for an hour or two and then gone, had struck a response in the artist.

His most ambitious paintings are his most uneven, ranging from the distilled erotic intensity of his own favorite, the magnificent *Jupiter and Thetis* of 1811 (Aix-en-Provence, Musée Granet), to the abysmal *Vow of Louis XIII*. His genius was his predilection for sinuous line, and, being genius, is inexplicable. One mentions Flaxman as a source; one wonders whether or not Ingres might, in some unrecorded way, have made an early discovery of Botticelli. And what about the Tuscan mannerists, especially Bronzino? But in the end, as usual, explanations are pointless in the face of the achievement.

Ingres found no followers worthy of the name, unless we can call Degas the one glorious exception. The young Degas idolized Ingres and built his early style on the foundation of Ingres's drawings. The painters who tried to follow Ingres more slavishly were, at the very best, graceful on occasion. Flandrin was a bit more successful than most.

Hippolyte Jean Flandrin (1809-1864) was not directly Ingres's student, but was an ardent and recognized disciple. Ingres once threatened to resign from the Academy when a Salon jury refused one of Flandrin's paintings. Usually, however, Flandrin was in good Academic favor. He was a director of the school in Rome and was popular as a muralist for churches. The walls of St. Germain des Prés in Paris are among those he disfigured. Flandrin produced one study of a male nude, exhibited in 1855, so close to Ingres (but more obviously sensual) that it is a great postcard favorite at the Louvre. But under the excessive influence of Raphael and the Nazarenes, Flandrin became a dry and pious bore. Delacroix always referred to him contemptuously. If there was a worthy conclusion to the neoclassical succession that began with David and continued in such an odd way in Ingres, that conclusion was made by Puvis de Chavannes.

Pierre Cécile Puvis de Chavannes was born in Lyons in 1824 to an aristocratic family and died in Paris in 1898, seventy-four years old, and an internationally respected painter. He must be very nearly unique as an artist who regarded himself as conservative but was adopted by young radicals as their prophet and model. Thus he is a curious link between the exponents of the classical-academic tradition who are scorned by the twentieth century and the late-nineteenth-century artists (Gauguin and Seurat among them) who are revered as the heroes of a new chapter of Genesis.

Puvis has other links that make him something like a universal nineteenth/twentieth-century adhesive. He was a friend of Delacroix's and listened attentively to Delacroix's ideas of what art was all about, although romantic tempestuosity is antithetical to his classical reserve. He had the double experience of being rejected at the Salon year after year, like any advanced painter, and then of becoming an entrenched member of the Salon jury (where his liberalism was a thorn in the flesh of his academic colleagues). He had the best of both worlds without suffering the ossification of the academicians or the persecution inflicted on the revolutionary experimenters.

Puvis expected, in the natural course of things, to follow his father's profession of engineer. (It may be more than a coincidence that the neat organization and the concise, diagrammatic legibility of engineering drawings are also characteristic of his painting.) But a trip to Italy made him an artist instead. Inspired by fifteenth-century frescoes, he changed course—so effectively that he was accepted in the Salon of 1850, when he was not yet twenty-six. The subject was a Pietà. Thereafter, his succession of rejections began.

Puvis's great works, his mural cycles in emulation of the early Italians, have begun to look a bit wishy-washy today. Painting in oil on canvas, which was then stuck to the walls,

he imitated the pale, chalky tones of most true fresco. There is an affectation here that offends today's taste for recognition of the medium as a determining factor in expression, and Puvis's oils can look insipid while the same tonalities in fresco retain their force. But even when they fail to stimulate, his murals are admirable as intelligent demonstrations. There is always something scholarly about his attack on the problems of painting, an approach that is appropriate enough in a style of classical reflection.

The group of painters called "synthetists," with Gauguin among their number, was dedicated to the idea that simplification of line, form, and color (the virtual reduction of drawing to a matter of flat-colored silhouettes with all detail suppressed) increases the intensity of expression. Whether or not it does so, depends on the artist; in Puvis the results were frequently pallid. Nevertheless, for the last ten years of his life he was the synthetist's messiah.

Pallid or not, what is present in a Puvis mural is true and firm. He extracted from early Renaissance frescoes a quality of serenity through simplification of pattern that the German Nazarenes had striven for but never approached. Without any question whatsoever, he re-established the concept of mural painting as an integral part of the wall. Even though he did not paint directly on the wall, he recognized the wall as a flat surface, a plane that should not be violated by the illusion of a third dimension. Maurice Denis (1870-1943), while Puvis de Chavannes was still alive, extended the great muralist's recognition of the integrity of the wall to a theory that all painting is necessarily two-dimensional in his much quoted "We must never forget that any painting—before being a warhorse, a nude woman, an anecdote or whatnot—is essentially a flat surface to be covered with colors arranged in a certain order."

Puvis's best work is the cycle of the life of St. Gene-

vieve, the patron saint of Paris, in that city's Pantheon, done between 1874 and 1878 and added to in 1898. But he was vastly productive in a wide geographical range. At the end of his life (1895-98) he painted a rather disappointing set of murals for the new public library in Boston, Massachusetts, where they may still be seen.

The schism between classicism and romanticism that seemed so violent to its participants seems more and more an artificial division between romantic attitudes. But between the two schools there was one difference that may seem trivial to the layman but is major to a painter and to most aestheticians: a difference of techniques. Ingres's objection to romanticism was generated by the vigorous brushwork, the fluid drawing, the rough surface, the broad modeling, the broken color, of the romantic style rather than by its mood or subjects. And Delacroix, of course, regarded himself as the only true classicist.

In the second half of the century, the split was pretty well patched up when a generation of academicians, both romantic and classic, joined forces in an attempt to rout a common enemy, realism. Just before that time, as if to bring the romantic-classic battle to a truce, there appeared one artist who venerated both Ingres and Delacroix, combined much of the best of both in his painting, yet was his own man.

Théodore Chassériau was born in 1819 in Santo Domingo and entered Ingres's studio at the age of eleven. At seventeen he was a Salon success. This was in 1836. Delacroix's storm had broken a dozen years earlier and was still raging. Ingres once said that if a painting was well enough drawn, it was well enough colored. Chassériau was not content to accept this limitation. Ingres had taught him to be an excellent formal draftsman; by Delacroix's example he

became a colorist as well, using color as an emotive factor and making it an impregnation of form rather than a tint upon its surface. Like Delacroix, he went to North Africa (in 1846, when he was twenty-seven), and like Delacroix he felt that the Arabs were more Homeric than the Greeks as visualized by Ingres.

Chassériau was an artist of tremendous versatility. His subjects included scenes of North African life along with reconstructions of the life of ancient Greece and Rome, portraits along with allegorical decorations, illustrations for Shakespeare, and religious meditations. His pencil portraits rivaled Ingres's—certainly an ultimate tribute. He should have become an eminent and unifying figure in French painting. Instead, he is a brilliant spot: he died at the age of only thirty-seven.

On October 10, 1856, Delacroix noted in his journal, "Poor Chassériau's funeral. There I met Dauzats, Diaz, and young Moreau the painter. I quite like him." This was Gustave Moreau (1826-1898), later a respectable academic workhorse whose exoticism, both decadent and pedestrian, was the tag-end of one aspect of Delacroix's revolution. But he taught, and taught very well, at the Ecole des Beaux-Arts, and the continuation of French art, the integral overlapping of periods and movements that we tend to think of as divorced from one another, is rather vividly brought out when we remember that the "young Moreau the painter" who appealed to Delacroix at Chassériau's funeral became the old Moreau who taught Matisse.

ROMANTIC REALISM
IN FRANCE AND
GERMANY

It is necessary to begin this chapter with a reminder that the painters under consideration, who found their inspiration in the world around them rather than in imagined or re-created or exotic ones, were not born, neatly, as replacements for the idealists who died at the end of the preceding chapter.

In general, realism in one form or another succeeded classic-romantic idealism in nineteenth-century French painting, but the borderlines are hazy. Corot (not a true realist, but we will explain all that) was born in 1796, and hence was Delacroix's contemporary. He was in fact two years older than the great romantic, but outlived him. Daumier, born in 1808, was only ten years younger than Delacroix. And Courbet was born in 1819, the same year as Théodore Chassériau, although he outlived by twenty-one years this painter who made a harmonious fusion of Ingres and Delacroix.

With this reminder that realism was burgeoning while classicism was being buried and romanticism was experiencing its climacteric, we may continue.

Jean Baptiste Camille Corot's father was a clothier who had been a hairdresser. His mother was a Swiss modiste. Together these two good people ran a prosperous shop in the Rue du Bac—kindly, honest, sensible people who could not understand their son's desire to be an artist. This desire could not have been passionate; Corot's life was neither enriched nor disturbed by passion of any kind. But the desire was steady and finally triumphant, just as Corot's life was steady and finally triumphant in its course.

He was born in Paris in 1796, was sent to school in Rouen, and then concluded an altogether undistinguished academic career at Poissy, near Versailles, drawing and painting in his spare time. To please his father (there was never a quarrel between them, just gentle resistance on the father's part and gentle determination on the son's) he took a job as assistant in a textile firm when he was nineteen. But in 1822, when Corot was twenty-six, his father gave in. The younger of Corot's two married sisters died, and the allowance Corot *père* had been giving her he now turned over to his son. *"Camille s'amuse"* remained the limit of the father's understanding of Corot's practice of art, even when (to the father's surprise) some of his paintings were purchased by the state.

The allowance was small, but with additional help from his father whenever it was needed, Corot lived on it quite happily, even into his middle age. He celebrated his new independence by studying briefly with two painters of classical landscape in the idyllic-romantic mood, Achille Etna Michallon (1796-1822), a prodigy exactly Corot's age who died that same year at twenty-six, and then with Michallon's

friend Jean Victor Bertin (1775-1852). But Corot was largely self-taught. He decided that he should see Italy, and in 1825 his father agreed to send him. During his three years there he was much encouraged by yet another painter in the classical landscape tradition, Caruelle d'Aligny (1798-1871), whom he always considered to have been his real teacher. It is typical of Corot that almost all the people he knew best and worked with best were people of inconspicuous reputation and quiet ways of life.

Corot made two more trips to Italy, one of them in 1834 when he was thirty-eight in the company of a painter friend named Grandjean (this time his father, still financing him, asked him not to stay more than six months because "your mother and I are not getting any younger") and again nine years later, when, after so long a time, he got around to taking a look at Michelangelo's ceiling in the Sistine Chapel. He described the visit as a "courtesy call." Even when he was among the old masters, Corot was not attracted to the titans.

During his first stay in Italy, Corot sent a picture, *The Bridge at Narni* (now in Ottawa, National Gallery of Canada), back to Paris and it was accepted in the Salon of 1827* It was hung between a Constable and a Bonington. Since Salon installations were seldom imaginative, we cannot credit some imaginative hanger with prescience, but in retrospect the juxtaposition was significant. Here was a Frenchman who was discovering, at last, what the English had known for a long time—that a landscape need not be a painter's invention, but can be a specific, existing segment of nature reproduced in accord with the artist's response to it in its presence. *The Bridge at Narni* still had elements of the picturesque-classical tradition, since Corot selected a view of nature appropriate to that tradition and painted the picture in the studio from sketches made on the spot. But the picture remains alive with

* Along with another, *Roman Campagna*, now destroyed.

his spontaneous reaction to that spot as an immediate visual fact poetically perceived.

It was at this time, in his earliest thirties, that Corot said, "Never lose sight of the first impression by which you were moved." And some twenty years later, in 1850, he wrote with even more commitment, "Abandon yourself to your first impression." His use of the word "impression" stands out here in anticipation of Monet's *Impression—Sunrise,* which gave a name to the impressionist movement in 1874.

Delacroix, along with Corot, was worrying about retaining the freshness of the early stage of a conception, but with Delacroix it was not a matter of retaining the visual and emotive impact of a first impression of nature, but of giving the final version of an elaborately synthesized work the freshness of the sketches made in its preparation. The distinction is rather important. Corot, never an intellectual artist and never an excitable man, responded not so much with his mind or emotions as with his eye. "The values—the relation of the forms to the values—*there* are the bases," he said. If a camera could talk, it might say the same thing, but Corot made the prefatory admonition, "Begin by determining your composition." Even this, of course, a photographer must do. But, for all his literalness, Corot's perception of "the relation of the forms to the values" was subject to nuances of response, and his composition was subject to adjustments, no matter how slight, that account for the difference between the interpretative vision of an artist and the mechanical vision of a lens.

Corot's vision is tranquil, very nearly placid, and eventless. A Corot view of the Tiber with the bridge and castle of Sant'Angelo and the cupola of St. Peter's (as in the beautiful painting in the California Palace of the Legion of Honor, San Francisco) may stir within us a mild romantic nostalgia —or we may be reading into this view of Rome, in its literalness, the nostalgia that the quiet parts of that generally noisy

city still inspire. Corot, like the English, learned that the topographical disposition of nature with its man-made objects needed little doctoring by the picturemaker although that little was important. But unlike Constable, he was never interested in the pulsing, flowing drama of a sky or of the fields and buildings washed in its light. He expressed in his painting a response to nature that we think of as typically French, a response to the peaceful and eternal (and hence classical) mood that can be sensed by initiates even on the weediest patch of nondescript riverbank.

For the first sixteen years of his professional life, Corot did not sell a single picture, although he was accepted with some regularity in the Salon and was awarded a Medal Second Class in 1833. In 1838, when Corot was forty-two years old, the Duc d'Orleans bought two pictures; the next year the state bought one, and in 1842 another. But it was not until 1855, when he was nearly sixty, that Corot became a great success. (His father had died seven years earlier, leaving him well off.) In the Salon of that year he won a Medal First Class* and the emperor Napoleon III bought a painting, *Souvenir de Marcoussis* (Louvre). Corot's reputation, long firm with other painters, was now made with the public, and his popularity was assured since, also, his painting had (by our way of seeing it today) somewhat degenerated, taking on a sweetly amorphous character that had an easy, sentimental

* Actually, a second-class award, since there were ten Grand Medals of Honor in this landmark international Salon in connection with the Exposition Universelle. Ingres and Delacroix, both of whom had large retrospectives, both received Grand Medals of Honor, as did the detestable anecdotal painter Jean Louis Ernest Meissonier (1815-1891); Alexandre Gabriel Decamps (1803-1860), a romantic painter who at that time rivaled Delacroix in prestige; Emile Jean Horace Vernet (1789-1863), of the dynastic Vernets; François Joseph Heim (1787-1865), a classical academician of the most hidebound sort; Louis Pierre Henriquel-Dupont (1797-1892), an engraver; and, as gestures of international courtesy, three foreigners: Peter von Cornelius (1783-1867), the German ex-Nazarene; Sir Edwin Landseer (1802-1873), the English animal painter; and Hendrik Leys (1815-1869), a well-connected and competent history painter from Belgium.

attraction. He had discovered the pleasant, poetic, but rather spineless style akin to soft focus photography—with its cottony trees, fuzzy swards, and somehow tepid-looking ponds—that is still the popular image of Corot.

These pictures were easy to imitate, and Corot became the most forged artist in history—the forgeries continuing long after his death by the hundreds and thousands. He added to the confusion by signing, now and then, a forgery brought to him by a distressed purchaser: Corot was a man with almost too good a heart, who was almost as surprised as his father at his own success.

His record of kindnesses is impressive. He supplied a comfortable house to the aging and impoverished Daumier; gave ten thousand francs, a large sum at that time, to the indigent widow and family of Millet, a painter for whom he had little sympathy and who disliked him; during the Franco-Prussian War (he was seventy-four in 1870) he put up his paintings for sale in batches and turned all the proceeds over to people in need. Artists young and old came to him for money and advice. Sometimes when a dealer wanted one of his pictures, Corot would insist on the purchase of one by a struggling colleague as a condition of sale.

Corot was seventy-nine years old when he died in his studio in 1875, and his benign aspect was hardly flawed even in his slightly touchy old age. He could not approve of the impressionists, although he had, in part, anticipated their effects. In a notorious satirical review of the first impressionist exhibition of 1874, the year before Corot's death, the critic Louis Leroy wrote in Charivari, "Oh, Corot, Corot, what crimes are committed in your name! It was you who brought into fashion this messy composition, these thin washes, these mud splashes in front of which the art lover has been rebelling for thirty years and which he has accepted only because constrained and forced to it by your tranquil stubbornness."

The impressionists refused to be rejected by Corot. "Old Corot opened our eyes," Renoir said. In the next generation Corot found admirers for a different reason: Signac, reacting against the looseness of impressionism, said in 1899 that the lesson of a Corot show he had just seen was that "the impressionists were wrong in giving up the search for composition. Corot created pictures; except for Renoir, [the impressionists] made nothing but studies." One of the most impressive tributes to the esteem in which Corot was held by his contemporaries came from Delacroix. At the age of forty-nine, mature, worldly, eminent, and the godhead for half the painters in France, Delacroix visited Corot in his studio (it must be remembered that they were almost exact contemporaries, and Corot at this time, 1847, was not widely celebrated) and went home to record in his journal Corot's advice to him as a painter, to which he had listened respectfully and with profit.

Corot's friends thought that toward the end of his life he was not sufficiently recognized by the Salon and the state. But after receiving the Cross of the Legion of Honor in 1846 he was made an officer of the Legion in 1867. He served repeatedly on Salon juries, for the first time when the system was temporarily reformed in 1848 and 1849 to allow representation of artists on the jury. The artists elected Corot. On later juries, after the system had reverted to its old status as a caucus, he made not very effective efforts to liberalize it.

Until his health weakened in old age, Corot was always a great traveler—not on long journeys, for Italy was his furthest reach—but on little *ballades* with friends, combining painting excursions with stays at friends' houses. He seems to have had dozens of dear friends everywhere. He never married, and if he was ever in love, or if he ever touched a woman, or if he ever felt any sexual repressions, there are no records either in documents or to be deduced at second hand from what he wrote or painted. He painted women over and

over again, and sometimes children, but men rarely. His women are notably asexual even when, nude, they are posed as bacchantes. Usually costumed, withdrawn in gentle reverie, they are part of Corot's tranquil world that nothing could disturb. These figure studies, not kept secret during his lifetime but relegated to obscurity by the indifference of a public that doted on his weakest pictures, now seem his masterpieces, or at least the equals of the earlier serene, meditative landscapes and cityscapes of a world that (Corot makes us believe) is so beautiful that a painter in search of the ideal need only select a part of it, and reflect it.

Théodore Rousseau was the most fervent of a group of informally related French painters—they can hardly be called a school—who discovered the natural out-of-doors as a paintable phenomenon in the first half of the nineteenth century. Their rather tardy discovery had been delayed by the ingrained French idea of nature as something irrational and disorderly that must be subjugated by the processes of reason. For the French, nature, with all its surface features, was only raw material for formal arrangements of the kind that reached supreme expression in the gardens of Versailles.

The discovery of nature as something better than a state of primitive disorder had been anticipated, of course, in England, and even in France by Corot, who moved in and out of the circle of new nature painters. These men found their painterly models among the seventeenth-century Dutch landscapists who had celebrated common aspects of the countryside.

Thus they managed to tie their art to the art of the museums. But what made them revolutionary was that they actually set up their easels in the fields, an idea that seems conventional enough now, but which was something of a

breakthrough that led to the even more direct relationship with nature adopted by the impressionists, who were not really happy when they compromised with nature by completing a landscape in the studio—a common practice with earlier men.

The thickest concentration of sprouting easels was in and around the Forest of Fontainebleau, a domesticated but not corseted wood about thirty miles from Paris. In the village of Barbizon, at the edge of the forest, some of the painters, led by Rousseau, took up residence; others came and went off and on. The village now consists largely of souvenir shops and tourist restaurants that attempt to re-create the picturesque rural air of a hundred years ago. Its attractions for painters at that time were that living was inexpensive, the unurbanized countryside was all around for painting, there were peasants, chickens, and cows to serve as models for the new peasant-chicken-and-cow painters, and Paris was close enough for uninterrupted contact with the studios, the Salon, and the salesrooms.

The so-called Barbizon school dates from about 1830. Rousseau became its leader when he settled in the village in 1836. He was twenty-four years old (having been born in 1812). A prodigy, he had made his Salon debut five years before, with a romanticized landscape painted in Auvergne. But he was now rejected at the Salon with such regularity that he became known as *"le grand refusé."* It became virtually an institutional bylaw that this should happen year after year, and it became also a kind of running joke to regard Rousseau as an oafish peasant, which, although he was a huge man who affected a great beard and country clothes, he was far from being.

By 1840, Rousseau was greatly admired by a circle of intellectual aristocrats and was selling a few pictures to discriminating collectors while the Salon continued to howl him

down. But he was finally re-admitted to the Salon in 1847, and by 1850 he came into general popularity along with the rest of the Barbizon painters. Their predilection for common subjects had had to compete with the official Salon snobbism by which all art had to be highflown. But a bourgeois public, weary of the intellectual strain, took the Barbizon painters to its heart as soon as it discovered that this was safe to do. Their greatest popularity came after their deaths, however, when they were collected, especially in America, as passionately as the impressionists are collected today, and at comparable prices.

But their popularity has waned, and in most cases it is easy to understand why. Rousseau has held his place better than most, but not as firmly as he deserves. He was much more than an imitator of pretty effects or a prettifier of the denizens of the countryside. He was a pantheist for whom everything in nature, from the turn of the seasons to the sprouting of a blade of grass, was part of a miracle. He passed from an early romantic preoccupation with rough and stormy aspects of nature to a more profound if less dramatic conception of the life that manifests itself in the texture of a tree trunk, in the disposition of rocks protruding from the earth, in everything animate or inanimate in its natural state. In his absorption he often concentrates adoringly and almost feverishly on detail after detail in a way that can be exhausting to the observer, but in his finest pictures these details coalesce into a unified vision.

Rousseau died in 1867 at the age of fifty-five.

For a decade or so on either side of the year 1900 (which was twenty-five years after his death), Jean François Millet must have been the most admired painter in America, the best-known to a general audience. He occupied a position

something like that enjoyed today by Vincent van Gogh. Reproductions of *The Sower, The Gleaners,* and *The Angelus* (all in the Louvre, with versions elsewhere), in a shade describable as "artistic brown," hung in every school building and in every home with ambitions toward aesthetic consciousness. Millet offered, in a single parcel, piety, social humanitarianism, and guaranteed culture.

Current efforts to revive interest in the Barbizon painters have not much improved Millet's standing with a post-World War I generation that learned to abhor sentimentality or with its children for whom Millet is not much more than a name in the history books, although *The Sower* and his other standard pictures remain clichés that young people recognize (and dismiss) as such without, perhaps, being able to identify them.

Millet has real virtues. On some scores, no apologies need be made for him. But when faced by his paintings, with very few exceptions, we are inclined to agree with Delacroix, who, in 1853, at a time when Millet had gained an admiring audience in Paris, wrote his opinions of Millet and Millet's art in his journal, after "someone" had brought the painter to his studio for a visit.

Millet talked to Delacroix about the Bible, which, he said, was virtually the only book he read. "This explains the somewhat ambitious look of his peasants," Delacroix reflected. Commenting that Millet himself was a peasant, Delacroix added "and boasts of it." He found in Millet "a deep but pretentious feeling" struggling to reveal itself. The deep feeling is admirable; the pretension, fatal.

Millet was born in 1814 in the hamlet of Gruchy on the coast of Normandy, of well-to-do peasant stock. He grew up on a farm and was first inspired to draw by the engravings in an illustrated Bible. As a youth who had demonstrated precocious talent, he was given lessons in Cherbourg by former

pupils of David and Gros. He so impressed himself upon the local authorities that in 1837 he was awarded a scholarship for study at the Ecole des Beaux-Arts in Paris. There he entered the class of Paul Delaroche.* Delaroche, who, it must be admitted, never gave any signs of being a very perceptive man, perceived less than no talent in Millet. He found him an impossible student. After a miserable two years, Millet withdrew from the school and began working instead at the Académie Suisse, a place where one could draw from models and receive informal criticism from time to time.

His misery continued. He eked out a living with whatever portrait commissions he could get and a great deal of hack work, anything that would bring in a franc—sign painting, cheap biblical pictures, and imitations of eighteenth-century pastels, including erotic nudes. In 1840 he had a portrait in the Salon, but the struggle to live was so discouraging that he returned to Gruchy. He was now twenty-six years old.

Things went a little better with the less demanding customers in Cherbourg. In 1841 he married a girl named Pauline Ono and took her with him to Paris the following year. Pauline died in 1844. He returned to Cherbourg, married again (Catherine Lemaire) the year after that, and also had a successful exhibition in Le Havre.

In Paris once more, his ups and downs continued until 1848, when he found himself as a painter of peasant life in the late-romantic tradition that gave a political cast to the eighteenth-century philosophical dream of "nature's nobleman." In the Salon of 1848 he had a real success with *The*

* Paul Delaroche (1797-1856) was a pseudoromantic history painter whose illustrations of storybook historical events were extremely popular with a storyloving audience that liked to think of them as fine art. Delacroix's contemporary, Delaroche is remembered largely as a mediocrity who was elected to the Academy while Delacroix was being blackballed, but whose death created the vacancy that Delacroix, near the end of his own life, was allowed to fill.

Winnower, in the vein that was to produce *The Sower* and the other standard Millets.

The Winnower (now lost, but existing in later versions) seemed to have been inspired by the noblest aspirations of the Revolution of 1848. The critics began to debate Millet's virtues, and the two Barbizon painters Diaz and Rousseau discovered and supported him. In 1849 Millet settled in Barbizon and, except for visits to Normandy, lived there the rest of his life.

Millet discovered better models than the old biblical illustrations and eighteenth-century pastels. Rembrandt and Michelangelo were his professed ideals. But the great Daumier, even if not acknowledged, by all evidence was by all odds the one who counted most. Now, 1850 produced *The Sower;* 1857, *The Gleaners;* 1859, *The Angelus.* Although not selling much, Millet was unquestionably a success in terms of exhibition and notoriety. The notoriety was concerned with accusations of political radicalism. There is no good reason to believe, however, that Millet was politically motivated. He brought a degree of social consciousness to the romantic-humanitarian ideal, but in no sense made an analytical declaration; he had an emotional response to the circumstances of his own experience—or, at most, confused the two.

In the year of *The Angelus,* Baudelaire reacted to Millet's peasants much as most people do today. "Style has been his disaster," Baudelaire wrote. "His peasants are pedants who have too high an opinion of themselves. . . . Instead of simply distilling the natural poetry of his subject, M. Millet wants to add something to it at any price." Baudelaire found in Millet's painting "a pretentiousness which is philosophic, melancholy and Raphaelesque. This disastrous element . . . spoils all the fine qualities by which one's glance is first of all attracted."

During the 1860's, Millet began to find a market for his paintings, and in 1867 he won a Medal First Class in the Salon and was elected to the Legion of Honor. But when he died in 1875, at the age of sixty-one, he had not managed to gather together an estate, and the good Corot had to rescue his widow with a donation of ten thousand francs.

In reducing the ungainly forms of ignoble subjects to a kind of monumental simplicity, Millet was in a French tradition that had found superb expression in the Le Nains in the seventeenth century, in Chardin during the eighteenth, and was finding its supreme expression in Daumier during Millet's lifetime. But something is wrong. Theoretically one admires what Millet did; in practice, one remains unconvinced of the nobility of the peasants who seem much too cleaned up and much too conscious that they are posing for our regard. Millet's best work is less pretentious because less ambitious than his most famous paintings. Some of his drawings, his etchings, and an occasional painting where he allows himself to respond naturally and tenderly to the subject matter that he usually tried to ennoble (but managed only to inflate) show what a charming artist was lost in a man who over-reached his talent.

Narcisse Virgile Diaz de la Peña, French, but of Spanish extraction as his name shows, is usually listed as the third ranking Barbizon painter, following Rousseau and Millet. They make an odd trio, and certainly not a "school." Of the three, only Rousseau held to the principle of painting nature as seen—an avowed principle of the painters who lived in or frequented Barbizon. Millet was primarily a painter of idealized Raphaelesque figures costumed as peasants but whose hands certainly bore no callouses. And Diaz, by any standard of realism, was a fantasist whose forests are as closely related

to the imagined scenes of Salvator Rosa in the seventeenth century as to any new ideas about respecting the face of nature. Around 1850 there was a positive craze for his work: the Barbizon painters in general now had an audience, and Diaz added to their appeal the old-guard appeals of academic painting.

After beginning as a porcelain decorator, Diaz found relief from this persnickety craft in Oriental and medieval subject matter painted with Delacroix's example as a model. About 1840 (he was born in 1807) he was attracted to the Barbizon and Fontainebleau locale, where he began doing forest landscapes. Although identifiable as ordinary woodland spots, his scenes are highly dramatized by artificial contrasts of romantically darkened thickets framing escapes into little glades where nymphs are likely to be surprised dancing in sultry light, or where peasants in picturesque rags trudge along a path.

Diaz painted in an exaggeratedly thick impasto and at times could be romantically effective enough for his pictures to charm today. Their small size is part of their attraction. But his work has aged badly conceptually (his romanticism seems trivial) and physically (his pictures have darkened and sometimes cracked). Delacroix admired these landscapes, but Baudelaire was merciless. In a review of the Salon of 1846, he objected to Diaz's sometimes rather messy impasto by saying that "he sets out with the principle that a palette is a picture," and criticized Diaz's drawing with a comment that the nymphs and peasants seem to have been made of stuffed rags, as they often do.

Thirteen years later, in 1859, Baudelaire was even harder on this artist who, although still popular, had passed his peak. Diaz was now attempting to enlarge his scope by enlarging the size of his canvas, and to solidify his drawing. He also departed from the heavy impasto and the darkling woods to

attempt ideal subjects. He tried to correct everything that Baudelaire had objected to, but Baudelaire, in a review where his delight in making mincemeat of Diaz is veiled by expressed regrets that honesty was forcing him to say what everybody else was whispering, called Diaz a worn-out artist who had never learned to draw.

This was true. But now and then one runs across a Diaz, usually a small one, where the evocation of romantic mood, no matter how obviously contrived, is a minor but, within its scope, perfect delight.

Diaz died in 1876, short of his seventieth birthday.

Although he never lived at Barbizon, Charles François Daubigny is usually grouped with the Barbizon painters. He does them much credit, and was even more insistent than Rousseau in his respect for a tenet with which the others compromised—that landscapes should be painted entirely out-of-doors, at the site.

Admired during his lifetime, Daubigny has lately been given stature only slightly less awesome than that accorded the impressionists. In his control of atmospheric effects, and in an understated poetic quality beneath an apparent objectivity, he is an impressionist. But he remains by full definition only proto-impressionist, since he did not experiment with the broken brushwork and color that were developed by Monet and his colleagues.

Daubigny, born in 1817, was twenty-one years younger than old Corot and twenty-three years older than young Monet. Friend of both, he is a link between the classical sources of French landscape and the full impressionist revolution. He met Corot in 1852—Corot was fifty-six, Daubigny only thirty-five—and for the remaining twenty-odd years of their lives they were good friends. Daubigny increased Corot's

interest in painting out-of-doors directly from the subject, and they exchanged visits and made trips together until Corot grew too old to travel.

Daubigny also hoped that Corot would help him liberalize the Salon system for the benefit of young artists. He was frequently a member of the jury, and in this capacity in 1870 he made a particular effort to enlist Corot's support. But Corot, a reformer himself many years earlier, was an old man by then and had lost interest. He even disliked the painting of the adventurous and maligned group of young men whom Daubigny wanted to help. Daubigny's championship went so far as to prompt his resignation from the 1870 jury when he was unable to effect the acceptance of even one painting by one of these young men—Monet.

Shortly thereafter he was able to help Monet, who, thirty years old, with a brand-new wife and baby, discouraged by this latest in a series of Salon rejections, and wanting to escape military service in the Franco-Prussian War, had fled to England in September of that year. Daubigny by then was painting scenes on the Thames and having a success with the English. Touched by Monet's distress, he introduced him in January, 1871, to Durand-Ruel, the perceptive dealer who had seen the Barbizon painters through their hard days and now had faith in the youngsters who were to be labeled "impressionists" a few years later. The introduction was not the end of Monet's troubles by any means, but it was a turning point in his life as a painter. Daubigny's part in this had an additional pertinence in that Monet, as a boy, had discovered one of Daubigny's paintings and, ever since, had regarded him as a master.

Daubigny was the son of a minor landscape artist from whom he received his first training; he later studied under the dull Delaroche at the Ecole des Beaux-Arts. He supported himself, until his paintings began to sell, as an illustrator and

an etcher of landscapes. By 1840, when he was twenty-three years old, he was dissatisfied with his skilled academic painting and began to discover himself as an artist in communion with nature. His work grew constantly broader, more peaceful—fuller, deeper and more sensitive, and more gently and sweetly impregnated with the soft, moist light of the Ile de France. He died in 1878, at the age of sixty-one.

Riverbanks with cottages seen across a stretch of water in the foreground were his favorite subject, and as early as 1857 he had constructed an open shelter atop a rowboat to serve as a floating studio. In this craft, rowed by his son, he made painting trips along the Oise. Daubigny at work in "Le Botin," as he called it, on the quiet river is a most agreeable symbol of the new concept of idyllic landscape that he helped reveal in France—the idyllic in what is natural and simple in opposition to the synthetic idyllicism of a faded tradition.

Four men can represent here the dozen or more lesser painters classifiable within the Barbizon school, insofar as it was a school. Their colleagues have disappeared except from the most exhaustive catalogues.

Constant Troyon (1810-1865) made more money off cows than a successful dairyman or cattle breeder could have done. He painted these placid creatures, standing in streams and meadows, with a perfection so consistent that Baudelaire, in a critique of the Salon of 1845, where Troyon as usual was much admired, referred to his "monotonously triumphant" brushwork. Troyon could identify the texture of his pigment with the pelt of his favorite animal in an uncannily illusionistic way. "He paints on and on; he stops up his soul and continues to paint . . . and by his stupidity and his skill he earns the acclaim and the money of the public" was an-

other of Baudelaire's murderous comments. "It is not pleas-
ant to see a man so sure of himself," he said yet another time.

Troyon had acclaim and earned money. He sold as much
as he could paint, and at very high prices. But Baudelaire's
evaluations, ungenerous as they were, gave Troyon more
credit than most critics allow him today even in retrospect,
and these once-expensive pictures are relegated to museum
basements except when an occasional one may be dusted off
and hung to complete the historical record—this being, also,
the only really good reason for including notes on Troyon in
this book. The appeal of the cow to the nineteenth-century
art public has never been satisfactorily explained.

Jules Dupré (1811-1889) was admired by Delacroix, and
at first acquaintance with his best work one can see why: he
frequently captured a dramatic, even tragic, mood in nature.
He was a great success, attracting attention in the Salon of
1831, when he was only twenty, and holding his own while
the other Barbizon painters were struggling for recognition.
His popular appeal is understandable, since he offers every-
thing he has, in the way of romantic mood, at first glance.
But a second glance is disappointing, and a third is unneces-
sary. Dupré became extremely repetitious, hardly changing
until, in his late work, he adopted a heavy impasto something
like that of Diaz—at which time Delacroix changed his mind
about him.

Dupré, however, was neither smug nor selfish in his
success. In 1847, with Rousseau, he tried to organize a so-
ciety to compete with the Salon, although he had fared well
in that quarter. The project got nowhere. Delacroix, among
others, refused his support.

Charles Emile Jacque (1813-1894), when he exhibited in
the Salon of 1845, was hailed by Baudelaire in the critique
where, more perceptively, Troyon was belabored: "Here we
have a new name which will continue, let us hope, to grow

greater." But Jacque's name has diminished today to the vanishing point. Baudelaire was writing about his etchings, but later commented favorably on his paintings, in which sheep figure prominently. Jacque was also a caricaturist.

Henri Joseph Harpignies (1819-1916) in his old age approached, because of failing eyesight, the fuzzy, generalized effects of Corot's least admirable paintings. He was quite popular with English and American collectors. The most remarkable thing about him is that he was born when the dust had hardly settled from the Battle of Waterloo and died during (not in) the Battle of Verdun.

Johann Barthold Jongkind was born in Holland in 1819, was educated there, and made regular trips back to that country, but by the age of twenty-five he was working more in France than at home. He studied under Eugene Louis Gabriel Isabey (1804-1886), a marine and genre painter and a respectable member of the romantic generation that succeeded in the Salon by shifting the romantic spirit into narrative gear. Isabey's Oriental and medieval (and other historical) subjects are essentially illustrations, although he was at times a more than adequate colorist. In his marine paintings he gave something to Jongkind. But the characterizing feature of Jongkind's art seems self-generated—a sparkling, translucent execution prophetic of impressionism.

Never a stable personality, Jongkind was already "quite mad" according to a letter written by Monet to Boudin in 1860 when Jongkind was just entering his forties. Artists at that time collected a fund to care for him, but he lived another thirty years and was truly mad at the end, which came in 1891 when he was seventy-two. As a young man he had a rough time financially; in middle age he was poverty-stricken; he ended his life in squalor.

Jongkind's mental trouble seems to have been a form of paranoia, yet in spite of his persecution mania he was a mild, gentle person. Excessively timid, he was modest, retiring, and kindhearted—a big, rawboned man who moved awkwardly and slowly, giving little indication of his inner disturbance.

But this disturbance was reflected (so it seems, by hindsight) in the restless, agitated manner of his painting. For a while he was a member of the Barbizon group. But their pastorales were not in accord with his sympathies. As a Hollander he had an affinity with water as the omnipresent circumstance of life—water disciplined within dikes and harbors and canals, bearing ships, always there, sparkling in the sun and roughened by the wind, a kinetic element. He abandoned Barbizon for Le Havre, where waters half domesticated and half wild afforded him perfect subjects.

This was where Monet met him, Monet as a youth who had not yet gone to Paris. (Monet's parents' long-sought permission to let him leave home finally came in part from their feeling that Jongkind and Boudin, another local painter, were not good companions or, as artists, proper mentors for their son.) Monet was sketching a restless cow in the environs of Le Havre one day when an unidentified Englishman attempted to hold the recalcitrant model by the horns, and thereafter told Monet that he knew an artist in Le Havre that the youngster might like to meet. The artist turned out to be Jongkind, and Monet in a memoir wrote that "to him I owe the final education of my eye," an education begun by Boudin.

Jongkind anticipated Monet's expression of transitory effects of light and air. In his watercolors he captured the fleeting, luminous aspects of times of day and kinds of weather; thereafter he translated them into oils in the studio (or into etchings, for he was one of the best etchers of his generation). Working thus he fell short, for whatever differ-

ence it makes, of the total impressionist premise that a landscape should be painted in the immediate presence of the motif. Habitually mentioned in the history books, along with Boudin, as the tail to Monet's kite, Jongkind was an independent artist capable of standing (if not quite soaring) on his own merits.

Eugène Louis Boudin was born in 1824 in Honfleur, the son of a harbor pilot. His native coasts were his finest subjects—perhaps not the beaches so much as the skies above them. Only Constable and Boudin have painted the sky so lovingly and so observantly as nature's everyday theater of action; the magnificent operatics of Turner's flaming heavens are another thing entirely. Both Constable and Boudin understood the growth and movement of clouds in the way great figure painters understand the structure of the body.

As a very young man, Boudin opened a shop in Le Havre where he sold art materials and frames, with the Barbizon men among his customers during their visits to the coast. (He also sold some of their pictures for them.) Millet tried to discourage him from going to Paris: the life there was too difficult, he said, and he knew. But Boudin saved enough money for the venture and extended it when the Friends of Art of Le Havre gave him a three-year scholarship. This was in 1851, and he was twenty-seven. He spent most of his time painting in the open instead of turning out the academic genre pieces that his sponsors expected, and they were disappointed when, home again, he not only elected to paint the homespun subject of local scenery, unidealized, but began to paint it in a curiously free, spotty way. But as he told a friend (and member of the local art commission) years later, in 1868, "I still persist in following my own little road, however untrod it may be."

As it turned out, the little road debouched into the main highway of impressionism. When Monet as a boy of fifteen had his caricatures for sale in the shop that Boudin had started and that now had a subsequent owner, he saw Boudin's paintings, also on sale there, and took a violent dislike to them and to the artist without having seen him. When the proprietor suggested that Monet should meet Boudin, Monet was scornful. But when they met by chance, the boy was won over to painting out-of-doors. It was Boudin, Monet always said, who first opened his eyes.

Boudin was never a theorist. It could have been said of him as it was said of his protégé that he was "only an eye, but what an eye!" except that he was also a heart, which Monet never was. When Monet induced him to participate in the first impressionist exhibition of 1874, Boudin was already fifty years old and had built a small reputation. He lived through and beyond the impressionist victory but never exhibited with the group again. Probably the scandal and general hubbub distressed him—not so much professionally as personally. He was a quiet man.

In 1889 at the age of sixty-five, Boudin won his first Salon medal. Three years later he was awarded the ribbon of the Legion of Honor. These were not great triumphs— striplings of mediocre achievement won them every year— but they were surprising ones for a man who had not courted them.

As in the case of his friend Jongkind's, Boudin's name immediately calls up the historical tag "proto-impressionist." But in the presence of one of his paintings—so small, so modest in size—one of his beach scenes, where ladies and gentlemen in holiday dress are disposed along the sand, sitting in deck chairs under parasols, each indicated with the most deft touches of white, blue, gray, and red, with the sky above them either drenching them with light or, sometimes,

darkening in storm, to their distressed agitation—faced by one of these paintings, we forget about schools and influences and share a vision of extraordinary charm and, somehow, of innocence.

Boudin died in 1898, seventy-four years old.

"That boy has Michelangelo under his skin," said Balzac, a comment so telling that no essay on Daumier can omit it. After the boy had grown up, another of his admirers made another connection between two supreme artists: "But it's Daumier!" cried Daubigny, standing in the Sistine Chapel and looking up at Michelangelo's ceiling.

A climactically magnificent age offered Michelangelo sublime themes—the Creation, the Fall, the promise of redemption and the mystery of the human soul in torment. A meaner society offered Daumier (who always said "one must be of one's time") the meaner subject matter of political corruption (less magnificent than the Fall) and the nineteenth-century bourgeois soul, no longer tormented, but shriveled, and smug in its reduced dimensions. For these reasons only, Michelangelo can be called a "greater" artist than Daumier, for whatever meaning that word has in comparing the genius of two artists whose times were so different.

Relative circumstances are not as extreme in their separation of Daumier from Rembrandt, since both painted for a bourgeois society. But in Rembrandt's century, grandeur was still conceivable as a circumstance of life, and mystery was still the ambience of the soul. Daumier in sixteenth-century Rome might have been Michelangelo, or in seventeenth-century Amsterdam, Rembrandt. But he lived in nineteenth-century Paris and was Daumier, a man who earned his living drawing cartoons for popular consumption. While critics have deplored as wasted the energy that Daumier had to

spend on his cartoons (not really the best word for his superb lithographic drawings turned out for the press, but it must do), the important thing to remember is that Daumier was not a frustrated Michelangelo or Rembrandt. He was ful-filled in his role as a force in his time and place, and if we think of the masters of earlier centuries as greater masters, we are comparing centuries, not artists—and are thinking mostly in the rut of art-historical habit. Michelangelo, Rem-brandt, and Daumier are equals and brothers.

Honoré Victorin Daumier was born on February 26, 1808, in Marseilles, of a sturdy, practical mother and a dreamy father. A glazier by trade, the father yearned toward the creative life, and in 1814 went to Paris to set himself up as a writer of plays and poems. He had neither talent nor luck, but his family joined him, the next year, in his poverty. They lived precariously, always on the move from one poor quarter of the city to another.

As soon as Daumier was old enough to find his way around Paris alone, he was put to work as a messenger boy for a bailiff in the law courts. It might be too much to give even this bright nine- or ten-year-old credit for early percep-tion of the venality and corruption of the legal profession of France of that day, but lawyers became one of Daumier's most frequent targets later on. And even as a boy he was learning to draw in the two schools that always taught him most—the streets, where every face and every stance was something to remember and set down later, and the galleries of the Louvre. He studied briefly with a friend of his father's, Alexandre Lenoir, a dedicated classicist who had developed a small museum of sculpture at the time of the Revolution and who set him to copying casts and performing other aca-demic exercises, and briefly again in one of those ateliers where anyone could draw from models for a small fee. He clerked for a while in a bookstore, but by the time he was

leaving his teens he was able to support himself as a lithographic artist. At twenty-two he was an independent professional at work for Silhouette, a satirical weekly, where he did his first antimonarchist cartoons. That year, 1830, a new liberal journal, ardently republican, was founded—Caricature—and he joined its staff.*

In his middle twenties Daumier was the most conspicuous, the most relished, and rapidly becoming the most feared, political cartoonist in France. In 1832, when he was twenty-four, he was sentenced to six months in prison for his cartoon *Gargantua,* which showed a bloated Louis Philippe gorging upon basketfuls of gold extracted from the poor and brought to him by a file of tiny underlings, and excreting it in the form of favors to other little men while the victims of the system—the proletariat and the war casualties—stand alongside helplessly.

It would make a better story if Daumier had been flung into a filthy cell and perhaps tortured while refusing to renounce his political faith, but no martyrdom was involved. He was allowed to serve half his sentence in a sanatorium and, during the other half, in the prison of Sainte-Pélagie, he continued to make lithographs and drawings. As he wrote in a letter, "I'm getting four times as much work done in my new boardinghouse as I did at papa's." The prison was divided into sections where inmates who shared political loyalties shared quarters. Hobbies were indulged, and recreations such as group sings were carried on. Daumier was much courted. Everyone wanted him to do portrait sketches.

This relaxed atmosphere did not modify Daumier's po-

* The woodcut, previously the means of mechanical reproduction in journals, was at this time largely replaced by the lithograph, invented by Aloys Senefelder about 1796. Like other illustrators, Daumier made his drawing directly upon a prepared stone from which the picture was printed. Thus the many hundreds of Daumier cartoons clipped from the journals and still available at low prices are original Daumier lithographs. He also issued sets of lithographs through publishers.

litical attitude, and he had been out of prison hardly more than a year when he issued a set of four lithographs that included two of his most trenchant accusations against folly and cruelty in high places—*Le Ventre Législatif* (best, if least delicately, translated as *The Legislative Belly*), a mass caricature of Louis Philippe's henchmen seated in caucus, and *Rue Transnonain 15 Avril 1834.*

Rue Transnonain shows a family—a mother, father, and child, and an old man—lying dead and bloody in a disordered bedroom. The title was enough to identify the scene. During a quickly squelched insurrection protesting government action against the leaders of a strike at Lyons, an officer of the civil guard in Paris had been killed by a shot fired from a window on the Rue Transnonain, and his companions had broken into the building—a workers' tenement—and massacred the inhabitants, innocent or guilty. Daumier showed the victims as the coarse-bodied, ordinary people they were. The pathos—and the indignation aroused—are more forceful than they could have been in any idealized or heroic treatment. *Rue Transnonain* combines the impact of immediacy, of reality, in its apparent factual objectivity. But in its compassion, emphasized by the mood of almost supernatural quiet that fills this chamber of death, it represents a revitalized romantic spirit that was ready to reject the isolation from real life, the exoticism, the theoretical emotionalism, of romanticism as represented by Delacroix.

The next year, 1835, Caricature was suppressed along with political caricature in general. Daumier joined the staff of Charivari, a journal of criticism and comment founded in 1832, and shifted from political to social satire. He was with Charivari for twenty-five years, turning out as many as one hundred and fifty lithographs a year. The entire human comedy was summarized by his crayon. Under the guise of humor, burlesque, caricature, and satire, he revealed not only

the follies and vanities and pretensions and stupidities of human beings, but as well their warmth, their capacity for goodness and affection, and frequently their innocence in the face of life. When they suffer or look foolish, they are usually only accepting life's imperfections as the natural course of things. His middle-aged married couples, bored, are the victims of forces that they do not understand but which it would never occur to them to question; others, old, fat, and altogether unlovely, continue to moon over one another, still in love. All the professions, all the trades, all the diversions, the whole parade that goes on year after year, was described and examined in more than four thousand lithographs during Daumier's years with Charivari.

We know what Daumier himself looked like as a member of the parade. Drawings, photographs, and descriptions of him are in accord. He was a stocky, sturdy, rather chunky man with a largish head that looked larger with its long disorderly hair (which thinned almost to baldness on top with age) and a brush of whiskers under the chin and along the lower jaw. His short, rather turned-up nose had a little the look of a vegetable; his eyes, not large, but well spaced and deep set, became half-hidden by thickened lids as he grew older but remained keen and sparkling. His lips were full and curling.

In spite of his position as an artist known to virtually every Parisian who could read, Daumier never made any money. Neither his cartooning for the journals nor the publication of lithographs in sets was very lucrative, and he had to live simply. He had no social ambitions, and, for that matter, was ill at ease in formal company. His friends were other artists, including some of the great names, and writers and journalists. His greatest pleasure was the theater, and his drawings show that he enjoyed the audience as much as he did the actors. His mastery of expressive bodily attitude, and

of totally revelatory facial expression, is that of a great char-
acter actor who draws instead of performing on the stage.
Molière was his favorite dramatist, and no wonder, since the
genius of the two men was akin, and Cervantes was his
favorite reading. Daumier made Don Quixote the personifi-
cation of the nineteenth century's romantic tragedy.

Marrying late—in 1846, when he was thirty-eight years
old—he chose a simple, hardworking woman fourteen years
his junior, Alexandrine Dassy, a seamstress. They set up
housekeeping in an apartment on the Quai d'Anjou—an awe-
somely fashionable address a century earlier, as it is today a
century later, but at that time a decaying neighborhood
where artists and writers, along with small businesses, could
find inexpensive quarters. With a studio in the attic above
their apartment, Daumier and his "Didine" lived on the Ile
Saint-Louis for seventeen years.

Always under the pressure to produce his stones for
Charivari, he still found time to study the masters in the
Louvre more carefully, and he began to paint. With the
Revolution of 1848 he returned to political caricature. Louis
Bonaparte's coup in 1852 brought him back to satirizing
modes and manners. But always his painting preoccupied
him more and more. There is no reason, however, to feel that
he regarded his lithographs as nothing better than hack work
that kept him alive. No man who would thus condescend to
an expression of his genius could have continued production
at a creative level so unflaggingly high and high-spirited. His
satires are serious art of a very important kind. Critics like
Baudelaire recognized his stature as an artist in these popular
works, as did his colleagues among painters. But he was tired
of being considered a draftsman only, and in 1849 and 1851
he had paintings in the Salon.

His paintings range in technical manner from the rich,
fluid, and agitated drawings-in-pigment to the firm modeling

of monumentally simplified figures. His friends saw the pictures in his studio (occasionally purchasing one, frequently receiving them as gifts) and recognized their greatness. Rousseau, Daubigny, and Corot knew, as Baudelaire did, that Daumier was a superb painter. But the public remained unaware of him as anything other than a cartoonist, and his work was seldom exhibited. For all the attention they received, his paintings in the Salon might as well never have been shown. In an aesthetic application of Gresham's law, Millet's debased reflections of Daumier seem to have blinded people to their noble model.

In 1860, for reasons that are not clear, Daumier quarreled with Charivari and after a quarter of a century with the journal was let out with half a month's pay. Now he abandoned caricature and cartooning except for random assignments and devoted himself to drawing and painting. During the years before his rapprochement with Charivari in 1864, he was in financial difficulties, but perhaps not quite in the desperate circumstances that are usually described. He was a man of tremendous stature among his colleagues, and if he had to borrow money from them from time to time (Rousseau was a generous lender) he still managed to support himself with dignity.

Upon rejoining Charivari, Daumier signed a lease for a cottage at Valmondois, where he had often spent the summer, keeping a room in Paris for brief visits to the city. He exhibited in the Salon of 1869—a man in his sixties now, and troubled with a form of death that can come to painters while their bodies are still healthy: he was going blind. He knew this by 1870; by 1872 he told his friends; by 1875 he could hardly see, although he still sold a little work. Corot bought the house at Valmondois and turned it over to him. With this and a pension from the state, which was granted through the intervention of friends, Daumier and Didine managed to live in some kind of security.

In 1878—he was seventy years old—the first one-man show by this great master was held. There were ninety-four paintings, watercolors, and drawings at Durand-Ruel in an exhibition that ended with a deficit but brought laudatory notices. Daumier died the next year on February 11, on the verge of his seventy-first birthday. He was buried near his studio. Friends carried his coffin, covered with flowers, to the grave. The flowers substituted for the conventional velvet pall, which the local curé had refused to a man whose Christianity had meant humanitarian love for his fellows rather than acceptance of the doctrines of the church.

One indication of Daumier's greatness is that although the crinolines, the poke bonnets, and all the other accessories of modes and manners are the raw material of his comments on society, and although his political cartoons deal with contemporary events and represent contemporary personalities, we never think of his picture of society as quaint or outmoded, nor do we think of his political cartoons first in terms of historical record—any more than we think of Goya's *Disasters of War* first as comments on the Napoleonic invasions that inspired them. Thus Daumier's stature reduces by contrast that of two men almost exactly his own age who also dealt with the world around them as artist-journalists—Gavarni and Guys.

"Gavarni" became the pseudonym of Sulpice Guillaume Chevalier (1804-1866) after he exhibited a watercolor of the *Cirque de Gavarnie* in the Salon of 1829. He worked for two of the journals that also employed Daumier, Silhouette and Charivari, as well as for other French and English publications. He pictured life on various levels of society, but it is always apparent where his sympathies lay—at the top. Gavarni was a skillful caricaturist, but he dealt only with surfaces, and not even true surfaces: he saw poverty as quaint-

ness. His work today is lively, frequently charming, often only trivial, and always a period piece.

Constantin Guys was much more of an artist. He is also an elusive figure. He led an active life and participated in great events, yet his life is not well documented. Even his birth date is doubtful: it might have been in 1802 or 1805, making him either twenty-one or eighteen years old when, at the same time as Byron, he fought in the Greek War of Independence. (The years were 1823-24.) For a while he served as a dragoon in the French army. For a while he lived in London, teaching drawing and French and selling illustrations to magazines. For some years he made his living as a foreign correspondent for journals, including the London Illustrated News, one of the few publications that carried pictures of current events. Traveling everywhere in Europe and as far as the Orient, he covered, among other events, the Revolution of 1848 and the Crimean War. His quick, sparkling sketches made on the spot, with notations for enlargement or variation, were sent back to his employers for translation into woodblocks or whatever other form of reproduction the journal used.

Such of these repertorial sketches as have survived are of great strength as well as great style, but Guys is best known for his hundreds, or thousands, of drawings of the courtesans and gallants of the Second Empire. In a billowing froth of crinolines and ribbons, with their umbrellas rising above them like blossoms, the women ride through the parks in sleek carriages drawn by prancing horses, their coachmen perched elegantly on the high seats while officers and dandies watch the parade. In the brothels the women dance with raised skirts, their great bosoms bursting out of deep décolletage.

As a draftsman, Guys had an unmistakable imprint; his drawings and watercolors need no signature. Yet his tech-

nique varied from the pearliest delicacy through spirited, dashing shorthand to an occasional coarseness and heaviness. Guys was thought of only as an illustrator but Baudelaire discovered him as something more, calling him "the painter of modern life." The only reservation that could be made today to Baudelaire's laudatory critiques would be that in spite of his brilliance Guys remains, after all, outside his material, an objective observer—in the end, a reporter, even though his reports are models of style.

Guys died a very old man in 1892, his life having very nearly spanned the century.

France during the nineteenth century birthed the leaders of the various revolutions in painting at neat intervals of twenty years (give or take a year or two). Ingres, inheritor of the neoclassical tradition, was born in 1780; Delacroix, his romantic opponent, eighteen years later; Courbet, who rejected classic-romantic idealism for realism, twenty-one years after Delacroix. And the impressionists, who superseded Courbet as the scandalous young men, were, as a group, about twenty years his junior.

Of all the rebel leaders from school to school, Courbet was the most belligerent, the most vociferous, and the most self-conscious—to a degree that makes one suspect that part of the time he antagonized the opposition more for the pleasure of being attacked in a spotlight than because the principles he defended needed such melodramatic championship. He was a man of really outrageous personal vanity whose demonstrations would have made him absurd if he had not been, also, an absolutely magnificent painter.

Jean Désiré Gustave Courbet was born in 1819 to a well-to-do landowner of the Franche-Comté, primarily a rural area, and attended the seminary in his native city of Ornans.

When he was eighteen, his father sent him to study at the Collège Royal at Besançon, with the idea of law school later on. Courbet, a conspicuously weak student, had no such idea, and managed to attend, at the same time, the local fine arts school, a near-mortuary under the direction of a fourth-rate student of David's, Charles Antoine Flajoulot.

It took Courbet no time at all to discover what was wrong with the Collège Royal and to launch his first revolution. The year of his arrival, he outlined a program for his schoolmates in the form of six principles of conduct, at least two of which anticipated his way of life in maturity.

Rule One was "Do not go to confession." Courbet remained vigorously anticlerical (a concomitant of republicanism), and in 1863—forty-four years old and old enough to know better—he indulged in a graceless bid for notoriety with a painting eleven feet long called *The Return from the Conference,* showing a group of toss-pot priests reeling home from an ecclesiastical assembly. The picture was of course refused by the Salon, as Courbet certainly intended it to be, and was even excluded from the Salon des Refusés, a special exhibition held that year for rejectees. It found a purchaser, however—a Catholic who bought it in order to burn it, thus doing Courbet a favor. But unfortunately for Courbet, *The Return from the Conference* had been photographed, and the record shows a picture so ill-drawn, so heavy-handed in its humor, and so naïve in its sensationalism, that one understands why even the critic Champfleury, usually one of Courbet's staunch supporters, referred to its painter as a "lout." ("Didn't the lout have anyone to advise him?") If not always a lout, Courbet at least was never a man whose intellectual edge was keen enough to understand, much less to create, the kind of satire that could have made *The Return from the Conference* a hilarious anticlerical damnation.

Rule Two in Courbet's student list was "Put obstacles in

the way of study." Rule Three listed some possibilities: "Compose music, write verses, novels, and love letters to the girls of Sacré Coeur."

Interest in the girls, for a boy of eighteen, is not a precocity. Courbet's interest continued, however, with exceptional strength. Like most physically vigorous, handsome, and vain men, Courbet was an ardent sexualist, although there is no indication that he ever knew either the pangs or the joys of true love. He never married, but became an unwed father in his early thirties (probably the year 1852), by one of his models, Thérèse Binet. The son lived with his mother in Dieppe until he died at the age of twenty. Although he had exhibited little talent for art, he had learned ivory carving. Courbet seems to have been fond of him, and saw him frequently.

Courbet's other suggested schoolboy reforms, which have been a bit too generously described by one biographer as "striking at the very heart of artistic and education theory in France," were, Four: "Try to find food"; Five: "Organize gymnastics and nocturnal fights"; and Six: "Play tricks on the monitors."

When he was twenty-one, Courbet left Besançon for Paris—to study law, his father thought, but actually to begin studying art seriously. He worked with a painter named Desprez and attended the Académie Suisse where models were supplied. But, like Daumier, he found his best instructors in the Louvre, and his choices repeated Daumier's—the Venetians and the seventeenth-century Spaniards, Flemings, and Dutchmen.

In 1844 he submitted to the Salon for the first time and was accepted; for several years thereafter he was more often rejected than not. His work during this time includes a series of narcissistic self-portraits, all handsome, all extremely romantic: Courbet seated on a hillside with a book and a black

dog (Paris, Musée du Petit Palais), his head arrogantly tilted, long locks flowing over his shoulders, eyes romantically shadowed; Courbet as a troubadour (New York, Private Collection), handsome legs in tights thrust into the foreground, luxuriant beard, and flowing hair framing eyes romantically shadowed; Courbet as a Renaissance sculptor (New York, M. Knoedler), in tights again, head very much thrown back, almost aswoon, eyes romantically shadowed; and finally, in a really superb painting, Courbet as Courbet the young artist (Montpellier, Musée Fabre), collar open, pipe in mouth, his handsome head handsomely thrown back and his handsome features handsomely shadowed, luxuriantly emerging from mysterious darkling gloom into mysterious light.

This last was an early masterpiece painted in 1846 when Courbet was twenty-seven. Five years later, Louis Napoleon Bonaparte wanted to buy it. But Courbet, with maximum publicity, refused to sell it at the price offered—asking double, which he later described as "keeping faith with one's self," the idea being, apparently, that when you differ with an individual politically, you should be available to him only at double the normal fee for your services. This substitution of a double fee for a "not for sale" is typical of Courbet's confused social consciousness, which he learned to append even to paintings that had been conceived with no social consciousness in mind.

Courbet has always been a painter's painter, and in the revolutionary Salon of 1849, which had liberal artists on its elected jury, he was admitted with a group of paintings including a portrait of an extraordinarily romantically handsome young fellow, *Man with a Leather Belt* (Louvre), which was, of course, a self-portrait. In his critiques, Champfleury now called Courbet a "realist," and the debate began as to whether he is more realist than romantic or more romantic than realist. It is still going on.

The storm that made Courbet the first great martyr of the Academy's villainy began the next year. In the 1850 Salon he showed a group of paintings—several landscapes, a portrait of Hector Berlioz (offered as a gift to the composer, who refused it because his mistress didn't like it, then offered to Berlioz's friend, Francis Wey, journalist, art critic, and friend of Courbet, who also refused it, and finally successfully offered to the painter Paul Chenavard; it is now in the Louvre), a portrait of Wey, and three peasant subjects: *The Peasants of Flagey Returning from the Fair* (Besançon, Musée des Beaux-Arts), *The Stone Breakers* (formerly Dresden, Gemäldegalerie; destroyed in 1945), and the centerpiece of the group, *Burial at Ornans* (Louvre), which has become one of the key paintings in the history of French art.

Burial at Ornans was painted as one of those Salon showpieces that, by pure size, insisted upon being looked at at least momentarily among the thousands of other paintings clamoring for attention. It is more than 10 feet high and almost 22 feet long, and shows, at life size, a group of about forty peasants and townspeople around an open grave in the harsh countryside near Courbet's birthplace. (Courbet himself stands, a handsome romantic presence, in the background.) As a technical exhibition, the picture is beyond cavil, beautifully drawn and painted, although as a pictorial composition it is undistinguished. But academic officialdom found plenty to object to. Courbet had already established himself as an insolent fellow, "realism" had become a fighting word, and the picture had a forcefulness that was easy to interpret as aggressive vulgarity.

This forcefulness was (and remains) Courbet's distinguishing characteristic as a painter out of the ordinary at mid-nineteenth century. Other painters, Millet among them, were more realistic than he—that is, they observed things less romantically—but Courbet's presentation of a subject in a

rich pigment that identified its own palpability with that of the object was a form of realism, the realism of tangibility, that no other artist had quite approached. His sensuous love of paint, a craftsman's love, puts all intellectual theorizing to one side and brings the painted objects to life with staggering conviction.

The attacks on *Burial at Ornans* were stimulated by a changed atmosphere in France. After 1848, Courbet's interest in common subjects paralleled the new liberalism, but after the coup d'état that established the Second Empire in 1851 and was accompanied by the repression of any manifestation of republican sympathies, Courbet's peasants, so different from the idealized pseudo-peasants of Millet, were too real for comfort. Napoleon III indulged in a great deal of moralistic cant, and the opulence of Courbet's nudes (his women are the most juicily fleshed since Rubens's) so offended the Emperor that he threatened to slash a painting of bathers in the Salon of 1853.

Partly distressed and partly enjoying the turmoil, Courbet found at this time a patron who remained a consistent support, the wealthy Alfred Bruyas of Montpellier, who bought the offending *Bathers* (Montpellier, Musée Fabre) and invited Courbet to visit him. Courbet did so. A record of the visit, now entitled *Bonjour, Monsieur Courbet* (also in the Musée Fabre), shows Bruyas the patron doffing his hat and bowing his head to the painter (head thrown back, etc.). The even less modest original title was *Fortune Saluting Genius*.

For the great Exposition Universelle of 1855, France planned a super-Salon. Courbet, like other artists, set to work to produce a masterpiece for it—in his case, a mammoth document celebrating himself and his ideas in opposition to those of Ingres and Delacroix, who were being given large retrospectives. In spite of his run-ins with the Emperor,

Courbet had been offered an official commission for the exposition by the usually stuffy Count Nieuwerkerke, Director General of the National Museums, with the stipulation, however, that a preliminary sketch be submitted for approval. Courbet not only refused to submit the sketch but proclaimed everywhere the fact that he had thus frustrated official efforts to bring him into line. (Nieuwerkerke's offer was, in truth, some such bribe.)

The government could hardly have been expected, after all this, to look on Courbet's submission for the epochal Salon with much enthusiasm, and Courbet compounded his defiance by entering not only his big new painting but, with it, the controversial *Burial at Ornans*. He felt safe, no doubt, since the liberal jury of 1849 had given him a medal, an honor that ordinarily allowed recipients to exhibit in subsequent Salons without going through the jury. But in this great year of 1855, the rule was temporarily abrogated, and Courbet's paintings were thrown back at him.

In retaliation, with the help of his rich friend Bruyas, he built a "Pavilion of Realism" to exhibit his paintings only, with the new one, *The Painter's Studio,* as its centerpiece. *The Painter's Studio,* now in the Louvre, is 230 square feet of canvas showing Courbet at work on a landscape, flanked on one side by the critics and friends who had encouraged and supported him and, on the other, by symbols of his special sympathies and antipathies—peasants and laborers to represent his socialism, priests to represent his anticlericalism, and so on.

Courbet's social and political philosophies had been developed for him by various friends (and enemies) who read them into his paintings. He had accepted himself as a socialist and a thinker upon the assurance of Pierre Joseph Proudhon, the radical theorist. It must have been Proudhon who suggested to Courbet the mishmash of *The Painter's Studio,*

which Courbet called an allegory of his life over the preceding seven years.

The public was not interested in the Pavilion of Realism. When Delacroix visited it one day (finding *The Painter's Studio* one of the extraordinary paintings of the century, which it is), he had the place to himself for an hour although the admission fee had been reduced to ten cents. Commenting on the short-sightedness of the officials in refusing the painting, Delacroix added that "a strapping lad like Courbet is not going to be discouraged by a small thing like that."

The strapping lad was now thirty-six and putting on weight. Whether because he was disappointed in the public response to his Pavilion of Realism or because he sighted middle age in the near distance, Courbet's work changed character during the following decade. He remained a glorious painter in terms of his sensuous pigment, his strong color harmonies, and his ability to relay with the immediacy of an embrace all the tactile reality of the objects he painted. But his selection of subjects and his response to them shifted. His nudes, always remarkable for their moist, warm fleshiness, were now presented as erotic visions, sometimes with flagrant vulgarity. His landscapes, often with animals, and his seascapes were as magnificent as ever, his rocks as solid, his verdure as opulent, his streams as cool, his skies a dark, vibrant blue blaze. With the general public his success was spotty, but he was collected, at high prices, by a few connoisseurs for whom he had become, as for Bruyas, something of a demigod. At this time, also, he found numerous commissions for portraits.

Courbet's radicalism waned—at least it was seldom now expressed in his painting, although he still acted the radical for the young painters who clustered around him. Perhaps concerned with this cooling off, but more probably nostalgic for the spotlight, he painted the disastrous anticlerical demon-

stration, *Return from the Conference,* during a stay in Saintes. If he had been in Paris where Champfleury and his other intellectual friends could have given him their usual advice, he might have been spared the ensuing scandal, which was embarrassing rather than stimulating. Even Champfleury had to give him bad notices in 1863.*

The year 1863 may be taken as a dividing line in Courbet's life. He was forty-four years old and obesity was upon him. As a scandal, *Return from the Conference* had backfired, and, even worse, a younger artist had aroused a scandal that made the sensations of Courbet's youth seem mild. This artist was Manet, with his *Déjeuner sur l'Herbe* in the Salon des Refusés. The former young radical from Ornans found that he had become a middle-aged reactionary.

But within the next years he became finally the grand old man of realism. He had considerable success outside France, and was acclaimed at Munich's first international exposition in 1869. Courbet's native Franche-Comté had affinities with Switzerland and Germany that could be more than coincidental with the sympathetic response to his work in Germany. He made several trips to that country and met the realists who were working there—Friedrich Wasmann (1806-1886) and Karl Blechen (1798-1840) in Munich, and Adolf von Menzel (1815-1905), a fine realistic draftsman if a disappointing painter. In Paris also, during his crucial year of 1855, Courbet saw Menzel, who, as early as 1836, had written, "The arts have always produced and carried out only

* Courbet's colleagues and supporters in the realistic movement, which was developing at the same time in literature, included Champfleury, whose real name was Jules Husson, Jules Castagnary, a novelist and codifier of a realist credo, and Edmond Duranty, who founded a magazine, Realisme. Their meeting places were the Brasserie des Martyrs and the Andler Keller, where young painters interested in new ideas came to listen to Courbet. Baudelaire was also an early friend and was portrayed as such in *The Painter's Studio,* but, like Champfleury, later showed disappointment in Courbet's work.

what their own period demanded," anticipating by twenty-five years Courbet's "I hold that the artists of one century are fundamentally incompetent to represent the things of a past or future century"—although this is not quite the same thing.

In 1870, Courbet was offered the Cross of the Legion of Honor, which he refused in declamatory terms. (Daumier also refused it, with dignity.) The same year saw his brief rise to a power that promised for a moment to equal David's after the Revolution, and then his plunge into an unhappy conclusion to his life.

In the Commune following the Franco-Prussian War, Courbet's vaunted socialism made him the natural choice to head a general assembly of artists. In a series of gestures, he abolished the Ecole des Beaux-Arts, the Fine Arts section of the Institute, the Academy in Rome, and all Salon medals—although he kept the Salon jury. But the Commune vanished before any of these changes were really effected, and during the reprisals that followed, Courbet, now entering his fifties, but seeming older, was first imprisoned and then, ill, removed to a nursing home.

The final disaster came when he was officially blamed for the wrecking of the Colonne Vendôme and ordered to pay the fortune required for its re-erection. During his brief tenure as national curator of fine arts, when he was assigned the protection of the Louvre and other national art treasures, he had suggested that the neoclassical monument to Napoleon's campaigns be removed from the Place Vendôme to the Invalides, a more appropriately military site. Unfortunately he had also said, before this, as an anticlassicist and an antimilitarist, that the column should be demolished. Whether or not he was in any way directly responsible for its being toppled by the mob during the Commune, he was held responsible. He had amassed some money, but could not meet the bill. He escaped to Switzerland, where he died an exile six

years later, on the last day of the year 1877, at the age of fifty-eight. A forced sale of his property and paintings had just been held in Paris, and he could have returned there.

Courbet's most notable expositions of what he meant by realism were made in 1855 to accompany his paintings in the Pavilion of Realism and in 1861 in an open letter responding to a group of students who had asked him to organize a school in competition with the Ecole des Beaux-Arts. Both were written with the help of people better at words (and more clear in their ideas) than he was. These manifestos deny to painting the right to represent anything other than "objects visible and tangible to the painter," thus ruling out all fantasy, historical re-creations, and mystical religious art. "Since beauty is real and visible, it holds within itself its own artistic expression," and the artist's only obligation, and his only privilege, is to "find the most complete expression of an existing thing. . . . The artist does not have the right to amplify this expression."

But of course Courbet did amplify it by the richness of his response to physical things and the richness of his brush in recording both the things and his response. He was a natural man and a natural painter whose stature as a personality (not as an artist) was reduced by his efforts to formulate an aesthetic and social program. The most astute of his comments was the opening sentence of his introduction to the Pavilion of Realism: "The title of realist," he wrote, "was imposed upon me as the title of romanticist was imposed upon the men of 1830."

Ingres, Delacroix, and Courbet all were flourishing at once over a period of years in France, although they represented three successive revolutions—neoclassicism, romanticism, and realism. During these years and on to the end of

the century, German painters were subject to the same combination of loyalties, although somewhat tardily in the case of realism. Once the original romantic impulse represented by Runge and Friedrich had faltered, German painters were not notable for their adventurousness until, in the twentieth century, they suddenly joined the leaders of the revolution called modern art.

The German painters considered here—classicists, romantics, and realists—were born during a span of only seventeen years, from 1827 to 1844 (they are taken up, for one reason or another, in reverse order of date of birth), and were busily working away at their problems during the decades when the French impressionists, the subject of the next chapter of this book, were fighting and winning their battles.

Wilhelm Leibl (1844-1900) was nineteenth-century Germany's most determined and most influential realist. Born in Cologne and trained in the Munich Academy—which was dedicated to the same general Salon standards as those being followed by the official artists in France—he began by admiring all the wrong men but soon felt his way toward the absolute truth to nature that became his fetish. He was twenty-five when he discovered exactly where he wanted to go. In that year, 1869, Munich held its first international art exhibition, and among the 1,631 paintings, Leibl discovered Courbet.

Courbet by this time was the grand old man of French realism, but he still seemed radical to German eyes, which were accustomed to nothing more controversial than the dispute between two brands of academic painting, Düsseldorf's and Munich's. (The Munich academy had just won leadership.) When he visited the city late in the year, Courbet thrilled Leibl and some other young painters who had begun to cluster around him (the "Leibl-Kreis") by acting out the character he had established for himself in Paris, that of the uncouth, earthy titan. Courbet must have enjoyed finding a

second young audience for this act; the audience he had originally excited in France was getting on toward middle age. Courbet praised Leibl's painting in reciprocal, and no doubt quite sincere, admiration.

For the next several years, up at least through 1873, the Leibl-Kreis made painting excursions in the country, held discussions in studios and restaurants, and devoted themselves to the Courbet-Leibl ideal of no idealism. The circle was not a formal organization and only two of its members, Wilhelm Trübner (1851-1917) and Charles Schuch (1846-1903), are given much attention today, although Johann Sperl (1840-1914) is remembered as the companion with whom Leibl spent the last decades of his life.*

After the mid-seventies, Leibl spent as little time in cities as possible, preferring the Bavarian villages in the foothills of the Alps, where on every hand he found his subjects —the peasants and their life. He did not ennoble them in Michelangelesque proportions as Millet had done, nor, naturally, did he prostitute them as picturesque material in the manner of the still-flourishing genre school.† He believed that he could paint them exactly as he saw them and thus reveal the inherent dignity that they shared with all other things and beings close to the soil.

Insofar as exact, noninterpretative rendering is possible for an artist who is interested in his subject matter, Leibl achieved his goal with *Three Women in Church* (Hamburg, Kunsthalle), in which he abandoned the richly painted surface for a tightly detailed polish that harked back to the

* Other members of the Leibl-Kreis were Rudolf Hirth du Frênes (1846-1916), Albert Lang (1847-1933), Fritz Schider (1846-1907), Ernst Sattler (1840-1923), and Karl Haider (1846-1912).

† Ferdinand Georg Waldmüller (1793-1865), of the Vienna Academy, represented this tradition at its best in his landscapes. He was also an expert portraitist. In his late landscapes he developed a Barbizonesque response to effects of outdoor light and air.

German tradition of Holbein. Hyperphotographic, *Three Women in Church* was received with an enthusiasm stimulated more by its sharpened technique—there is always a public ready to respond to meticulous detail—than by the success with which Leibl had revealed the dignity of his models. In Paris the comment was made, "It is no longer painting!"—an expression of amazement and admiration in the face of the illusion of reality. The same comment, however, could have been made to indicate Leibl's weakness. His extreme preoccupation with photographic realism was turning him from a painter into a camera.

The picture remained Leibl's high point. He had worked on it from 1878 to 1882. He now began another painting of a group of men, *The Poachers,* but after four years of work was so dissatisfied that he dismembered it. The fragments (Berlin, Nationalgalerie) are strongly painted, and a photograph of the picture before it was cut to pieces shows that it was solidly composed. It suffers, however, from a combination of determinedly literal realism and too-obvious artifice of arrangement. The conflict was the final demonstration of Leibl's own difficulties as a theorist of realism—difficulties that Courbet had never met because, whatever his theories about painting dunghills, he had always been a painter first of all, an artist in the great tradition in spite of his position as a nominal revolutionary.

Hans Thoma (1839-1924) would probably win the title of nineteenth-century Germany's most distinguished realist if a vote were held among critics today. The best of his painting, however, would have to be culled from the mass of his extremely uneven production. He invested his observations of the world with gravity and repose, sometimes with suggestions of romantic melancholy.

Thoma developed rather slowly. In 1867 as a twenty-eight-year-old student in Düsseldorf, where a school of narrative genre painting was deeply entrenched, Thoma met Otto Scholderer and, the next year, went with him to Paris. There he met Courbet and studied briefly with him. He was also much impressed by the Barbizon painters. But what he learned in France stood him in bad stead upon his return to Germany, where his work was rejected on much the same terms as Courbet's had been rejected a decade before in France. During the next years, Thoma was on the fringes of the Leibl-Kreis, but he was always (like Courbet) as much a romantic as a realist, and Leibl's efforts for expression through literal objectivity were not really appealing to him.

Thoma had to wait until 1890 for his first success, in an exhibition in Munich. By this time his realism had been modified by a streak of sentimentalism (the chronic failing in German painting all through the century) picked up during a trip to Italy in 1874, where he admired, and applied in weakened form, the romanticism of his countryman Hans von Marées.

Thoma had begun his life as a painter in Karlsruhe, where he was a student at the Academy. In 1899, sixty years old, he returned to that city as professor in the Academy and director of the museum. (This must have been a special satisfaction to him, since it had been in Karlsruhe that his work had first been attacked.) As a successful painter he executed numerous murals, all of them best forgotten. When he died at the age of eighty-five in 1924 he had been an anachronism for nearly fifty years.

Hans von Marées (1837-1887), although the close contemporary of both Leibl and Thoma, was unaffected by the realistic movement of his generation in Germany. It was a

generation that Von Marées, as an artist, skipped: he combined the romanticism of his precursors with a modernism that has given him the name of Germany's Cézanne.

Like other German romantics, he yearned toward Italy as the embodiment of a beautiful past, the antithesis of the industrial and military society of the new Germany. In 1864, when he was twenty-seven, he expatriated himself, and although he returned to Germany and fought in the Franco-Prussian War in 1870, he went back to Italy in 1873.

In Naples he executed his most important commission and made a great success with it, the frescoes in the Aquarium. No other opportunities for literally monumental paintings came his way, but the rather tired adjective "monumental" must be employed to describe even his smallest pictures.

He held philosophical ideas about the nature and function of art that helped turn Böcklin (who was ten years older) toward his final mystical expressions and, in an opposite direction, influenced the twentieth-century German, Max Beckmann, in his impressively scaled forms—adapted, in Beckmann's case, to themes of social humanism. But in spite of the variety of influences he exerted, Von Marées was not one of those artists in whom several impulses are at war. He was one of those many nineteenth-century European painters who harmonized romantic and classical ideals.

Anselm von Feuerbach (1829-1880) was another German refugee to a spiritual home in Italy, where he settled in 1855 when he was twenty-six, after studying in the academies in Düsseldorf and Antwerp, and with Thomas Couture, Manet's teacher, in Paris. Later on, 1873-76, he tried to resettle in the North, spending these years teaching, and miserable, in Vienna. He had become ineradicably infected with Raphaelism, which was endemic not only in Couture's studio

but, of course, in Italy. After the Viennese interval, Von Feuerbach spent the rest of his life—four years—in Venice.

All but unknown outside Germany, Von Feuerbach is an excellent painter, sometimes remindful of Ingres in the nicety of the precise definition of his portraits, although these are somewhat warmed by the richer pigmentation that he learned from Couture and by the examples of Courbet and Delacroix, both of whom he admired. A classicist on the surface, he was at heart a gentle romantic who responded to the world in intensely personal terms (which was also true of Ingres). In a classical style he expressed romantic feeling —reversing the classical-romantic harmony of his contemporary, Von Marées, whose romantic manner was employed in the service of classical generalities.

Arnold Böcklin (1827-1901), born in Basel, is a prominent figure in Germanic romanticism, yet he cannot be tied to any single aspect of nineteenth-century painting. An independent, vigorous, and restless personality, he is connectible with Wagnerian Nordicism, seventeenth-century Italian picturesque landscape, Düsseldorf and Munich realism, Pre-Raphaelitism (he was an almost exact contemporary of Millais, and shared the Pre-Raphaelite idea that the mystical could be described in explicitly realistic detail), expressionism (influencing Edvard Munch), surrealism (anticipating the mood of Giorgio de Chirico), and a few other schools or individuals who flourished earlier and later than he. If we have to choose between calling his art a compendium or a goulash, a goulash it will have to be.

At eighteen, Böcklin was studying under the Düsseldorfer Johann Wilhelm Schirmer, a painter of Christian legends set in explicitly defined landscapes of the Holy Land— from whom Böcklin probably acquired his idea that the mystical is best expressed through the factual. In his early

twenties (in 1850) he went to Rome, and there found such surcease from Germany's industrialized society, which he hated, that he stayed for seven years. All during his life he traveled a great deal, in Germany, in Flanders—where he was attracted by the morbid aspects of the art of Hugo van der Goes—and in France.

Until about 1870, Böcklin was painting romanticized visions of classical antiquity filled with sentimental symbols of love, poetry, youth, and art. Staying in Munich from 1871 to 1874, he met Hans Thoma, and was attracted by Thoma's solid romantic realism, which he tried to fuse with the Wagnerian rodomontade. He began painting Nordic mythological beings along with Pan and other deities of antiquity in a heavy, richly pigmented style, presenting the fantastic subjects with all the meat-beer-and-potatoes heartiness of the rathskeller.

In 1880, when he was fifty-three, Böcklin created his masterpiece, *The Isle of the Dead* (Metropolitan Museum), which he repeated several times thereafter. Once an internationally familiar picture, it has been unjustly neglected recently. It shows a barque bearing a lonely robed figure to a mysterious, rocky, templed island.

During this final period of his life and his art, Böcklin was obsessed with themes of death and destruction. He was seventy-one in 1898 when he painted *The Plague*, in which he harked back to the greatest masterpiece of Germanic mysticism, the *Isenheim Altarpiece*. He died early in 1901 at San Domenico, near Fiesole outside Florence, where he had settled. He had become famous, but immediately after his death his reputation was demolished by critics belonging to the new century, who could accept neither his realism nor his sentimentalism. He is not always easy to accept today, although he was sympathetically re-evaluated during the rise of surrealism.

THE IMPRESSIONIST VICTORY

The history of painting, like the history of anything else, is a record of change following change in correspondence with the course of events in general. Impressionism, a climactic expression of the nineteenth century, has taken its place in art history as a natural, an inevitable, development in a sequence of developments. But when it appeared, its guise was revolutionary because the standard of comparison was the entrenched conservatism of an Academy that, because it misunderstood the past, had blinded itself to the present. The French Revolution, as far as art is concerned, occurred in 1874. In that year the impressionists, despairing of official recognition in the Salon, held their first independent exhibition. There had been a prophetic skirmish against the aesthetic Bastille eleven years earlier, the Salon des Refusés of 1863.

By hindsight it now seems obvious enough that artists

living during a time of rapid change should have become interested in recording fleeting impressions of the world. But it seemed outrageous to the Academicians, and to a public educated by them, that the impressionists should adopt casual, even accidental (and non-picturesque) aspects of the world as subjects for serious painting. This pedantic and Philistine audience was even more offended by the technique adopted to present these subjects. Color broken up in many small contrasting strokes seemed a deliberate malformation of visual truth—and yet this manner of approximating the vibration of natural light was actually a form of realism by which the truest effects of nature were set down in accord with laboratory discoveries of the physical character of light. But a public that expected painting to reproduce the look of things failed to recognize in impressionist paintings the very ideals it held most dear, perhaps having become chronically laggard in such matters by the latter half of the nineteenth century. The impressionists are now loved for their reflection of bourgeois delights—the countryside, domestic felicity, and all the uncomplicated pleasures that are no longer typical of our lives. But the denizens of the bourgeois world rejected impressionism's loving record of its character.

If impressionism in itself was not as revolutionary as it seemed, it yet held the germ of the most profound revolution in painting since Giotto—the revolution by which Cézanne, beginning with the impressionist idea of divided color, reconceived the idea of form in painting. Because he did so, he is not included in this discussion of his colleagues in the impressionist circle, their opponents in the armed camp of the Academy, and some related figures in the battle, such as Whistler. Cézanne will have his own place later on as the terminal figure in this long story.

The Impressionist Victory

Edouard Manet, born on January 25, 1832, was a reluctant revolutionary. He was—art-historically speaking—the natural son of Courbet and the unwitting father of the impressionists, standing alone in a position between the two as a landmark and a boundary line, the pivotal figure in the scandalous disputes that finally discredited the French Academy and established the right of any artist to paint exactly as he pleased. The storms that burst over him appalled him. He wanted only one kind of success, the conventional success of popular acclaim and official honors, the success of the ribbon in the lapel. He did not need to paint for money; he was a member of a social class new in his century, the bourgeois patrician, and he had inherited adequate means if not real wealth. But even if the food on his table had depended on his changing his way of painting to a popularly and officially accepted one, he could not have done so, not because he was under any limitation of talent, but because he was always a painter who went about his work with a certainty that was inborn rather than calculated.

Although Manet took part in discussions at the Café Guerbois where a group of young artists met, he was not much of an intellectualizer. He established a new aesthetic in painting by trusting his hand and his eye, but left to others the job of formulating statements of his principles after the fact of his achievement. Conservative by temperament, he could have seemed radical only to the reactionaries who were entrenched in the offices where the kind of recognition he wanted was dispensed. The irony of his battle for favor is that by rejecting him the Academicians undermined the foundation upon which their whole structure of privileged authority rested. The scandal of the Salon des Refusés in 1863, with Manet victimized at its center, marks the beginning of the modern artist as a man whose creative independence is subject to no check beyond his own conscience. Since

then, the privileges of this position have been as much abused by men without conscience as were the privileges of the Academy, but it is nevertheless the position established by Manet as the only possible one for the creative artist today.

The revolution of 1863 took place in a world that seemed idyllic for the artist. Paris was the center of the art world and proud of it. The government supported or sponsored a system of schools, studios, and exhibitions dominated by an Academy of Fine Arts that had been formed to honor great men during their lifetimes and, from Olympian heights, to encourage and discipline young talents. Paris provided artists with the largest and hungriest audience that art had ever attracted. Thousands of people crowded intō the annual Salons, the official exhibitions where talent and industriousness were rewarded by prizes that launched new careers or boosted established reputations to new levels. The Salon was the annual climax when the arts of painting and sculpture, so assiduously cultivated, bloomed to the glory of France. One had only to prove oneself to share in this glory.

Such was the idyll. But human frailty had lowered the benevolent institution of official patronage in France to the level of organized favoritism, while the admirable academic intention of preserving and developing the best expressions of French creative genius had been debased into the enforcement of dogma. In the second half of the nineteenth century, the whole system of instruction, patronage, and proselytization of art in France seemed directed toward the discouragement of any painter who applied his talent to anything better than repetition of the threadbare formulas of the pedants who had vitiated the system.

The absolute power of a Paris Salon jury in Manet's time is difficult to imagine today when the function of taste-making has been dispersed around the world among dealers, museums, art schools, cultural foundations, and various

fringe organizations, all of them grinding their axes in com-
petition with one another, and all with access to hundreds of
sources of publicity for the popularization and sale of this
kind of art or that, whereas the Salon in its heyday stood
alone and impregnable. True, there were rivalries within the
walls, and true, also, Salon juries varied from liberal, as the
exception, to hidebound, as the rule. But since the Salon
represented officialdom in the arts, and since officialdom by
its nature is concerned with the perpetuation of the status
quo to which it owes its existence, the Salon was hardly a
breeding ground for change.

There were then few dealers in Paris, and even fewer
that were not essentially Salon outlets. Painters with new
ideas worked their way into acceptance painfully and over
many years. By the time they were established in the Salon
and of sufficient consequence to serve on its juries, they were
themselves likely to look with suspicion on innovations, even
those that might have grown out of their own. Corot, a gentle
spirit whose art contributed so much to impressionism, re-
ferred to the impressionists with contempt when, in his old
age, these young men who admired him declared their inde-
pendence from the Salon.

The 1863 jury, which seems to have been dominated by
a now-forgotten mediocrity named Emile Signol, rejected at
least three thousand paintings. Since a good five thousand
had been submitted, this still left what sounds like a big
enough show. But as Salons went, the proportion of rejections
was a massacre. The word is not too strong, since a rejected
artist suffered from more than wounded vanity and damaged
prestige. Rejected pictures became unsalable at any decent
price to a public unsure of its own judgment and fully confi-
dent of the Salon's. Acceptance in the Salon did not insure a
painting's sale, but rejection put it in the class of defective
merchandise.

Even before it met, Manet didn't have a chance with the 1863 jury. He had always been a little troublesome. As a student he had been unwilling to follow without question the teaching of his master, Thomas Couture, a painter of strong talent and feeble imagination who put his faith in the academic formula. Nevertheless, Manet had received an honorable mention in the Salon of 1861, when he was twenty-nine, where a picture of his parents (always a safe subject) and another of a Spanish guitar player (safely picturesque) had attracted favorable attention. Perhaps this small success ruffled the pedants who remembered his defections as a student. Manet also made the mistake of exhibiting a group of paintings just before the opening of the Salon with an adventurous dealer named Martinet. It was a rash move, even an impertinent one, for a painter in a precarious spot, and the critics were hostile with a violence that justifies a suspicion that they enjoyed the opportunity to pounce. Finally, some of the jurors no doubt disliked Manet personally; he could be standoffish to the point of snobbishness, and was temperamentally incapable of currying favor. For whatever combination of reasons, the Salon jury was ready to cut Manet down to what they thought was size, and his three submissions were thrown out.

A good, selective weeding by a fair jury might have been just what the Salons needed, since only a fraction of the several thousand paintings in a typical one were anything more than proficient exercises (the technical level of Salon painting was high, if pointless). But the objections of the rejected painters in 1863 were clamorous, and in a country where the arts were closely bound to government, the uproar amounted to more than a bit of picturesque unpleasantness in the studios. Napoleon III summoned his Superintendent of Fine Arts—Count Nieuwerkerke, an incorruptible Pharisee—and not only told him that something had to be done, but told him what to do: he was to set up an auxiliary Salon

where the rejected pictures were to be hung, and the public was to judge for itself whether the jury had been right or wrong.

The flaw in this situation was that the public never made a judgment of its own when it had an official one to follow. The Emperor himself was not exactly an aesthetic radical. His taste is well enough exemplified in the painting he chose to purchase from the Salon that year, a sugary *Birth of Venus* (Paris, Luxembourg) by the slickly competent academic painter Alexandre Cabanel, in which a seductive blonde was displayed in seductive nakedness—a painting with every qualification for embellishing the wall of an expensive brothel, but posing as the legitimate descendant of classical idealism.

The Salon des Refusés, so far as it can be reconstructed from its rather sketchy catalogue, appears to have been only a larger and spottier Salon. Several artists were represented in both exhibitions, and the bulk of the rejected pictures had been rejected, no doubt, for the legitimate reason that they were inferior productions in the standard manner. The idea that the Salon des Refusés was the declaration of independence for a group of revolutionary painters—that it was studded through with works of an originality to which the jury had been blind—is attractive but incorrect. The Salon des Refusés has tremendous importance as the first official hint that the jury's official taste might be questioned, but as proof of the jury's fallibility it seemed, at the time, to have backfired. Whistler had a painting in it; Pissarro had three. But the handful of other names that have become famous were represented by early or minor works that only an oracle could have singled out—with the exception of the three canvases by Manet.

Two of these—*Young Man in the Costume of a Majo* and *Mlle Victorine in the Costume of an Espada,* both now in the Metropolitan Museum—were of the type that had

struck the critics as barbarous in Manet's show at Martinet's, with their strong colors dashed against grays and blacks. But the real shocker was a painting called, in the catalogue, simply *Le Bain*, which soon took on the title it still carries, *Le Déjeuner sur l'Herbe*. Basically, *Le Déjeuner*, now in the Louvre, was a type of demonstration painting familiar in the Salon: combining a nude, a section of still life, and some landscape, it permitted an artist to display his skill in a set piece. The trouble was that Manet, as a pure painter, violated the approved methods of representation, and thus offended the Academicians. Additionally, he offended them— and the public too—by supplying none of the clues (facial expressions and the like) that Salon painters ordinarily planted to tell people how to respond to a picture.

The main reason *Le Déjeuner* offended so deeply was that it puzzled, and by puzzling it threatened. The Salon audience was still raw, composed as it was of early generations of the mass audience created after the French Revolution with the shift from aristocratic to bourgeois patronage. Eager to feel cultured, this audience gave its favor to the kind of painting that took it by the hand and pointed out which one of several standard conventional responses the cultured person was expected to feel. The result was that the more obvious the indicated response—the more vulgar in the most generous sense of the word—the more successful a picture was likely to be. The most popular Salon paintings were essentially waxwork displays created to please an audience with no interest in the aesthetics of painting—with, in fact, no real consciousness of aesthetics—who expected to be offered pictures to be read much as one would read a story, a tract, or a description.

But *Le Déjeuner* left you hanging. It was apparently some sort of woodland scene dominated in the foreground by a young woman seated naked on the grass, casually glanc-

ing at the observer, while two fully clothed young men, half reclining near by, engage in conversation. In the background another young woman, wearing some kind of thin shift, seems to be taking a wade. What was it all about? It offered no clues; it was and is a painting that makes sense only as an aesthetic statement. It proposes no moral or social lesson, and whatever anecdotal content it has (four young people went on a picnic and the girls went bathing) is not only very slight but is presented with a total absence of comment. What was supposed to be going on, and what were you supposed to think of it? What, for that matter, did the artist think of it? Manet seemed to have set the stage and peopled it with actors without supplying a script. Even the title, which could usually be depended on as a clincher in cases of doubt, was noncommittal—*Le Bain*. The only conclusion was that this fellow Manet was indifferent to moral values, a coarse-grained man devoid of idealism, and that his picture, if indeed not conceived as a piece of insolence, was at least indecent.

The Salon mentality was both cautious and parasitic, eager to learn but more eager to conform. The public would no doubt have followed the critics' lead to praise as quickly as they followed it to damn, but the majority of the critics held their positions for the very reason that their views and tastes were as smugly narrow as most official taste—and damned the picture was. It was damned as indecent, and it was damned as technically incompetent.

To give the critics their due, *Le Déjeuner* is a curious picture that does tend to break into parts, a series of brilliant studies done for the pure satisfaction of painting. As was pointed out at the time by the picture's few defenders, *Le Déjeuner* could be looked at as a modern counterpart of Giorgione's *Fête Champêtre* in the Louvre, where clothed male youths sit in a countryside with two nude females of voluptuous contours. But the Giorgione is a highly poeticized

scene, perhaps an allegory with a lost key. Its air of lyrical mystery is antithetic to Manet's odd statement of fact, which is both incontrovertible and unexplained.

The scandal distressed Manet rather than angered him. It made his name a byword, but he was not one of those men who can equate notoriety with fame. And in 1865—Manet was then thirty-three—his masterpiece, *Olympia,* now a star in the Louvre, created an even worse scandal.

Olympia was a modern version of the old test-theme of the reclining nude, with special reference in this case to a near-erotic portrait of a Venetian courtesan by Titian, the *Venus of Urbino* (Florence, Uffizi). Manet's Parisian courtesan is a rather chunky girl of the people, arrogant not in her display of nudity but in her indifference to nakedness. Again Manet made no comment; he simply presented an objective statement. By presenting with vivid completeness an image that has all the non-interpretative immediacy of a snapshot, he accepted the practical realism of his time, its faith in the apparent and the tangible, its rejection of anything that could not be established by proof through common experience. This was the century's scientific attitude, but in its popular manifestation it could take on all the tawdriness, stodginess, and self-satisfaction that eventually made "bourgeois" a derogatory word.

Manet's translation of his century's realistic philosophy into an aesthetic statement in *Olympia* was completely misunderstood. Whatever the century's scientific and practical ideals, the public expected art to offer sugar-coated assurance that its spiritually grubby culture was holding to the elevated principles and refined sensibilities that, presumably, were historically typical of all great artists and their patrons. *Olympia* assured the public of no such thing. The picture was simply there; it was there with all the force, all the life, all the vitality that Manet had now learned to reveal in his paraphrases of actuality; it was there with a maddening ex-

istence of its own that rejected all compromise. There was something brash about this girl's glance that was infuriating; but there was something aloof, too—which was unforgivable. *Olympia,* a picture of a common girl, happens to be one of the most elegant paintings of its century, and if Manet's critics sensed this, it must have been the final and intolerable violation of their security, a reasonable explanation for their attacks upon the painting for its brutality. The only insult Manet was spared was the accusation of effeteness. *Olympia* is not effete, but it comes closer to being effete than prurient, and prurience became the major charge against it.

Olympia was accepted for the Salon of 1865, perhaps as a safety measure after the Emperor's rebuke of 1863, and no doubt in the way an unwelcome guest may be invited to a party by a hostess who plans to give her a bad time. The attacks on *Olympia* were abominable. It was compared to "high" game, and the visitors crowding around it to sight-seers at the morgue—which may have been a legitimate comment on the visitors, but not on the painting.

During the decade following Manet's debut as the Academy's whipping boy, the younger men who were later to be known as the impressionists were having equally rough going, although they were less violently attacked (at that time) than Manet because they were less conspicuous, a small comfort. When they organized as an exhibiting group in 1874, Manet, still with his sights set on success in the Academy's pattern, refused to join them in spite of the urgings of Degas. Degas, a man of Manet's own age and social position, was most nearly his friend. But Manet by temperament was aloof in friend-ships and not at all attracted by membership in an insurgent group. Even when the Salon began to accept Manet's work with some regularity, he remained an outsider.

Finally, in 1881, less than two years before his death on April 30, 1883 at the age of fifty-one, Manet was awarded a Medal Second Class in the Salon and was nominated for the

Legion of Honor by a boyhood friend, Antonin Proust, a career politician who had just become Minister of Fine Arts. It is appropriately ironic that when official awards finally came to Manet, they had to come through the channel of a well-placed friend: he had indeed succeeded according to the Academy's pattern.

Both of Manet's parents came from families with money, and his father expected his son to follow him in a legal career. When Manet resisted, begging to paint, they compromised on the navy, and the boy went to sea as an apprentice cadet. In 1849, when he was seventeen, the ship stopped briefly at Rio de Janeiro, a city picturesque enough at that date. There are the usual stories of boyish escapades aboard ship and ashore; in one of these Manet probably contracted the disease that, finally paralyzing him, resulted thirty-four years later in his death after the amputation of a leg.

When Manet failed his examinations for the navy, his father allowed him to enter Couture's studio. Manet also entered into a liaison with Suzanne Leenhoff, his slightly older piano teacher, and in 1852 she gave birth to a son. Ten years later Manet's father died, and in 1863—a landmark year all around—Manet received his legacy and married Suzanne, although he kept up a fiction that the son was her younger brother. The boy called Manet "godfather," and not until he was nearly grown did he learn his true relationship to his mother and to Manet. (The relationship is assumed. In the birth registration the father was identified, or rather not identified, simply as one "Koëlla," a person whose existence has never been verified).

During the complicated years of the liaison and the birth and early childhood of the son, Manet's mother supported the little family. His father never learned of the affair nor, astoundingly, did Manet's friends. His marriage (when the son was nearly twelve years old) came as a great surprise to them.

During all these years Manet seems to have been deeply devoted to Suzanne, and he remained so the rest of his life in a curiously impersonal way. Suzanne was a plump, comfortable Dutchwoman, not at all the type that Manet was (again and again) attracted to. As an expert pianist, she took pleasure in joining forces with the elder Mme Manet in musicales at home. The impression is always left that she occupied in the household more the position of a favorite aunt than of a wife. She never visited Manet's studio, and one may take the word of whichever biographer one chooses, from among those who knew Manet, as to whether he was true to Suzanne, or a great womanizer, or a man of moderate extracurricular indulgences.

He was certainly a man with a boulevardier's quick eye for a pretty woman. He was also something of a dandy, although, as seen in some drawings by Degas, his dandified haberdashery was worn carelessly. Never truly giving himself fully to anyone, he seems to have found Suzanne an agreeable ballast rather than a companion. Among the various women probably involved in brief affairs that served him as diversion, none had much more to offer than prettiness and a talent for dalliance. Manet's consistent refusal to share himself fully with another person ruled out women of any other kind.

One woman, with whom it would be difficult to conclude that Manet enjoyed a Platonic relationship, may serve as an example, if a rather extreme one—Nina de Callias, to give her the surname of her estranged husband, or Nina de Villard, to give her her mother's maiden name, which she adopted, or Marie Anne Gaillard, to give her her true name. By any name she was a charming eccentric whose personal salon, if it can be dignified by the term, ran at all hours—fueled by alcohol, peopled by artists and writers, and a-twitter with small birds and animals. She was tiny, talented (at the

piano), and goodhearted in a completely unselective way. One admirer described her as "a slightly demented muse." Manet, as an occasional fascinated observer of Nina's erratic Parnassus, asked her to pose. When she announced to the press that Manet had completed a portrait of "Madame de Callias," her husband wrote a stuffy letter pointing out that Nina had agreed to use "any name but my own" and demanding that the painting not leave the studio. Manet complied and kept it there until his death. Nina—drunken, bankrupt, half insane—died the year after, leaving a will written in verse. The portrait, *The Lady with the Fans,* in the Louvre, comes as close to being an analysis of personality as anything Manet ever allowed himself to paint.

Manet was called to the colors in 1870 and went through the subsequent Commune, but Berthe Morisot, who was more than half in love with him, reported that his chief concern was to keep his uniform well pressed. His letters to Suzanne give no hint that he was involved in exciting events, although one does feel that he was trying to convince himself that he was doing more than marking time until he could get back to his easel. The great adventure of Manet's life, and (to resort to a hackneyed metaphor) his true mistress, was painting.

Manet's friends speak rather consistently of his contempt for bourgeoisism, yet the kind of success he wanted conformed to the bourgeois ideal. He was distrustful of eccentricity and bohemianism in other artists, including the impressionists, seeming to regard it sometimes as a sign of weakness and sometimes only as a matter of social gaucherie. Yet he was more patient with his friend Baudelaire, when that poor man in his decline took to painting and powdering his face like a cocotte, than some other friends were able to be. There are accounts of Manet's charm and his enjoyment of good company, of his wit, sparkle, and social grace. And there are ac-

counts of his surliness, his irritability, and his preference for seclusion. He could behave at times with an almost feminine excitability in spite of the one trait that, when everything is balanced, seems most persistent in his character whatever the contradictions. This trait was an essentially aristocratic reserve, a self-containment that forbade all casual intimacy and accepted intimacy of any kind only up to a point—and, in turn, respected the privacy of other people.

Quite possibly we exaggerate the reserve of Manet's personality because reserve is so characteristic of his painting. A man's painting is not always a safe clue to his personality, but it is a safe enough one in Manet's case. Manet's friend Zola formulated the idea, basic to virtually all spontaneous response to painting today, that a work of art is first of all a reflection of the temperament of the artist, and this is more true in the nineteenth and twentieth centuries than it was in, for instance, the Renaissance, when the worst profligate and debauché might develop a convincing formula for holy pictures.

Zola's definition of a work of art as "a bit of creation seen through the medium of a powerful temperament" holds only when art is a matter of inventive individualism, the basis to which it shifted in Manet's century. And it would not hold for an artist who did not have fully the power of expression: how appalling to think that all the Salon painters whose art consisted only of surface exercises were men of corresponding inner vacuity! But Manet's expression of self must have been complete—to the extent, of course, that he felt the self should be revealed to another. He seems never to have doubted that the kind of painting he was doing was exactly what he was after. He worried about the reception of his work to such a degree that Berthe Morisot could report finding him, at a Salon opening, standing outside the room where his pictures were hung, afraid to enter for fear of what people might be

saying about him. But it never occurred to him to paint in a way calculated to placate his hostile audience; nor did he, as Courbet had done when similarly attacked, enter into battle to defend his way of painting. His painting was his only manifesto, and he seems from the first, and until the end, to have painted the way he did because it was so completely his own way that to modify it was impossible for him.

Manet as a personality, then, may be identified with his art to at least the extent of his tactful objectivity. In his portraits he seems to feel that it would be an invasion of privacy to put on record anything more than the appearance his subjects chose to present to society. But his objectivity is never cold. We see his interested response reflected back to us from every face he painted. More often than not the eyes look directly into ours. Typically the glance is noncommittal but alert, sometimes almost questioning but always a little guarded. We know a great deal about the character of Manet's people, but what we know is the result of spontaneous deductions that are inevitable when we face the brilliant presences Manet materializes for us. Even in the exceptional cases of his several portraits of George Moore (one of the best is in the Metropolitan Museum), which are devastating revelations of a sensitive and intelligent but rather watery young man, Manet has not interpreted a character so much as he has summarized the salient aspects of an appearance that was an open statement of the person who lived behind it. There is never any feeling that Manet is unperceptive; there is always the feeling that as the artist observes the model and the model observes the artist, whatever they think of one another may legitimately be sensed but, out of mutual courtesy, must remain undeclared.

And always there is the beautiful paint. As a pure painter —which is to say by the contemporary yardstick that eliminates an artist's pictorial subject matter and judges him by

what is left—as a pure painter, Manet anticipated the kind of contemporary abstract art where paint both as a physical substance and as color is manipulated for the pure delectation it affords in itself. Manet's withdrawal from storytelling, from idealized statement, from psychological investigation, from the pictorial clues that tempt the observer to read a painting rather than to see it as a work of art with an independent existence—these withdrawals are prophetic of a time when the withdrawal has become complete.

The act of painting itself was for Manet even more important than the subject that served him as a framework for this act, which explains why he frequently allowed himself the convenience of borrowing the general scheme of a painting from Titian, as he did in *Olympia,* or from Raphael, as he did for the grouping of the three foreground figures in *Le Déjeuner.* He borrowed frameworks only; it was the doing of the painting that counted.

It has seemed logical to contemporary painters to eliminate the pictorial framework altogether and to let the act of painting exist for itself. "Nothing is important to me except what is happening on the canvas as I work," they have said. Manet, in a still life of inconsequential objects or even in the secondary details of a major painting, comes within a hairsbreadth of this contemporary conclusion. But his greatness is not in his prophecy; it is in the completeness with which he fused the delight of painting with a vivid record of his world.

When the Franco-Prussian War broke out in 1870, Frédéric Bazille joined the Zouaves, a branch of the infantry that was given hazardous assignments because of the traditional daring and courage of its members. As a sensitive, urbane, almost effete young man, Bazille was not conven-

tional Zouave raw material. The story that he chose to serve in this unit because it was the only one in which the men were allowed to wear beards could be true. The beard that Bazille had cultivated as a young artist in Paris was blond, silky, and exquisitely shaped, and he was vain of it. Also, the Zouaves (today uniformed in khaki) were at that time glamorously set apart from the common infantry by their colorful garb, inherited from the Algerians who composed the original group when it was formed in 1831 as an exotic regiment. Fighting in costume, since one had decided to fight, must have appealed to Bazille. Almost to a man, his artist friends found ways to avoid combat. They also lived to fulfill promises that were no greater than Bazille's had been. Sergeant Bazille was shot down at the age of twenty-nine at Beaune-la-Rolande on November 28, 1870.

Jean Frédéric Bazille was born in 1841 to a well-to-do family of the bourgeois aristocracy in Montpellier. As a compromise between a respectable career and the one he really wanted to follow, he combined studies in medicine and art in Paris, the art under Marc Gabriel Charles Gleyre (1808-1874), a Swiss who had settled in Paris. After great Salon successes in 1840 and 1843, Gleyre succeeded the lamentable Delaroche as the most popular teacher at the Ecole des Beaux-Arts. His studio is described in contemporary accounts as a sort of madhouse filled with everything from young men like Bazille, Renoir, Monet, and Sisley, to old men still hoping to get a painting in the Salon. As a painter, Gleyre was a skilled technician with no imagination and complete faith in the rules, although, as Renoir once said, "At least he leaves us alone." His impressive record as a teacher of masters (in addition to those just named, there was Whistler) is probably only his normal share of luck. By the law of averages, there had to be some good painters among the six hundred or more who passed through his studio.

The Impressionist Victory

At Gleyre's Bazille met two starveling students his own age, Monet and Renoir, and the three of them, with Sisley, went on outdoor painting expeditions around Barbizon. Before long, Bazille abandoned his medical studies, having failed the course in dissection, which, in his fastidiousness, he loathed.

Very tall and almost too slender, immaculately tailored and barbered, sociable, with a good face and a fresh complexion that (Zola noted) took on a rosy flush at the slightest provocation, Bazille also had a talent for that kind of safely eccentric behavior that gives an attractive young man a reputation for being slightly and charmingly mad and hence a desirable dinner guest. In this character he became acquainted with Manet and Degas; but Renoir and Monet were closer to him.

The association with Monet was frequently painful. Bazille and Monet were an odd combination in any case—Monet was common, aggressive, self-seeking, and rather sly. But for a while they shared a studio. Bazille's tact was sorely strained when Monet moved his young mistress in to share the small and intimate quarters. Penniless during these years, Monet received a monthly allowance from Bazille in the form of time payments on the purchase price—twenty-five hundred francs, which was very high—of a painting. Monet was graceless enough to write abusive letters (he moved around here and there during the years) when Bazille fell behind on installments; he also begged for additional funds or advances and wrote a really unpardonable letter when Bazille, unable to supply money immediately, suggested that part-time income-producing work might be the answer to Monet's chronic problem.

Bazille, of course, was on the lucky side of the fence. Although he was frequently behind in the rent when other debts piled up (he once pawned his watch to help Renoir out

of a hole), he did have a doting mother with money who could be counted on to take up the slack. He consented to stand as godfather when Monet's mistress had a son. He was a natural selection for this honor on two scores: the young girl, disinherited by her family, saw in Bazille at least the hope of a stable and respectable connection for the child, while Monet was eager to establish an additional affiliation with a source of income.

It must be remembered that although Bazille was closely associated with the impressionists, impressionism during his lifetime was still emergent from the outdoor landscape school represented by men like Daubigny and Boudin: Renoir was still painting in an essentially academic style—richer and more fluent than the standard academic formula, but true to the highest academic standards, and Monet was still working more in terms of conventional light and shade than in terms of light as the spectrum. The pitifully few works left by Bazille show that he was aware of the problem of unifying human figures with landscape as interdependent components of the spectacle of light out-of-doors. But the most powerful aspect of his work is an anti-impressionistic formalism. In a group portrait of his family seated on a terrace (Louvre), painted in 1868, and in a group of male bathers, *Summer Scene* (Cambridge, Mass., Fogg Art Museum), painted in 1869, his compositional arrangements are elaborately calculated and uncompromisingly defined. He seems more closely related to Seurat, who reacted against impressionism's shattered forms, than to the colleagues who lived after him to fulfill the impressionist prophecy.

In the year of his death, Bazille painted a beautiful and, under the circumstances that developed, most poignant souvenir—*The Artist's Studio,* now in the Louvre. Renoir, Zola, Manet, Monet, a musician friend named Edmond Maître, and Bazille himself are grouped in comradeship in

the peaceful room. To the extent that he was given time to prove himself, Bazille remains a fully worthy member of that impressive circle.

Monet is always called the purest impressionist. He is the exemplar and to a considerable degree was the inventor of the techniques peculiar to impressionism that were intended to approximate in pigment our retinal responses to outdoor light. There is a fine and convenient simplicity about his historical position: as a link in the continuum, he descends more directly than any other impressionist from the outdoor painters (the Barbizon generation) who were proto-impressionist, and at the end of his life he produced some paintings that have been seized upon as connecting links between impressionism and modern abstraction. Finally, his career summarized in one man's life the revolt, rise, and triumph of impressionism in general: he refused to compromise with tradition, was beleaguered by traditionalists in power, and his final victory was total.

With all this to establish his position, there is no real need for Monet to have been, as well, a noble spirit, and this is fortunate, for his was not a great soul. The aphorism attributed to Cézanne, "Monet is only an eye—but what an eye!" makes sufficient allowance (that is, makes none at all) for the spiritual and philosophical content of Monet's art, and hardly skimps him on any other score.

Oscar Claude Monet was born in Paris in 1840, the elder son of a grocer who five years later took his family to Le Havre where he went into business with his more prosperous brother—a ship chandler as well as grocer. Claude grew up as a rough-and-tumble boy, unremarkable except for a knack for caricature. He was selling his drawings by the time he was fifteen and studied for a while under a Jacques

François Ochard. He might have become a commercial artist if at eighteen he had not met Boudin, who turned his interest toward painting landscape directly from nature. The next year, he convinced his parents that he should study in Paris. Reluctantly they let him go for a trial period, but while they thought he was complying with their stipulation that he study under proper instruction, he was attending instead the instructorless Académie Suisse. This first stay in Paris was cut short in 1860 when he had to begin his military service.

His army duty took him to Algeria, where he fell ill in 1862. Sent home on sick leave, he was spared the completion of his military stint when his parents bought him out of it by paying a substitute—as they had offered to do in the first place if he would give up painting.

Reunited with the good Boudin, Monet painted with him for a while in Normandy. He also met Jongkind, who, he said later, trained his eye. In the fall he went to Paris and worked in Gleyre's studio, where he met Renoir, Sisley, and Bazille. He went on sketching jaunts with them, and the impressionist adventure began. He was twenty-two, a rather stocky young man with an unimpressive body but a rather handsome face that, in an early photograph, looks at once soft and arrogant.

It is not necessary to follow in detail Monet's contacts with the contemporaries who were to become famous with him. He knew them all, as well as the stars of an older group. In 1864 he met Courbet, just then at the dividing line between his early position as the leading young rebel and, as he relinquished that distinction to Manet, his later enthronement as the grand old man of realism. Monet, even before the meeting, had been painting very much under Courbet's influence.

In 1865, twenty-five years old, he met a beautiful eighteen-year-old girl named Camille Doncieux, seduced her,

and when she broke with her family, found himself saddled with a penniless mistress. Exactly why he fought the idea of marrying her is a question. She was dependent upon him in any case, served all the functions of wife, including child-bearing, was his model as well, was true to him, was lovely to see, and was patient and sweet-tempered into the bargain. He did marry her in 1870, three years after the birth of their first son, Jean, but for the sordid reason that thus she could acquire a portion of what should have been a substantial dowry. There were mean and lengthy arguments with her family over the money, none settled favorably for Claude and Camille. A sum was finally agreed upon after Monet signed an inventory of all the worldly goods he was bringing to the marriage (his possessions were evaluated at five hundred francs, with the clothes on his back included), and relinquished all claim and control to any portion of Camille's pitiful settlement.

The five years of liaison before Monet and Camille were married were complicated and difficult but full of rewarding excitements. The year after he met Camille, Monet made a success in the Salon (of 1866) with her portrait, called *The Green Dress* (Bremen, Kunsthalle), which he had painted in four days, a bravura performance. (Manet, who had been rejected by the jury that year, was infuriated when, his name having been confused with that of the newcomer, he began receiving congratulations.) Briefly, it seemed that Monet had arrived. But he was unable to catch up on his debts (Camille, for all her sweetness, was not a perfect manager), and the next year he was rejected from the Salon. Not only that. Camille was pregnant.

Monet's action at that time is unforgivable no matter how one may try to defend him. His family, which had virtually disinherited him, was unwilling to send him money to continue living in sin in Paris, but was willing to give him,

alone and virtuous, shelter at home. He left poor Camille in the care of a shady medical practitioner (apparently either a disqualified or a never-qualified medical student) and went home. Never, then or at any time during his life, did Monet consider for a moment taking work to make ends meet, which may be regarded as selfless devotion to art or as obsessive selfishness, whichever you wish. He borrowed money from friends here, there, and everywhere to see Camille through the emergency, and continued over many years to write begging letters.

It is true that Monet's financial condition was chronically in crisis over a long period, but in reviewing his correspondence one can easily see why his continued supplications were finally passed from one hand to another as he exhausted the patience of one friend after another, seldom giving any indication of gratitude for help. He must have written literally hundreds of letters to acquaintances and associates asking for money. Dozens of these still exist, and over the years their refrains change very little. "I am without a penny. . . ," ". . . ask help very fast . . . ," "Carpentier [the paint dealer] has closed my credit . . ."—these from letters to Bazille. To Manet: ". . . not a penny left and no more credit . . . could you send me by return post a twenty-franc note?" and then, after ten days, ". . . would you again advance me the little sum of sixty francs. I am in the hands of the bailiff . . . ," and later, ". . . without a penny . . . fifty francs at least . . . ," and ". . . do not abandon me . . . Help me if you possibly can." To Georges Charpentier, a publisher and collector: ". . . five or six louis . . . terribly troubled . . . unable to find a penny." To Georges de Bellio, a physician and collector: ". . . do me a *last* service . . . another two hundred francs . . . terrible spot without a sou." To Victor Chocquet, a minor government official and collector: ". . . a little indulgence for a man who is penniless." To Paul Gachet, a physician and amateur

artist: ". . . though I am already in your debt for a hundred francs . . . would you again advance me a hundred francs." To Eugène Murer, a pastry cook, collector, and owner of a small restaurant: ". . . in a cruel situation . . . one hundred francs . . . give the messenger what you can, but try to make it a hundred."

The desperateness of Monet's financial situation, however, was only relative. If he never held on to money, it is still true that enough ran through his hands from one source or another, including all the borrowing, so that he and Camille should have been no worse off than tens of thousands of small tradesmen and civil servants who managed to survive on smaller incomes than theirs. These survivals, we must grant, were dull and dolorous. When Monet and Camille were flush, the money went for pretty clothes and holidays at the beach. Camille's loyalty seems to indicate that in her sweet, day-to-day way she was a willing partner rather than Monet's victim in the arrangement by which she was left behind to bear a child under dubious care while her lover found comfortable free lodging with a family that would not accept her.

In spite of everything, Camille, being a healthy girl, bore a healthy son, who was named Jean, one of the prénoms of his reluctant godfather, Bazille. This was in 1867. Monet was now twenty-seven, poor, and a father. The next year, living in Fécamp with Camille and Jean, he wrote Bazille a tale of attempted suicide—a quick dip in the ocean—and described himself as dispossessed and thrown naked into the streets. In 1869, rejected by the Salon yet again, he saw his paintings seized by creditors and had no money to buy paints. He was rejected again by the Salon jury of 1870—the rejections had quite obviously taken the form of a year-by-year vendetta—and in his desperation he married Camille for the dowry that didn't materialize. Then at the end of the year

came the Franco-Prussian War, and he left Camille and the child with relatives in Brittany while he fled to London to avoid service. It was a year before he returned to France, which he did by way of Holland, painting en route.

But there had been, at least, one bit of promise. In London he had run into Daubigny, who introduced him to another refugee, the dealer Durand-Ruel. During the following years there were further crises, but at least he began meeting collectors and, occasionally, selling. And he was the major stimulus, during these years, of an event that is a landmark in the history of painting—the first impressionist exhibition in 1874.

The Salon's persecution (the word is not too strong) of Monet had been particularly severe, but other members of his fraternity also had very shaky relations with that autocratic and hidebound institution. In 1873 Manet had had an unusual Salon success (with an unusually conventional painting, *Le Bon Bock,* now in the Philadelphia Museum of Art), but Pissarro, Monet, and Sisley had decided not to submit anything, and Renoir had had two paintings rejected. There had been a new Salon des Refusés that year, but this great hash of rejected paintings was not a very effective counterattack against Salon abuses. After all, the only basis for acceptance in the Salon des Refusés was the negative one of refusal from the Salon proper.

What was needed was a new kind of exhibition in which Salon unacceptability might by the nature of things be a requirement for submission of a painting, but in which merit would be the criterion for its acceptance. Monet along with other young Salon victims visualized this exhibition as taking place through a society of artists, and the first impressionist exhibition of 1874 was the result. Its organization was marked by much confusion, much argument, and many hurt feelings. Degas insisted on the inclusion of favorites that other mem-

bers of the group objected to; Cézanne (a most questionable figure at that time) was admitted only on Pissarro's insistence; Manet, who should have been the key figure, was still bent on holding out for Salon honors and refused to exhibit. The lovely Berthe Morisot, in spite of Manet's appalled advice to the contrary, worked like a beaver for the cause and decided never again to send anything to the Salon, where she had been accepted every time she had submitted during the previous ten years.

The exhibition opened on April 15 to run for a month, with thirty painters represented.* The story of the furor has been told and retold. Conservative critics had a field day with satirical or scurrilous reviews. A cartoon showed a policeman keeping a pregnant woman out of the place for the protection of her unborn child, and the label "impressionist" was coined in derision under the inspiration of Monet's *Impression— Sunrise* (Paris, Private Collection), painted at Le Havre in 1872 but on public view for the first time. The word *"impression"* had appeared sporadically as an informal (and not necessarily derogatory) term in art criticism and journalism for some years before it now burst into full flower when the jibe provided the name the group had been hunting for. The catchall title of the original incorporation, "Société Anonyme des Artistes Peintres, Sculpteurs, Graveurs, etc.," was soon changed to "Peintres Impressionistes."

The scandal reached such proportions that the painters began to wonder whether they had done themselves more harm than good. But they were now a school with Monet, Degas, Pissarro, Renoir, Sisley, and Berthe Morisot at its core. In spite of dissensions, feuds, abstentions, and some very

* The alphabetical list, including names that have become all but lost otherwise, was Astruc, Attendu, Béliard, Boudin, Bracquemond, Brandon, Bureau, Cals, Cézanne, Colin, Debras, Degas, Guillaumin, Latouche, Lepic, Lépine, Levert, Meyer, De Molins, Monet, Morisot, Mulot-Durivage, De Nittis, A. Ottin, L. Ottin, Pissarro, Renoir, Robert, Rouart, and Sisley.

curious inclusions among exhibitors from year to year, the group held eight exhibitions (1874-76-77-79-80-81-82-86) before it dissolved for the double reason that its purpose had been achieved and its entity shattered by the introduction of new, essentially anti-impressionist talents in the final shows.

The fifth exhibition in 1880 was already a meager affair. Degas had antagonized nearly everybody, and he, Pissarro, and Morisot were the only true impressionist names in a decimated mixed bag of exhibitors. Monet had refused to come in, as had Renoir and Sisley, in protest against Degas's highhandedness. For Monet, the six years that had elapsed since the first exhibition had been a turbulent period, bringing despair, tragedy, new life, and the first indications that he was about to become rich, famous, and revered. Year by year, it went like this:

In 1875, when he was thirty-five, his fortunes were at a new low—although they had not yet reached their bottom. Durand-Ruel was going through a financial crisis of his own and could not help his stable of hopefuls. Monet begged money of Manet, and submitted Camille to the indignity of serving as an unrefusably appealing messenger girl to collect it. Plaguing his friends with importunate letters, he alienated one after another.

In 1876, Camille submitted to a crude abortion and suffered a torn womb. But Monet this year, in a nice bit of dovetailing, met a wealthy—and obese—department-store owner named Ernest Hoschedé, whose wife, Alice, was attracted to Monet and assumed Camille's obligations as sexual partner when that poor child could no longer perform them. Monet at this time was living at Vétheuil, being sued for the rent, and pawning everything, including a locket so dear to Camille that, after her death, he begged a friend to retrieve it for him from the pawnshop in order that it might be buried with her.

In 1877 he moved back to Paris with Camille and Jean, now ten years old. For the second time he visited the Hoschedés at their estate. His money troubles continued.

In 1878, Manet helped him again, and his begging letters —with Zola now included in the list of recipients—increased in range and intensity. This was necessary: Camille, enfeebled as she was, looking old and worn at thirty-one, gave birth to another son, Michel. Ironically, Monet's new patron, Hoschedé, whom everyone had thought of as a rich man, suddenly went bankrupt. And now a very curious thing happened. When Hoschedé fled to Belgium, his wife with her four daughters and infant son (she also had an older son who was never part of the curious household) joined Monet in Vétheuil, where he had again settled, and while Camille sank toward death, Alice ran the ménage-à-trois with its appendage of seven children.

In 1879 Camille died at last, and the liaison with Alice Hoschedé became open. The family lived a vigorous, harmonious life. Alice, who was Monet's age (now thirty-nine), was a short, very plump, homely woman who as the wife of a rich man had been a hostess with a reputation for charm. She was a practical person, and after her husband's bankruptcy, protected by a little nest egg of her own, she set about making ends meet by doing a bit of dressmaking and performing other services for a clientele that included the fashionable people she had once entertained. She was a good match for Monet. Both were shopkeepers by inheritance. Where Camille had been sweet, passionate, and inefficient, Alice was pleasant, warm, and levelheaded. Now, in 1880, at forty, Monet not only refused to exhibit with the impressionists (he relented once, for the seventh show in 1882) but also dismissed the Salon. The 1880 jury accepted only one of the two pictures he submitted and he was dissatisfied with the position in which it was hung. He never submitted again.

Everything, now, fell into place for him, as if Alice had been the catalyst. He had an orderly, full—very full—affectionate household, and an efficient housekeeper, mistress, and business assistant combined. In 1882 the family set itself up in Poissy (Paris itself, as far as Alice's old friends were concerned, could not accept the liaison, and divorce was impossible) and then in 1883 in Giverny, where they lived for the rest of their lives. Monet's paintings were selling well. In 1889 he became the central figure of a cause célèbre when he organized a subscription fund to buy Manet's *Olympia* for the Louvre (rather, the Luxembourg, the Louvre's waiting room). In 1890 he was so prosperous that he bought a house and property at Giverny. He was now fifty years old, and Alice once again had as many servants as she wanted. Hoschedé died in 1891, and the couple in the friendliest way brought the body to Giverny, where it was buried in the churchyard only a few steps from their door.

Claude and Alice were free to legitimize their union of twelve years, which they did the following year under the stimulus of establishing a respectable background for one of Alice's daughters, Suzanne, who was marrying an American named Theodore Butler. (In 1897, Monet's first son, Jean, at the age of thirty, married another of Alice's daughters, Blanche, two years his senior.)

In 1900, as the result of an accident, Monet temporarily lost the sight of one eye, a sinister prophecy. In 1904—he was sixty-four years old—he entered into an engaging adventure: he bought an automobile, and at a time when automobiles were not very dependable, drove with Alice all the way to Madrid.

By 1908 he was ill, and his vision was failing. Nevertheless, he and Alice made a trip to Venice. She died in 1911, aged seventy-one, as was Monet. The next year, he was under the care of an eye specialist. There were certain colors he

could not see, but he continued to paint with obsessive determination in spite of depression and his dissatisfaction with his work. His water-lily pond at Giverny had interested him as a subject from time to time since 1899, and in 1916, when he was seventy-six, he began painting the large water-lily panels, now a national monument in the Musée de l'Orangerie in Paris. For this commissioned undertaking he had built a studio 49 feet high and 75 feet long by 39 feet wide. He painted on and on. At the age of eighty-two in the fall of 1922, almost blind from double cataracts, he was forced to abandon work for a while. But in 1924 and 1925 he painted anyway, hardly able to see anything, but painting, repainting, and then walking as far away from the canvas as possible to get some idea of what he had done. Death finally put an end to all this in December, 1926, three weeks after his eighty-sixth birthday. He had become a national hero.

Since the middle 1950's, exaggerated attention has been given to Monet's very late work. Some truly inferior examples that should be interesting only in the context of his struggle against darkness have been dragged out, dusted off, and offered as hitherto unappreciated masterpieces. In their loose, wavering areas of color and their gigantic brushstrokes, these saddening (if courageous) efforts seem to have affinities with the abstract-expressionist school that was triumphant in the late 1950's in New York. But these apparent affinities depend too heavily on coincidence. They can more legitimately be found in the murals of the Orangerie and the studies for them, since these huge canvases are held together by rhythms of the brush that can exist satisfactorily as abstract patterns without the support of the subject matter, which is a synthesis of water, air, and light fused into a single visual phenomenon.

This synthesis, emphatically, must not be confused with Turner's apotheoses of water, air, and light as cosmic manifestations. Nor should Monet's latest paintings, done when

he was more than half blind, be defended by the example of those that Titian did at the same time of life when, to accommodate his dimming eyes, he painted in a broad loose style (which, incidentally, anticipated impressionist effects). Titian's late paintings were profound spiritual expressions; Monet was not interested in spiritual expression (having no capacity for spiritual experience), but in the translation of visual phenomena into pigment. And when your eyes are gone, visual phenomena are difficult to cope with.

As far as any kind of emotive expression is concerned, Monet's most satisfactory paintings are those in which his re-creation of a scene, with all its qualities of a time of day and time of year and kind of place, evokes personal associations for the observer and thus, by a sort of Pavlovian reflex, stimulates the emotional glands. But in pictures of this kind, Monet is not revealing much. He is only supplying (if supplying superbly) the visual stimulus. We come back to Cézanne's "only an eye—but what an eye!"

This eye wrote its most important dissertation on light and atmosphere in the series of paintings showing the same subjects at different times of day and in different weathers— notably, the haystack series of 1889-93 and the Rouen Cathedral series of 1892-94, numbering more than thirty and, like the haystack series, scattered in collections around the world. Except as a point of departure left so far behind that it can hardly be seen, the mere semi- or pseudo-scientific business of splitting color into prismatic tones for reblending by the eye has little to do with the mounds of yellow, lavender, and rose that are the haystacks or the tinted curtains evolved from the stone façade of the cathedral. What his eye discovered— that eye trained to see all light as pure color—it revealed in terms so exaggerated that we are brought to the edge of the twentieth-century revolution of fauvism, where color became completely arbitrary.

But it must always be remembered that for Monet the eye remained the supreme master of the brush, and that the eye was dependent on the motif—the motif in nature that Boudin had insisted that he begin with. Whatever transformations Monet effected were made within these limits. They were visual, not intellectual, no matter how assiduously we may intellectualize today the painting of a man who abhorred and consciously avoided any theoretical approach to the problems that obsessed him.

This obsession most dramatically forced itself upon his consciousness early one morning in 1879 when, after a night of vigil at the bedside of the dying Camille, he looked at her face in death and found himself analyzing its nacreous tones. He fled the room in horror, feeling that his insatiable eye had made a monster of him. In a way, it had. But it also made a place for him as one of the colossi in the history of painting. Monet had few, virtually none, of the sensitivities that we think of as imperative in great artists in any field—painters, writers, musicians, or any other. Faced by the corpse of his wife he was inspired to no reflections upon death, upon love, upon the curious patterns that human relationships assume, upon the corruption of innocence and of the flesh, upon mortality or immortality or even to any thought of what kind of woman the poor, worn creature on the bed had been. He saw Camille at this awesome moment only as an object of a special kind—a corpse—illuminated by a special light, the cold, bluish light of earliest morning, which had to be observed quickly before it changed. One does not frequently have the opportunity to study the look of a corpse at dawn. Monet's multiple limitations and his unilateral strength were summarized at that moment.

Habitually we think of Renoir first as an impressionist, and it is true that he identified himself with the impressionists in their struggle for recognition. And he produced, over a period of years, a quantity of paintings done out-of-doors in impressionist technique. But he was not first of all an impressionist: he was a traditional artist strongly affected by impressionism, the natural (and conscious) descendant of a patriarchal line established by Titian. He inherited the tradition and fortune of the house as it descended from Titian to Rubens, from Rubens to Watteau, from Watteau to Boucher and Fragonard, and, from all of them, through the Louvre where he saw them, to himself.

The common theme of this lineage was the celebration of the sensuous world, with woman as its primary symbol and color as its most potent expression. There is no more difference between Renoir and any of the other painters in that list than there is between any other two of those painters. Renoir was exactly the kind of artist that the Academy, by the ideals of its foundation, was supposed to breed and protect—one who revered and understood the past, who grew directly from it, and in full knowledge continued it. The trouble was that the Academicians had come to think of their sterile repetitions as a living tradition. From no other point of view could an artist as traditional as Renoir have been identified with the rebels.

Pierre Auguste Renoir was born in Limoges in 1841. His father, a tailor, brought the family to Paris four years later. When the boy was thirteen, he was apprenticed in a porcelain factory, where he painted plates. (It is conventional to point out that the fresh blue and rose tones of painted porcelain were continued in his work on canvas.) When the factory closed, he found work in another commercial decorative field: he painted fans and window blinds in accordance with a vogue for neorococo ornaments and figures. By the

time he was seventeen he knew he wanted to be a painter, and he began saving money to study. (He found one source of income in painting religious subjects on wall hangings that could be carried about by missionaries as chapel decorations.) He took evening classes in drawing until, in 1862, twenty-one years old, he entered Gleyre's studio. The Louvre remained his best schoolroom, but at Gleyre's he met Bazille, not quite a year younger, and Monet, a few months older than he.

Until Bazille was killed in 1870, Renoir was his constant companion, and—like Monet, but more courteously—shared his studio at times. Renoir during these years is a most attractive figure. Although he was as poor as Monet, he made ends meet with odd jobs of commercial work and bits of porcelain painting while Monet was bedeviling his friends for loans. But Renoir was not a drudge. He was blessed with a natural social grace that made him charming in any company. He knew Diaz, Corot, Daubigny, and Courbet among artists. Later on, his personal attraction, which had nothing to do with calculation or ambition to rise in the world, was a help in the social circles of the collectors and dealers who had discovered him professionally. Renoir was affable and fun-loving and could have been a lion if he had wanted to. But his tastes were simple, and he painted incessantly.

During these early years, before 1870, he had a spotty career in the Salon. His first acceptance was in 1864, with a painting called *Esmeralda*, which he later destroyed. In 1865 he had two acceptances. The next year, in spite of the intervention of Corot and Daubigny, he was refused, as he was the following year. In 1868 he was accepted with a portrait of his mistress, Lise Tréhot (Essen, Folkwang Museum).

The liaison with Lise, the daughter of a country postmaster, had begun in 1866 (perhaps 1865) when Renoir was twenty-five and she eighteen. He met her through a prosper-

ous friend named Jules Le Coeur, a one-time architect, from a family of architects, who had taken up painting, a widower whose mistress was Lise's sister Clémence. Lise appears again and again and again in Renoir's paintings over the next six years—a dewy, full-bodied girl—in roles ranging from Diana the Huntress to her own self. But like virtually all of Renoir's painted women, even the majority of those in portraits, Lise in any role is more a generic symbol than an individual. All women were generic symbols for Renoir. Nude, borne ashore on the waves of the sea, a woman might be Venus, or, nude, getting out of bed, she might be called Nini, he once said. But in either case, he added, no better subject could be invented for painting.

Renoir's affair with Lise survived their separation during the last half of 1870 and the first months of 1871 when he was in military service (he had enlisted, but did not see battle). But in 1872 Lise married, and never saw Renoir again. From time to time he had given her paintings; as a wedding present, he did her portrait in a white shawl (Private Collection). She never let any of these paintings go. Widowed, after thirty years, in 1902, she was famous along with Renoir by reflection. But in 1922, a little more than two years after his death, she burned all her records of their relationship—letters, photographs, souvenirs, everything but the paintings. From a biographer's point of view this was a disaster, but it makes an appealing figure of Lise in her reticence and devotion.

Renoir was thirty years old when he was demobilized. He was already a very fine painter, with Courbet and Manet as the contemporary influences who modified his eighteenth-century inheritance. His connection with them is one explanation for his rejections from the Salon, which were regular from year to year during most of the 1870's. But he had no serious financial troubles. He reached an agreement with

Durand-Ruel that brought him a steady income, and became a favorite with perceptive new collectors like Caillebotte, Chocquet, and Charpentier. He was also a dependable portraitist, and through these well-connected friends he found enough clients to keep him profitably busy without having to turn out the kind of portrait that is hack work.

Renoir entered the lists with the impressionists when the first show was organized in 1874 partly out of loyalty to his participating friends and partly because he recognized that some kind of action had to be taken against the Salon. But he always believed in the Salon system and maintained that the thing to do was not to break away from it but to break into it. And he did break into it again, in 1878, with a portrait of Mme Charpentier and her two little girls. The picture was a great success—and still is, in the Metropolitan Museum, where people admire it every day for the same reason that the Salon public admired it then. It is a charming, happy, and really quite conventional picture of a charming woman with her two entrancing little girls and their big dog, a reassuring statement of faith in upper-class bourgeois values, which are perfectly legitimate ones. In 1878, the social position of the sitter gave an additional fillip to the picture's attraction.

With the success of the Charpentier portrait, Renoir began to be regularly accepted in the Salon and decided to stop exhibiting in the impressionist shows. He yielded only once for the seventh and next-to-last show in 1882, when both he and Monet returned, much like distinguished alumni of a school that by then was much changed.

Renoir was forty years old in 1881 when he married a pretty girl named Alice Charigat and settled down to his ideal existence. The income from his painting allowed him to live easily on the scale he liked best. Alice grew plumper and more comfortable year by year, devoting herself to the man-

agement of a household where first things came first, which meant Renoir's painting first of all, even when a buxom housemaid was commandeered from her proper duties to serve as model. Renoir was a good husband and father in return. "I am stranded in Pornic where I am teaching my son to swim," he wrote Berthe Morisot in 1892, although he complained in the same breath that it took time from painting. This was his seven-year-old son Pierre, born in 1885. His second son Jean (who became the film director) was born in 1894.

During the ten years between the end of the war and his marriage, Renoir went through the impressionist experience and found it wanting. In 1874 he was painting with Monet at Argenteuil. Both Renoir and Manet had listened to Monet's arguments about painting directly out-of-doors, and among other souvenirs of their conversion (which proved to be even more temporary in Manet's case than Renoir's) they left versions, painted simultaneously, of Camille Monet and her son under a tree in the Monets' garden. But both Manet and Renoir were at heart studio painters. Renoir's masterpieces of his impressionist period—both painted in 1876, both shown in the third impressionist exhibiton of 1877, and both now in the Louvre—were evidence of his divided loyalty at the time. *The Swing*, showing a young girl standing in a rope swing while a suitor hovers nearby, was painted in Renoir's garden in Montmartre. But the great *Moulin de la Galette* was a studio picture carefully organized to capture an effect of spontaneous vision. A crowd of young people dancing in the flickering sunlight and shade of the Moulin's garden seem to have been caught and recorded at a fortunate moment. Both paintings are celebrations of youth and courtship that would surely have delighted Watteau and Fragonard.

The next year Renoir made his Salon success with the Charpentier portrait as already mentioned, and defected from

the impressionist ranks—as there should never have been any doubt that he would do in accord with his declared conviction that the Salon was the real battlefield. He made a concession—a large one, exhibiting twenty-five pictures—when he joined the 1882 exhibition, but in that same year he took an Italian trip and decided that he had "wrung impressionism dry." He set out to re-educate himself in the firm drawing and the decisive composition that he felt he had sacrificed to the impressionist cultivation of spontaneity and effects of natural light.

In Italy he rediscovered, of all artists, Raphael, whose virtues had been plagiarized and perverted for a century by his acolytes in the Academy. Renoir also came upon a copy of Cennino Cennini's late-fourteenth-century handbook on the art of painting, and under its inspiration began to re-examine ideals five hundred years old. He returned to his studio an anti-impressionist, and for three years, in his very badly named "harsh period," he retrained himself in the drawing and painting of strictly defined forms—these, however, sometimes played against freer, nearly impressionistic backgrounds. His *Bathers* (Philadelphia Museum of Art) of 1884-87 is the great painting of this period.

Then—almost as if with a sigh of relief that the strenuous exercises had been completed and had served their purpose—he loosened his brush and expanded his forms into the fullest, richest, at once most opulent yet superbly controlled paintings of his career.

As early as 1881, Renoir began to be bothered by a form of arthritis that by 1900 had twisted and crippled his hands. By 1912 both legs were paralyzed and he could not move his gnarled fingers. His brushes had to be strapped to his hands. It was a cruel illness, cruelest because it attacked him at the apex of his creative powers. He coped with the physical disability by adapting his style to a looser stroke, and coped

with any emotional distress by reaffirming his faith in the joy of life. He had once said that he wanted to reveal the world as an earthly paradise; now this paradise was revealed in warmer and warmer colors, more vibrantly played against one another in forms swollen and surging with the force of vital fecundity within them.

He had made long stays at Cagnes-sur-Mer in the hope that the southern climate would relieve his pain, and at the turn of the century he settled there permanently. In 1904 he had an entire room in the Salon d'Automne. In 1912 he began a second career as sculptor, directing a young assistant who served him as a pair of hands. In 1914 his sons were mobilized in World War I, and in 1915 Jean was badly wounded. Alice rushed to visit him in the hospital. But it was she who died, suddenly, shortly after her return. Renoir was seventy-four. He died in December, 1919, not quite three months before his seventy-ninth birthday.

Alfred Sisley was the gentlest of the impressionists, the most self-effacing and also the most sensitive in his response to one of impressionism's major themes, the countryside. He is often thought of as a charming but rather weak postscriptual member of the impressionist brotherhood. This is a mistaken way of seeing him. He was, rather, something of an independent outsider. Although Monet and Renoir were his close personal friends, he did not think of himself as an impressionist and rejected classification as one. Nor was he French. He was English, and the English half of his hybrid art sets it apart from that of his impressionist friends.

Although Sisley was born in France and lived there for all but a few years of his life, both his parents were English and he was never naturalized as a French citizen. No painter (not even Corot) has left a more loving record of rural France with its streams, its villages, and its changing seasons, but

Sisley's vision and response were inspired more by the example of Constable than by any French predecessors. From his impressionist contemporaries—specifically, from Monet— he picked up whatever technical devices served him best, but he was never interested in carrying impressionist technique to the extremity where nature was dissolved into a tinted mist. His houses remain solid houses rather than becoming, like Monet's, denser areas of a fog, and his trees remain trees rather than becoming veils of green chiffon against the blue veil of the sky. Above all, his streams and rivers and ponds retain the heaviness of water beneath their sparkling surfaces.

Sisley was only secondarily interested in light and air as physical phenomena affecting the appearance of objects. He was interested in his response to the objects themselves—to the old stones of churches and bridges, to the drama of the sky. The other impressionists, faced by nature, were in an outdoor studio; their emotional response to nature was that of Parisians with picnic baskets. But for Sisley nature was the basic truth of the world, a habitable truth with which one could become identified. He was never interested in the wild, stormy nature that excited the visionary romantics; he was content with the intimate, gentle, and generous nature of the Ile de France that, after centuries of companionship with men, depended upon them for company in a mutual exchange of affection.

Sisley was born in Paris in 1839. His father, from Manchester, ran a prosperous business in what sounds an unlikely field, the export of artificial flowers to South America, until one remembers the quantities of such adornments in the costume of the day and in the churches. His mother was a Londoner with a degree of social position and an interest in music. When Sisley was eighteen, he was sent to London to learn the coffee and cotton brokerage business. But he spent most of his time in the museums, and after four years, in

1862, he induced his parents to let him return to Paris to study painting.

He entered the studio of Gleyre, making friends of Renoir, Monet, and Bazille, but did not last long there. In London he had been attracted to painting by the landscapes of Constable, Bonington, and Turner, and of these, Constable's were his touchstone. Gleyre had no use for landscape except as it might be required as background for a figure subject. Sisley entered the studio in the fall; when spring came he could no longer abide the place, and left to paint in the open air near the Forest of Fontainebleau.

He was not a very hard worker. Photographs, and Renoir's portrait of him with the pretty girl he married in 1866 (Cologne, Wallraf Richartz Museum), show a stocky young man with a handsome head, elegantly bearded. In a photograph taken sixteen years later, the body has grown portly, but the head is handsomer than ever, as dramatic as an actor's but carried with the dignity of a statesman.

In his youth and on through his twenties, Sisley's father supplied plenty of money to allow him to live well and paint as a cultivated *amateur* rather than as a professional. But in 1870, when he was thirty-one, things changed. The Franco-Prussian War bankrupted his father, who died soon after. Now Sisley was faced with the support of his wife and their two children, a boy and a girl. During the siege of Paris the family had moved to the village of Louveciennes, and Sisley decided to remain there, in a small house, to save money. For the rest of his life he never more than eked out a living, and frequently was tided over the roughest spots only because Durand-Ruel supplied him with a little money by buying pictures that, he knew, he had small chance of selling.

Even after the impressionist victory, which Sisley lived to see, the public remained indifferent to his paintings. He spent the last nineteen years of his life in the vicinity of the

village of Moret-sur-Loing; it supplied the water, the sky, the old stones, and the tranquil mood that were his subjects. His wife died in October, 1898, and Sisley died a few months later in January, 1899. In the last week of his life, desperately ill, he called for Monet and entrusted him with the welfare of his children.

A sale of the canvases left in Sisley's studio was organized for the children's benefit, and Sisley became an immediate posthumous success. Dealers and collectors bought the pictures at good prices, and the next year prices zoomed. One painting, *The Flood at Pont-Marly,* now in the Louvre, was sold by its owner a year after Sisley's death, for 43,000 francs, close to four hundred times what Sisley had received for it.

Sisley was not a formula painter and there is a wide variation in his work. The tendency is to regard as his finest those works that most closely approximate the look of Monet, but this is a faulty yardstick for Sisley's excellence. A snow scene by Monet, for instance, is usually and quite properly called *Effet de Neige,* and a "snow effect" is just what it gives us. But a village in the snow as painted by Sisley gives us that special character, more than a visual transformation, that relays the chilliness of the outdoors and suggests at the same time the warm comfort on the other sides of the walls of houses. A snow scene by Sisley has spiritual cousinship as far back as the fifteenth century with the beautiful February snow scene from *Les Très Riches Heures du Duc de Berry,* and in the sixteenth with Bruegel's *Hunters in the Snow,* and with any other paintings by artists sensitive to the identity that villages and villagers share with nature in their daily routine.

Berthe Morisot occupies an unassailable position as an impressionist artist, but if she had never touched a brush, her

letters would be a valuable chronicle of the school. They are also a fascinating reflection of a personality.

She must have been an enchanting creature—good to look at, thoroughly feminine but with no time for whims and coquetry. Her fresh, tender, and gentle paintings echo her deep capacity for womanly love; the paintings other artists did of her—especially those by Manet—show how vivid her presence was. Her correspondence with her family is equally vivid, and loving. It reveals a spirited intelligence sharp enough to strip pretenders naked and objective enough for her to see herself as clearly as she saw other people. She could tolerate foibles and weaknesses when they were not vicious, but at the same time she was too feminine to resist the pleasure of taking a neat poke at a rival now and then. Few people in the ghostly immortality of letters come through with such vitality. Berthe Morisot has been dead since 1895, but people are still falling in love with her.

She was at one disadvantage in life: she was too independent of mind and too talented an artist to find many men she could respect on her own ground, and whether or not she put it to herself in just those terms, the situation brought her to the edge of spinsterhood in a society that offered its spinsters very little. Nineteenth-century maiden ladies who did not have to earn their food and shelter as housekeepers for relatives were conventionally relegated to genteel amateurism in the arts—usually watercolor and piano. Foresighted parents saw that their daughters were given painting and music lessons on the theory that such skills increased their desirability as wives while providing them with a means of passing the time pending either marriage or death.

In line with this custom, Berthe Morisot and her two sisters, Yves and Edma, were given painting lessons, an additional argument in favor being that they were granddaughters of Fragonard. All three were talented, and Edma before

her marriage was quite an acceptable painter. Berthe was much more than that. She was a good painter from the beginning and was well trained from the age of sixteen under popular teachers named Chocarne and Guichard until, at nineteen, she began studying with Corot. Through Corot she met such men as Daubigny and Daumier. At her mother's Tuesday dinners she met fashionable painters and musicians —including Rossini, who commented favorably on Berthe's musical talent.

It is possible that good connections of this kind were responsible for Berthe's acceptance in the Salon of 1864, when she was twenty-three. After that, she was accepted regularly until, in 1874, she decided never to exhibit there again as a gesture of loyalty to the impressionists, who had become her friends and her cause. She helped organize their first show that year and exhibited in it—against the protests of a man who, in the meanwhile, had become, we know, her mentor in painting and, we are safe in deducing, the central figure in her personal life—Edouard Manet.

Born in 1841, Berthe was twenty-seven when she met Manet in 1868. (He was thirty-six.) A few months later she wrote Edma in great relief that a certain Monsieur D., a suitor for her hand, had "fortunately turned out to be completely ludicrous. I had not expected this, and was quite surprised, but by no means disappointed!" She described herself as being "free of all anxiety" now that Monsieur D. had been dismissed—the fear having been, apparently, that she would have to marry, and the reasonable assumption being, from all evidence over the next several years, that no suitor could successfully face comparison with Manet, with whom she was now in constant association.

There is no letter, or at least no published letter, where she says anything of the kind, but the record of their association makes the assumption inevitable. Manet had seen and

approved of Berthe's work in the Salon (where she was having much better luck than he) and had heard friends speak of her good looks. She had admired him as a painter and as the victim-hero of the scandals of 1863 and 1865 when his *Déjeuner sur l'Herbe* and *Olympia* were attacked. Their mutual friend Fantin-Latour introduced them at Manet's request, and he asked Berthe to pose for one of the figures in a picture he was planning, *Le Balcon*. She is the seated woman at the left in this painting (now in the Louvre), which she described so well as making "the impression of a wild or even slightly green fruit" among the standard mediocrities of the Salon of 1869, where it appeared.

She thought that Manet had painted her as "more strange than ugly," and other people said that he had made her look like a "femme fatale." Not strange, certainly not ugly, and anything but a femme fatale, she was made to order as a Manet model with her black hair, greenish eyes, pale skin, and crisply defined features—all suggesting his abrupt definitions between shadow and light, his spots of astringent color, and his uncompromising brushstroke. He painted her many times, always showing her alert with life, but he painted her as he painted everything—from the outside, with enormous interest but no apparent affection.

Manet must certainly have been attracted to Berthe Morisot and perhaps in his removed way was a little in love with her. But by this time his work was so obsessively the core of his life that there was no room for a grand passion, and he would have been too sensible to involve himself in a troublesome affair by the seduction of a girl of good family and irreproachable reputation even if Berthe had been foolish enough to want him to. Furthermore, her family and his were now good friends. His patient, tactful, and comfortable wife (Berthe referred to her in the safety of letters to Edma as "his fat Suzanne") supplied him with the stable, bourgeois respectability that his temperament required, while casual

sexual exercises in his studio with appropriate partners provided whatever variety he needed when he was not engaged in more extended liaisons with professional or amateur courtesans.

There is no evidence in letters or memoirs that Manet's feeling for Berthe went beyond respect for her as an artist, pleasure in her talk, or, at the very most, the kind of friendly affection that recognizes a dangerous possibility and rejects it by banter and teasing. With Berthe it was different. She had everything to offer in marriage— herself, plus social position and money—and as she approached thirty the situation must have troubled her, although in a different way, as much as it did her family. Yet on the occasion of the dismissal of Monsieur D., she could write her sister, "I have missed my chance, dear Edma, and you may congratulate me."

It is apparent that she was attached to Manet by a male-maestro–female-disciple relationship of a familiar kind. If Manet had been only an unavailable man with whom she had fallen in love, she would have terminated her folly with decision if with anguish. But she was a woman with a great talent and an ineradicable interest in painting, and Manet was the painter of all painters whom she most admired. The bond was strengthened because of the Salon's persecution of Manet: in such attachments the disciple always thinks that the maestro is unappreciated, needs defense and support—and in this case this happened to be true. In his own way, Manet must have depended heavily on Berthe.

After six years of this stalemate, when she was thirty-three, Berthe found the solution in marriage to Manet's brother Eugène. He was a quiet, pleasant man. But he had failed to distinguish himself or even to settle into a profession, and Berthe could not but have compared him with his brother, and could not have been blind to the nature of her compromise.

Her decision was probably catalyzed by the death of her

father. Still in mourning for him, she married Eugène Manet in December, 1874, and shortly thereafter, in a letter to her brother Tiburce, she wrote: "I have been married a month now; it's strange, isn't it? I went through that great ceremony without the least pomp, in a dress and a hat, like the old woman that I am, and without guests. . . . I have found an honest and excellent man, who I think loves me sincerely. I am facing the realities of life after living for quite a long time in chimeras that did not give me much happiness"—a sad enough comment from a bride, but a clearheaded one from a courageous and sensible woman.

By "chimeras" she did not mean her painting. However the marriage began, Berthe Morisot-Manet carried it through successfully as a wife and the mother of a single child, a daughter, while she vigorously continued her career as an artist. She exhibited in all the impressionist exhibitions except the fourth, in 1879, when she was weakened after the birth of her child. Until Eugène's death in 1892 their house was virtually a club for the impressionists and their friends. When she died at the age of fifty-four in 1895, Renoir became the guardian of her daughter, who was then sixteen years old.

Manet had died twelve years earlier. He did not live to see his triumph, but Berthe Morisot did. In 1890, *Olympia* was purchased (in spite of objections from the Academicians) for the Luxembourg. The year before her death, Berthe joined him in this sanctum when her painting *Young Woman in Ball Dress* was also purchased by the state as the result of efforts by her friend and Manet's, the poet Mallarmé.

It had been nearly twenty years since the second impressionist exhibition, which the art critic of Figaro had described as a group of paintings by "five or six lunatics, one of whom is a woman." There was never a woman more sane than Berthe Morisot.

The Impressionist Victory

Camille Pissarro was the oldest, and the steadiest, of the impressionists. He was a year and a half older even than Manet, who of course was not a true impressionist but rather a link between impressionism and mid-nineteenth-century realism. He was ten years older than Monet—which made a great difference at the time they met, 1859, when Pissarro was a mature young man of twenty-nine and Monet a youth just leaving his teens, as were Renoir and Cézanne. Partly as a result of this gap in age that affected their early associations, but largely because he was always a man of such patient, reasonable, and kindly temperament, Pissarro became the benevolent patriarchal figure of the group. As a man of staunch fiber he was consistently admirable, but, alas, this does not make his story consistently interesting.

He was born in 1830 on the island of St. Thomas in the Virgin Islands, then a Danish colony, where his father, Abraham Pizarro, a French Jew of Portuguese descent, had married a local girl and set up as a general storekeeper. The boy was sent to school in Paris until he was seventeen, when he was called back to help in the family business. But he had already contracted an infection endemic in Paris: he wanted to become an artist.

His father objected, and in 1852 (he was twenty-two) Camille ran away with a young Dane, four years his senior, an adventurous wanderer-painter named Fritz Melbye (1826-1896) whom he met sketching on the docks. After a spell in Caracas, Camille yielded to his parents and came home. In 1855 they yielded to him, and now, twenty-five years old, he went to Paris to devote his life to painting.

The devotion was constant, but the father's contention that painting pictures was a way of life less secure than running a general store was constantly affirmed. Pissarro, who led a frugal existence, was harassed by money troubles until his very old age. But his life as an artist, while henceforth

devoid of pleasures and excitements of an exotic kind like the Venezuelan adventure, was rich in satisfactions.

Arriving in Paris the year of the great international Salon with sections devoted to Ingres and Delacroix, and Courbet's Pavilion of Realism an illegitimate offspring just outside the exposition gates, Pissarro set about acquiring an academic training, first in the Ecole des Beaux-Arts and then primarily on his own, in the Académie Suisse. This was where he met the teen-aged Monet. In the same year, 1859, he had a picture in the Salon. His idol was Corot, and this good man, approached, permitted Pissarro to name him as his teacher in his Salon submissions. These were sometimes accepted, sometimes rejected. But by 1866 Corot had disinherited him, apparently because he thought Pissarro's technique a bit too free. With the help of Daubigny, though, Pissarro managed to exhibit in the Salons of 1868 and 1869.

Pissarro was a father by this time. He had formed a liaison—a marriage in everything but documentary sanctification, and a thoroughly moral union in the light of Pissarro's advanced sociological ideas—with Julie Vellay. Their son Lucien, the first of their children (five sons and a daughter), had been born in 1863. Pissarro struggled along, making ends meet somehow or other, taking commercial jobs when necessary. Unable to afford living in Paris, he settled in a simple house in Louveciennes, where, at the age of forty in 1870, he could look with a combination of pride (in their quality) and disappointment (in their unsold accumulation) at several hundred paintings that represented his lifework up to the middle age that was now upon him.

All but forty of these paintings were destroyed in the Franco-Prussian War. Taking refuge in London, where he had a half-sister (he married Julie the same year, perhaps as a concession to this relative's feelings), Pissarro heard that his house had been used as a butchery by the Germans. His

storeroom was rifled of paintings to supply canvas that could be used for various purposes. They served, for instance, as duckboards in the muddy shambles that had been the garden.

And so he started to work again. In London, along with Monet, who was also a refugee from the war, he had been much impressed in the museums by his first acquaintance with the painting of Turner and Constable, which supported, and perhaps enlarged, his ideas about the artist and nature. Back in France, he began taking painting excursions north of Paris (Pontoise, Auvers) with Cézanne, whom he had met in 1861 when Cézanne was a confused twenty-two-year-old. Cézanne had been working in a heavy, rather turgid manner that drew equally on Courbet's rich, heavy surface and dramatic devices adapted from Italian baroque artists. Pissarro urged him to lighten and freshen his style and taught him to look more sympathetically at nature and less dependently at the work of other painters. In turn he learned from Cézanne a new respect for the weightiness of objects, including those in nature that, in the work of the other impressionists, were growing always more vaporous.

In 1874 he exhibited in the first impressionist show— and thereafter became the only artist to exhibit in all eight. Everywhere he made new friends as a kind of saint to younger artists. He introduced a younger generation—Gauguin, Signac, Van Gogh, Seurat—to the impressionist circle, while in his own career he went through periods of abysmal discouragement. He was never free from financial troubles. He was fifty-six in 1886 when he joined his son Lucien and the "pointillists" who were in revolt against the raggedness of the impressionist brushstroke and were attempting to solidify it into a systematic technique.

For about four years Pissarro tried to combine this semi-scientific approach with the fresh, spontaneous quality that he had always insisted upon as the first principle of

painting. Insofar as any pointillist hybridized these antipathetic points of view, Pissarro did, but by 1890 he knew that pointillism was an excessive discipline for him and, at the age of sixty, he returned to impressionism enriched by the experience. In the ten years allowed him before his sight failed, he produced his finest work. This was also a period of recognition at last: his large retrospective in 1892 was a success.

Pissarro had always resisted, and he resisted until the end, the normal impressionist development that led the other members of the group to paint more and more loosely, with increasingly fragmented drawing, color, and composition. He was at heart a conservative painter—this again, perhaps, because he was older and less malleable than his colleagues when impressionist theories emerged as a revolution. His basic sympathy with impressionism was stated in his own simple credo: "One must have only one master—nature."

"Nature" in Pissarro's case must include the city. His countrysides are charming and by choice he might not have painted the city at all. But after 1895, when failing health forced him to work indoors, he painted Rouen and Paris from windows. These cityscapes may be his finest (they are certainly his most individual) work. The figures and carriages that move through the streets and across the bridges of the Seine; the trees that sparkle against buildings held to human scale in the most humanized of all cities; the skies full of light and alive with clouds—everything suggests both life and order, movement and stability, change within permanence.

There is always about Pissarro an impersonal tone in spite of his first premise of recording immediate responses to nature. This may be because he alone among the impressionists thought of his art in terms of social theory. The problems of impressionism for the others were problems of technique and personal expression. Pissarro, a dedicated socialist and

reader of Proudhon, thought of truth to nature as a philo-
sophical commitment. Any affectation, any sentimentality (to
his distress, he recognized both in Gauguin), the reduction
of art to an aesthetic game—the principle of art for art's
sake—he regarded as a betrayal of art and hence as a betrayal
of humanity. As a socialist, he would never have thought of
making dramatic proclamations of his loyalties in paint, as
Courbet did. But everything he painted was conceived in
harmony with those loyalties.

In 1898 Pissarro painted his beautiful series of the
Avenue de l'Opéra, eight versions of the view up the street
from the Théâtre Français. He died five years later, in 1903,
seventy-three years old, and blind.

Degas, one of the supreme artists not only of his rich
century in France, but of any century anywhere, is also one
of the most frustratingly elusive personalities. This is odd,
since he moved in several social and professional enclaves
where he was observed with fascination by people who de-
scribed him, recorded his conversation, and gave their impres-
sions of him in letters, diaries, and memoirs. He lived to the
age of eighty-three, and his life as a series of outward events
is without mysteries. It can be traced without serious inter-
ruption through the years, and in detail. His life as a creative
artist is documented just as fully by drawings and paintings,
beginning with those done when he was twenty years old, a
wealthy young aristocrat, and continuing for half a century
until he became a nearly blind recluse, a white-bearded,
shrunken old man who, groping his way through the streets
of Paris, reminded some people of Homer, others of Lear.

By this time he had cut himself off from the few of his
colleagues who had not died, but he had always lived in
self-enforced loneliness. Even during the days when he went

about in society as a prize lion and wit, he distressed a sensitive and intelligent woman who knew him well and had some idea of how great an artist he was—Berthe Morisot—by the callousness of the defenses that protected his vulnerable tenderness. A barricade of irreverence and sophistication protected him within his fortress, an intellectualized, patrician view of the world that he cultivated against the assaults of common humanity, whose warmth and sweetness he recognized but could not quite bring himself to share.

Degas cannot be understood unless we are willing to begin by accepting his patrician stance. Any other would have been unnatural to him. But we come immediately to the kind of contradiction that frustrates all efforts to define this man. Born De Gas, he preferred the more republican Degas, and although his aristocratic reserve precluded anything like the exhibitionistic social consciousness of Courbet (who, in comparison with Degas, was a buffoon), it did not preclude a recognition of the virtues of simple people that was so profoundly sympathetic, and so quietly stated, as to turn Courbet's proclamations of identity with the common man into sideshow performances. And when Degas, a city man, shows us the urban equivalents of Millet's peasants— laundresses at their ironing boards or delivering bundles, milliners' assistants trimming hats or waiting on customers— he says more about the dignity of common people than Millet ever did, simply because beneath the apparent objectivity, the refusal to idealize reality, Degas is genuinely respectful of the goodness in people that is vitiated when an artist sweetens and prettifies it.

But what we have called Degas's "patrician stance" was less isolating than something else—a form of timidity, of apprehensiveness, of fear or even of revulsion, and certainly of self-mistrust—something too complex for identification by a single name and explicable only by conjectures too dubious,

too presumptuous, to be tolerated. He once said that a painter could have no personal life—an absurd statement. He never married, he never formed a liaison, and he seems never to have been drawn into a passion either natural or unnatural. Yet he was neither a cold man nor a eunuch. He had his own explanation: "There is love, and there is work, and we have but a single heart," he said, ignoring the obvious rebuttal of the record over the centuries of great artists who, single-hearted, have loved and worked with equal abundance.

Whatever the explanation for his refusal or his inability to yield himself to another person, Degas was aware, in his middle age, of how much this reticence had cost him and, as well, had cost his friends. In 1890, when he was fifty-six, he wrote to one of them, Evariste de Valernes, a poignant letter that came close to confession. Frequently in his conversation ("and even more frequently in your thoughts," Degas told him) Valernes had felt that during their long friendship Degas had been harsh with him. "But more than that, I was harsh with myself," Degas wrote. "I was, or seemed, hardened against all the world, with an habitual brutality that came from my own self-doubt and bad temper. I felt myself so poorly equipped, so ill-made, so weak—and at the same time it seemed to me that my conclusions about the nature of art were so right. I was resentful against all the world, and against myself. If with the excuse of this accursed art I have hurt your noble spirit, perhaps even your heart, I ask for your forgiveness."

The De Gas family had Italian ramifications, both by blood and in business. Augustin de Gas, Degas's father, was an international banker, born in Naples. His wife, Célestine Musson de Gas, was born in New Orleans. Hilaire Germain Edgar was their first child: he was born in Paris on July 19, 1834. Four years later there was another son, Achille; then two daughters, Thérèse and Marguerite, born in 1840 and

1842, and finally in 1845 another son, René. Degas was deeply attached to this brother eleven years younger than he, and drew and painted him repeatedly as he grew up. No other person has been more affectionately recorded over the years of boyhood and adolescence than René de Gas, but this affection, probably the strongest of Degas's life, was sorely tried during René's manhood.

Degas entered the Lycée Louis-le-Grand when he was eleven (and made there his best friend for life, outside his family—Henri Rouart). His mother died when he was only thirteen, but Augustin de Gas, who was a cultivated man, took his son to the Louvre and to concerts. Like Manet, Degas was expected to study law, almost automatically the profession for intelligent young men of his class. But when he was eighteen he had already turned one room of the house (looking out over the Tuileries) into a studio. The next year he received his degree from the Lycée and enrolled for law classes at the Faculté de Droit. But he also registered at the Louvre and the Bibliothèque Nationale as a copyist.

His law studies did not last long. When he was twenty, Degas rebelled. His father yielded (perhaps with some ill-feeling, since Degas at this time began to live apart from his family), and Degas began to study drawing with Louis Lamothe, a priest of the cult of Ingres.

Degas was already a neophyte of the cult, and his drawings over the next ten years, even while they steadily took on greater warmth and freedom, are tributes to the linear refinement and subtle modeling of the classical master. For that matter, Degas's drawing all his life remained within the classical tradition. Even when it became most free, even when the lines grew thick and blunt, lines drawn by an old man nearly blind, the first principle of classical drawing was inviolate: forms were described as compact masses defined by unbroken contours.

Degas managed to meet Ingres once in 1855. (He was twenty-one, Ingres, seventy-five.) Degas had induced a friend of his father's, the collector Edouard Valpinçon, to change his mind and lend Ingres's *Turkish Bather* (now in the Louvre and called *The Bather of Valpinçon*) to the Ingres retrospective in the Salon of 1855, and when Valpinçon told Ingres of this, Degas was invited to visit Ingres in his studio. Ingres was not accepting students at this time, but he offered Degas the oft-quoted advice "Draw lines, young man, many lines," and Degas always did. Very few artists since the Italian Renaissance have approached Degas, and none, not even Ingres, has surpassed him, as a draftsman who can hold a form implacably within a line, and yet not cramp it. The constantly increasing freedom of his draftsmanship was not a violation, but an expansion, of this classical principle.

Nothing in Degas's early career hinted that one day he would ally himself with a group in revolt against the Salon. On the other hand, he was not interested in following the usual course of an ambitious student. He never considered competing for the Prix de Rome. He was uninterested, for whatever reason, in the advantages the Prix offered a careerist painter, and as a young man with plenty of money he could go to Italy and do as he pleased without being shackled to the Academy.

He first went to Italy in 1856 (he was twenty-two). On several trips made over the next three years he visited his grandfather, René Hilaire de Gas, in Naples, and his French and Italian relatives named Morbilli and Bellelli in Naples and Florence. In 1859, in Florence, he painted a portrait of his aunt, the Baroness Bellelli, her husband, and their two little girls (*The Bellelli Family*, now in the Louvre)—superficially a beautifully disposed family group, but beneath that an exploration, acutely perceptive and profoundly tactful, of four personalities and their harmonies and conflicts, a paint-

ing that justifies the use of a much-abused word—masterpiece.

During these years he did many portraits of family and friends, drew from the model, copied in the Louvre and in Italian museums (drawing after Raphael, Michelangelo, Botticelli, Mantegna, Filippino Lippi, and Leonardo), and worked at large biblical and classical compositions suitable for Salon presentation. He probably met Manet in 1862, the year before the scandal of the Salon des Refusés, although their acquaintance did not mature until a few years later. Manet was only two years older than Degas, and the better part of a decade separated the two of them from Monet, Renoir, Bazille, and Sisley, who at this time were youngsters cultivating their first beards. Manet's and Degas's social and financial backgrounds were enough alike for them to feel at home together and become friends who, later on, felt themselves a little apart from (which is not to say better than) the rest of the rebels.

A bit of De Gas family history must be interpolated here. In 1863 there arrived in France, somewhat as refugees from the American Civil War, Degas's New Orleans uncle, Michel Musson, with his wife and their daughters Desirée and Estelle. Estelle, the one who concerns us, was already a tragic figure. Married at eighteen to a young army captain named David Balfour, she was widowed while carrying their child when he was killed in battle. René de Gas, in his late teens, fell in love with his cousin Estelle, two years his senior, and when the family returned to New Orleans in 1865, René went with them, combining courtship with an apprenticeship in the family brokerage business. Estelle, a gentle creature who all her life was dogged by a malevolent fortune that sent blessings only to snatch them away, was struck totally blind by ophthalmia shortly after the family's return. But she and René were married, nevertheless, in 1869, over the protests of

her father and under special episcopal dispensation to allow the union of first cousins. She was granted a period of happiness pending further tragedy.

During this time, three years after his marriage, René returned to France for a visit, and urged Degas to accompany him back to New Orleans. The brothers sailed in October, 1872. Degas was approaching a dividing point in his life as an artist, and perhaps some sense of this led him to make the trip. For one thing, although he was not yet forty, he was complaining of eye trouble. For another, he was now conscious of the importance of the young impressionists-to-be and of the nasty tactics of the Salon. He was having no difficulties in that quarter himself: he had been accepted in the Salon of 1865 and those of the subsequent years through 1870. That year when the Franco-Prussian War broke out, he enlisted in the artillery, and the next year, recuperating from a wearing experience, he did not bother to submit to the Salon. He never submitted again. After sitting out the Commune with his friends the Valpinçons in Normandy, he returned to Paris where he began working again and discovered a new subject, ballet classes, making his first studies at the old opera house in the Rue Le Peletier. It had been a period of restlessness, and the prospect of a trip with his beloved younger brother came opportunely.

The ship landed in New York. Degas was amazed and impressed by the bustle and modernism of the place—an interest in industrial society never reflected in his painting. He wrote home rapturously about the ships in New York harbor, going out and coming in from all over the world as frequently and as casually as buses in a city. He was fascinated by electric street cars. After the four-day train trip to New Orleans he reported with excitement on the sleeping cars—with berths you could lie down in at full length—and the general luxury of travel on American trains.

In odd contrast, his letters about New Orleans make him seem oblivious to the complicated situation there. In the post-Civil War agony, Louisiana and New Orleans were near chaos politically and economically. Degas, however, saw (or wrote about) only the good life of René, the charm of the Musson mansion on Esplanade where René and his family lived with the Michel Mussons, and the pleasant society, against a background half European, half exotic, in which Estelle and his brother moved. He found New Orleans too picturesque to afford subject matter for painting (a neat demonstration of the shift from romantic values: Delacroix would have been fascinated with its exoticism). But he could not write enough about the women. The Negroes, mulattos, and quadroons he found most beautiful; the white women he described as having just that taint of ugliness that can make an otherwise pretty woman even more fascinating. René's happiness made Degas wonder about himself and marriage, or so he said. It made "a series of casual affairs" seem unsatisfactory, although this reference is left hanging without specific substantiation, like so much else in Degas's life.

His relatives and their well-meaning friends evinced, alas, a provincial attitude toward their visitor. As an artist (it must be remembered that he was not yet a reputation) he was regarded somewhat as the possessor of skill in a superior parlor trick that he was expected to demonstrate in drawings and portraits. He managed, nevertheless, to work seriously during his stay. Two of the paintings, a portrait of Estelle and an interior of Michel Musson's office, are among his impressive number of superb realizations.

The portrait of Estelle (Washington, National Gallery) is one of many proofs that Degas must be placed at least on a par with any other painter, including Rembrandt, as an artist who understood and could reveal the mysteries of the human spirit in its loneliness and at the same time its majesty.

Majesty may seem too strong a word for use in connection with Degas's century, but there is majesty in any spirit that can see beyond the confusions of daily life to perceive a reason for being. Blind, but gazing into a distance beyond ordinary sight, Estelle is seated on a sofa with her arms folded in her lap—an attitude that, plus the fullness of her dress, protects the swelling of her pregnant body. Only one other of Degas's portraits is quite so moving—the one painted a short time before (*c.* 1869-72), of his father with a friend, Lorenzo Pagans, who is singing and playing the guitar (Boston, Museum of Fine Arts). The old man, stooped and bowed, listens to the music and, quite apart from the world, roams among memories. Such a subject should be appallingly sentimental, and in most hands would be. Degas gave it a dignity that saves it not only from sentimentality but from a poignance that otherwise would be close to unbearable.

The Cotton Market, as it is usually called, although its correct title is *Portraits in an Office* (Pau, Musée Municipal), is a view of his uncle Michel Musson's office including that good man's portrait and those of René and Achille de Gas (who had settled in New Orleans as René's business partner) along with a dozen or so clerks, buyers, and associates, all portraits. In arrangement the picture is as calculated as any Salon historical or classical demonstration piece, equally observing principles of rhythm and balance. But the rhythms and balances are now concealed within a structure that seems accidental, seems to reproduce a chance arrangement that occurred at a moment during daily activity.

Degas, having served his time with biblical and classical subjects, had become a painter of modern life without losing faith in classical disciplines. He had already discovered in ballet rehearsals a subject allowing for apparently casual but actually studied and arbitrary dispositions of figures in space. *Portraits in an Office*, where each person seems to have

been caught unawares, and where some of the figures are chopped off as if within the chance frame of a snapshot, was the climactic painting of his early realistic stage. During the rest of his life Degas's compositions, on the same principles, yield increasingly eccentric arrangements. Seen at odd angles, sometimes in "key hole" visions of naked women at their unloveliest private moments, these compositions include not the slightest degree of accident. Ingres himself never calculated his arrangements more carefully than did Degas.

Degas returned to France early in 1873, the year before the first impressionist exhibition, and made his first close contacts with the younger artists. He joined the cause for the idealistic reason that he believed in it. In practical terms he had nothing to gain from an affiliation with the insurgents, and something to lose. Quite aside from the likelihood of its costing him his entree to the Salon, his participation could not but involve him in the kind of noisiness that he abhorred, in the company of certain artists whose painting he respected but whose companionship he did not enjoy. But where Manet abstained, Degas not only joined but became one of the hardest-working members of the group. The only trouble was that he was if anything too interested. He had his own ideas and could become truculent or waspish when they were opposed. He insisted on including as many artists as possible and forced the acceptance of candidates that the other members, often with good reason, thought unworthy. As the exhibitions went on (Degas participated in all but the seventh) he grew more and more difficult, just as he grew more and more isolated from his friends during the years after 1874. The severity and ill-temper that might have increased in any case were aggravated by the circumstances following his father's death, which coincided with the impressionist scandal of that year.

When Augustin de Gas died in Naples, the affairs of his bank were discovered to be in appalling condition. To make

things worse, the terms of his will were a grotesquely complicated tangle. In a first move to stave off bankruptcy for the family, Degas, in 1875, sold the respectable art collection he had acquired, but this was only a stopgap. In the liquidation of the estate and the final accounting of the affairs of the bank, his brother René, who had made disastrous speculations on the market, was unable to meet his share of the obligations that would save the family name, and Degas and a brother-in-law (Henri Fèvre, an architect) made up his portion, although they were under no legal obligation to do so. Degas had never lived in luxury, but he had always lived in rich man's comfort, and it now became apparent to his friends that he was having to pinch even while living on a simpler scale. He was extremely sensitive on this point, just as he had always been reticent, even secretive, about all his personal affairs. When the gossipy litterateur George Moore broke the taboo and commented in print on Degas's money troubles, Degas refused ever to see him again.

For the first time, Degas had to submit to the embarrassment of asking his dealer for advances. Shortly after abandoning the Salon, he had begun to exhibit with Durand-Ruel. Now he became dependent on sales. He had never been indifferent to them. For one thing, the sale of a painting was a satisfying form of recognition as well as a source of income, and even before the financial debacle Degas had written from New Orleans to a friend, James Tissot,* that his visit there had given him a lively appetite for the acquisition of money. The time came when Degas could sell whatever he produced,

* James Tissot (1836-1902) and Degas knew each other as young men in Paris, and Tissot is the subject of one of Degas's finest early portraits (1868; Metropolitan Museum of Art). After serving in the Franco-Prussian war, Tissot settled in London and became a great success there. He did not yield to Degas's pleas to exhibit with the impressionists. Regarded now with some esteem for his charming, if too illustrative, scenes of genteel Victorian life, he devoted most of his energies to biblical subjects, which he tried to re-create with meticulous archaeological accuracy. He spent ten years in Palestine at work on the two-volume "Tissot Bible."

and he left an estate of some twelve million francs after the sale of his studio in 1917. But up into the 1880's he was in uneasy circumstances.

During this time also he suffered deeply from a development that estranged him from René, or perhaps completed whatever estrangement had begun during the settlement of their father's affairs. In 1878 René, now thirty-three years old, suddenly returned to France, abandoning Estelle for a Mrs. Léonce Olivier of New Orleans whom he married after his divorce was arranged. He and Estelle had been married nine years and had had two daughters and three sons. A month after René's departure (in classic fashion, he vanished one day leaving a few lines of farewell) the youngest son, aged two and named for his father, died. Before the year was out the younger of the two daughters, Jeanne, Degas's godchild, died in a yellow-fever epidemic. She was followed early in 1881 by the oldest son and the one child, a daughter, that Estelle had had posthumously by her first husband. Michel Musson adopted the two remaining children of the six in order to rid them of the hated name De Gas, and Estelle also assumed her maiden name. The Mussons' fortunes had declined. The remnant of the family continued to live quietly in the great house. There were some quarrels with René's brother and one-time partner, Achille, before he left New Orleans in 1883. With him the name De Gas vanished from the city.

In the year of the last impressionist exhibition, 1886, Degas was fifty-two. He participated in this, but he was now well on his way to becoming a recluse cut off from all but his closest friends of longest standing. In addition to the disruptions of his personal life, he was increasingly troubled by failing eyesight, a progressive and irremediable condition. Around 1886 he gave up painting in oil. The medium had never been really sympathetic to him; he admired the rich fluency of the brush as Delacroix employed it, but this ro-

mantic flexibility was foreign to his nature. For Degas, the brush was a necessary link between him and the canvas, but it remained only a link. The crayon was different: it was not a link, but a part of his hand that left no separation between him and the paper. All of this is to say that Degas was a draftsman first and a painter second. Now he established a union between painting and drawing by revolutionizing the medium of pastel.

The limitation of pastel had been inherent in its character as a powder that yielded exquisitely delicate, grainy tints when deftly applied, but allowed for no reworking. Its life, its vibrancy, depended on its granular interplay with the paper, a form of transparency that limited color to pale tints. Degas, by the use of a special fixative (its composition is unknown), transformed the medium and its technique. He was able to give body to the pigment where body was needed and, most important, could apply one color over another or work one into another without the cloudy, deadened look that pastel ordinarily takes on if the initial stroke is touched again. As his sight failed his pastels grew bolder, their lines broader, their colors more brilliant and more vigorously interwoven. Not until the very end was there any wavering of the decision and the essential accuracy with which he expressed the structure and movement of the human body. He found compensation, too, in another medium, sculpture. Where sight failed, touch could take over, and he produced the miraculous little wax figures, now known in bronze casts, of nude dancers and other women caught in momentary attitudes. His last important drawings and pastels were done around 1905. There is no sign of weakening of the hand, certainly none of failing of the intelligence, but the forms, at last, begin to dissolve here and there, half seen, suggested rather than defined.

And now such contacts with the world as he had not

rejected began to drop away from him. He was deeply dis-
tressed by the death of his brother Achille in 1893. Two years
later his sister Marguerite died in Buenos Aires. It must have
been at this time that he became reconciled with René; it is
known that they spent a vacation together in 1898, when
Degas was sixty-four. As the last of his old friends died, some
younger admirers bothered, or dared, to see him. The painter
Suzanne Valadon, a former model, was one of these. In 1912,
when he was forced to leave the studio he had occupied for
twenty years, she helped him find a new one.

The war in 1914 was Degas's final tragedy, and he did
not live to see France victorious. The news of his death on
September 27, 1917, at the age of eighty-three, surprised
people who, familiar with his name as a great one in the
history of art, had not realized that he was still alive.

Mary Cassatt was the youngest of the impressionists by
about five years, having been born in 1845, and did not join
the group until the fourth exhibition, in 1879. The wonder is
that under the circumstances of her origin and background
she ever became part of the group at all. She was exceptional
among rich, well-bred young women of the nineteenth cen-
tury in the unstunted independence of her intelligence. But
she was more remarkable in the way she managed to follow
where this intelligence led while, at the same time, observing
strictly the genteel conventions of the way of life to which
she was born.

She was born in Allegheny City, now part of Pittsburgh,
the daughter of a banker who shortly thereafter moved to
Philadelphia. The family's wealth later included sizable in-
terests in the Pennsylvania Railroad. When she was sixteen
she entered the Pennsylvania Academy of the Fine Arts and
studied painting for four years, an activity that, for many

young gentlewomen, conveniently filled the interim preceding their introduction to Philadelphia society. The Academy was run on a system similar to that of the Ecole des Beaux-Arts, and she drudged away vigorously at routine exercises that might have been planned to stifle original talent, and, no doubt, often did. There is no evidence that she displayed an original talent at this time, but the record shows that she was industrious.

Against her father's objections she insisted upon going to Europe to study further, and went in 1866, aged twenty-one. She was under watchful chaperonage for some years but, except for appearances, Mary Cassatt never needed a chaperon. She loathed bohemianism, and in her old age spoke caustically of American students in France, objecting not only to their loose way of life but to the fact that they came to France at all. Things had changed, she said: in her youth, it had been necessary to come to France to find proper instruction, but this could now be found at home. She was right enough.

The young Mary Cassatt traveled extensively in Italy, Spain, and Belgium, studying and copying all the while; Correggio, Velázquez, and Rubens were the strongest influences on her early painting, which was already skilled but routine. Established in Paris by 1873, she first studied under a fashionable painter with the easily remembered name of Charles Chaplin but began to discover Courbet and Manet for herself, and to admire them above the socially successful Academicians whom she met in her conventionally regulated life.

She was accepted in the Salons of 1872, 1873, and 1874. In 1875 one of her entries, a portrait, was rejected. Her faith in the Salon was dealt a mortal blow when the same painting was accepted the following year after she had painted out the bright background using the murky tones of a museum painting in need of cleaning. She was rejected the next year and

never submitted again—partly, at least, because she had met Degas.

Degas was of all artists the one Mary Cassatt came to admire most (with Manet as a less and less close second). And although she was never directly Degas's student, he was her mentor and her model to the extent that many of her paintings reflect his style sharpened in line and somewhat sweetened in spirit. Together they discovered Japanese prints, and Mary Cassatt's etchings and drypoints, which are possibly more important than her paintings, owe direct but not plagiaristic debts to that Oriental art form. In these and in her paintings her most frequent subject is mothers and children, sensitively observed. Neither Renoir's lush vision of maternity nor Degas's acute perception of psychological relationships between parents and children can be read into Mary Cassatt's extremely charming and solidly patterned, impeccably executed prints or paintings. She is always admirable, seldom moving; one is never quite sure, having noticed this, whether she is a little cold or is only well mannered. Her work never allows an explanation on the assumption that her subject matter was chosen as compensation for frustrated desires.

When Degas asked her to exhibit with the impressionists in the fourth show of 1879 she did so, as well as in all the following ones except the seventh. During the organization of that one, Degas became so outrageous in his demands that he had to be opposed. When he was, he refused to participate. Mary Cassatt knew that he was in the wrong, but she also withdrew as a declaration of personal loyalty.

Jean François Raffaëlli (1850-1924) was the immediate cause of Degas's quarrel with the seventh impressionist exhibition, and his, Raffaëlli's, name persists in the history books largely because of that quarrel. A protégé of Degas's for reasons beyond comprehension, Raffaëlli had been included

in the fifth and sixth impressionist exhibitions at Degas's insistence and to the distress of the other members. His paintings of picturesque genre types and picturesque nooks and crannies of Paris, are direct ancestors of the pseudo-impressionist Parisian scenes still ground out by the thousands for sale to tourists today. His superficial impressionism, which involved a kind of vaudeville brio technique, could not hide from Monet and Renoir his unutterable banality, and certainly could not really have hidden it from Degas, or from Mary Cassatt either. Raffaëlli as a social individual seems to have had some attractive graces. He made great headway, and after the seventh show ceased to be a problem, since he began making so much money that he was able to renounce his opportunistic impressionist association. Degas let him go at the same time, having supported his candidacy, it seems, only out of pique at having been opposed.

Mary Cassatt often suffered from Degas's irritability and pessimism. She once wrote in a letter that Degas "dissolved" his friends when he was in one of his black humors, and left them feeling "Oh, why try, since nothing can be done." But there was a real bond between the two. It was not of the emotional kind that attached Berthe Morisot to Manet. It had to do, rather, with a mutual fastidiousness that demanded reticence almost to the point of snobbery. And there is not much question but that Manet and Degas were closest to Mary Cassatt as artists because they were also the most sympathetic as social beings. Monet was a boor and Renoir a charming sensualist in Mary Cassatt's opinion, although she owned paintings by both. Whatever the bond was, Degas recognized it on something better than a social level when he saw Mary Cassatt's painting in the Salon of 1874. He had not met her at that time, but he said, "This is someone who feels as I do."

Like Degas, Mary Cassatt never married, but she enjoyed people and, unlike Degas, never became a recluse. She loved

conversation, and entertained the best talkers in France (along with streams of Americans sent to her by family and friends) in her apartment in Paris and later in her château near Beauvais. She was forty-eight years old when she moved (with her mother) into the Château de Beaufresne, and she died there thirty-three years later. The acquisition of this seventeenth-century lodge gave her special pleasure because she purchased it with money from the sale of her paintings.

Mary Cassatt was not a beautiful woman, but she presented an aspect of regal gentility enhanced by fine dresses and hats. A photograph taken in her château in 1925—she was eighty years old, and it was the year before her death—shows a quite wonderful-looking old lady in a lacy morning cap and a pretty white collar, her face immensely wrinkled and fragile. But the photograph is somewhat misleading. In her last years, Mary Cassatt became querulous, ill-tempered, embittered, and intolerant of the art movements that had followed impressionism. She had some reason for personal bitterness: partly blind by 1912, she was unable to work from 1914 on, which left her twelve years to fret away until her death in 1926. But she had also received generous recognition, including the ribbon of the Legion of Honor in 1904.

Mary Cassatt was an admirable painter, but if she had never painted a stroke she would still hold a strong position in the history of art in America. Among her American friends were the Havemeyers and the young Carroll Tyson. These were the most prominent among the moneyed Americans whom she advised and, in truth, educated as collectors. They purchased what she suggested (her letters describing the proposed paintings show that she was not acting on the advice of Durand-Ruel, the dealer who handled most of the painters she recommended, but was remarkably astute in her own judgment) and as a result the Metropolitan Museum in New York with its Havemeyer pictures, including not only impres-

sionists but Goya and El Greco among other masters, and the Philadelphia Museum of Art, with Carroll Tyson's small, gemlike group—Cézannes, Renoir's *Bathers,* a Goya, and others—own pictures that are the envy of all museums in the world.

Mary Cassatt was indeed an extraordinary woman. The only thing that is puzzling about her is how she could have been as extraordinary as she was and at the same time so conventional. Perhaps Cézanne's remark about Monet, that he was only an eye, but what an eye, could be modified to fit Mary Cassatt. Perhaps she was only a student—but what a student. And it is the latter half of that characterization that is important.

Jean Baptiste Armand Guillaumin (1841-1927) was an active member of the impressionist group and an assiduous painter, but he is difficult to think of today except as a peripheral figure. The best of his rather bland pictures of the Seine in Paris and of landscape on the outskirts of the city might sometimes be mistaken for that rare thing, a poor Sisley. Guillaumin comes off best if regarded as a sensitive amateur, for he seldom meets the technical standards that are the measure of the professional—particularly when it comes to organizing a picture.

This is not to say that Guillaumin is never charming; he usually is. And if his talent for painting was not strong, his talent for friendship did much to make up for that weakness. Although he was of an age with Renoir and Monet, Guillaumin also became companion to a younger group. Signac was a close friend, and Van Gogh, always yearning for a spot in somebody's heart, haunted his studio. He was very close to Pissarro. Cézanne—touchy, hypersensitive, and generally difficult—was more comfortable with him than

with other colleagues. The two met at the Académie Suisse and later painted out-of-doors together. When they painted the same scene they left in the twin pictures a record of friendship but, also, a conclusive demonstration of just where Guillaumin's limitations lay.

Guillaumin shared the chronic poverty of his first friends during, and beyond, their early days. A native of Moulins, he came to Paris at sixteen with a job in his uncle's shop. From this he graduated to employment with the Department of Bridges and Roads of Paris, where he worked three night shifts a week in order to keep his days free for painting. This left him little time for the socializing and the talk about art that went on in the cafés, but he was an enthusiastic helper in the organization of the first impressionist show, and exhibited in all but the second and fourth of the eight.

Guillaumin's self-portrait in 1878 at the age of thirty-seven (Laren, Collection V. W. van Gogh) shows a dark young man with a bulging forehead, intense eyes beneath jutting brows, a small nose caved in at the bridge, and a beard—a face that could belong to either an artist or a ditch-digger and belonged to a man who worked as both. He slaved away at his job and at his painting. One trial recess from his job with the Department of Bridges and Roads, during which he tried to support himself painting blinds, had been a failure. Until he was fifty, it seemed that his exhausting compromise would have to continue until death. And then one wonderful day in 1891 he won the prize of one hundred thousand francs in the Paris lottery, and was able to quit his job and devote his entire time to painting.

Eva Gonzalès (1849-1883) was the only person Manet ever allowed to name him officially as teacher—to the irritation of Berthe Morisot, who was just as much his pupil and

was doubly put out because Eva had good looks and talent. The daughter of Emmanuel Gonzalès, an immensely successful writer of popular novels, Eva was twenty when she met Manet, and promptly left the studio of Chaplin to work with him. He had spotted her, with her dramatic beauty, as a perfect subject for a portrait.

Eva Gonzalès was a sound painter who imitated Manet as closely as she could but is better remembered, and quite justly so, for his portrait of her, begun in 1869 and exhibited in the Salon the next year, than for any of her own work. She is shown seated at her easel in a flowing white gown, her pale skin, masses of dark, curling hair, handsome aquiline nose, and black eyes, all combined in a flashing image. The portrait, now in the National Gallery, London, was used in the background by Sir William Orpen (1878-1931) when in 1909 he painted his *Homage to Manet* (Manchester, City Art Gallery).

Eva had rather spotty acceptances at the Salon, usually depending on whether Manet was in or out of favor with the jury. When Manet refused to join the impressionist exhibition, so did she. In 1878 she married the engraver Henri Guérard, an habitué of the impressionist table at the Café de la Nouvelle-Athènes. Grief-stricken upon receiving the news of Manet's death in 1883, and unable to attend the funeral because she was still confined after the birth of a child, she insisted on making him a funeral wreath. It was her final creative endeavor. She died five days after Manet, very suddenly, of a blood clot, at the age of thirty-four. In a letter to Manet's widow, Manet's mother relayed Berthe Morisot's description of Eva in death—her skin waxen pale, with flowers against her face, flowers wreathed in her black hair, and masses of flowers held in her hands.

Stanislas Lépine (1835-1892), one of Corot's pupils and a friend of Boudin and Jongkind, synthesized from these sources a most agreeable style, to which he added a dash of impressionism. He does not offer much variety. Berthe Morisot found his landscape in the Salon of 1869 "charming" but "as always, a view of the banks of the Seine near Bercy." At this time, when he was thirty-four, Lépine was reaching a comfortable position. He had a certain reputation, his paintings were attractive and just adventurous enough to hold their own somewhere in the rear of the vanguard, and he was finding purchasers. Nevertheless, at the risk of losing caste, he accepted the invitation to exhibit with the impressionists in their first show, and also joined them in the second, third, and fifth. In the scandalous reviews of the first show he was kindly treated by the critics, as if he had wandered by mischance away from his respectable milieu. Later on, when Durand-Ruel held his first exhibition of impressionists in New York, Lépine was included as a shock absorber. Lépine's pictures remain extremely agreeable today. One misses in them only that spark that once caused shock but has remained as a source of the life that Lépine, somehow, lacks.

Two painters closely bound to impressionism, Whistler and Fantin-Latour, will conclude this chapter, but this is a good spot to interpolate some consideration of the Salon favorites who, now neglected or forgotten, were eminent during their lifetimes as the standard-bearers of tradition against the realists and impressionists. Ingres was the last leader of the academic forces who was also a great artist. After him, the deluge of mediocrities or glossy shams. Most of the names in the following notes are present mainly for the record, but the first of them, Couture, is worth more than casual attention.

Thomas Couture (1815-1879), whose lifetime coincided

very nearly with that of Courbet (1819-1877), might with bet-ter luck have been conditioned (according to the premise that early experience determines character) in the direction of inquisitiveness and generosity, and might thus have be-come a great artist. He had a great gift, but he was a man so hidebound, so vindictive, so defensive in his overweening self-esteem, and so self-blinded to the virtues of any painter who did not follow him in the path he had chosen, that it is difficult to feel any sympathy for him. Yet, now and then you run across a Couture so richly painted, so moody, of a subject so sympathetically observed, that you recognize the expres-sion of a superior talent that in other demonstrations—its ambitious ones—was perverted into eclectic banality.

Couture was a student of Gros, whose influence is ap-parent in his taste for sensuous color and surface, and of Delaroche, whose influence, alas, is apparent in his respect for the moth-eaten inflation that passed as history painting. He won the Prix de Rome, and a few years after his return to Paris made a spectacular success in the Salon of 1847 with his *Romans of the Decadence,* now in the Louvre. He is always remembered in the first breath as the painter of this Salon monument, and in the second as Manet's teacher.

Romans of the Decadence is impeccably drawn, painted, and organized, all by classical-academic standards. Draped on couches, embracing languorously, displaying nicely rounded buttocks and handsomely sinewed thighs, thirty of the best-built models in Paris are disposed in and out of their togas, defiling by their presence a noble hall symbolical of the virtues of ancient Rome. As an orgy picture of a type popular in the Salon, where culture served as a veneer for libidinous description, *Romans of the Decadence* was a sure bet for popular success while faultless as an academic exercise. But it has a little something more. Delacroix saw it at the Salon and came home to write in his journal, "He is very complete, in

his own way. What he lacks, I think he will never acquire. On the other hand, he is full master of what he knows." And *Romans of the Decadence* remains an arresting picture where hundreds of other examples of its type that were Salon successes are now only laughable.

Couture ran one of the most popular of all the academic studios, and Manet not only chose to study with him but stuck with him in spite of conflicts. Couture is seldom given credit for the strong influence he had on Manet. The elements in Manet's art thought of as Spanish, if they could be broken down and separated, would yield many that came from Couture—the somber blacks of the shadows, the breadth of the lights, for instance. Again and again in museums one sights a fine portrait across the room—usually not of great size, and unpretentious—and discovers that it is by this Couture whose pretensions in his showpieces were so appalling.

Couture's adulation of his own prowess was all but pathological, as was his corollary hatred of all artists who challenged his premises. He never missed a chance to make scurrilous jibes at Delacroix, Rousseau, or Courbet in talking to his students. (But he was a great admirer of Géricault, who was safely dead, and one may trace some of Couture's rich painting, his dramatic darks, to *The Raft of the Medusa*.) He sounds, in his attacks on other artists, like a man intent upon justifying to himself a conservatism in which he is unwilling to admit his loss of faith—a suspicion supported by the fact that in the last years of his life he gave up painting. He died an embittered man, where his colleagues in the academic clique continued to believe that they were the chosen of God in spite of the rise of Courbet, Manet, and the impressionists.

During his last soured years, Couture wrote a series of essays called "Studio Conversations," which, published privately in France, received little attention, but, translated in

America, had a respectable success. In one of these dogmatic, chip-on-the-shoulder sermons, poor Couture summarized the mentality of the Salon public and the Salon artist in a sentence that, noble in intention, reveals the ignoble sterility of the Salon in practice. "People want you to speak to their hearts and to represent what they love and admire," he said, stating a limited goal for painters but one that would be acceptable so far as it goes except that in the context of the Salon as it was, the sentence should have read, "People want you to give them sentimental clichés that they have been told are elevated cultural expressions, and if you want to make the grade, that is what you had damned well better give them."

Jean Louis Ernest Meissonier (1815-1891) was probably the most popular and most successful artist of his generation, and the next generation as well (for he lived a long time). Crowds stood before his pictures in the Salons, and he asked prices the equivalent of those commanded by Picasso today. But except for these prices and a long white beard that hung to his waist in old age, everything about him was miniature. He was a tiny man, dwarfed in spirit, who painted tiny pictures in a technique so persnickety that Baudelaire once referred to his figures as "M. Meissonier's fleas." Microscopically detailed execution was his forte. If this had also been, for instance, an aspect of the art of Jan van Eyck, with Meissonier it was different in that the microscopic execution was an end in itself. Aesthetically and expressively it was pointless, for Meissonier was without imagination. Even the poses and costumes and relationships and anecdotes that he set up like still life, and then painted exactly, were as trite as they were meticulous.

Meissonier made his first appearance in the Salon at the

age of nineteen with a picture called *A Visit to the Burgo-master*. The title classifies him. He imagined that he was recreating seventeenth-century Holland (although he also did scenes of contemporary life) in anecdotes of the kind depicted by the Little Dutchmen, but he had none of the control of, and apparently no perception of, the powers of formal organization that could turn an anecdote into a masterpiece in their hands. Later Meissonier added military scenes to his repertoire, with Napoleonic subjects among them. People knowledgeable in military history can identify the regiment to which one of his "fleas" belongs by examining the buttons on a soldier's coat with a magnifying glass.

Meissonier won his first Salon medal in a lower bracket when he was twenty-five. A year later he won a better one. The next year, he went up another notch. He was equally rewarded five years later, and then in the famous Salon of 1855, aged forty, he won the Grand Medal of Honor (to the indignation of Couture, who refused his mere Medal First Class). Napoleon III purchased Meissonier's *Le Rixe* (showing a brawl between models costumed as seventeenth-century guardsmen) for presentation to Queen Victoria upon the occasion of her visit to the Exposition Universelle. (It is still in The Royal Collection.) This meant that Meissonier was unquestionably France's most eminent painter, and he became the first French artist to receive the Grand Cross of the Legion of Honor. Neither he nor the vast majority of his contemporaries found it absurd that he should pose for portraits in a long velvet robe with bejeweled belt (beard carefully arranged in artistic points) in the traditional aspect of such Renaissance masters as Titian.

Meissonier can still amaze as a technician; he is, as Zola called him, but not flatteringly, "the titular artist of Lilliput." And there is just a chance that he is not quite as bad as he looks. When he was not elected to the Academy in 1860

—the electee that year was the Raphaelesque pedant Signol, who three years later dominated the infamous jury that birthed, unintentionally, the Salon des Refusés—Delacroix noted in his journal that Meissonier was an "original artist" who had been brushed aside for a mediocrity. And Vincent van Gogh tremendously admired Meissonier. But Van Gogh's enthusiasms were frequently eccentric.

During the Franco-Prussian War, Meissonier was appointed a non-combatant colonel, and Manet, a staff officer of the National Guard, was under his command. Meissonier maintained a pretense of being unaware that this was the same Manet who had painted *Le Déjeuner sur l'Herbe* and *Olympia*. At the close of the war he was a leader in the persecution of Courbet, and said to members of the Salon jury, "He must be considered by us as one dead." He was a rancorous, mean-spirited, smug, and envious little man, which means that he must have spent an uncomfortable life in spite of his preposterous success.

Marie Rosalie (always called Rosa) Bonheur (1822-1899) was a child prodigy who, doubly exceptional on the scores of her youth and her sex, first exhibited in the Salon when she was nineteen and won a Medal First Class in 1848 when she was only twenty-six. Five years later she became world-famous with her huge *Horse Fair,* which, if it had been painted by a man, would probably have been popular but would hardly have been the Salon sensation that it was. Reproduced in engravings, it became known all over Europe and America. In 1887 it was sold for 268,500 francs, a staggering price for a painting by a living artist—still staggering, too, for any artist alive today if translated into current values.

In France at the time of this sale, Rosa Bonheur had passed the zenith of her renown (which came around 1860),

but the English love of pictures of domestic animals and America's rather laggard pursuit of culture sustained her reputation in those countries at a very high level. *The Horse Fair,* now in the Metropolitan Museum, was known to every American school child well into the twentieth century and has only recently disappeared from the kind of popular compendium that carries a title like "Great Masterpieces the Whole World Loves."

We frequently regard it as an accolade to say of a woman painter that she paints like a man, and this can be said of Rosa Bonheur, who was a vigorous if somewhat coarse-grained realist. She also behaved as much like a man as she could. An admirer of George Sand, she followed that ambiguously sexed author's example and disported herself in men's clothing upon occasion. To her credit, she was sufficiently high-spirited and broad-minded to make a try at impressionism in her later years, but it did not work. She was better at straightforward animal painting even though, as has been pointed out, she tended to confuse art with taxidermy.

Jean Léon Gérôme (1824-1904) at the age of seventy distinguished himself with a remark that has given him a clown's spot in every history of impressionist painting. He fumed that "only a great moral slackening" could induce the French government to accept the "filth" offered it in the legacy of the Caillebotte collection—the filth consisting of some of the finest paintings by impressionist masters. That anyone could still say this in Paris as late as the mid-1890's seems incredible, yet Gérôme's little fulmination was a summary of the persistent attitude of the Academy. The government accepted only a part of the bequest—some fine Cézannes were among the rejected pictures—but those that were ac-

cepted are now at the heart of the Louvre's impressionist collection.

Gérôme, if not exactly admirable, is almost awesome in the consistency of his blind devotion to his misconception of the Davidian classical ideal. He was as slick a technician as ever lived, and his first Salon success, made in 1847 at the age of twenty-three, *The Cock Fight,* showing a sweetly draped Greek maiden and an even more sweetly naked male youth, is a saccharine echo of the tradition in its candybox manifestation. Gérôme inherited the tradition, in its final diluted stage, from his teachers Delaroche and Gleyre. In the Salon of 1855 he gathered a medal and the ribbon of the Legion of Honor, the first of continuous recognitions. He was a ubiquitous member of Salon juries during his long life, a popular teacher at the Ecole des Beaux-Arts, and fantastically a public favorite. *The Cock Fight* is in the Louvre.

Because he was a perfect craftsman, Gérôme's pictures today are as fresh and glossy as when they left the easel. In meticulous detail, he turned classical and Oriental subject matter into realistically depicted anecdotes. Being a man of no imagination whatsoever, he could perceive no virtues in any but his chosen style. Redon, who was briefly his pupil, left a record of his tyranny in the studio. Yet Eakins, Maillol, and Vuillard were also among the pupils who chose to study with him.

Alexandre Cabanel (1824-1889) is remembered first for his *Birth of Venus,* since Napoleon III purchased it from the Salon of 1863, the year of Manet's scandalous reception in the Salon des Refusés with *Le Déjeuner sur l'Herbe.* The Emperor thus provided a classic demonstration of the combination of salaciousness and prudery typical of the Salon public. Cabanel's goddess is an alluring cocotte who, rather than

being washed ashore according to the legend, is couched upon a stage-prop wave, twisting and sighing as if yearning for a lover while casting an evaluating eye at the observer as a prospect.

With Bougereau, Meissonier, and Gérôme, Cabanel typifies the Salon artist to perfection, and he was one of the most honored of all. He received his first Legion of Honor ribbon in 1855. In 1863 the *Venus* brought him a promotion in the Legion, election to the Academy, and a professorship in the Ecole des Beaux-Arts. Two years later he won the Grand Medal of Honor, and two years after that he won it again.

While the Academicians take on the look of nitwits or villains from our distance (their actual sin was mediocrity), and while the impressionists naturally resented them, it should be remembered that for the vast majority of painters they were heroes. During the period when painters elected members of the Salon jury, Cabanel, Gérôme, and Bougereau always received thumping votes while Corot and Daubigny, the liberals, lagged behind or failed of election. The doubters were very few. Two doubters' comments on Cabanel may be quoted, one hilarious, one poignant. "If Raphael were to see a Cabanel he would say, 'Oh, dear! That's my fault!' " said Degas. But Manet, on his deathbed, said bitterly, "That man has good health."

Adolphe William Bouguereau (1825-1905), among all the Academicians, is most refreshing for his comment, made when he was seventy-four, that the only reason he didn't like the "mystics, the impressionists, the pointillists, etc." was that he didn't see the way they saw. He neither regarded them as villains nor behaved toward them in a villainous fashion. He sat content and unassailable atop the mound of money bags and laurels collected as awards of public popularity and

official esteem. Saying more than he knew he was saying, he made an interesting comment as a teacher in the Ecole des Beaux-Arts, a position he held for twenty-five years, when he objected to curriculum reforms proposed in 1885. "I fear the mental fatigue that this innovation will cause," he said.

No mental fatigue on his part or on the part of the observer could possibly be occasioned by anything Bouguereau ever painted. He spoke always of his truth to nature, by which he meant photographic exactitude retouched by a perfumed wash of the Academy's diluted Raphaelesque ideal. His skill at smoothing out and slicking up served him well whether he was painting Madonnas, pretty peasant children, or bacchantes pursued by satyrs. His paintings are unapproachable in their harmony of a routine mind applying, to perfection, a routine technical process. Bouguereau is the ideal official painter, and this was recognized while he was alive. He won the Prix de Rome, naturally, at twenty-five, his first Salon medal at thirty, and then acquired all the other honors during his full fifty years as a Salon exhibitor.

Carolus-Duran was the professional name adopted by Charles Auguste Emile Durand (1837-1917). The fancying up of the rather prosaic "Charles" and "Durand," abetted by hyphenation, supplied him with a name more resounding in the social circles that he served as the leading international portrait painter of the day. Born to an undistinguished family in the undistinguished city of Lille, he was the possessor of a strong and potentially original talent. He sold out to fashionable reputation and money, gained both at spectacular levels, and never regretted his choice for a moment during a lifetime that fell just short of eighty years.

After a career as a child prodigy in Lille he studied in Paris. He made his Salon debut when he was twenty-four, in

1861, and the painting that impressed him most that year was by another debutant, Edouard Manet—*The Spanish Guitar Player* (Metropolitan Museum). Carolus-Duran made his own Salon sensation four years later with a dramatic bit of Courbet-esque realism, *The Assassin* (Lille, Musée des Beaux-Arts). But after 1870—during the war of that year he served in the same outfit as Manet—he settled down to the job of making a social and financial success. He affected suède boots, velvet jackets, and a long, black cape lined with scarlet satin. This hidalgo outfit was supposed to tie him to Velázquez, whom he frequently referred to in terms of companionship. He had a supreme, unquestioning faith that along with Velázquez and others he was a genius for the ages. He was a braggart and an egomaniac and a thoroughly dependable portraitist.

"I don't know whether I like him or dislike him," Berthe Morisot's mother wrote her, after meeting him at a dinner party. In most people's minds there was no question: they liked him. Young ladies were reduced to the point of swooning in his presence, but they could not compete with his handsome wife.

Carolus-Duran did an etched portrait of Manet—not very good—and Manet tried a portrait of him, which did not work at all. Manet admitted to his friends that he envied Carolus-Duran his assurance, his money, his acclaim, and his honors. These last were too many to attempt to list, but they included the highest ribbon of the Legion of Honor and the directorship of the Academy in Rome, this in 1905 when he was sixty-eight and ready to slacken the pace.

The Louvre has numbers of Carolus-Duran's portraits. The best is *The Lady with the Glove*, where a distant cousinship with Velázquez is legitimately established. His portrait of Mrs. William Astor in the Metropolitan Museum is an accurate indication of his type of portrait and type of client.

His favorite student was an American—John Singer Sargent, whose career as a roaring international success echoed his master's.

Ignace Henri Jean Théodore Fantin-Latour (to get his full name out of the way immediately) was a quiet presence among the impressionists during their very early years, their respectful and respected friend although never a participant in their theorizing or their struggles. At the Café Guerbois he used to sit on the sidelines not saying much, and he is usually accorded a sideline position in impressionism's history. He was never revolutionary, never experimental, and never adventurous, unless his willingness to be identified as a companion of the rebels was a form of daring. What he was, was a first-rate Salon realist, with all the virtues and none of the shortcomings of Salon art.

If Fantin has any impressionist connection technically, it is one that goes as far back as Velázquez: in his portraits, a slight atmospheric haze, which softens details, including wrinkles, is painted between the subject and the observer. His sober, perfectly controlled brush reflected the visual world with great fidelity, and in his flower pieces this fidelity included an extraordinary re-creation of the grain, the texture, the body as well as the surface, of a leaf or a petal that makes him probably the finest of all flower painters. In a contradictorily romantic and somewhat fuzzy manner Fantin also did allegorical subjects, often on musical themes (he was a great Wagnerite). But on the strength of these alone, even though they were his most ambitious conceptions, he would have to be remembered as a very minor figure indeed.

Moved by Delacroix's death in 1863, Fantin painted a group portrait of artists and writers, including himself, Manet, and his friend Whistler, in two groups flanking Dela-

croix's portrait, a picture-within-a-picture, on the wall behind them. This *Homage to Delacroix,* now in the Louvre, was a success in the Salon of 1864 in spite of its inclusion of Manet and Whistler, who had been the most scandalous figures in the Salon des Refusés the preceding year. In 1870, Fantin repeated the idea with a group of painters and friends surrounding Manet, shown at work at his easel. The painting, which has also wound up where it belongs, in the Louvre, was accepted for the Salon of 1870, but *A Studio in the Batignolles Quarter* was chosen as a more tactful title than *Homage to Manet,* since so many young rebels were represented. Renoir, Bazille, Monet, and Zola were there as well as the sympathetic critic Zacharie Astruc, the musician Edmond Maître, and a good friend of Fantin's named Otto Scholderer, who on this single occasion achieved identification with the great. Scholderer (1834-1902), a German, worked mostly in London, where Fantin had met him, but made occasional stays in Paris. He was a painter of still life, landscape, and figures, frequently of considerable charm, in the romantic tradition with a bit of impressionistic leavening.

Fantin was born in Grenoble in 1836. When he was five, the family moved to Paris. His mother, Hélène de Naïdenoff, was, rather impressively, the adopted daughter of Countess Zoloff, born Princess Kourakine. One of his two sisters, Nathalie, was committed as a young woman to the madhouse at Charenton. The other, Marie, to whom he was deeply attached, married an officer in the Russian army after waiting for eight years while he attained the adequate rank of colonel. Her departure caused Fantin much distress.

His father, from Metz, was a portrait painter and gave the boy his first lessons. At fourteen, Fantin was studying with Lecoq de Boisbaudran, a teacher who is remembered for having initiated the practice of drawing not from the posed model but from memory or during sessions when the

model moved freely about the studio. This was as close as Fantin ever came to experimenting. At seventeen he entered the Ecole des Beaux-Arts as a probationary student. His precocious mimetic skill, which he had demonstrated from the age of ten, failed to gain him full admission, and now he turned that skill to making copies in the Louvre. He continued to make copies as a source of income until his flower paintings began to sell as fast as he could produce them. Portrait commissions added to his income. He was not entirely pleased with the success of his flower paintings, but they stand now as his most important work.

In the Louvre he met the impressionists, including Whistler, a fringe member like himself, and in 1859 he visited England at Whistler's invitation, finding there his first important patrons. He also met, in the Louvre, a girl named Charlotte Dubourg, whom he later married.

After some preliminary rejections, Fantin was regularly accepted in the Salon. Increasingly a recluse in his later years, he was not a misanthrope: he was simply very happy staying at home with his wife, content to paint, rather repetitiously, in the manner that pleased him most and, by happy conjunction, pleased the customers too. He occupied the same studio in the Rue des Beaux-Arts from 1868 when he was thirty-two until his death in 1904 at the age of sixty-eight. As innovations followed one another and his own style remained static, he seemed more and more conservative. (Degas called him an old maid, and Berthe Morisot thought that his copying in the Louvre had ruined him: he regarded the old masters not as sources for growth, as teachers should be, but as inviolable models.)

Fantin's divorce from the impressionists began not long after 1870, the year of *A Studio in the Batignolles Quarter*. He refused to participate in the first impressionist exhibition of 1874 (where, indeed, he might have looked rather out of

place). Although Manet had also refused to exhibit, Fantin began to accuse him of deteriorating in the company of noisy "dilettantes" who were more interested in stirring up excitement than in painting well. The two men became reconciled, in a way, when Fantin served as a pallbearer at Manet's funeral.

Fantin wears very well today. One may feel uncomfortable in the presence of his rather cottony allegories, but his flowers are as beautiful as ever. Flowers have not changed, and he painted them to perfection. His tact, his sobriety, and his dependable craftsmanship are sources of unalloyed, if limited, pleasure.

James Abbott McNeill Whistler (he added the "Mc-Neill," his mother's maiden name, when he was seventeen) is called an American artist—by Americans—and, indeed, was born in Lowell, Massachusetts, one week after the Fourth of July, 1834. In the picture generally known as *Whistler's Mother*, which he entitled *Arrangement in Gray and Black, No. 1* in an unsuccessful effort to avoid sentimental response from the public, he produced surely the painting most admired by the widest audience of Americans over the longest period of time. But by his chosen habitat and by his position in the history of painting, Whistler was not an American. He was an English artist with French affiliations who spent very little time, and none of his adult creative life, in his natal country.

When Whistler was nine years old, his mother took him and his younger brother to Russia, where their father, a civil engineer, had been at work for a year on the St. Petersburg-Moscow railroad. After five years in St. Petersburg he was sent to school in England, but when his father died the following year, the widow and both boys returned to America. Whistler was fifteen.

After two years in Pomfret, Connecticut, he was admitted to West Point (where General Robert E. Lee was commandant). He was discharged three years later, having failed to make the grade in chemistry, a deficiency that supplied him with one of his most-quoted witticisms: "If silicon had been a gas, I would have been a general." But he had led his class in practical drawing, and was taken on by the U.S. Coast Geodetic Survey to etch maps and topographical plans. Here he lasted three months, resigning in 1855 after establishing something of a record for absenteeism.

At the Military Academy, Whistler had entertained himself and his classmates with his talent for caricature and had ornamented not only his own notebooks but those of his friends with marginal drawings, some humorous, some serious. He had always drawn; some extant textbooks from his boyhood are liberally ornamented. Now he went to Washington with the idea of setting up as a portrait painter. But after six months he terminated his American experience once and for all with the decision to go to Paris—it was still 1855 and he was twenty-one years old—to study painting in earnest.

He stayed in France from November, 1855, until May, 1859, studying at Gleyre's studio, traveling a bit, and learning a great deal. He did his first series of etchings, *The French Set*; was rejected from the Salon (in 1859) with a very good painting, *At the Piano* (Cincinnati, Ohio, Private Collection); met Courbet (who was enthusiastic about *At the Piano* when it was privately exhibited); and, among other contacts with artists, made a lifelong friend of Fantin-Latour. He also led a rather self-consciously bohemian life.

With a protective income of three hundred and fifty dollars a year, which in 1855 was not as picayune as it sounds now, he was not forced into the rat-hole existence of the poor artist, nor did he affect this kind of bohemianism. He did become just a bit of an actor, playing the part of a more bizarre personality than he was by nature. This special kind

of posing is always acknowledged to have been characteristic
of him for the rest of his life—no matter how sympathetically
he is regarded. By origin, by education, and even by predilec-
tion for the most part, he was an intellectual bourgeois gen-
tleman. But as an artist whose sensitivities went against the
grain of gentlemanly academicism, he was allied with the
rebels on principle, and he theatricalized his inherent but
minor eccentricities, exaggerating them as declarations of his
genuine aesthetic adventurousness.

When Whistler moved to London he was twenty-five,
and he remained a Londoner who commuted to Paris on
occasion and even lived there for short spells from time to
time until his death, in London, in 1903 just after his sixty-
ninth birthday.

Whistler represented a peculiarly English type, the
dandy-as-rebel in social-intellectual circles. He went about
much in society, but when we try to place him exactly, he
ends in a half-world of his own. Now in and now out of
favor at the Royal Academy exhibitions, he was an aesthetic
question mark in a city that did not offer painters very much
in the way of the convivial sharing of ideas that French
artists so enjoyed in their studios and favorite cafés. On his
visits to Paris, Whistler shared their world, but he never
shared it fully. He was a gentlemanly foreigner who chose
the more gentlemanly rebels as companions; he was a fre-
quent presence, but never a great force. It was appropriate
that Fantin-Latour, as his closest friend among French art-
ists, was more of a sympathetic sideliner than an active rebel.
The poet Mallarmé was also among his acquaintances, and
Whistler more than any other individual of the time (with
the possible exception of George Moore) accounted for such
liaison as there was between French artists and literary peo-
ple and such advanced talents as there were in London.

Portraits and caricatures of Whistler show a slender,

elegantly rakish man who looks more as if he had stepped out of a drawing-room comedy than like an artist who created a tender, dreamily sensitive world. As a public figure he performed in an equally contradictory way. Where scandals were visited upon the impressionists, to their distress, every time they exhibited in Paris, Whistler seemed to welcome and even to court notoriety in London. He might have acquired a taste for notoriety when his *White Girl* rivaled Manet's *Déjeuner sur l'Herbe* as the centerpiece of the scandalous Salon des Refusés in Paris in 1863. It was at about this time that he became an assiduous writer of letters to the press. And since he had a lively pen—witty, audacious, and waspish —he became, over the years, almost an informal columnist in the London newspapers.

The White Girl, which he later rechristened *Symphony in White No. 1* (in the National Gallery, Washington), had already been rejected for exhibition at the Royal Academy the year before he submitted it in Paris. But two others of his submissions had been accepted, and the rejection of *The White Girl* stirred no excitement. In the same year Whistler won a gold medal at The Hague for etchings exhibited there. He was never rejected to the extent that Manet and the other French impressionists were, and not long after he took up residence in London, he was finding loyal clients as well as backers who were sufficiently influential to insist upon the inclusion of *The Artist's Mother* in the Academy show of 1872, even though the picture refuted the conventions of the English portrait formula, thus puzzling and offending a jury that wanted to throw it out. Eleven years later (1883) he submitted the picture to the Paris Salon and won a Medal Third Class. In 1891 it was purchased for the Luxembourg, where it became the first painting by an American or, if you wish, one of the very few by Englishmen, to enter that astral institution and then the Louvre.

The Artist's Mother was the last picture Whistler submitted to the Royal Academy. He was finding profitable portrait commissions and had also entered the lists as a painter-decorator, developing and executing schemes for entire rooms dominated by his paintings. He was working hard, going about more than ever in society, and in general getting along extremely well as an unconventional success until his luck turned in the late 1870's.

In 1875 he exhibited *Falling Rocket, Nocturne in Black and Gold* (Detroit Institute of Arts), in which the bright embers floating down through a dark sky are represented by gobbets of paint. Like so many paintings that shocked people in the later nineteenth century with what seemed outrageous violations of conventional techniques, his *Falling Rocket*, which looks mild enough today, employed nothing more revolutionary than a variation of a technique that no one ever questioned in the old masters. Live coals had frequently been represented in the past by heavily loaded touches of vermilion and yellow. But when *Falling Rocket* was exhibited a second time in 1877 at the opening of the Grosvenor Gallery in London, John Ruskin wrote his famous comment, accusing Whistler of "flinging a pot of paint in the public's face."

Worse things than that had been said of *The White Girl* at the Salon des Refusés, but in 1863 Whistler had not yet made himself vulnerable by establishing a reputation as an impertinent fellow, and the comments had not come from the most powerful critic in England. From a lesser critic than Ruskin, the jibe might have afforded Whistler a welcome opportunity for another clever letter to the newspapers, but Ruskin was so respected that Whistler now found the sales of his pictures evaporating and his portrait commissions dropping off. In a fatal dramatic gesture, he entered a libel suit against Ruskin for his comments on the Grosvenor show.

In November, 1878, the case was tried—or, you could almost say, was performed in public as a kind of satirical skit. The curtain came down with a witticism on the part of the judge that Whistler might have envied if he had not been the butt of it: Whistler won the case, but was awarded damages of one farthing, as if his reputation, and his painting, were worth about that. This was humiliation enough, but there was a rider to the decision by which Whistler had to pay the costs of the suit. This expense, added to loss of income, reduced him to bankruptcy the next year. He had to forfeit his house, which had been a special pride. His personal treasures as a collector—china, etchings, and paintings—went up at auction. What pictures from his own hand he could not sell he put in supposed safekeeping here and there, and saw very few of them ever again. In the fall of 1879, less than a year after the trial, he left for Italy with virtually no assets other than a commission for twelve etchings of Venice. He was forty-five years old. When he returned to London he went into lodgings.

After the trial, Whistler had published an open letter in the form of a pamphlet called "Whistler v. Ruskin: Art and Art Critics," which became the first of a series recording his quarrels. In 1890 his pamphlets and letters, often rewritten to better suit his purposes, were finally published in book form under the title, "The Gentle Art of Making Enemies."

It was an art in which Whistler was experienced. He quarreled with his brother-in-law Seymour Haden so violently (knocking him through a plate-glass window, in fact) that thereafter he could see his sister Deborah only secretly. He quarreled, after fifteen years of friendship, with the painter Walter Sickert, who had left the Slade School when he was twenty-two (in 1882) to become Whistler's pupil and assistant. He once challenged George Moore to a duel. (No

response.) He quarreled with the other members of just about every artists' society he joined. He quarreled with patrons. Unwilling to admit that his wife was incurably ill with cancer, he broke with his brother William, a physician, who had told Whistler the truth.

Mrs. Whistler died in 1896, less than eight years after their marriage in 1888 when Whistler was fifty-four. She had been Beatrix Godwin, the widow of E. W. Godwin. Whistler's late entrance into matrimony had been preceded by two long liaisons. His first wife in effect had been a beautiful auburn-haired Irish girl named Joanna Heffernan, always called Jo, who became his model and mistress when he came to London after his youthful French sojourn. (In Paris, among other adventures as an aspiring bohemian, he had lived for a while with a dainty little trollop named Fumette who is remembered because in a fit of pique she once destroyed a batch of Whistler's drawings.) Jo appears time and again in the pictures done during the six years she and Whistler were together. During the couple's visit to France on one occasion she was painted by Courbet, who made the most of her glorious hair and fair skin. Around 1874, when Whistler was forty, Jo's place in his life was taken by Maud Franklin, who also began as his model. Although the relationship with Maud had cooled fourteen years later, she added to Whistler's trouble during the bad years by creating embarrassments after he married.

If Whistler was skillful at making enemies, he also had an attraction that could attach friends to him unshakably. The American etcher Joseph Pennell and his wife were assiduously attentive during the last years of Whistler's life, and later published a monumental and adulatory book that they described as his official biography, in spite of contentions by Whistler's executrix that it was not a book of the kind that Whistler had authorized.

Whistler found an enduring friend in Charles L. Freer of Detroit just when he needed a friend most. In 1894 Mrs. Whistler had begun to fail badly, and Whistler was involved in one of his most bothersome litigations—with a client, Sir William Eden. Freer, who had been collecting Whistlers for some time in America, called on the artist in Paris (where the Whistlers were ending a two-year period of residence) to pay homage. The call was the start of an undisturbed friendship that did a great deal to support Whistler, in two senses of the word, during his last years. The Freer collection, housed in its own gallery in Washington, D.C., is a major Whistler depository.

Whistler today is an artist who, as soon as you begin to pick at his shortcomings, rises above them, but who, as soon as you begin comparing him with the great men of his generation, is drastically enfeebled. He made his major contribution in etching, where he raised the process of wiping the plate from the level of a near-mechanical routine that could be performed by any technician to an inherent part of the creation of the print. By leaving a certain amount of ink on the plate to control the general tonality of the print, and to create gradations beyond those defined by the etched lines, he made the wiping of the plate a form of painting or drawing. Aside from this, he made of the etching a medium for brilliant suggestion, where it had previously been limited to precise definition.

As a painter, Whistler fused three major influences and in the process weakened them all without finding compensatory strengths within his own talent. He learned from Velázquez how to silhouette a figure against an anonymous background for a full-length portrait, and learned also that black could be a color. He employed an approximation of Velázquez's atmospheric veil, but the veil in Whistler's case too often half-concealed feeble draftsmanship. From Japa-

nese prints he learned how to spot shapes within a rectangular area (the *Mother* being a good example), and from Oriental ceramics he derived fluent ornamental motifs. Both of these sources, Velázquez and Oriental arts and crafts, he shared with the French impressionists, from whom or with whom he learned that the everyday world could yield material for the artist above the level of anecdotal genre painting.

But Whistler's position must remain a secondary one because, although he combined many excellences within a single art, he was excelled in each excellence by a contemporary. He had an eye for the psychological heart of the people he portrayed, but he never approached the depth and acuteness of Degas's perception. He understood toilette as part of the feminine mystique, but not with the flash, the brilliance or for that matter the masculinity of Manet. He understood that as a visual spectacle the urban world is a body of natural light and air surrounding man-made forms, but he approached the cityscape with the sentimental responses of any popular nineteenth-century landscapist. He was, on the whole, a rather conventional, even cautious, painter beneath his impertinent mask. One thing he never did was what Ruskin accused him of having done. He never threw a pot of paint in the public's face—a gesture that might just possibly have released a talent that just possibly was never consummated.

VICTORIAN ENGLAND

The current of the history of painting in nineteenth-century France is so strong that, once caught in it, you are offered no pause to see what is happening elsewhere—which is why the last several chapters in this book have been concerned almost exclusively with the mainstream of events in Paris and its environs. In a history of academic art this would not have been so, since the nineteenth-century Academies in whatever country were dedicated to a common set of values with only slight differences in accent to distinguish one national group from another. But the history of the century is not the history of the Academies but of revolts against them and of further revolts against preceding revolts, as we have seen while following the classical-romantic-realist-impressionist sequence in France.

Outside France there were only two independent national expressions of much importance—an American adven-

ture, much underrated, which will be the subject of another chapter in this book, and a revolt in England—the famous Pre-Raphaelite movement, with its curious blend of idealism and absurdity. One hardly knows whether to applaud the Pre-Raphaelites for their good intentions, to weep for them in their frustrations, or to admit that, everything considered, their story is frequently as comic as it is pathetic. The Pre-Raphaelites as we see them today are like actors in a tragedy who have met with an embarrassing accident on-stage, an accident altogether unavoidable but at once humiliating and hilarious.

Accounts of the Pre-Raphaelite movement and evaluations of the paintings it produced seem marked by a straining (especially on the part of English critics) to convince not only the reader but the writer himself that the Pre-Raphaelite pictures are better than they look. But not much can be done to alter the evidence of the pictures themselves, even when we remember that today we may be overconditioned by over-exposure to the great French painters of a century that, in England, seems to have exhausted itself with the creation of its giant, Turner.

The Pre-Raphaelites' birth dates occur in the late 1820's. These men were about ten years younger, as a group, than the Barbizon painters, and about ten years older than the impressionists. But since they painted their best pictures very early in the game, they can be thought of as belonging to a few years at mid-century even though, with a common faculty for longevity, they lived on and on and on to the edge of, and into, the 1900's.

John Ruskin was the first inspiration, the mentor, and the defender of the Pre-Raphaelites. It may help the reader to keep chronology straight if he remembers that Ruskin has already appeared in this book—first as a very young man whose "Modern Painters" was begun as a defense of the aging

Turner, and then as a decaying man who in late middle
age attacked Whistler's impressionistic painting. The Pre-
Raphaelites occupied him in between. The following biog-
raphies include some of the eminent Victorian painters along
with the Pre-Raphaelites. There is much less difference be-
tween the rebellious Pre-Raphaelites and the Victorians they
rebelled against than is generally (and habitually) thought.

From the womb to the grave, a passage that took him
sixty-seven years, John Everett Millais was one of the most
fortunate beings in England. His birth, however, was not
attended by the congress of gods who had cooperated in 1577
to endow Rubens with all good things—genius among them.
By 1829, when Millais was born, the gods, who had never felt
really at home in England anyway, were reduced to a group
of senile figureheads who continued to lend their threadbare
cachet to allegorical paintings but had few gifts at their dis-
posal. Genius in the nineteenth century was finding non-
Olympian release. (Charles Darwin, for instance, was twenty
years old at the time of Millais's birth.)

A painter of real genius, one feels, would have been an
embarrassment to Victorian England, an aberration bred
within a respectable family. Of godlike attributes, Millais
had only the respectable and understandable ones: he was
tall, beautifully formed, with a golden, handsome head. He
was intelligent, and, better yet, he was charming. He was so
prodigiously talented that he could be thought of as a genius
by people who, if he had been a genius, would have rejected
him as a freak. And to any hint that Millais was, after all,
nothing more than a society painter, a suave conformist so
skilled, so well mannered, well tailored, and famous that he
could charge two thousand good, solid Victorian pounds for
a prettified portrait, there was always the rebuttal that he

had begun his career, after all, as a rebel who upset his patrons in the Royal Academy with a picture called *The Carpenter's Shop* where the Virgin Mary was pictured unprettily enough to stir Mr. Dickens to passion. Dickens fumed in a review for the magazine Household Words that young Millais had painted the Virgin as a creature who "would stand out from the rest of the company as a monster in the vilest cabaret in France, in the lowest gin shop in England."

Millais was barely twenty-one years old at that time, but he had put fifteen years' experience as an artist behind him, if we begin with the likenesses, said to be accurate, that he drew of friends of the family when he was six. He was born in Southampton to prosperous middle-class parents who, certain from the first that he was a genius, groomed him for fame. By all reports they created around him an atmosphere of adoration and sticky sentiment that should have turned him into a psychotic. Because his mother had convinced herself that he was delicate, he was given his earliest schooling at home, mostly under her tutelage. She was assiduous in showing portfolios of his work to established artists, and he was admitted to the classes of the Academy at the age of ten —a concession unheard of before or since.

At the Academy also he was acclaimed as extraordinary, and became a pet. When in 1843 he won the gold medal offered for the best drawings from the antique, a sixteen-year-old named William Holman Hunt, who was studying at the British Museum, came to the ceremony to catch a glimpse of the prodigy everyone was talking about. The next year, as an Academy student himself, Hunt met Millais. As teenagers and best friends they held long, serious talks about art, what it was in England and what it should be, and a little later they admitted to these intimacies a third student, the exotic Dante Gabriel Rossetti. In 1848, ready to begin their careers, even though hardly more than adolescents (Millais

was nineteen, Hunt twenty-one, Rossetti twenty), they formed that odd, half-childish, partly prankish and deadly serious secret society called the Pre-Raphaelite Brotherhood. Not long a secret, never firmly a society, and Pre-Raphaelite only if we allow for the members' misconceptions of medieval history and fourteenth-century life and art, the Brotherhood dissolved after a few years without having coalesced. Yet its influence spread like a drop of powerful dye whose tint is still discernible in British painting of a hundred years later.

As everybody knows, no secret society is properly formed unless its membership is composed of the mystical number seven. The three founders were joined by four friends, who are usually forgotten by all but the most determined readers of footnotes:

James Collinson (1825?-1881), an ambiguous figure, won his way into Rossetti's heart as a patient auditor of his exuberant talk during long walks, but he had a tendency to go to sleep at meetings of the Brotherhood. Not long after its founding, he abandoned it, and intended to abandon the world in general, becoming a Catholic convert and making a tentative exploration of the monastic life at a Jesuit college. He found that the disciplinary chores outweighed potential spiritual reward, came back to the world, proposed marriage to Christina Rossetti, Dante Gabriel's sister, was refused, married the daughter of an Academician, and gradually faded from sight, having painted very little.

Thomas Woolner (1825-1892) was a sculptor who met Rossetti through a neighbor. Bitter about the state of sculpture in England—he was very ambitious and was having trouble making a living—he emigrated to Australia in 1852 with the intention of picking up a fortune in the gold fields. Ford Madox Brown's *The Last of England,* showing a couple moodily posed at the ship's rail as the wind whips them, was inspired by this departure, although Brown and his wife are

the couple represented. Australia was a disappointment to Woolner. After two years he returned to England, and now, at home, he found gold. He became a member of the Tennysonian circle, and by the time he entered his forties was nearly as great a success as Millais. His portrait medallions were extremely popular, and he became so adept, even unscrupulous, at the game of annihilating his competitors that he was awarded quantities of public and memorial sculptural projects. He also turned his hand to poetry now and then.

William Michael Rossetti (1829-1919), a year younger than his brother Dante Gabriel, held a job with the Inland Revenue Department and was not a painter but, rather puzzled, consented to join the Brotherhood on the basis of his interest in letters. He became an art critic but bent his major efforts toward protecting his eccentric brother. Dying at ninety, he outlived Dante Gabriel by thirty-seven years, during which he edited his brother's letters and other manuscripts and became a historian of the movement.

Frederic George Stephens (1828-1907) toyed with the idea of becoming a painter but, instead, became a successful, if not vividly remembered, art critic.

Millais was often an uneasy bystander while Hunt and Rossetti discussed the principles to which the Brotherhood would be dedicated. The idea of attacking the Academy made him uncomfortable, for social as well as professional reasons. But the Academy's Raphaelesque formula was the core of the young men's dissatisfactions—as the name "Pre-Raphaelite," settled on half by chance, indicated. Like the Nazarenes of Germany, although they perceived that these men were dry and sterile, the Pre-Raphaelites felt that the vigor, the truth, and the inspirational faith of earlier centuries had been sacrificed to less admirable ideals in the High Renaissance, and that even the Raphaelesque ideal had foundered during the eighteenth century.

To correct this situation, "truth to nature," a phrase dear to Ruskin (whom they had not yet met), was adopted as a basic principle. But "truth to nature" is a phrase permitting multiple definitions. Constable had been wondrously true to nature in his recording of skies and light; the impressionists were to become his heirs in this form of truth. But for the Pre-Raphaelites, truth to nature meant the meticulous observation and meticulous re-creation of every detail, down, literally, to the last blade of grass in a field.

Also, the brown shadows of the Academy must give way to pure, brilliant color everywhere. All subject matter must be serious—no more nymphs and satyrs. Serious subject matter meant uplifting subject matter, and this meant religious, historical, legendary, and mystical subjects with complicated symbolism worked out according to a new iconography. It is no wonder that the Pre-Raphaelite credo was never conclusively defined. It was a mixture of everything—realism, in its insistence upon acutely accurate representation; romanticism, in its yearning toward mystical values; revolt, in its rejection of the Academic scene, but also retrogression, in its abandonment of that scene for a return to what the Brothers believed to be medieval standards. If there had been any chance of this mixture's working, that chance was killed by the movement's basic infirmity: it was, of course, a literary movement in disguise, a disguise that its founders donned without recognizing it as a disguise. They thought of painting not as painters, but as literary men involved in a job of illustration. There is hardly a Pre-Raphaelite painting that, if not actually the illustration of a poem or story, could not be improved by translation into verbal terms by a good poet or storyteller.

When the Brothers exhibited their first pictures (adding the initials P.R.B. to their signatures, just as the Academicians added R.A. to theirs), they were not too badly

received. Apparently no one tried very hard to discover what the initials P.R.B. meant, and the general attitude of the conservatives was one of amused interest in the efforts of some bright youngsters who were having their fling. But the second year, 1850, there was a scandal, with Millais's *Christ in the House of His Parents*, usually called *The Carpenter's Shop* (Tate Gallery) as the center of the uproar. It was at this time that Dickens made his unperceptive comment about low women in cabarets and gin shops.

The picture shows the boy Jesus being comforted by his mother. He has just run a nail into his palm. His father examines the wound with a matter-of-fact air, and another boy approaches carrying a bowl of water to bathe it. An older, grandmotherish woman (St. Anne) and a young man stop work for a moment—they are helping the father with a job of carpentry—in normal concern. But the mother is set apart by her expression of mystical anguish and the very odd tilt of her head (Dickens was rude about the drawing of the "dislocated throat"). She senses that the nail in the palm is a prophecy of the Crucifixion. Every bit of the shop, a crude place, is microscopically detailed, down to the wood shavings on the floor (which became famous) and the tools, as archaeologically exact as Millais could make them, that hang on the wall. The figures are drawn with a photographic verisimilitude that should have pleased the most demanding pedant, and the picture for all its relative severity of style is in the tradition of sentimental storytelling that the public loved. But several things combined to ignite general wrath.

In the first place, Rossetti, always the undependable member of the group, let out that P.R.B. stood for Pre-Raphaelite Brotherhood, and this little discovery was printed in a gossip column. The unthinkable had happened: Raphael's godhead had been questioned. With this sacrilege as an incitement, it was decided that *The Carpenter's Shop* was

blasphemous in showing holy figures as common people. Actually, the family, decked out in freshly minted costumes, is very well scrubbed, and quite obviously genteel: members of Millais's family acted the major parts as models without stepping out of their own characters.

Rossetti and Hunt also came under attack. The Brotherhood, having set itself up as a secret society, was suspected of undercover Romanist affiliations. And as if Popery were not enough, weren't these impertinent youngsters guilty also of social radicalism? The representation of Christ's family as common people was taken as a confession of alliance between the aesthetic rebels and Chartism, the workingman's reform movement, which, with strikes and other unpleasantnesses, had come to a head the very year the Brotherhood was formed. But all this nonsense was put to rights when Ruskin appeared, a veritable St. George. When the attacks flared again with the exhibition of the following year, the *Times* of May 30, 1851, carried a long letter from him. Ruskin began it by admitting that when he had first seen *The Carpenter's Shop* the year before, he had been largely in accord with its critics, but concluded it, after lengthy exposition of his reasons for changing his mind, by prophesying that if the Pre-Raphaelites could temper the "courage and energy" that they had already shown with the "patience and discretion" of experience, they might "lay in our England the foundations of a school of art nobler than the world has seen for three hundred years"—that is, since Michelangelo, Raphael, and Titian.

Ruskin, at thirty-two, ten years senior to Millais, was the most respected critic in England. He had turned out to be right when he committed himself to the defense of Turner, and furthermore he was a gentleman with money. Under his sponsorship, the Pre-Raphaelites eventually reversed general opinion as they had his and came into a position that must

be unique in the history of painting: they were considered avant-garde at a time when the avant-garde was shunned by the mass public, and at the same time were accepted by the prosperous middle class where Philistines bred most prolifically. The explanation is easy: whatever their virtues, their avant-gardism was nominal, only seeming innovational surrounded as it was by stagnation. They were accepted because they satisfied on a more ambitious plane the same taste for sentimental storytelling that was served by the more obvious painters of Victorian anecdote.

The seven members of the Brotherhood were not, to a man, equally keen on Ruskin as a critic, but nothing reconciles an artist to a critic as quickly as a favorable notice, no matter what other opinions the critic may hold. Hunt and Millais had been saved (Rossetti had not exhibited that year) and they sent Ruskin a note of thanks—two rescued Andromedas to his gallant Perseus. As a result, Ruskin and his wife Euphemia paid a call on Millais, and as a result of that, after several intermediary steps, Euphemia married Millais, having annulled her marriage to Ruskin on the grounds, uncontested, of impotence.

The surprising thing about the whole affair was the gracefulness of it. There were no hysterics, no accusatory tirades, and although Ruskin stopped seeing Millais—shifting his attention to Rossetti—social decorum would have demanded this cessation even if cooled friendship had not. Ruskin, always a difficult man to figure out, seems to have tried to retain an objective attitude toward Millais the artist, although he also seems too generous to some of his paintings, and bludgeons others—these, however, being of a kind that invited bludgeoning.

Ruskin's marriage to Euphemia had been arranged by his parents, and his impotence was a matter of indifference to (or distaste for) the sexual allure of mature women, and

not a matter of simple physical malfunction. The romance between Euphemia and Millais bloomed in 1853 during a five-week sojourn in Scotland when Ruskin, Euphemia, a friend of Ruskin's from Oxford (Dr. Henry Wentworth Acland), and Millais and Millais's brother William were housebound by a long rainy spell. Millais was at work on a portrait of Ruskin (which Ruskin, after the annulment, urged him to finish for the sake of art). Everyone behaved with the strictest propriety during the interim when the annulment was in process. Millais and Euphemia were married in 1855, and for forty-one years their lives were unmarred by the slightest public blemish or, apparently, the tiniest private one. Like her new husband, Euphemia was beautiful, although not as beautiful as he, and ambitious and intelligent. They made a fine couple. A Scot, she was an efficient business manager. She ran his affairs, both household and professional, with a canny hand.

During the development and consummation of the romance—by 1854—the Pre-Raphaelites as an organized Brotherhood, insofar as they had ever been organized, had separated. For one thing, Rossetti had been frightened by the original scandal and, as his sister Christina put it in a humorous elegiac verse for the P.R.B., "shuns the vulgar optic." For another, Woolner had emigrated to Australia, and Hunt was getting ready to set off for the Holy Land. But the most potent reason was that in 1853 the Royal Academy had elected Millais an associate. Instead of initialing his paintings P.R.B., ". . . the champion Great Millais/Winds up his signature with A.R.A.," lamented Christina.

The election had been more than a paternal gesture toward a prodigal son. To seduce from its cloister the Brotherhood's star member was a political coup. Millais was happy —he had come home—and during the first years of his combined life as a married man and Academician he produced

several of his best pictures, including the poignant *Blind Girl* (Birmingham, City Museum and Art Gallery). Unseeing, does she sense the beauty of the vivid landscape around her and the glowing rainbow that arcs across the sky? The potentially—almost inevitably—mawkish subject is treated with enough restraint to save it, but if compared with Degas's portrait of his blind cousin, Estelle Musson, it shows what was wrong with Pre-Raphaelitism.

Although Millais was painting well, he and Euphemia had begun a family, and, not content to live poorly, they were pressed for money. In 1859 Millais had a failure in the Academy exhibition, *Sir Isumbras at the Ford,* a picture he had labored over. Ruskin called it "not a fiasco but a catastrophe," making that opinion unanimous. The conjunction of the frustration of sincere effort and an empty purse was decisive for Millais. Quite deliberately, as he told Hunt, he now set about the job of pleasing a public that "won't be taught" to understand serious art. He would give this public something it was bound to like. "A physician sugars the pill, and I must do the same."

The trial flight turned out to be all sugar and no pill, and was a huge success. The picture showed a soldier taking leave of his sweetheart while a pet dog, Landseer-like (Millais had made friends with Landseer), shares the emotional moment to the full. Millais's reconciliation with Dickens was cemented by his choice of Kate Dickens, his daughter, as model for the girl. Nobody could find a taint of the cabaret or the gin shop here. Kate was all sweetness and purity, her soldier sweetheart all manly virtue and patriotic idealism. *The Black Brunswicker* (London, Tate Gallery) was the star of the 1860 Academy exhibition and was purchased by a dealer for a thousand guineas.

From that time on, Millais's life was a succession of social and professional triumphs. He and Euphemia were

Victorian England

courted by everybody, went everywhere, and lived on a pala-
tial scale. Millais's income reached a figure that would be at
least a quarter of a million dollars a year, probably more, in
today's values. He became a great huntsman and a great club-
man, working hard in his studio all the time—his energy was
inexhaustible and he never lost his looks. He was so univer-
sally admired that he could address Cardinal Newman as
"you dear old boy."* He was made a baronet in 1885. In 1896
he was elected president of the Royal Academy and then, in
August of that year, having rounded off the career that had
begun with his admission to the Academy's halls as a golden
tot, he died.

Millais is always pointed out as the very type of artist
who sacrifices integrity for success. There is a story that a
friend (Lady Constance Leslie), entering a retrospective ex-
hibition of his works in 1886, met Millais on the stairs, leav-
ing, and in tears. He was unmanned, he told her, or is said
to have told her, because he was "overcome with chagrin that
I so far failed in my maturity to fulfill the forecast of my
youth." If the story is true, it is sad. Yet it has almost too
much the air of a Victorian moral lesson; there is something
too pat about it, too obvious, like the little moral narratives
told in Victorian painting. It is also unique in reflecting
Millais as a repentant sinner. All other reports—and records
—show him ebullient, loving success, always golden, a happy
man content with the bargain he had made. As for "the fore-

* In his book "The Pre-Raphaelite Dream," William Gaunt lists as
among those who "paid conclusive homage" to Millais the politicians and
men of action Gladstone, Lord Salisbury, Lord Rosebery, Sir William Har-
court, Viscount Wolseley; the scientists Sir Henry Thompson, Sir James
Paget, and Sir Richard Owen; the writers Meredith, W. S. Gilbert, A. W.
Pinero, Mark Twain, Bret Harte, Henry James, Matthew Arnold, and Robert
Browning; and among actors and musicians, Sir Henry Irving, the Bancrofts,
the Forbes-Robertsons, Lily Langtry, the violinist Joachim, Sir Arthur Sul-
livan, and Mme Albani. He also tells that reproductions of Millais's paintings
were found in places as far afield as the house of a Samoan chief and the
shelter of a Hottentot shepherd in the Great Karoo.

cast of my youth" that he is supposed to have betrayed, that forecast carried no guarantee. Hunt stuck to his guns and painted worse and worse pictures. It is quite possible that Millais chose the course that was best for him not only as a careerist but as a creative artist. Whether his late successes are better or worse than his early Pre-Raphaelite paintings, they are the best of their kind. No matter how he offended with such trumpery as *The Black Brunswicker* from time to time, Millais also produced pictures like the Tate Gallery's *North-West Passage* (where a young woman reads to an old seaman who is lost in recollection) that rise with a certain solidity, even dignity, above the gooey narrative standards that they serve.

Let us cover as briefly as possible the early years of William Holman Hunt, in order to bring him quickly to the age of twenty-seven, when, seated at his easel under an umbrella in the blazing sun at the edge of the Dead Sea, in the presence of a dying goat and a puzzled Arab, he came as close as he was destined to come to the realization of his curious powers.

He was born in 1827, the son of a warehouse manager. The family was of Puritan stock, and Hunt all his life was increasingly a Puritan in the sense of extreme moral and religious strictness. For him religion, personal conduct, and aesthetic theory could not be separated one from another.

The family had little money, and at thirteen Hunt was helping support himself. By sixteen he was studying at the British Museum and the National Gallery, having failed of entrance to the classes of the Academy school. The next year, however, he was admitted, and there he made the acquaintance of his idol, the boy prodigy Millais (fifteen years old), who was to disappoint him in manhood, and, later, of Dante

Gabriel Rossetti, who puzzled and attracted him from the beginning, but whose loose life appalled him later on.

In 1848, when the three oddly matched youths—Millais the model of middle-class elegance, Rossetti the exotic, erratic sensualist, and Hunt, the plodding evangelist—formed the Pre-Raphaelite Brotherhood, Hunt was the one who tempered Rossetti's flighty ideas and shored up Millais's indecision, giving the group whatever form and program it had. He always thought of himself as the only true Pre-Raphaelite, and by his own severe standard he was.

When scandal broke over the Pre-Raphaelites in the Academy exhibition of 1850—his picture that year was *Christians Escaping from the Persecuting Druids* (Oxford, Ashmolean Museum)—Hunt thought of forsaking painting and taking up farming, even though the scandal had centered on Millais's *The Carpenter's Shop*. But farming offered opportunities for only the quietest kind of evangelism—argument for virtue by inconspicuous example—and Hunt was by temperament a preacher. He stuck to painting as a form of preaching, although certainly he did not put it to himself in just that way. His easel became his pulpit, and it must always be remembered that he was totally convinced, totally sincere, in his proselytizing of Christianity-cum-aesthetics.

When Ruskin came to the rescue of the besieged Pre-Raphaelites, Hunt shared the good fortune. He began talking to Millais at this time about a picture that he had in mind, a painting of Christ that he would call *The Light of the World*, based on the text in Revelation, "Behold, I stand at the door and knock." While this picture was gestating, he produced *The Hireling Shepherd* (Manchester, City Art Gallery), a symbolical charade of love, life, vanity, mortality, and resurrection but enjoyable at a lower level as an exquisitely detailed painting of two handsome young people embracing in the countryside. Thomas Carlyle called it the greatest picture

ever painted by an Englishman, thus leaving untarnished his record as his century's most fallible art critic. *The Hireling Shepherd* was in the exhibition of 1852. Hunt was twenty-five years old.

The next year the Pre-Raphaelite Brotherhood was dissolving. Hunt's picture that year was *The Awakening Conscience* (London, Collection Sir Colin Anderson). It shows a kept woman suddenly rising in horror from the side of her lover (the scene is an elaborately furnished living room and everyone is fully clothed) as she suddenly realizes to what depths of sin she has sunk. Hunt designed the frame, which, a testimony to his constant attention to symbolism, is a pattern of marigolds, symbolical of sorrow, and ringing bells, symbolical of sorrow and warning—also, of course, of joy, but not here.

In 1854 he exhibited *The Light of the World* (this original version is now at Keble College, Oxford) in which Christ, with a lantern, knocks at the door of a cottage that, half choked by weeds, has surely been dank and dark. Ruskin expounded the meaning of the picture; it was tremendously popular, and in replica toured America where crowds thronged to see it. It was considered half miraculous in itself, with its effect of lamplight (laboriously worked out by Hunt in a specially constructed closet) and its elaborate detail, with leaves described vein by vein. *The Light of the World* is still a sentimental favorite in some quarters and has become such a cliché that it is difficult to think of it as a picture original in its conception. But it was. Its representation of the Savior in straightforward definition as part of a realistic setting, instead of as a mystical figure in a celestial drama, has been called the Protestant Christ.

In his obsessive study of naturalistic detail (the exact renderings of minutiae in *The Hireling Shepherd* and *The Light of the World* are agonizing), Hunt was applying the

Pre-Raphaelite tenet of truth to nature. But complete truth to nature in the kind of subject that absorbed him could not be achieved unless he painted these subjects in the locale of their happening—the Holy Land. Thus in 1854 Hunt set out for Palestine, and there he remained for two years. He brought *The Scapegoat* (Port Sunlight, Cheshire, Lady Lever Art Gallery) back to London with him and exhibited it in the Academy show of 1856, to the bepuzzlement of the critics.

The Scapegoat is based on the text in Leviticus (16.21) describing that part of the ritual of atonement in which it is directed that "Aaron shall lay both his hands upon the head of the live goat, and confess over him all the iniquities of the children of Israel," after which the goat is driven into the wilderness to perish. Hunt tethered his sacrificial victim (as it proved really to be: the poor beast did not survive the experience) in the most desolate spot he could find, the skeleton-studded, salt-encrusted shore of the Dead Sea, and while his Arab guide and guard looked on nervously, he began work on the picture on the Day of Atonement itself. He painted under conditions that amounted to voluntary torture and risked murder by brigands in an isolated part of a disturbed country. His fanaticism extended to the gathering of samples of salt and mud for analysis in the studio. *The Scapegoat* cannot be called an interpretative picture. It is an obsessively detailed reproduction of a heat-stricken animal standing in a specific, ghastly landscape. But something of Hunt's fanaticism carries through to lift *The Scapegoat* above the level of a zoological and geological record by a painter-photographer. It may, in fact, be a more effective picture if left unexplained: simply as a picture of a goat in a bizarre setting it seems an invention combining horror, something unnatural, with contradictorily objective rendition of every detail, every hair on the animal. From this point of view it

has been laureated by the twentieth-century surrealists, but this makes it an entirely different kind of picture than Hunt intended. The goat for him was a symbol of "the church on earth, subject to all the hatred of the unconverted world."

For Hunt's public *The Scapegoat* was a failure. It puzzled everybody. (One young lady, called in by a dealer for an impromptu reaction, said, "How pretty!") It was merely a picture of a goat, although the critic of the Art Journal, sensing some of the quality that can be read into the picture today, admitted that this goat was "an extremely forbidding specimen of the capriformous race." *The Scapegoat* is an extraordinary picture, whether a success or a failure, and the year of its exhibition, which was also that of Millais's *The Blind Girl* and Henry Wallis's *The Death of Chatterton* (London, Tate Gallery), is often called the high point of the Pre-Raphaelite movement.*

Hunt returned from the Holy Land to find that he had lost contact with Millais and Rossetti. There was no mending the breach. Millais was now cultivating the right people. ("Take my advice, old boy, accept the world as it is, and don't rub up people the wrong way.") The separation from Rossetti was aggravated by a really serious quarrel of some kind not quite clear but involving a woman. (We must suppose that Hunt represented the forces of right against Rossetti's devil of the flesh.) As far as histories of art are concerned, Hunt's life beyond this point is seldom followed, but he had another fifty-three years to live and they were busy ones.

* Henry Wallis (1830-1916) is remembered for *The Death of Chatterton* alone. It is one of those pictures like *April Love* (London, Tate Gallery) by Arthur Hughes (1832-1915), exhibited the same year, that are part of the Pre-Raphaelite galaxy of best paintings but are unequaled by other efforts by the same artists. *The Death of Chatterton,* showing the youthful suicide in his attic (the body is disposed, perhaps by coincidence, in almost the same attitude as that of the victim in Prud'hon's *Justice and Vengeance Pursuing Crime*), had special pertinence at the time because Chatterton was becoming a cult figure with Pre-Raphaelite poets.

He occupied himself with the completion of a painting he had begun in Jerusalem, *The Finding of Christ in the Temple* (Birmingham, City Museum and Art Gallery), which had been held up by the difficulty of finding the proper types willing to serve as models and by threats when he attempted to sketch in holy spots. But five years after his return he completed it and sold it for 5,500 pounds. *The Light of the World* had become one of the most celebrated (and in reproduction one of the most profitable) pictures in England and America. Hunt's prices were high, and he could have made a great fortune if he had set out to. He was not interested in that, but as it was he was more than prosperous. He accepted portrait commissions while working away, very slowly, on his major projects. He was systematic, conscientious, a meticulous researcher, and more and more a dull, dull painter.

This ossification began early. He was only entering his thirties upon his return from the Holy Land when he broke with Millais and Rossetti. Just as Hunt's seriousness had once given much-needed weight to Millais's facility, so had Rossetti's sparkling, neurotic presence enlivened Hunt's solemnity to give it an intensity that saved it. With the break, Hunt became a religious pedant.

All this time he had been a bachelor. At the age of thirty-eight he married Miss Fanny Waugh, and the next year, 1866, they set out together for a second trip to the East. Checked by a cholera epidemic, they got only as far as Florence, where Fanny died. Hunt returned to England, but set out once more for Jerusalem in 1869, and stayed there through 1873. His major picture during this time was *The Shadow of the Cross,* in which Christ, in the carpenter's shop, raises his arms and the Crucifixion is prefigured in the shadow thus made on the wall. He worked with morbid intensity in his usual way (to his disappointment, he discovered that carpenters in the Holy Land were using modern tools

imported from England, thus involving him in much re-
search) and sold the picture to Agnew's for 5,500 pounds.

In 1873, forty-six years old, he returned to England long
enough to marry again—this time to Miss Edith Waugh—
and then went back to Palestine for two and a half years.
Home in England once more, he worked and worked and
worked, and prospered. Reproductions of his paintings sold
for as much as eight guineas. During the 1890's he became a
self-righteous and rather un-Christianly vindictive old man.
He fulminated against the French impressionists—they were
obviously the product of a corrupt, licentious, devil-loving,
and lascivious society given to every form of abominable
aberration—and occupied himself with writing his history,
"Pre-Raphaelitism and the Pre-Raphaelite Brotherhood," a
compound of record and wishful thinking, published in 1905,
in which he alone emerges as a Pre-Raphaelite. He lived an-
other five years, dying in 1910 at the age of eighty-three. Full
of honors already, he was buried in St. Paul's, thus scotching
the old aphorism that virtue is its own reward. He had out-
lived his clay-footed idol Millais by fourteen years and the
dissolute Rossetti by twenty-eight, thus scotching another—
that the good die young.

Insofar as the Pre-Raphaelite movement was a romantic
revolt, Dante Gabriel Rossetti was its typifying artist. He
filled the role not only as a painter but also as a personality
cast in the mold synthesized by nineteenth-century novelists
for romantic artists as colorful lost souls. Few of the great
romantic creators fitted this mold, which required that an
artist be temperamental, by turns gay and moody, profligate
in his amours but possessed by one grand (and if possible
hopeless) passion, that he yearn toward the unattainable, that
he suffer, and that he be subject to an aberration, an ailment,

or a vice to set him outside the limits of normal experience. Rossetti filled this bill as well as it could be filled by any man who was not an absolute freak, and in addition was of the preferred facial type. He had large, dark eyes, long wavy hair, and full sensual lips framed by a beard. His body was a disappointment—almost feminine in cast with its meager shoulders and ample hips.

As a romantic artist, Rossetti was a yearner. He yearned toward the past, the far past—the medieval past, which the Pre-Raphaelites misconceived as a time of harmonious union between the individual and society in contrast with the ugly impersonality of the industrial age. Rossetti's nostalgia reflects little sociological concern, however: for him the Middle Ages supplied the exotic ambience in which chivalric and amorous visions flourished best.

His father was an Italian poet and critic, Gabriele Rossetti, whose liberal views made him an exile in 1824. He fled to England and, in 1831, became a professor at King's College, London. Dante Gabriel, born in 1828, was the first child. (His mother was half Italian, half English.) Precocious —making verses as soon as he could lisp, and pictures as soon as he could hold a pencil—the boy studied drawing at King's College between the ages of nine and fifteen, and then after some private instruction entered the Academy school at eighteen—where he was a rambunctious presence and spasmodic student whose racy tongue and flamboyant appearance won him an admiring following among the younger and flightier students. When he sought out Millais and Hunt they, too, were impressed. The year he met them—he was nineteen— he read them a poem he had just written, "The Blessed Damozel," an expression of his sense of the gap between the ideal and the attainable, the paradisiacal and the earthly, the spiritual and the physical, a theme that he treated all his life —without ever greatly enlarging, and too seldom approach-

ing, either in his painting or his poetry, the expression he gave it in these precious lines.

Rossetti had been studying (fitfully) with Ford Madox Brown, but now he asked Hunt, only a year his senior, to give him lessons. Hunt tried. It was no use. Rossetti found Hunt's idea that art begins with discipline (drawing bottles) a bore. Hunt was attracted to this wild man in spite of himself, but he was not at all sure that he wanted to share a studio with him. Rossetti liked the idea and moved in with Hunt for a while. The stay did not last very long. Rossetti was always getting ideas and discarding them, moving into a place and moving out again. Both dazzled and beleaguered, attracted and disapproving, Hunt was distressed during the autumn of that year, 1848, by Rossetti's frolicsome attitude during the secret formation of the Pre-Raphaelite Brotherhood. Millais, too, had an uneasy feeling about Rossetti, which was shown to have been justified when Rossetti let the cat out of the bag and the no-longer-secret society was plunged into the scandal of 1850. Hunt and Millais, braving it out, could not help but feel that Rossetti was reneging. Like a child alarmed by the fire set by his mischievous match, Rossetti abjured exhibition the following year. (In 1849, the year of the Brotherhood's debut, he had jumped the gun and exhibited in a private gallery before the Academy show opened.) Rossetti was undependable, Rossetti was capricious, and Rossetti was self-centered—no doubt about it.

But he was seductive, damn him, and Hunt and Millais forgave.

Rossetti now became involved in the first of a trio of intertwined love affairs that ran through the Pre-Raphaelite movement as major motifs until he died. In 1850 (he was twenty-two, she eighteen) he met Elizabeth Siddal, always described as a beauty. She was not a conventional beauty by the record of Rossetti's paintings, and hardly a beauty at all

in some drawings and photographs that show a sullen, long-nosed girl. But a beauty she must have been, at least by Pre-Raphaelite standards, since in describing her one artist after another found use for their favorite laudatory epithet, "a stunner."

Elizabeth Siddal, when the Pre-Raphaelites discovered her, worked in a milliner's shop. She was a lower-middle-class girl whose letters and verifiable conversation (there was not much of it; she was a silent type) reflect an appallingly affected gentility. She was always ailing, always wan. She dragged around in an apathetic way that sounds insufferable, but she had large eyes, great masses of light auburn hair, a long, curving neck, and by her very apathy was a theatrically effective foil to Rossetti's ebullience. Able to sit for hours without moving and apparently without thinking, she made a perfect model. Millais posed her, fully dressed and lying on her back as if dead, in a bathtub, and superimposed the image, without tub, on that of a stream and its banks painted *in situ* for his *Ophelia* (London, Tate Gallery). The Pre-Raphaelite tenet of truth to nature could be approached no more closely than this, posing in the stream being impossible. As it was, the lamp that was placed under the bathtub to keep the water warm did not function properly, and "Guggums," as Rossetti was now beginning to call her, was severely chilled.

Over the ten years that elapsed between their meeting and their marriage, Rossetti ("Gug") and Guggums saw one another constantly. She was his mistress in terms of medieval romance, Beatrice to his Dante, lady to his knight, but surely not his mistress in terms of bed. This function (just as surely) was taken over by a woman named Sarah Cox who called herself Fanny Cornforth, a semiliterate hussy of huge size (Rossetti called her "Elephant") whom he picked up somewhere and who served as a model and for a while as his

housekeeper. Elephant married twice, but until his death Rossetti knew and saw her and sent her money. There was a rough affection between them; she must have been a good sort for all her relaxed standards of virtue, and in an odd way this coarse-grained and intemperate woman was the healthiest thing that ever happened to Rossetti. She was troublesome only when she tried to argue him into letting her join him as co-guest in respectable company, but she never won her plea and, at worst, grumbled a bit.

As their interests diverged, Rossetti and Millais and Hunt saw less and less of one another. The Brotherhood dissolved in 1853, and before the decade was up Rossetti had so tried the patience of the other two that they were avoiding him. But as the one relationship declined, another rose. Rossetti became the center and the hero of a group of bright young Oxford men who were just enough his junior (by five or six years) to adopt him as a leader while accepting him as a companion. His position as a poet was also a great factor in his attraction for this literary-minded group. William Morris and Edward Coley Burne-Jones replaced Millais and Hunt as second-generation Pre-Raphaelites, and Rossetti's neomedievalism became the movement's hallmark.

Rossetti's Oxford association began in 1855 when he was twenty-seven. In 1857 his group conceived a major scheme: they would decorate the library of the Oxford Union, a neo-Gothic building, with appropriate murals. Nominally a project in which the communal effort of a medieval craftsmen's guild would be re-created (the participants charged only for their lodging and materials), the venture resembled much more the kind of class exercise that might be carried on today in the lower grades of a moderately progressive elementary school. There was much skylarking. It was all a great deal of fun as well as indisputably advanced intellectually. But technically the new brethren were innocents. The murals

began to flake off the walls as soon as they dried, thus becoming symbols of the naïve delusions involved in their conception.

During this time, although Elizabeth Siddal's ailments increased in severity, Rossetti's friends began wondering why he did not marry her. She remained a constant presence, occupying herself now with a bit of painting and then with a bit of poetry-making. But the Oxford Pre-Raphaelites had discovered a new goddess, Jane Burden, the daughter of a livery-stable manager. They caught sight of her in a box at the theater—a pure Rossetti type with her long, eventful neck, a great weight of raven hair flowing in waves, dark, slightly protruding eyes, and a small, full mouth with curling lips. Jane Burden was the ultimate Rossetti girl, although she, Elizabeth Siddal, Fanny Cornforth, and other women painted by Rossetti are almost indistinguishable on canvas except as blonde-, brunette-, or auburn-crowned versions of the same face. It is not that they looked alike, but that Rossetti was obsessed with a type that he had invented and into which he forced any model's features. Heavy-lidded, sad and removed, languid, vacant, suggesting at once sensuality and anemia, these creatures, half woman and half effigy, are heavy-laden with jewels, brocades, and the eternal cascades of more hair than any normal scalp could accommodate.

William Morris fell in love with Jane Burden on the spot, and shortly thereafter married her. Rossetti liked to believe that he, too, had fallen in love with her at first sight, but he was much given to the pleasure of yearning toward ineffable but unattainable sexual delight, and anyway he was involved with both Elizabeth-Guggums Siddal and Fanny Cornforth at the time. In 1860 he married Miss Siddal. They dragged off joylessly to Paris for a honeymoon. Joylessly they dragged themselves back home. She was only twenty-seven, but now half wasted away. There are confusions as to exactly

what her illness was. She seemed to have tuberculosis of the lungs, and now she developed a terrible neuralgia. In this pitiful condition she bore a dead child. Fretful, enervated, pretending to occupy herself with pictures and poems, she took laudanum to relieve her pain, and one day two years after her marriage she took an overdose and died.

The inquest made it officially an accidental death, and the official record of events was that Rossetti and Swinburne (a great friend at the time) had been out to dinner together, that Rossetti had come home early and found Elizabeth getting ready for bed, that he had gone out again to pay a visit to the Working Men's College (where Ruskin had found classes for him to teach) and that when he came back home he found Elizabeth unconscious. The empty laudanum phial was at the bedside.

No one questions seriously that the death was suicide. Gossip at the time conjectured a quarrel, or jealousy of Rossetti's other women, particularly his special other woman, Fanny Cornforth, or the lovelessness of a marriage long delayed and perhaps contracted by Rossetti as a duty. But all this is speculation, and the poor woman might only have been unable to bear any longer the pain and weariness of staying alive. Whatever the circumstances, Rossetti was anguished after the death. Now that she was lost, Guggums became more than ever his Beatrice. He buried with her the manuscripts of his poems (later exhuming them for wildly successful publication) and all but deified her. In death she fitted perfectly into a role that he had anticipated fifteen years earlier with his creation of a blessed damozel leaning across the golden barrier of heaven and weeping for her lover on earth, while he in turn was suffering similar torments of separation.

In his mid-thirties now, Rossetti was decaying rapidly. He was fat, his handsome face had fallen into slack folds, and

his messy toilette was a distress to the immaculate Ruskin. He began to dabble in occultism and mesmerism, and rejected his old companions in favor of an extraordinary person, Charles Augustus Howell, part genuine romantic adventurer and part charlatan, whom he adopted as combined manager and mountebank-in-attendance. He trusted the unscrupulous Howell completely while becoming suspicious of everything and everybody else except Fanny Cornforth. He read signs, portents, and threats everywhere. He cut himself off from Ruskin, whom he had always privately ridiculed as a critic but whose influential pen had been valuable to his career. He could no longer abide Ruskin's telling him not only how to paint, but how to tidy up his appearance and his living quarters, which were now half zoo with his collection of odd birds and beasts, including a kangaroo. Somehow he managed to work steadily at paintings and illustrations and at writing. Although he had always been careless about money and had been hard up from time to time, he was now famous and had as much money as he needed.

His physical deterioration was obvious enough, but his collapse in 1872 came as a shock to his friends. For two years he had been addicted to chloral, which he combined with quantities of whisky as a sleeping draught. After a spell in the hospital he was sufficiently strengthened to return to the life that had become normal with him—more bickering, more lost friends, and much victimization by the people who could still tolerate him, including the unquenchable Fanny, who was always needing money, and getting it. (The old Elephant, he scolded, had become a Rogue Elephant.) The chloral continued; so, somehow, did the painting and writing. But finally in 1881 he had an attack of paralysis, and in 1882, fifty-four years old, he died.

In 1877, in the same article in which he precipitated a lawsuit by calling Whistler an impudent coxcomb who asked "two hundred guineas for flinging a pot of paint in the public's face," John Ruskin made a second error. "I *know*," he declared, referring to works by his disciple, Edward Coley Burne-Jones, "that these will be immortal, as the best things the mid-nineteenth century in England could do, in such true relations as it had, through all confusion, retained with the paternal and everlasting Art of the world." The reference to Whistler, which the court decided was libelous, was only incidental in an essay on Burne-Jones, which time has found much too generous.

Born to a prosperous family in 1833, Burne-Jones (he always hated the latter half of that name) entered Oxford at twenty, a pale, delicate youth given to poetic moonings of the sort that are normal compensations for many intelligent, unathletic late adolescents. He discovered the most modern critic in England, Ruskin, and the exciting new painters, the Pre-Raphaelites. He also discovered Malory's "Morte d'Arthur," which became a kind of bible for him, a world of escape beyond the indignity and the grime of the industrial world.

Burne-Jones was always an escapist, and the world of ladies in trailing robes and knights in well-tailored armor was the best escape of all. But he was one of those fortunate people for whom escapism does not preclude participation in the enjoyment of whatever good things a bad world offers. As a charming and sought-after dinner guest, he found that the blessings of industrial society, although unequally distributed, were nevertheless pleasurable when summarized in the well-set tables of fine houses. In relation to the rest of the world, Burne-Jones led a cloistered life, so cloistered that even Ruskin thought it too withdrawn from such realities as slums and diseased beggars. But Burne-Jones refused to

look at these even to please the idol of his youth who became his friend, mentor, and best press representative.

The turning point in Burne-Jones's life occurred when Rossetti visited Oxford. The adventure of the murals in the Oxford Union (on subjects from the "Morte d'Arthur") crystallized his decision to become a painter. He topped off his Oxford education with a tour of Italy, where he discovered Botticelli, Mantegna, and Signorelli—a powerful trio whose greatness, eclipsed for two centuries by Raphael's shadow, could be recognized only by a truly adventurous perception. Burne-Jones added the study of medieval and Renaissance literature to his discovery of Quattrocento painting. He would have made a good professor of the history of art. His undoing as a painter was his failure to understand that the past cannot be re-created in its own image.

At twenty-six he married Georgiana Macdonald, one of five daughters of a Nonconformist minister, and thus, when two of his wife's sisters produced sons, became the uncle of Stanley Baldwin and Rudyard Kipling. In the meanwhile he became one of the great names of his England, no matter how faded his reputation today.

He revisited Italy in 1862 with Ruskin, who insisted that he copy Tintoretto—whose vigor did not rub off—and then in 1863 joined a university friend, William Morris, in his effort to revive handicrafts on the medieval pattern. More than painting, Burne-Jones liked designing tapestries and stained glass and decorating furniture. In his association with Morris he managed to remain an inhabitant of never-never land. Morris's respect for craftsmanship and his war against the machine had a corollary in his respect for common labor and led him naturally to socialism. Burne-Jones was saddened by this development, but continued to live in two worlds at once and collaborated with Morris in the founding of the Merton Abbey factory for decorative works in 1881.

In 1897, when he was sixty-four, Burne-Jones was created a baronet. His aesthetic position, however, was under attack by a new avant-garde. Whistler's ideas of art for art's sake, imported from France and taken up by a new generation of bright young men (including Oscar Wilde) were winning the day. (Whistler was a personal friend of Burne-Jones's, as he had been a personal friend of Rossetti's; their differences on aesthetic theory caused no friction between them as sociable beings.) With the death of Rossetti, Burne-Jones became the grand old man of a revolution that had become an academic routine. He died in 1898 at the age of sixty-five.

As an artist, Burne-Jones was devoid of original ideas. As a decorator, he watered down and polished up the manners of Rossetti and Botticelli and garnished them with attractive derivations from Mantegna—with taste and intelligence but, again, without real invention. He seems, today, to have settled firmly into position as a period piece.

Ford Madox Brown has been called the true father of the Pre-Raphaelite movement, an opinion with which he concurred as a bitter old man who thought himself underrated. He was not a member of the Brotherhood, however. He was twenty-seven when it was formed, a virtual patriarch in comparison with Millais's nineteen years, Rossetti's twenty, and Hunt's twenty-one. The youngsters talked him over among themselves, and decided not to include him. No doubt they thought him too staid. Nevertheless, Brown's ideas were fundamental contributions to the Brotherhood's program, and he in turn was influenced by the younger men in a give and take that balanced out pretty evenly.

He was born in Calais in 1821, the son of a retired purser in the navy. Like so many of the Pre-Raphaelites he was precocious, but then, still like them, met something of a stale-

mate. Somewhere he missed the early stimulus that might have turned him from a very honest, sound painter into a fine or even great one. Between the ages of sixteen and twenty-four he studied on the Continent, first in Antwerp, then in Paris, and finally in Rome, where he met the Nazarene leader, Friedrich Overbeck. This meeting, of dubious worth, seems to have been Brown's closest approach to acquaintance with any but the most routine second-string academic painters during his European days.

He was back in England by 1845, a very solid, serious artist. Rossetti's questing eye discerned something out of the ordinary in his work, and he wrote Brown asking to study with him. The letter was so high-flown that Brown thought it a hoax and was infuriated, but when he met the extraordinary youth he accepted him as a pupil. As pupil and master they did not jibe, and Rossetti was soon on his way again, but Brown had talked to him about painting as a social force, and about the purity of painting before Raphael. These ideas Rossetti relayed to the group even though his own Pre-Raphaelitism took on a more perfervid character.

Of the declared Pre-Raphaelites, Brown was closest kin to Holman Hunt. He did not share Hunt's religious mania, but he became equally fanatic in his insistence upon the combination of realistic detail and elaborate symbolism. This he put into the service of his *chef d'oeuvre,* a wearing social allegory begun in 1852 and finished thirteen years later, that bears the apt title *Work* (Manchester, City Art Gallery). Much admired today by most historians of English art, it is nevertheless an overcrowded, overlabored, overdetailed composition that would look better if it were less remindful, in its social preaching, of some of the overreaching that typifies WPA murals turned out in America during the Depression. Like so much Pre-Raphaelite painting it is a piece of literature—in this case, a sermon and a tract.

The theme of *Work* is the dignity of labor in contrast with the paltriness of life at the levels of society that live off labor's fruits. Workmen with nobly proportioned bodies are shown repairing a street ("truth to nature" required that it be a real street, and it is—Heath Street, in Hampstead, outside London) while a daintily gowned society lady, in contrast with a flower seller and a little girl, both in rags, distributes uplifting pamphlets. In the background, sandwich men bearing slogans for a corrupt political candidate are parading. Standing at one side are two spectators of eminent reputation—Thomas Carlyle and Frederick Denison Maurice (1805-1872), a leader of the Christian Socialist movement who was a founder of the Working Men's College in London (1854) where Ruskin and Rossetti, among others, gave art lessons in accord with a Pre-Raphaelite idea that anybody could learn to draw and paint and that art should be rooted in common rather than esoteric experience. In Brown's allegory, Carlyle and Maurice represent hopes for a better social system, and have paused during a stroll to observe the scene.

This description is unkind in tone, but there is no denying that *Work* is a tiresome conglomeration for all its individually excellent passages. Its excellences are the excellences of craftsmanship; it recites its social message clearly, but without force. Brown is admirable as the Pre-Raphaelite who faced industrial society and accused it, instead of escaping from it either into Rossetti's Middle Ages or Millais's compromise as a kept artist, but many an admirable painting is a dull one. Brown took quite seriously Ruskin's edicts that art should perfect man's ethical state, that no painter could be great unless he were—capitalized—Good, and that a nation's art is the "exact component of its ethical life." Ruskin, that odd, odd fellow, was able to harmonize these sentiments with his enthusiasm for the affectations of Rossetti and Burne-Jones.

Brown also painted some charming figure studies and landscapes, but his other most famous work is *The Last of England*. (There are three versions: in Cambridge, Fitzwilliam Museum; in Birmingham, City Museum and Art Gallery; and in London, Tate Gallery.) His friend Woolner's emigration to Australia was the immediate inspiration, but when he chose to paint himself and his wife gazing sadly at the disappearing shores of England he was thinking of his own situation: his pictures were not selling, and he was considering emigrating to India.

Later he said that he also thought of the picture as a symbol of the emigration movement in general. In painting it he observed as closely as possible the Pre-Raphaelite stricture that all scenes should be studied, if possible painted, *in situ*. He worked on the picture only in the open air on dull days and, for the flesh passages of the passengers on the bleak deck, on cold days. "The minuteness of detail," he said, "which would be visible under such conditions of broad daylight I have thought necessary to imitate as bringing the pathos of the subject home to the beholder." It is true that the passengers look uncomfortable.

Over many years Rossetti and Brown remained close and affectionate, if sometimes puzzled, associates. But in 1874 they were both involved in an unpleasant quarrel over money matters connected with changes in the reorganization of William Morris's shop, which had been one of Brown's sources of income. Rossetti backed Brown, out of personal loyalty rather than from conviction. But the ensuing bitterness resulted in a break with Morris and such strain on his friendship with Brown that it never again was a close one. Brown even quarreled with Hunt, who was drawn into taking sides. A stable, independent personality through middle age, Brown was vindictive and irascible in this instance and became more so as he aged. Mountebanks and charlatans had corrupted the movement that owed its generation to him, he thought,

and here he was, old and in debt, for all that he had worked so hard in the service of a social ideal. He died in 1893, at the age of seventy-two.

William Powell Frith was born in 1819, only four years after the Battle of Waterloo, and died in 1909, only five years before the outbreak of World War I. In terms of art history, this means that he was in his early thirties when Turner died, in his forties when Delacroix died, that he lived (and prospered) through the rise and fall of the Pre-Raphaelites at home and the rise and triumph of impressionism in France, that he outlived all four of the post-impressionists— Van Gogh, Gauguin, Seurat, and Cézanne—and saw, or could have seen if he had been interested, the explosion of fauvism and the birth of cubism. And yet throughout all these years Frith hardly changed. He was the archetype par excellence of the Victorian genre painter, and, for that matter, of the Victorian art public, sharing as he did its respect for conventional, often Philistine, values. There is something awesome in the consistency of his perceptual limitations, but without question they supplied him, as an artist, with a kind of aesthetic bastion comparable to Queen Victoria's impregnable position within her definition of personal and national rectitude.

Frith began his career as an illustrator, and it could be argued that he never became anything else. He reached the height of fame as the most popular artist in England because he was the consummate master of narrative anecdote in pictorial form. In public exhibitions his paintings (with such titles as *A Village Pastor, English Merrymaking One Hundred Years Ago, Life at the Sea Side,* and *New Ear Rings*) had to be roped off to protect them from damage by the eager crowds pressing around for a glimpse.

Frith's most famous picture, *Derby Day,* painted in 1856-58 and now in the Tate Gallery, London, no longer needs this special guard, but it is rarely without a group of fascinated visitors even so. With its hundreds of figures, from dandies and fine ladies in their carriages to touts and strolling acrobats, all acting out their stories and represented in great detail, *Derby Day* is an expertly organized social panorama so interesting (and for that matter, so well painted) that critics who disapprove of narrative genre per se take refuge in comparing Frith to Dickens. He has also been called the Victorian Hogarth, but "Victorian," here, means more than "Hogarth."

Frith was a genial man but, good Victorian that he was, he was contemptuous of preciosity and was likely to dismiss as preciosity anything that he did not understand. His scoffing judgments on the swooning niceties of the Pre-Raphaelites, however, are not far from some of the objections we have come to hold to those painters today. In 1881 Frith painted an indoor panorama, *Private View at the Royal Academy* (England, Private Collection), and satirized the new aestheticism by the simple device of representing such visitors as Oscar Wilde and Gerald du Maurier realistically, along with such fashion plates as Lily Langtry and some solider figures—Gladstone, and Frith himself.

Frith became a close friend of John Everett Millais and to some extent influenced him in his defection from the Pre-Raphaelite ideals. Together, laden with academic honors and swollen purses, they toured Europe. Frith's judgments on art (he loved Meissonier) were uniformly those of the Salon public, and his comments on the old masters are farcical in their blindness. He seemed unconscious of the existence of the men who were fighting the nineteenth-century battle in France.

In England's most celebrated art-battle of the century,

Whistler's libel suit against Ruskin, Frith was called as a witness for the defense. Although Frith represented a mass common denominator in taste that was offensive to Ruskin, Ruskin probably chose him as witness because Frith's reputation was absolutely secure and because, whatever Frith thought of Ruskin's Pre-Raphaelites, he thought even less of Whistler. Frith testified that as far as he was concerned, Whistler's paintings were not serious works of art.

Whistler, however, more than got his own back for posterity when Frith wrote in his autobiography that it had been a tossup as to whether he would become an auctioneer or an artist. "He must have tossed-up," Whistler observed. Most critics and historians since then have agreed with Whistler, until very recently. But *Derby Day* (rather than Frith's work as a whole) is so fluent technically, and, if its ponderous sociological comment is forgotten, is such a sparkling representation of a subject held dear by the impressionists, that it is now permissible not only to link Frith with Dickens and Hogarth, but to see him as a Victorian Manet.

Edwin Henry Landseer was an admirable artist at the age of thirteen and remained one until he was about forty, a fact that is usually forgotten. Thereafter, until he died at the age of seventy-one, he painted the deplorable pictures for which he is remembered, those pictures of animals, usually dogs, in the throes of sublime emotional experience, that made him the darling of the Royal Family and the Victorian public, but the laughing stock of the twentieth century.

Landseer was born in London in 1802, the son of an engraver, John Landseer. He was extremely precocious, and at the age of thirteen exhibited animal drawings at the Academy. In the same year, 1815, he became a pupil of Benjamin Haydon, who made him dissect animals and, a

curious combination, draw the Elgin Marbles. These had
been brought to London from the ravished Parthenon in
1806 and Haydon became partly responsible for the govern-
ment's purchase of them in 1816.*

After a period in the Academy school, Landseer at eigh-
teen was so adept at painting animals in the rich, fatty, fluent
manner of Rubens and Snyders that Géricault, visiting Eng-
land, wrote enthusiastically about him. ("Even the masters
have produced nothing better of this sort.") At this time,
Landseer was affected by the romantic impulse in England
that had produced both Constable and Turner along with
many smaller men, and in 1824, when he was twenty-two, he
went to Scotland with a somewhat older friend, Charles Rob-
ert Leslie (1794-1859), a discardable genre painter best
known for his writings. Here he visited Sir Walter Scott at
Abbotsford. Scotland thereafter was his romantic dream. He
painted landscapes—the sketches are perhaps better than the
completed pictures—and animals, including stags of a legiti-
mate majesty as opposed to the later synthetic dignity with
which he invested them, as if they were members of Her
Majesty's cabinet.

Landseer was elected to the Royal Academy in 1831, did
his first portrait of Victoria in 1839, and became an intimate
of the Royal Family, the Queen's favorite painter. Then
came the decline, with increasing honors. The worse the pic-
ture—the more sentimental, the more banal—the greater
was Landseer's success. Even Ruskin, who usually spoke of

* Benjamin Robert Haydon (1786-1846) is one of the romantic personali-
ties in England. Determined to revive history painting in the grand manner,
he failed miserably, and his pictures are so blackened that few are more than
barely recognizable today. These few indicate that the blackened ones are
little loss. But he teemed with ideas, with projects, and with a romantic fasci-
nation with himself. His friends were poets and literary men; his "Autobiog-
raphy and Memoirs" makes him more a literary figure, or at least the author
of a romantic document, than a painter. He died a suicide, and his best
decipherable paintings are a handful of genre scenes that deny all the princi-
ples to which he dedicated his life.

him disparagingly, said that *The Old Shepherd's Chief Mourner* (London, Victoria and Albert Museum), showing a dog looking doleful alongside his dead master's bed, was a perfect poem. For the young Pre-Raphaelites, however, Landseer was an early target. Their dislike for this beloved master, along with their irreverent attitude toward Raphael, established them as radicals.

Landseer was knighted in 1850. In 1855 he represented England in the great international Salon in Paris, and was one of the three foreigners who were awarded the Grand Medal of Honor. (The other two were Peter von Cornelius of Prussia and Hendrik Leys of Belgium.) He went everywhere, knew everybody, and was finally buried in St. Paul's in 1873. Sir John Everett Millais, who had begun as one of the Pre-Raphaelites who damned him (but, in Sir John's case, hesitantly), had become his dear friend, and finished his last picture for him, a representation of Nell Gwyn as a huntress (London, National Gallery).

Landseer left a more creditable late work—the lions at the base of the Nelson Monument in Trafalgar Square, which he modeled when he was nearly seventy. Their majestic confidence in the invulnerability of the British Empire is a Victorian and Landseerian apotheosis.

George Frederick Watts, when he was at his best, was the best of a group of painters who represent a reprise of the classical revival in England. Inspired by the Elgin Marbles and by an early teacher who venerated them, the sculptor William Behnes (1794?-1864), Watts rejected both the pseudo-medievalism of the Pre-Raphaelites and the narrative-documentary genre painting that dominated the popular academic field. As a painter he was self-taught, but exhibited in the Academy when he was twenty (he was born in 1817) and then,

six years later, after winning a prize of three hundred pounds, went to Italy and stayed four years. Here he developed a passion for Titian, a not entirely compatible mate for breeding with ancient Greek sculpture. Obsessed with the beautiful, clinging folds of drapery on the Elgin Marbles, Watts tried to repeat them in Titian's terms of softened, glowing light. As a final difficulty, he was intent upon moralizing—the universal fallacy in Victorian painting. His efforts to combine didactic sermonizing with Greek idealism and Venetian sensuousness often made his pictures triply divided against themselves. "I am a thinker who happens to use a brush instead of a pen," he once said, unintentionally pinpointing the weakness of the large historical sermons in the form of murals with which he decorated public buildings.

For Watts and his companion idealists in the second classical revival, avoidance of all reference to the commonplaces of the world around them was mandatory. Ruskin scolded Watts for this, pointing out to him a pile of litter in a gutter and saying *"That* is reality! Paint it!"—much as Courbet had advised Parisian students to paint dunghills. In the curious mélange of aesthetic mésalliances in Victorian England, Ruskin typically saw no contradiction between this theoretical dedication to sordid realistic detail and his addiction to gentility.

In his most famous painting, *Hope* (London, Tate Gallery), in which a classically draped female figure, blindfolded and seated atop the globe, plucks the last unbroken string of a lyre, Watts rises above his confusions sufficiently to show how fine a talent was defeated. It was painted in 1885 when Watts was sixty-eight years old, the same year in which he refused a baronetcy from the Gladstone government. (His fellow honoree that year, John Everett Millais, accepted with alacrity.)

Watts died in 1904 at the age of eighty-seven. His pro-

duction had been tremendous, including portraits of so many political, religious, and intellectual leaders that, if assembled for exhibition, they would provide a solemn concourse of a majority of the most ethical Victorians. But Watts was denied the one great project in which he hoped to summarize his moral vision in allegorical form: his offer to decorate Euston Station with a series of murals to be called *The Progress of the Cosmos* was rejected. All in all, he is a difficult painter to evaluate—too easily scoffed at, and yet seldom good enough to warrant enthusiasm. Now and then, as in *Hope* and his portrait of Ellen Terry (London, National Portrait Gallery), he is close enough to Pre-Raphaelite sensitivity to make one feel that he could have been the best of them if he had not been misdirected toward Greece and Venice.

Among men younger than Watts who were (or thought they were) followers of the revived classical tradition inspired by the presence of the Elgin Marbles, were Frederic Leighton, Lawrence Alma-Tadema, and Albert Moore.

Frederic Leighton (1830-1896), who was Lord Leighton of Stratton, spent most of his youth abroad and returned to instant success under the patronage of Queen Victoria. President of the Academy from 1878 until his death, he brought that institution to its apogee as a center of the highest society if not of the best of English art. He was a skilled designer, moderately erudite in researching details for the subject matter of his pictures, but primarily a first-rate performer in the academic pattern rather than an artist of original ideas or personal sensitivities.

Sir Lawrence Alma-Tadema (1836-1912) effected a successful compromise between the genre pictures that were so popular and the classicism to which he was so devoted: he treated the ancient worlds in terms of Victorian anecdote.

His Greeks are essentially refined Victorian ladies and gentle-men performing a series of *tableaux vivants* in settings and costumes approximating those of antiquity. Born in Friesland and educated in Belgium, Alma-Tadema came to England at the age of thirty-three, and, a naturalized citizen, was heaped with honors, including knighthood.

Albert Moore (1841-1893) also saw the ancient world in terms of anecdote, and the slightest of anecdotes, at that. He was a graceful technician, fondest of painting fresh young female nudes who, somehow, never lose their pink-cheeked English look or their schoolgirl refinements, no matter what their supposed activity.

THE AMERICAN
ADVENTURE

Virtually unknown in Europe, competing only feebly in America with our absorption in the French tradition, thought of as provincial rather than as an indigenous expression, fenced off in the history-of-art books as a kind of postscript beginning "Meanwhile, in America . . . ," American painting of the middle decades of the nineteenth century has been everybody's stepchild. It must be the most undervalued of all schools—if it can be called a school, in all its variety, and in spite of a resurgence of interest, within the last few years, among dealers and collectors.

That American painting from about 1815 to about 1875 should have taken on the character of an appendage was unavoidable. American artists during the middle of the century were isolated from the great currents that swept through European art. At the beginning of the century, Washington Allston's generation represented the tag end of an eighteenth-century European tradition that could be transplanted into a

country where the major cities remembered their colonial past. But as America began to expand and to take on its wonderfully multifaceted national character, with new cities being born and even the old ones being transformed as the country grew—with all this, the French aestheticism that was setting the course of the history of painting was too removed from American experience for adoption by American painters.

Near the end of the century, American artists closed the gap with a renewed access of Europe-worship in the Henry James period when we pulled ourselves up by our cultural bootstraps, often very awkwardly. But in the interim, American painters, without setting out to do so, created a national expression.

It was a romantic exploration. The European romantics had found escape from world-weariness in exotic and distant times and places—in Algeria and the Near East as a geographical escape, in the Middle Ages as an escape in time. But America was new: there was no *mal du siècle,* no need to reject the present. The present was fascinating and as mysterious as the past. The present was romantic, something to plunge into. The Americans were discovering a continent wilder and more picturesque than anything Europe could offer. The Indians in the western territories were a living people more picturesque than the Bedouins (also, more difficult to get to), and living in a time removed from modern experience not by the centuries that separated the nineteenth century from the Middle Ages but by the tens of centuries that separated it from primitive societies.

American romanticism took the form of exploration rather than nostalgia. Even the recently domesticated landscape of the eastern states was discovered for itself. New Englanders suddenly began to respond to their countryside much as Wilson and Constable had responded to theirs. And for

the genre painters there were subjects inexhaustibly pic-
turesque—the life of the southern plantations with their
slaves, the life of the boatmen on the Mississippi, the rural
life of the farms at the edge of the wilderness. There were,
for a scientist-artist like Audubon, new forms of wild life to
be recorded in a hitherto unheard-of combination of science,
art, and personal adventure.

John James Audubon's "The Birds of America" is a
work of art born of romantic passion in the guise of scientific
research. Audubon's life combined his obsessive dedication
to this project with the material for a picaresque novel—
exotic birth, adventures in primitive country and in London
drawing rooms, poverty and prison, success and fame. Al-
though he was French by birth and had to go to England for
the publication of his great work, he could have happened,
as an artist, only in America—not just because the continent
offered him exceptional ornithological material, but because
the American aspect of nature, still so wild, so teeming, in-
spired everything he painted. His birds are creatures of the
wilderness, strangers to the park and the aviary.

Audubon encouraged a legend that he was of noble birth
and had been spirited out of France as a child to save his
neck from the Revolutionary guillotine, the implication
being that he was, in truth, the lost Dauphin. The truth was
nearly as romantic, although less impressive socially. He was
born in Haiti (then Santo Domingo) in 1785, the bastard off-
spring of a chambermaid and a sea captain living temporarily
in Les Cayes. His mother (named Jeanne Rabine) died the
year of his birth, and about four years later Captain Audu-
bon brought the boy to France, where his lawful wife took
him into the family. He was christened Jean Jacques Fougère
Audubon.

He was a handsome boy, a charmer, but not very serious. Like most youngsters, he found a hobby: he was an amateur ornithologist and enjoyed drawing pictures of birds. As a draftsman he gave little indication of talent, and he never did become a facile artist. Eventually he taught himself to draw much in the way one learns a difficult laboratory technique. If, as he claimed, he studied for a while at the age of seventeen with Jacques Louis David, he must have been an altogether undistinguished student.

When he was eighteen his father shipped him off to America, perhaps to save him from military service, and perhaps to see whether a bit of responsibility would make a serious fellow of him. He took over an estate near Philadelphia that his father had acquired during an American sojourn, and played at being a country gentleman. He continued his hobby of ornithology, going out to shoot his birds (according to the story) in satin breeches and silk hose. He also found an attractive neighbor in an English-born girl named Lucy Bakewell, and married her, thus setting her on course as a wife famous in the annals of art for her patience, her devotion, and her strength. She did not know that she was marrying a man for whom art would ever be anything much more than an avocation and neither, at that time, did Audubon. It would be another twelve years before, at the age of thirty-five, he conceived the project that made him a great artist.

Now, in his early twenties, he took Lucy down to Kentucky—first to Louisville, and then to Henderson—to try his fortune as a frontier merchant and speculator in real estate. They had two sons, Victor (1809-1860) and John Woodhouse (1812-1862). Audubon was not much of a businessman, and the coup de grâce to his commercial career was delivered by the panic of 1819, when he went bankrupt and was imprisoned for debt. Released, penniless, he took his family to

Cincinnati, where he scratched out a living from crayon por-
traits, teaching, and whatever else came to hand.

In 1820 the thirty-five-year-old Audubon exhibited his
bird drawings at the Western Museum in Cincinnati. These
are not to be thought of as anything better than first efforts
toward the drawings we know, but they were enthusiastically
noticed by the Cincinnati Inquisitor Advertiser. Nothing like
them had ever been seen "west of the mountains," the re-
porter wrote, and "good judges" with more experience than
he assured him that the drawings were superior to anything
of their kind in the country. If these good words crystallized
the decision Audubon now made, and they seem to have done
just that, then the person who wrote them certainly holds
some kind of championship as a force in art history out of all
proportion to his degree of prominence as a critic. Audubon's
decision was—simply and grandly—to record in paintings all
the birds of America against backgrounds of their natural
habitats and to publish the paintings as engravings.

Leaving Lucy behind for the time being with the two
boys (they were eleven and eight years old), he set out
on October 12, 1820, as a working passenger on a flatboat
bound for New Orleans, the first expedition in his project.
His equipment for his lifework consisted of his gun and his
drawing kit, perhaps a reference book or two, and a letter of
introduction from Henry Clay. He brought along his flute,
which was not only a means of recreation, but could also be
a source of income. And, pending the education of his own
boys as assistants, he brought along an apprentice, a thirteen-
year-old student with a talent for drawing plants and flowers.
(Years later, when Audubon was famous, Joseph Mason made
bitter comments on Audubon's failure to acknowledge his
contribution during the two years that they worked together
side by side and day after day.)

With neither money nor reputation to back him up,

Audubon attacked singlehanded a project that could have intimidated an artist possessed of both. He often worked seventeen hours a day; he sometimes gathered as many as a hundred specimens between dawn and dark, and into the dark, no doubt. During eighteen years of working incessantly at the collection of specimens, painting more than a thousand subjects, arranging for their publication and supervising the engraver's translation of the paintings into 435 plates, he became convinced that he had been allotted his project by Nature herself, and his triumph, finally, was great enough to justify our conceding that perhaps this was true.

Lucy may never have arrived at such a semimystical attitude, but from the beginning she was sufficiently fascinated to be willing to support the family during the first rough years. She held three bodies and souls together in Cincinnati after Audubon took off for New Orleans, while he supported himself as a personable teacher of drawing, French, music, dancing, and fencing in a habitat natural to him—a French one. (He never learned to speak English correctly.) He also painted signs and an occasional mural for a riverboat. After fourteen months Lucy and the boys joined him in New Orleans and she found work there as a governess. She brought with her the drawings that had been exhibited in Cincinnati with such success, but Audubon was no longer satisfied with them, and discarded them except as reference material.

He was working at making an artist out of himself, and at the same time developing techniques peculiar to the nature of his project. He learned to wire the body of a freshly killed bird into a natural attitude—flight, feeding, battle, or, as in his *Great Black-Backed Gull*, downed, with one shattered wing bleeding, the other stretched upward in death agony. Every bird was painted at exact size, by measurement, and with increasing mastery of design—design that in the silhouette of a single bird could reveal the beauty of its con-

tours by purifying (without distorting) a natural line, design that combined birds, leaves, branches, flowers, nests, insects, snakes, berries, fruits, in patterns beautiful by the most demanding abstract standards of creative art. To reproduce colors and textures he worked in combinations of watercolor, pastel, and tempera, using the white of egg to give sheen to passages where it could not be represented in other ways.

Audubon had a first disappointment in 1824 when he exhibited the first group of paintings in Philadelphia and was rebuffed by ornithologists there. They objected (as ornithologists have continued to do) to the quality that made Audubon a fine artist but a questionable scientist—the dramatization of his subject matter. Hurt, Audubon called Philadelphia "this icy city" and abandoned it henceforth.

He saw that only in Britain could a project of the scope he envisioned be carried through. In 1826, now in his forties, he sailed with a portfolio of 240 paintings and drawings and good letters of introduction. When the work was exhibited in Liverpool and Edinburgh, it impressed critics as an expression of the "wild abundance" of America. Keeping alive by hack work and by painting replicas of some of the most popular birds, Audubon set about finding a technician he could trust (and bulldoze) to reproduce the paintings accurately by engraving and hand coloring. He found this man in Robert Havell, Jr. Acting as his own publisher, Audubon began to issue the prints. The first plates, exhibited in Paris, made a sensation.

Audubon by now was becoming famous. He took Lucy and the boys to England in the spring of 1830, was back in America in 1831-34, making two trips to the Florida Keys and one to Labrador, went back to England, was in America in 1836-37, went back to England once more, and in 1839 returned to America for the last time. His son John Wood-

house had become his artist-assistant, and his son Victor helped manage business matters, supervised the engraver when Audubon had to be away, and worked on an occasional background.

In Europe Audubon had become a lion, courted, admired, talked about. Still handsome in full middle age, he made the most of his paradoxical combination of allures. He was at once the Frenchman of mysterious aristocratic origin and the American frontiersman, nature's nobleman endowed with all the social graces. No artist since the young Benjamin West in Rome had presented such a seductive combination of exotic origin, a fine head, a good figure, and a talent. With his hair down to his shoulders (frontiersman style by popular image) he indulged in a few romantic fabrications for the pleasure of the drawing-room audiences who doted on him. All of this helped sell subscriptions to the plates that finally, in 1838, were completed in four volumes under the title "The Birds of America, from Original Drawings, with 435 Plates Showing 1,065 Figures." People had grumbled about the price, but when the King subscribed, the success of the project was assured. Between 1831 and 1839 Audubon prepared the "Ornithological Biography" as an accompanying text. It is also an emotional biography of his fascination with birds. His descriptions of their manners of flight, their cries, their habits, are always vivid, and frequently lyrical.

With the "Birds" completed, Audubon announced a new project, "Vivaporous Quadrupeds of North America." In 1843—fifty-eight now, toothless and suddenly aging—he made an expedition far up the Missouri River to gather mammal specimens, reaching Fort Union at the mouth of the Yellowstone. It was his last great trip. Two years later he stopped work entirely. He had built himself a house on the Hudson River on land that is now Audubon Park in New York City, and there he slid prematurely into a benign senility. John Woodhouse Audubon completed "Vivaporous

Quadrupeds." In 1848, sixty-three years old, John James Audubon died.

From the time of their first appearance in Havell's engravings, Audubon's birds proliferated in other prints and reproductions of varying sizes and quality, and are still doing so, further stimulated by photoengraving processes that have produced them in everything from respectable approximations to terribly disfigured versions that may be found, among other places, pasted as decoration on cheap wastebaskets. All these repetitions* are born from the egg of Havell's engravings; the paintings themselves are seldom thought of, for the curious reason that they exist as a block, instead of being scattered through museums and private collections of the world. In 1863, through public subscription, the New-York Historical Society purchased them from the widowed Lucy. They remain in the museum's cabinets, a unique concentration of the lifework of a great artist, exhibited, a few at a time, for the delectation of the comparatively small number of people who are aware of their existence.

The passion that inspired Audubon as an artist-ornithologist was paralleled and perhaps in intensity even excelled in George Catlin as an artist-anthropologist who recorded the American Indian. It is customary to apologize for Catlin as an artist while recognizing the historical value of his seven hundred sketches and nearly five hundred paintings of Indians, Indian country, and Indian rituals. But when the Smithsonian Institution exhibited its 445 Catlins in 1965, cleaned and repaired after more than a century of abuse and neglect, Catlin emerged as a much more impressive artist than, habitually, he has been called.

It is true that Catlin was an extremely uneven artist.

* With the exception of the two-volume "The Original Water-Color Paintings by John James Audubon for 'The Birds of America'" published by American Heritage in 1966.

And for good reason. He could not shoot his subjects and then wire them into position in the studio as Audubon could his birds, and he sometimes had to do as many as twelve paintings in a single day in the wilderness in order to capture his subjects on canvas. And because he had captured them alive, he was afraid to do much repainting afterward from memory. As an artist he feared that he might lose the freshness of touch and color; as an anthropologist he feared even more that he would falsify his description. Hence his range as a painter runs from feeble or inept to full and solid. But at either extreme there is the excitement, if only associative, of the fantastic material he searched out, and the fantastic life-adventure that this search, and its conclusion, entailed.

Catlin was born in 1796 in Wilkes-Barre (the fifth of fourteen children) and grew up about forty miles from there on a farm on the banks of the Susquehanna. There were still men and women—including his own mother, who had been carried off, but not harmed—who could remember the Wyoming (Pennsylvania) massacre of 1778 after the defeat of the settlers by a party of Tories and Indians. George played Indian with the other boys and had a vigorous interest in Indian stories, but his obsession, like Audubon's, bloomed late.

He studied law to please his father, was admitted to the bar, and began practice in 1818. But he had decided that he wanted to paint. In 1823, when he was twenty-seven, he sold everything he had—including his law library, but excepting his gun and fishing tackle—and moved to Philadelphia. Completely self-taught, he made an adequate success at portraits—a success that is a comment on the undemanding standards of his clientele rather than on the talent he demonstrated, for he was a semiprimitive portraitist of little distinction. Nevertheless he was elected to the Pennsylvania Academy early in 1824.

The forces within him that were receiving random ex-
pression coalesced late in the 1820's to give his life a single
all-powerful direction. The catalyst was his sight of a delega-
tion of Indians from the West when they passed through
Philadelphia on their way to Washington. In their native
regalia, majestic in their reserve, they resembled neither the
whooping savages of the boyhood stories nor the respectable,
deracinated Indians of the eastern reservations with their
plain cloth suits and their conventional, flavorless lives.
These western Indians came from the land of the sun like
gods of the earth, as noble and beautiful as the ancient
Greeks, he thought—man at his apex, "freed from the killing
restraints of society."

Catlin's idealism, emotional and half deluded as it was,
was accompanied from the beginning by a premise that he
accepted without question: the Indian, for all his majesty,
was doomed. Catlin never had any idea that the Indian could
be protected, that Europeanized American civilization could
be held in check in its westward spread, that any geographical
or legal fences could save these beautiful people and their
culture. The western Indians at that moment were at their
apogee. The introduction of the horse and firearms had pro-
duced a society more flexible, better able to feed itself, more
secure, than the old one. And in their confident strength, the
Indians themselves had no premonition of their incipient
annihilation by smallpox, politics, and the gap between a
primitive and an industrialized society.

Just as Audubon thought he had been designated by
Nature herself to perform his task, so Catlin felt that he was
the instrument of history. And he became one. His pictorial
and verbal records (he was a fluent, vivid writer) are primary
sources of anthropological knowledge that was not uniquely
his but that would have disappeared in great part without
him.

In 1830, when he was thirty-four (almost the same age at which Audubon had begun his project just ten years earlier), he left his newly acquired wife, Clara, behind and went to St. Louis, the territorial capital, to begin a record that, he had determined, would include every Indian tribe. For the better part of two years, taking in what money he could by painting portraits of white men—wan subjects—he painted the Indian chiefs who came to St. Louis to represent their people, and penetrated the edge of the country he wanted to explore. In 1832, he went deep into it.

General William Clark (of the Lewis and Clark Expedition) was superintendent of Indian affairs in St. Louis and was impressed by Catlin. When the American Fur Company sent the first steamboat—the Yellow Stone—up the Missouri River, he helped arrange for Catlin to be aboard. (It may be remembered that Audubon took the same trip eleven years later to gather specimens for his new work on mammals.) In three months the Yellow Stone worked its way up two thousand miles of river, the second thousand through territory largely unmapped, to Fort Union in what is now northwest South Dakota. Catlin returned with the Yellow Stone as far as the Mississippi, and then drifted down to St. Louis in a skiff, tying up to visit the tribes along the banks. Everywhere the Indians found him as interesting as he found them. Always he managed to win their confidence, to overcome their superstition at being painted (one superstition was that a man represented with his eyes open would never sleep again), and to respect local protocol in the course of finding out just which ceremonial courtesies were the proper ones to observe.*

* The next year, 1833, the Indians were treated to a second contact with a white artist. The explorer Maximilian, Prince of Wied-Neuwied, eager to repeat the success he had just made with a book on Brazil, took the Yellow Stone up the river with the Swiss artist Karl Bodmer (1809-1893) in his entourage. Bodmer's assignment was to make drawings for later transcription into tinted engravings for Maximilian's project. The party went by keelboat

Catlin spent a year completing his pictures, putting his notes in order, and holding exhibitions in Pittsburgh, Cincinnati, and Louisville. The exhibitions drew great crowds, but Catlin did not sell the pictures. He charged an entrance fee for what was presented not as an art exhibition but as a kind of natural-history-museum exhibit.

The next year, 1834, he set out to accompany the First Regiment of Mounted Dragoons from Fort Gibson, near what is now Tulsa, on a peacemaking expedition across the plains all the way to the Rockies. Taken ill in southwest Oklahoma, he was left behind with the Comanches, who did not live up to their reputation for viciousness. In 1835 he went up the Mississippi to the head of navigation, Fort Snelling (St. Paul), and then up the Des Moines River. He was the first white man to venture into the sacred quarry where the mineral—pipestone—that supplied the material for peace pipes was mined. Later it was given the name catlinite.

Now he had six hundred pictures, and in 1837, charging fifty cents a head, he opened "Catlin's Indian Gallery" in New York City. Again it was a great attraction, but when crowds began to thin after two years, he decided to take it to England. In 1839, forty-three years old, he sailed. When he came home to stay he was seventy-four, and near death.

The interval was both adventurous and disastrous. He traveled with Catlin's Indian Gallery in England, France, and

even beyond the point reached by Catlin. Bodmer and Catlin painted some of the same tribal rituals and even some of the same tribal dignitaries. But Bodmer was a skilled representational draftsman, where Catlin was sometimes very nearly a primitive artist. By a reversal of values, Bodmer's skill made him less effective than Catlin. His eyes and hand were so well trained in the European studio tradition that he tended to Europeanize the proportions, the stances, the whole character, of his Indians, although his specific details are precise as records of costume and other accessories. Compared with Catlin's expressive paintings, however, Bodmer's drawings are diagrams. He returned with Maximilian to Europe in 1834, his American experience concluded.

Holland, and became, with an exaggeration that is a bit embarrassing in retrospect, a showman. With his skin, dark for a white man's, and his aquiline nose, he looked something like an Indian, although his blue eyes added a freakish contradiction. He dressed in Indian clothes, and invented the Wild West Show in entertainments purporting to reproduce Indian ceremonies, and with real Indians as the actors. He met Queen Victoria and then, in France, Louis Philippe, who invited him to exhibit in the Salon.

Here Baudelaire pops up in Catlin's life—an odd, out-of-time, out-of-place dislocation—as the only critic of standing to recognize Catlin as an artist. Reviewing the Salon of 1846, Baudelaire said, "When M. Catlin came to Paris, with his Museum and his Ioways, the word went round that he was a good fellow who could neither paint nor draw, and that if he had produced some tolerable studies, it was thanks only to his courage and his patience." (Roughly this is still the too-harsh judgment on Catlin.) But, Baudelaire went on, "M. Catlin can paint and draw very well indeed. . . . I believe that what has led the public and the journalists into error with regard to M. Catlin is the fact that his painting has nothing to do with that *brash* style to which all our young men have so accustomed us that it is the *classic* style of our time."

Thus was Catlin understood in the Paris of Delacroix, Ingres, and Daumier. Baudelaire was asking, that year, "What is romanticism?" and writing his most important essay on Delacroix. London was the London of the aging Turner, and the Pre-Raphaelite Brotherhood was formed three years before Catlin had to close his Indian Gallery there. It is difficult to think of him in these contexts—naturally, since he was not really thought of as an artist.

By 1851, Catlin had so far exhausted public interest that he resorted to sensationalizing his Gallery performances. In

addition to damaging his reputation, these devices failed to attract customers, and soon he could no longer afford to run his expensive operation, and opened negotiations for the sale of his collection to the United States government. Daniel Webster and the northern senators sponsored the acquisition, but the southern bloc fought it. They saw the West as an area for the expansion of slavery at the expense of Indian rights and feared that Catlin's paintings would stir up sympathy for the tribes—as well they might have. The southerners won; the bill was defeated in 1852.

Catlin was now fifty-six years old, in debt, and alone. His wife and son had died in Europe, and his wife's family had claimed his three daughters and taken them back to America. He had nothing but his collection. Now he lost this. A rich American manufacturer of boilers, Joseph Harrison, paid all Catlin's debts and took the collection in exchange.

In the face of these financial and emotional calamities, Catlin gave up any idea he might have had of going home. He tried to re-create his Gallery in Paris, London, and Brussels from sketches and memory, but neither he nor the public found much satisfaction in it. Old and deaf now, he decided that he must begin all over again on a new Indian project. He wandered through South America, Central America, and up along the western coast of North America in an effort to repeat his great adventure with new material. But he found the Indians ugly and brutalized. His noble red men had vanished along with his energy.

In 1868 he published "Last Rambles Amongst the Indians of the Rocky Mountains and the Andes," and two years later he returned home, at last, with his new paintings, which he called "Catlin's Cartoon Collection." They attracted little attention. He was seventy-four when the Smithsonian Institution gave him a room in a tower of its building, a kind of studio-pasture as a reward for the man whose "Letters and

Notes on the Manners, Customs, and Condition of the North American Indians," published in 1841, had already become the transcription of a world of the past.

Catlin occupied his eyrie in the tower for two years until his death in 1872 at the age of seventy-six, harassed always by worry as to what would become of his Indian Gallery. The Gallery all this while was moldering in storage in Mr. Harrison's boilerworks near Philadelphia. In 1879, Mr. Harrison's heirs gave it to the Smithsonian. The paintings had deteriorated seriously, but were exhibited sporadically until interest in Catlin, and Indians, waned to the vanishing point. The paintings were not exhibited primarily as art until 1965, after their cleaning and repair. Even then, they were not greeted with the interest they merit. Catlin has yet to come fully into his own as an American painter.

Catlin has no rival in his field, and hardly a nominee for the spot, in spite of the plethora of painters of Indians since his time. But Alfred Jacob Miller (1810-1874) may be granted certain claims to attention. Miller was taken on at the age of twenty-seven—the perfect age for an adventure—by a somewhat harebrained but wealthy Scotsman, William Drummond Stewart, to make souvenir paintings of a hunting trip by caravan across America as far as the Rocky Mountains. This was only a few years after Catlin began his great treks, but Miller traveled the set routes in comparative—very comparative, of course—luxury. The son of a prosperous Baltimore grocer, he had studied under Sully and then in Europe, where, although portraiture was his first interest, he had learned the storybook formula for romantic scenes modeled after Decamps. Back home in Baltimore, he was practicing as a skillful portrait painter when his Scottish patron took him west.

Making sketches in crayon and watercolor as records to be turned into large paintings to decorate Stewart's house in Scotland, Miller produced some fresh, delightful drawings. But it is difficult to identify them with the spirit of the West; they look, rather, like sketches for a theatrical performance based on descriptions of the frontier. He managed to make his mounted Indian braves look like Arab raiders, while, at closer range, both braves and squaws appear to have been drawn from models in a Paris studio and then retouched. Such documentary interest as his paintings have must be deciphered beneath this veneer. But his sketches, lost for a century and then discovered in a storeroom of the Peale Museum in Baltimore, are delightfully evocative of a personal experience.

Miller had no interest in the West and in Indians except as accessories to this adventurous holiday. He never went west again, but combined portrait painting, at which he was most adept, with repetitions of his western material, which he emasculated.

Thomas Cole discovered American landscape as the combined expression of God's majesty and the spirit of a new continent. No matter that he painted in the first half of the nineteenth century when the continent had already grown its cities and tamed its forests. Painters before him had not responded to the Americanness of the land and skies around them, or, even when responding as men, had been unable as artists to set down their world except in terms modified by the synthetic formulas of the eighteenth-century ideal landscapists. Nor had landscapists anywhere observed a countryside with Cole's feeling that nature represented a moral force —a feeling never made explicit, but always present.

Cole had the advantage of ignorance: he had never seen

a landscape by a traditional master when he began to paint. But this is only a negative accessory circumstance that does not help much to explain why, when he was nearly twenty-five years old, the spectacle of the Hudson River and the Catskill Mountains came upon him with the quality of a revelation. His landscapes came also as a revelation and fulfillment for an American public that responded to the first sight of them. It took only a few more years to change Thomas Cole from an unknown journeyman portrait painter of no reputation and little apparent talent into a first-rate artist holding a position in popular and critical esteem second only to that of the American dean, Washington Allston.

Allston, in his incidental landscapes, had created romantic reveries, shadowed, melancholy, and suggestive. Cole's landscapes came not as reveries but unexpectedly as celebrations. Suggestion was impossible for him: every littlest shrub within a great valley was part of a total wonder too ecstatic to be neglected by so much as a leaf. Yet his landscapes are never cluttered. He was one of those rare artists who can be explicit in infinite detail within a painting that makes, and holds, its first impression as an indivisible unit. To examine carefully one of Cole's greatest landscapes (such as *The Oxbow*, a view of the Connecticut River near Northampton, or *View on the Catskill, Early Autumn*, both in the Metropolitan Museum) is like seeing the actual landscape with a pair of powerful binoculars. Every precise detail is revealed. Yet the moment the binoculars are lowered, the great sweep of the whole absorbs the minutiae.

Cole was English by birth, from a family that, on both sides, included members who had made experimental sojourns in America. He was born in 1801, in Lancashire. His father was a handicrafter who had fallen victim to the industrial revolution, and there was about the family an air not only of reduced circumstances but of reduced caste. Cole's

four older sisters, who petted him, occupied themselves with whatever ladylike activities could bring in a bit of income, which meant, mostly, teaching.

Cole went to school at Chester and then was apprenticed as a calico designer and an engraver until, in 1818, when he was seventeen, the family emigrated to America. It was a rootless ménage, wandering from Philadelphia to Pittsburgh to Steubenville, Ohio, and back and forth from time to time. In Ohio the sisters established a seminary for young gentlewomen. Cole added a brief visit to the West Indies to his own itinerary, and on his return walked a good part of the distance to Steubenville, where his father had set up a wallpaper business.

As an artist, Cole was entirely self-taught, if we forget some elementary instruction from an itinerant portrait painter named Stein who in 1820, when Cole was nineteen, taught him a little something about applying paint to canvas. In this year Cole decided he wanted to be a painter, and himself became an itinerant, going from town to town with his studio on his back, doing portraits for food and lodging. By his own account, his efforts were primitive. Within a couple of years he had wandered from Ohio to Philadelphia, and here the germination of his dedication to landscape occurred when he saw, at the Pennsylvania Academy, some landscapes by Thomas Birch and Thomas Doughty.

Thomas Birch (1779-1851) was a superior member of a subcaste of American painters who supplied detailed renditions of local scenes and, on commission, "portraits" of gentlemen's estates. He was thus, by the most literal definition, a landscape painter. (He was also adept at marine painting.) But his interest was limited to topographical records at the level of souvenirs, which, although in his case invariably charming, were devoid of any interpretative element. Doughty's landscapes were another matter. Based on

specific locales but romantically moody, they surely prepared Cole for the direction he was on the verge of discovering.

Shortly after his twenty-fourth birthday, Cole was in New York, where his peripatetic father had settled. Now he took his trip up the Hudson, and his life began. The power of the river, the grandeur of the Palisades, the stretches of the Catskills, the cultivated areas nestling within terrain that still remembered the wilderness, all spoke to him of God, man, purpose, life, and hope. The trip produced three landscapes that were exhibited in the window of a frame shop and spotted there by John Trumbull ("Colonel" Trumbull, he insisted on calling himself, fifty years after the American Revolution) to the eternal credit of this crotchety, mean-spirited little man whose record in old age holds little else that is admirable. Trumbull bought one of the pictures for twenty-five dollars and called the others to the attention of two other artists, William Dunlap and Asher B. Durand, who bought them at the same price.

William Dunlap (1766-1839) was, as well as a painter, the art critic for the New York Mirror, and published a laudatory article about the new, youthful painter. Cole's sensational rise began. With official critical approval in a country that had become culture-conscious, these pictures that also grasped at the American heart were coveted by every collector. Only a year after his discovery by Trumbull, Cole became a founding member of the National Academy of Design.

Cole was humble enough in his success to realize that he knew virtually nothing about the art of the past, and he set out to learn something. In 1825 he was corresponding with a Baltimore collector, Robert Gilmor, first with a request to see Gilmor's collection, since "I have never yet seen a fine picture of any foreign landscape painter," and later on to discuss the questions as to whether figures had to be in-

cluded in a landscape in order to give it interest and meaning (Gilmor thought so) and as to whether a landscape could be complete without a pool, a river, or water of some kind (Gilmor thought not). Cole's ideas on landscape were more original than Gilmor's, but he was nagged by the suspicion that he was a provincial know-nothing, and he made bold to ask Gilmor to lend him money for a European trip.

From the middle of 1829 until late in 1832 Cole traveled in England, France, and Italy. In England he could not understand Constable, who, although he had discovered the English countryside much as Cole had discovered America, saw landscape as a spectacle bathed in light and air rather than an accumulation of miraculous natural details. Nor could Cole accept the late Turner, whose abstraction of the cosmos, antithetical to Cole's passion for the factual, made the great man seem the very prince of evil. The early Turner however, impressed Cole as a reflection of Claude and Gaspard Poussin, both of whom Cole had now discovered.

Cole in turn failed to impress the Englishmen. Whether or not because of political jealousies, which he suspected, he was coolly received by the Royal Academy, and his pictures, some of them biblical subjects and some landscapes, were assigned the worst possible locations in the exhibitions. Disgusted with London, Cole went to Paris, where he was disgusted again, finding the place given over to modern painters at the expense of the old masters. But in Italy he went into raptures. He saw the ruins of ancient Rome (with not altogether fortunate results, as it developed) and felt that in Florence he had discovered the very womb of art.

After his return to America (he was only thirty-one) Cole spent less and less time in New York. Now a family man and already famous across the country through engravings of his work, he continued his landscapes but also began work on a series of moralizing subjects that, today, occupy a dubious

position. He had outlined the project for the first of these before he left for Europe and elaborated it while he was there. *The Course of Empire,* completed and exhibited in 1836, consists of five scenes now in the New-York Historical Society, whose titles alone reveal both the ambition and the curious intellectual innocence of their conception. Playing the romantic theme of the poetry of decay, but with none of the melancholy identification with decay felt by the European romantics, Cole sermonized on the subject of human vanity by tracing the course of empire from *The Savage State* and *The Arcadian or Pastoral State,* which of course was unalloyed bliss, to *The Consummation of Empire,* where a great city suggesting ancient Rome was shown at its apogee. The last scenes, *The Destruction of Empire* and *Desolation,* show that war and ruin are the inevitable retributions when mankind's ego becomes inflated.

These are curious and wonderful pictures, but they are the efforted products of a second-rate artist rather than the inspired creations of a first-rate one, which Cole was when he painted American landscape.

For *The Course of Empire* he borrowed freely, if not quite plagiaristically, from a popular commercial panorama he had seen in London. Although he apparently thought he was inspired by Volney's "Les Ruines: ou, Méditation sur les Révolutions des Empires" (1791), a book that had captured the romantic imagination of the time, his sermons lacked both the historical knowledge of this scholar and traveler and, of course, his religious skepticism.

But *The Course of Empire* was a roaring success. People thronged to see it; as a natural product of its time and place it satisfied the yearning of a new American public for cultural elevation without strain on the intellect. Cole followed the series with another tract in four scenes, *The Voyage of Life* (Utica, N.Y., Munson-Williams-Proctor Institute). In the

first scene, a golden boat piloted by a guardian angel and bearing a newborn babe emerges on a stream that flows from a cavern suggesting, to our eyes, but surely not to Cole's, the uterus. In the second scene, *Youth,* the guardian angel relinquishes the helm to the passenger, who is headed toward a visionary castle of bizarre design symbolizing all young men's hopes of achievement. In *Manhood* the boat is in trouble, beset by storm and the demons of lust, intemperance, and suicide, while the guardian angel looks on from above. In the final picture the angel has taken the helm once more to guide the old man beyond the horizon of an infinite sea.

Cloying as they are, easy as it is to condescend to them, and defective as they may be in organization, these allegories are landmarks of American cultural history in their seriousness of purpose and in the tremendous enthusiasm with which they were received. *The Voyage of Life* was painted in a second and a third version by Cole himself, copied many times, and reproduced in hundreds of engravings. With *The Course of Empire* it established painting as a serious art rather than a form of decorative craftsmanship. There are arguments, it is true, that painting might better have been left to be appreciated by the few instead of being given over to the many, but the pros and cons make no difference in the fact that after the appearance of Thomas Cole, painting was no longer the province of only the collectors, intellectuals, and dilettantes. It had reached a mass audience.

Cole went back to Europe in 1841 and painted ruins and picturesque scenes in the Roman Campagna and Sicily. At home again he began another tract, *The Cross of the World,* but it was hardly beyond the stage of sketches when he died in 1848, at the age of forty-seven. William Cullen Bryant delivered the funeral oration, in which he said that Cole "reverenced his profession as the instrument of good to mankind," that his paintings "are of that nature that it

hardly transcends the proper use of language to call them acts of religion," and, very truly, "they were the sincere communications of his own moral and intellectual being." Asher B. Durand, who had bought one of the three landscapes by an unknown youth that were discovered by John Trumbull in the framer's window, painted a commemorative picture, *Kindred Spirits,* showing Cole and Bryant standing on a rock in the woods, communing with nature.

THE HUDSON RIVER SCHOOL

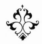

As a term identifying American romantic landscape painting of the nineteenth century, "Hudson River School" is of limited appropriateness, but it sticks. Insofar as it refers to a few painters more or less inspired by the example of Thomas Cole and working in the northeastern states, the term can suffice. But it does not recognize the diversity of these painters' interests, and leaves some eligible painters dangling on the geographical fringes. It is totally inappropriate for some younger painters, including Cole's only pupil, Frederic E. Church, who went as far afield as the Andes.

The usual time limits given for the Hudson River School are from about 1825, when Cole, its nominal originator, began working in New York, to about 1875, when a second generation began dying off or succumbing to European influences. But the artists included here were busy until the turn of the century when European innovations

put an end to interest in American landscape as such—an end explicable, also, by the taming of the continent.

The painters of the Hudson River School were never organized as a group with a program, although many of them knew one another and some of them worked together.

Critics during Thomas Doughty's lifetime used to call his landscapes the "sweetest" pictures in the exhibitions, and "sweet" still applies if we can rid it of the pejorative tinge it has taken on today. Doughty was a painter whose loving response to the countryside (where a solitary figure identifiable as our proxy often contemplates the view) is all the sweeter because it triumphs over a vestigial objectivity inherited from purely topographical treatment of landscape. Part of his charm is a certain innocence untainted by painterly sophistications. Doughty is called sometimes the first Hudson River master, and sometimes the prophet of the school. His claim to either title is that by a margin of a few years his partial discovery of an American philosophy of nature anticipated the fuller expression by the rest of the school. As a further claim, Doughty's landscapes were admired by the young Thomas Cole, eight years his junior, whose eminence as the first really great American landscapist is indisputable.

Born in Philadelphia in 1793, Doughty was the contemporary within a year of William Cullen Bryant (born in 1794). In 1817, the year when the precocious young lawyer published "Thanatopsis," Doughty was a successful twenty-four-year-old leather merchant who had changed his listing to "painter" in a Philadelphia directory. Four years later he abandoned the leather business and, in spite of a tight squeeze now and then, made a go of it as a painter until he died in 1856, aged sixty-three.

Doughty's father was a shipwright who apprenticed him to a leather currier at the age of sixteen. But in his earliest teens the boy had begun to draw under the stimulation of his spontaneous and intense love of nature. He was a passionate hunter and angler; the sketching kit was a frequent adjunct to the rifle and the rod in early nineteenth-century American art.

Except for a bit of advice from Thomas Sully, Doughty was self-taught, and in a country where pure landscape painting was as yet unloved, because unknown, his first commissions were for paintings of gentlemen's estates. But the same spirit that had visited Bryant and Doughty had also touched Americans in general, and they responded immediately to Doughty's reveries upon hills and streams and clouds when in 1826 he exhibited in the first annual exhibition of the National Academy of Design. He settled in Boston for the next four years—1826 to 1830—and at various times lived there, in Philadelphia, and in New York.

In 1837 he made a two-year trip to England and his paintings of the countryside sold readily. He made another trip, to England, Ireland, and France, in 1845 and 1846, and again he was well received. On both trips he tried to assimilate more of Claude than was good for him. He was never a sensational success, but people seem always to have responded (as we still do) to a naïveté and a genuine sensibility that make up for an undeniable monotony in Doughty's work. The more he painted, the less imaginative he became. He was a poet whose single meter is too simple to be effective except in small doses, but he was a poet for all that.

Asher Brown Durand is often called the typifying painter of the Hudson River School, and no doubt he has an edge over his colleagues for the title. His love of the American

countryside for its own sake, combined with a propensity for falling into romantically moralistic reflections during the contemplation of nature, make him pure Hudson River in spirit. And as a representative of the Hudson River technique, he was equaled only by Thomas Cole in his ability to paint a landscape in minute detail and yet to fuse this microscopic complexity into a restful entity.

Durand came late to painting, but he came with extraordinary preparation through his experience as one of the most impressively skilled engravers of his generation, either in his country or in Europe. He was born in 1796 in Maplewood (then called Jefferson Village), New Jersey, and learned the rudiments of engraving from his father, a watchmaker and sometime silversmith of Huguenot stock. The parents imbued young Asher with a Protestant piety that he never abandoned; he always avoided drawing from the nude because any woman who would expose her body was, ipso facto, a bad woman and thus a contamination of the purity of art even though she might be posing for an allegorical figure of Virtue or of Truth.

But the family's Puritanism was gentle, not fanatic. Durand's father seems to have had an engaging impractical, poetic streak as well. Either not a very good watchmaker or not a very good businessman, he raised his family on the land, and Durand can be thought of as beginning life as a farm boy.

When he was sixteen he was apprenticed to the engraver Peter Maverick of Newark, and was soon so expert that when his apprenticeship ended in 1817 he became a member of the firm. This association lasted only three years, not because the young man was deficient in any way but because he was too good. In 1820, old Captain Trumbull was looking for the best man to engrave his tiresome but historically important and very popular magnum opus, *The Declaration of Inde-*

pendence. He chose the twenty-four-year-old Durand over the men who had trained him, and their jealousy broke up the partnership.

Durand worked for three years on Trumbull's commission and produced the largest engraving to that date in the United States, as well as one of such technical brilliance that he was recognized overnight as the foremost engraver of the country. We have lost sight today of the importance attached to these reproductive engravings made from paintings at a time when there were no photomechanical processes. The engraver was more than a mechanical eye and hand: he was a translator. To reproduce by a black-and-white mesh the textures and values and luminosities of a painting exacted a combination of aesthetic sensibility, technical knowledge, and manual dexterity, all at high levels. Engravings after paintings were given attention by critics as seriously as were the originals, and Durand's reproduction of Vanderlyn's *Ariadne* has been called superior to its model. This is an odd comment, since accurate translation rather than improvement would naturally be the engraver's goal, but it is true that Vanderlyn's languorous nude, etherealized by Durand, has a dreamlike air that mitigates the rather obtrusive model-in-a-studio quality of the painting.

Up until he was about forty years old, around 1836, Durand continued to do engravings although painting occupied him increasingly. He engraved subjects by Thomas Cole and Thomas Doughty (as well as some of his own) and in 1830 formed a project with William Cullen Bryant for a publication, The American Landscape, for which he would make engravings to be accompanied by Bryant's text. Only six of the plates appeared before the project was abandoned as a financial failure. But Durand was always busy with profitable commissions for the gift books that were popular during those years, and for bank notes and related papers.

He devised a vocabulary of allegorical figures with surrounding ornament that is still reflected in American currency, bonds, and stock certificates.

When, at forty, Durand began to give his major attention to painting, he had been for a couple of years under the patronage of Luman Reed—this just at the end of that remarkable man's life. Born in 1785, Reed began his career as a clerk in a country store near Albany but by the time he was twenty-eight was already on his way to a fortune as a wholesale grocer. After a false start collecting dubious old masters he became one of the first great patrons of American art. He turned the third floor of his New York mansion into an art gallery and commissioned, among other paintings, Thomas Cole's *The Course of Empire*. After he died in 1836 at the age of only fifty-one, his collection was established as a public gallery through subscription by his friends; it is now in the New-York Historical Society.

Through Luman Reed, Durand became a friend of Cole's, and although Durand's first paintings were rather pedestrian portraits, he began sketching in the woods, first in Hoboken (he complained that New York, with its teeming multitude of 250,000 souls and its five-story skyscrapers, stifled him) and then more ambitiously in the standard haunts of the other American landscapists—the Catskills, the White Mountains, the Adirondacks, and the Berkshires.

In 1840, with the financial help of Jonathan Sturges, who had been Luman Reed's business partner, Durand went abroad with Thomas Rossiter, John Casilear, and John F. Kensett. He saw museums in London, Paris ("another planet," where he was fascinated by Gothic architecture and horrified by libertinage), Rome, and Florence. He fought the influence of the old masters, but, in spite of himself, could not resist the tutelage by example of Claude Lorrain, and henceforth his American landscapes were infused with

Lorrainesque light. Back home, he became a favorite with a group of collectors, and in 1845 was elected second president of the National Academy of Design, of which he had been a founding member.

When Thomas Cole died, Durand paid tribute to him, as already noted, in *Kindred Spirits* (New York Public Library), showing the painter and William Cullen Bryant communing with nature. Bryant was always a paramount influence on Durand, whose most elaborate vision, an imaginary one painted in 1850 and now in the Metropolitan Museum, is *Landscape—Scene from "Thanatopsis,"* inspired by the lines beginning "Rock-ribb'd, and ancient as the sun."

In 1855, now venerable, Durand summarized his aesthetic principles as "Letters on Landscape Painting," in a short-lived magazine, The Crayon, published by his son. When he was seventy-three he quit New York and retired to his birthplace, where he built a studio and lived happily until he died in 1886 at the age of ninety.

John W. Casilear (1811-1893), like Durand, had been apprenticed to the engraver Peter Maverick, and was in demand as a banknote engraver. Durand helped him obtain other commissions. At the time of his European trip with Durand he was twenty-nine years old. He stayed three years, but worked another ten at engraving when he returned to New York, before he felt financially secure enough to devote himself entirely to painting. He was successful, and admired for the "serenity" of paintings that now seem, rather, to be little more than placid in a routine way.

Like Cole, Durand, and Casilear, John Frederick Kensett was yet another Hudson River painter who was trained as an engraver. Even more than his predecessors, this leader

of the second Hudson River generation carried into his painting the precise definition of detail with careful tonal modulations that is dictated to the engraver by the nature of his craft. Tightly detailed rendering does a great deal to account for the limited popularity of Hudson River painting today, when broad, fluent techniques are most admired. But this very tightness, combined with each Hudson River painter's individual sensitivity to American landscape, and his use of color in the expression of light, gives the school its special character, a character hardly approximated anywhere else in painting. Often considered trite, Hudson River painting in truth demands almost esoteric sensitivities for full appreciation.

Kensett was born in 1816 in Cheshire, Connecticut, and learned engraving from his English father and an uncle, Alfred Daggett, of New Haven. In 1840 he went—as an engraver—to Europe with Durand, Casilear, and Thomas P. Rossiter.* A backlog of orders from American patrons helped establish him, and he stayed for seven years, first working as an engraver in Paris, where he postponed his visit to the Louvre for three weeks, fearing that he could not survive exposure to the old masters. He did survive, but said later that his life really began when he discovered the wooded parks of England, in 1843. After further visits to France and a tour of the Rhine and Switzerland, he spent his last two European years in Rome, where he shared a studio with young Thomas Hicks.† They were an attractive pair of young Americans and endeared themselves to the foreign colony.

* Thomas Pritchard Rossiter (1818-1871), born in New Haven, was twenty-two years old at the time of this European trip. After extended study, he returned and settled finally in Cold Spring, New York, where he painted religious and historical subjects.

† Thomas Hicks (1823-1890), born in Newtown, Pennsylvania, and trained at the Pennsylvania Academy, became a successful portrait painter in New York where he settled in 1849 after several years abroad. His subjects—Lincoln, Henry Ward Beecher, Edwin Booth, and Hamilton Fish among them—are sometimes more interesting than his painting.

And Kensett was faring well at home, even in his absence. When he returned to New York in 1847 (by way of Venice and Germany) he had become a major reputation with the paintings he had sent back to the National Academy from Italy. He was elected to the Academy the next year and was continuously successful—and influential—from then on.

Kensett was a sociable, stable bachelor whose personal success was a tribute to a quiet attraction that is typical also of his paintings—usually small, always pellucid. Silvery skies, clear calm air, a pensive, delicate mood may be rather fragile charms in comparison with the response to natural forces that invigorated the work of the earlier men. Kensett often seems more to be remembering landscape, the parklike landscape of a cherished time and place, than to be working from immediate reference.

In 1866, on a western trip with Worthington Whittredge and Sanford R. Gifford,* he could not respond, as a painter, to the Rockies. He died in 1872, at the age of fifty-six, eminent and much loved.

Worthington Whittredge was an exception among Hudson River painters in being born in the Middle West. With such a start he should, for historical convenience, have become the most American of the mid-nineteenth-century landscapists, but he was nearly forty years old before he discovered himself as an American painter after a ten-year detour to Europe, and his discovery was never quite complete.

Whittredge had the distinction of being born in a log cabin (in 1820), although his family was even then building a frame house on their farmland near Springfield in the pio-

* Sanford R. Gifford (1823-1880), a great traveler, went not only to the West but to the Near East and Egypt. His paintings, however, no matter what their subjects, are never exotic in treatment. They closely resemble Kensett's in their pensive mood, their calm, and their gentle light.

neer country of southern Ohio. Until he was twenty-three he made a series of unsuccessful stabs in the direction of becoming an artist. He was apprenticed to a sign painter, tried to be a commercial photographer, and worked unhappily as an itinerant portrait painter. Then, in Cincinnati, he saw his first Hudson River paintings and was set on course as a landscapist. Within the next few years he made a local reputation, and in 1849—he was a year short of thirty—he went to Europe with the help of Ohio patrons.

Without even pausing in New York he went to London, Belgium, and Paris. Whatever he had hoped to find was missing. He heard that there were some young Frenchmen painting in the woods around Barbizon and he went there, but he was not attracted by their work. Then he went to Düsseldorf, where he thought he had found what he was after.

The Düsseldorf painters held a great appeal for Americans at just this time. Old-fashioned in its slickly finished pseudo-realism with its artificial, sentimental anecdotes enacted by well-scrubbed models posing as peasants in well-manicured scenery, and its historical pictures adapted from the German theater, the Düsseldorf formula was easy for a provincial artist to grasp. At the same time its technical polish could be accepted as a standard of European excellence. French painting was too varied, and too adventurous in ways that took a great deal of catching up with. And when it wasn't adventurous, when it was the standard stuffy Salon product, it seemed, like French life in general, regrettably lax in moral attitude. The Düsseldorf school primly avoided the nude; prim Americans felt at home in the German studios. They also felt at home with German people: the beer hall was more to their taste than the café.

In Whittredge's case, the appeal of Germany must have been increased by his experience of the German-American

life led by his Cincinnati patrons. He spent four years in Düsseldorf turning himself into a formula landscapist, then moved on to Italy and spent the next five there. But he never quite downed an uneasy feeling that perhaps Europe was not really the place for an American painter. When he came home in 1859 he went, the first day, to the New-York Historical Society, and there, faced by the paintings of Cole and Durand, he wept.

Thus he reached the point where he might have begun. He left for the Catskills and isolated himself in their recesses, luxuriating in a true poetry that revealed the artificiality of the Düsseldorf formula. In this untended forest a tree was left undisturbed wherever it fell instead of being cut up by peasants for firewood; underbrush and the litter of leaves and twigs covered the ground—half delighting but also disturbing Whittredge in comparison with the parklike German forests.

In the best of Whittredge's landscapes of this time, the observer does not so much participate in the miracle of nature as stand at a privileged vantage point catching the miracle unawares. But Whittredge was often frustrated by his inability to paint with the freshness that he felt; his Düsseldorf brush and palette insisted on marking his new efforts with the old stamp.

In 1865 Whittredge discovered, literally, a new horizon when he and Sanford R. Gifford, joined later by Kensett, accompanied a government tour of inspection to the Rocky Mountains. It was not the horizon of the mountains—although in his paintings they may loom in the far distance—but of the plains. He found a new poetry also in the western light. Much more than Bierstadt, the Düsseldorfer who was becoming famous and making a fortune with his paintings of western scenery, Whittredge saw the West with an American eye. But it had become an eye that still, for all its

native response, could not altogether retrain a hand that had acquired German habits. The Indians who roam Whittredge's plains are not quite pure: they have a bit too much the appearance of actors in costume that characterized the peasants or personages of the Düsseldorf manner.*

Whittredge died in 1910 at the age of ninety.

When Frederic Edwin Church died in 1900 he was seventy-four years old, a rich man who had had a full and adventurous life. But his reputation as a painter had been declining for some twenty-five years. The Metropolitan Museum staged a diminutive memorial exhibition (of fourteen paintings), but even this was less a tribute to Church as a painter than a courtesy to Church as a patron who had been a founding member of the institution.

Then for sixty-six years there was not another Church show. His reputation continued to decline until he was hardly more than a residual name in a period of American art history that seemed dull and trite in comparison with European developments. But in 1966 the Smithsonian Institution organized a large survey of his work, and Church emerged again as a major American painter. We have needed the perspective of a full hundred years (Church's best work

* Posing in costume, Whittredge gained an incidental immortality as the figure of the Father of his Country in Emanuel Leutze's *Washington Crossing the Delaware* (Metropolitan Museum, on indefinite loan to the Washington Crossing Park Commission, Pennsylvania). Leutze (1816-1868) is usually listed as an American painter, but he was born in Württemberg and, after having been brought to Virginia as a child, went back to Germany when he was twenty-four, married, and stayed on for nearly twenty years. After studying in Düsseldorf he set up a successful studio there, specializing in subjects from English and American history. In 1859 he returned to the United States, settled in Washington, and captured the commission for the mural *Westward the Course of Empire Takes Its Way* in the national Capitol. A good technician who combined conscientious historical research with idealistic modifications, Leutze served up the resultant dish in generous portions that do not compensate for its flavorlessness.

was done between the mid-1850's and 1870) to understand in the history of a vanished America the spirit that made Church a creative artist and accounted for his tremendous popularity. The same historical perspective helps explain his decline, and by doing so makes even stronger his position as one of the great expressive Americans of his century. He represented a moment of confidence in the heroic destiny of America, a moment when, to Americans, it seemed that the promise of the ages was on the brink of fulfillment, a moment all the more poignant in retrospect because of its innocence.

It was a moment when scientific discovery and religious faith seemed to have joined hands: geology was a harmonious confirmation of the biblical story of the Creation; physics merely explained the practical forces that put God's original miracles into the service of man. The industrial revolution, represented by new machines that could carry people across the continent and others that could work faster than hundreds of hand laborers, seemed all promise and no problem. There was in America a sense of release, of opening up, of expansion, in which the intellect and the spirit found their physical counterpart in the vastness and richness of a continent no longer mysterious but still only half known, a wilderness no longer uncharted but still suggestive of the primeval miracle—and ready to share that miracle with all of us.

Church, born in 1826 in Hartford, Connecticut, was the only surviving child of a wealthy insurance adjuster. He was not interested in a conventional career; he enjoyed working with his hands, and his study of drawing under local teachers may have been a compromise with his mechanical aptitude. But his first experiences with landscape were so vivid that at eighteen he set up residence in Catskill, New York, to study as the only pupil of the great man of the day—Thomas Cole. The next year he exhibited a Hudson landscape at the National Academy, where, among other places, he exhibited

from this time forward as long as he was interested in submitting.

He knew nothing of Turner (an old man at this time), but he was increasingly preoccupied with light as the element that bathed all nature in color—something Cole had never understood. Whatever New England offered in the way of stormy skies and spectacular sunsets, Church seized upon. What it had in the way of mountains for climbing, he climbed. He yearned toward the vast, the phenomenal, and the exotic, hardly understanding this yearning but half expressing it in paintings such as *Moses Viewing the Promised Land* (1846; Private Collection) where, in an oval less than ten inches high, he tried to transform the landscape he knew into a boundless vista studded with crags and palm trees. He was twenty years old.

At the end of the next year, 1847, he completed nearly three years of study with Cole and moved to New York. When Cole died a few months later, Church planned a large allegorical picture as a tribute, but never completed it. He traveled restlessly, ranging as far north as the Bay of Fundy, as far south as Kentucky, and as far west as the upper Mississippi, making sketches from which he later synthesized paintings in the studio. He painted a great deal, exhibited widely, and his pictures sold readily. In 1852 his *New England Scenery* (painted in 1851, and now in the George Walter Vincent Smith Art Museum, Springfield, Mass.) brought 1,300 dollars, his best price so far but not a sensational one, and his *Natural Bridge* (University of Virginia, Charlottesville) was exhibited at the Royal Academy in London. But these successes were only preliminaries to the great adventure that Church had been seeking. He found it the next year, in 1853, just as he was turning twenty-seven.

His friend Cyrus W. Field (1819-1892), who was seven years older, had already accumulated a fortune in the paper

business and chose this year to retire. (The retirement did not last long. This was the same Cyrus W. Field who the next year conceived the idea of the first Atlantic cable and finally succeeded in laying it.) Field and Church had been traveling companions in the Middle West, and now Field asked him to come to South America, where he hoped to find a brother who had vanished into that continent. In late April the two young men arrived in Barranquilla, Colombia. When they reached New York again six months later, Church had seen Colombia, Ecuador, and Panama—jungles, volcanos, and the Andes.*

During the next three years he exhibited South American landscapes painted from sketches made on the trip, but in spite of public interest in their exoticism Church had not yet managed to assimilate the experience. The landscapes look a bit like New England in disguise or, at their most successful, like dramatically tinted geological studies. His great success, which established his reputation internationally, came during these years with a North American subject that Thomas Cole before him had considered but had decided he could not cope with: Niagara Falls. Exhibited in New York and London in the spring of 1857, it had a tremendous success. As a painting, *Niagara* (now in the Corcoran Gallery of Art, Washington) is disappointing today, partly, perhaps, because it has suffered damage and repairs but largely because in spite of being daring in its way—a picture of sky and water at a time when landscape painting was a mass of detail—it seems a tour de force of realism rather than a creative expression. But for the public at that time it combined the allure of tourism with the spirituality of a national

* As an explorer-painter, Church was inspired by the example of the German explorer-scientist Alexander von Humboldt, whose record of explorations in Central and South America in 1799-1804, and efforts to discover unity within the complexity of nature, were translated into English shortly before Church's first South American trip.

symbol, and when it was exhibited in England Ruskin admitted a little grudgingly that there was such a thing as American landscape painting.

Fresh from the success of *Niagara,* Church made his second trip to Ecuador, this time traveling with another artist, Louis Remy Mignot (1831-1870), leaving in May and returning in August. They covered much of the same ground that Church had covered with Field, but this time Church was coming back to an experience that had been too rich to comprehend, and this time he absorbed it. Like Turner—of whom he was still ignorant—he was obsessed with fire as the reigning element, and he found it triumphant in volcanos and the sun. Our temptation to keep comparing Church to Turner, however, is misleading. Church had no concept of the cosmos as a metaphysical abstraction. He continued to think of landscape in terms of Thomas Cole's minute realism, even when he was constructing a panorama of the Andes with peaks, valleys, waterfalls, rainbows, storms, idyllic crannies, and (as we shall see) a bit of Christian symbolism included to top things off. Nor was Church a semipantheist like some of the Barbizon painters who were his slightly older contemporaries. He did not see nature as an animating spirit. Rocks, skies, rivers, falls, trees, and the sun were parts of the catalogue of geological and botanical fact that all together confirmed the existence of the single God of the Bible. Sunsets and storms in the Andes verified the words of the parson of the white-steepled church on the village green of New England. Nature, however, did not sing the praises of God; it was simply God's handiwork, which men, as scientists, were beginning to understand in its fascinating history since the Creation.

Hybridizing planetary scale with geological observation, Church summarized his South American experience in a series of landscapes during his peak years—up to the late

1860's. The finest of these paintings might be *Rainy Season in the Tropics* (1866; New York, Middendorf Collection) or the Metropolitan Museum's *The Heart of the Andes,* of 1859, which was far and away his most spectacular success. It was purchased by William K. Blodgett for ten thousand dollars, at that time the highest price ever paid for a painting by a living American and still a very high price if translated into today's values. When it was exhibited in New York it brought in six hundred dollars a day in admission fees. People stood in line to enter the darkened room hung with palm leaves brought up from Ecuador; the painting was illuminated by the light of gas jets directed onto it by silver reflectors. The newspapers gave column upon column to the occasion.

Exhibited in London (where the Pre-Raphaelites were at the height of their success), *The Heart of the Andes* also attracted crowds, but it was appreciated much in the spirit of the panoramas that had been popular earlier in the century. The painting in truth owes much to this kind of picture, which, covering the wall of a circular enclosure, told a long continuous narrative or surrounded the spectator with an illusionistic representation of some famous site, such as Versailles. Visitors were urged to observe *The Heart of the Andes* through opera glasses or at least through a circular metal tube, wandering over its surface much as one might try to take in the details of an actual landscape from the peak of a distant mountain.

The conventional objection to the picture and to the rest of Church's best paintings is that while they may be fascinating bit by bit, and staggering in the copiousness of their descriptive detail, they do not hold together as entities when regarded as a single surface. Whether or not this objection is valid depends upon the degree of one's immersion in the aesthetic precepts of traditional French and Italian painting. It perhaps takes a clearer and more independent eye to

enjoy Church than it does to enjoy his contemporaries in France and England.

In the year of this climactic success, Church was thirty-three years old. For another dozen years, anything he exhibited made news. He continued to travel in the United States, and in 1859 he went to Newfoundland and Labrador, but the icebergs never took on in his paintings the power of his volcanos. From late October 1867 to late June 1869 he was all over Europe and the Near East, but great patience is required to find much interest in the paintings that came from this lengthy excursion. He took oddly little interest in London, spending only a week there at the beginning of his trip and only four days more at its end. He spent more time in Paris, where *Rainy Season in the Tropics* was exhibited in the Exposition Universelle—the Paris where Courbet, seven years older than Church, was the grand old man of realism, and Manet, Church's junior by six years, was the *enfant terrible*—but his sights were leveled at Egypt, Greece, and the Holy Land.

After the Andes, everything must have looked small to him. Quite possibly his own synthesized visions of those mountains had so colored his imagination that henceforth no real world could excel or even match them. Church's Egypt is inconsequential, his Greece a rocky map spotted with uninspiring broken buildings. But in the Holy Land he found a subject for his last great success: *Jerusalem from the Mount of Olives* (New Hampshire, Private Collection). Exhibited in New York in 1871, it attracted crowds comparable to those that had come to see *The Heart of the Andes*.

Church's decline as an artist and as a public figure had a double cause. A physical explanation is that around 1876, when he was fifty years old, he began suffering from an ailment diagnosed as inflammatory rheumatism that eventually cost him the use of his right hand. But his paintings had

developed internal weaknesses earlier than that. When, in 1862, he had painted into *Cotopaxi* (New York, John Astor Collection) the sign of the Cross formed by the reflection of the sun in a lake, this identity between God and nature was still intellectually acceptable in America. But when he repeated this device in 1877 in *Morning in the Tropics* (Washington, National Gallery), the interval of only fifteen years had seen not only the disillusioning tragedy of the Civil War but the rise of Darwinism as a refutation of the kind of harmony between science and religion that had been conceivable only a few years before. Church sensed the change: he seems to have tried to meet it with painting of more breadth, groping toward the abstract cosmic forms that Turner had achieved many years earlier. It was not in him, and by 1880 he had ceased all serious work. His prices dropped while critics shifted toward Europeanized taste. The collectors looked to France for their standards, and the new aestheticism of art-for-art's sake made Church look old-fashioned.

But while his career dwindled he continued to live a rich personal life. He had married in 1860, when he was thirty-four, and ten years later had begun construction of a villa on the Hudson—Olana, his "center of the Universe," a Persian-Victorian fantasy that today, as a national historic monument, is probably the best-preserved example of exotic architectural eclecticism in America. Olana and its embellishment with appropriate furniture and works of art became his creative activity. His wife, after the loss of their first two children in a diphtheria epidemic, bore four more. In 1883, Church began a series of Mexican journeys. His wife died in 1899 after thirty-nine years of marriage. He spent the winter in Mexico with his son Louis, and returned the next spring. He died a few weeks later just before his seventy-fourth birthday, in April, 1900.

It had not been too bad a life.

Albert Bierstadt's rise, decline, and fall is surely unsurpassed in its extremities by that of any other artist. Not long after the sale of Frederic E. Church's *The Heart of the Andes* for ten thousand dollars, which set the record for the highest price paid for a painting by a living American, Bierstadt tripled that figure. His castle-studio on the Hudson at Irvington was one of the sights of America. (It had thirty-five rooms.) At the height of his fame he was thought of as a national hero; Congress purchased his paintings for the nation, and foreign celebrities begged introduction to him. He was laden with medals from the Czar of Russia and the Sultan of Turkey along with others from less exotic monarchs in Austria, Bavaria, Belgium, and France. He died rejected and all but bankrupt, and recent efforts to refurbish his reputation have been only partially effective.

Bierstadt's success is easily explained: he was an expert illustrator (who looked like a very good painter) of the American Far West just at the time when its reaches—half-tamed wilderness between the flourishing cities of the Middle West and the roistering settlements on the west coast—were being opened up. The wagon trains of the pioneers and the Gold Rush of the forty-niners had established paths through these territories, but they were still a romantic never-never land in American and, even more, in European consciousness. Having staked an early claim on western scenery as his subject matter, and being possessed of a standard Salon technique for its presentation, Bierstadt offered an irresistible combination of topical interest and cultural cachet.

Bierstadt was born in 1830 in Solingen, Germany, near Düsseldorf. When he was two years old his family emigrated to New Bedford, Massachusetts, where he grew up. He demonstrated a precocious talent for business, but by 1853, when he was twenty-three, his interest in painting shifted from avocation to profession, and he returned to Düsseldorf to

study. During three years he grew proficient in a rather suety aspect of the school of picturesque genre that flourished there, depicting peasants disporting themselves in Alpine scenery. (His Indians in the Rockies never lost this Swiss flavor.) He spent his last European winter, 1856-57, in Rome with Worthington Whittredge, who was not impressed by him.

Back in America, Bierstadt tackled Hudson River subjects and explored the White Mountains with a camera. He was one of the first artists to make use of this handy helper. Only four years younger than Church, he began his career so much later that when Church's *Niagara* made its great success in 1857, the twenty-seven-year-old Bierstadt was in effect a member of the next generation of painters. He was much impressed with the attention paid *Niagara* and with the showmanship of its presentation.

A year later, 1858, the Federal government sent General Frederick W. Lander into the Far West to map an overland wagon route across the high plains of the North Platte and on to the Pacific. Bierstadt accompanied the mission as far as what is now Wyoming, where he stopped to spend the summer sketching the mountains, returning that fall to a studio in New York to turn the sketches into pictures by the recipe he had mastered.

He had learned in Düsseldorf an efficient formula for painting by tones, the formula that Corot in France made sublime by personal sensitivity. For Bierstadt the formula was a kind of hand-and-brush photography. But here one must pause, as is always necessary in the case of this artist, since Bierstadt's art, or craft, is too easily denigrated. In spite of all his shortcomings—his lack of imagination, his mechanical vision, the artificial, stuffed-specimen quality of the animals and Indians who pose for us in his cleaned-up wilderness—he did render paintings that by the very grandeur of

their natural subjects, the valley of the Yosemite and the sweep of the Rockies, cannot be dismissed.

In 1863, Bierstadt's *The Rocky Mountains* (Metropolitan Museum) made him Church's competitor, and for twenty years his success was fantastic. He made several trips west. American critics and artists recognized Church as a more creative artist and a more American one, but Bierstadt's adherence to a familiar European formula in the presentation of unfamiliar American subjects made him the darling of the Continent and gave him a reassuring European aura for culturally timid Americans.

But a shift in European taste accounted, also, for Bierstadt's deflation. Coincidentally his castle, representing a large portion of his fortune, burned in 1882. He was fifty-nine years old in 1889 when a committee of New York artists appointed to select American paintings for the Paris exposition of that year refused his *Last of the Buffalo* (Washington, Corcoran Gallery), a bit of mawkish Americana that was out of step with the new international adoption of French aestheticism.

The committee was quite justified, where they might have been quite wrong in refusing one of Bierstadt's earlier landscapes. He had become by this time a sentimental depictor of animals and Indians in a picturesque vein devoid of either painterly tact or documentary truth. He lived out the remaining years of his life—he died in 1902 at the age of seventy-two—as a has-been.

Bierstadt and a number of painters who more or less followed his lead are sometimes called "The Rocky Mountain School," at the suggestion of James Thomas Flexner, the historian of American art. Certainly the designation is more appropriate than "Hudson River." Mr. Flexner suggests the following names as other members of the group.

Thomas Hill (1829-1908), born in England, had little

success as a painter of White Mountain scenery. But when he adopted the Yosemite Valley as an American Barbizon, he found ready sales at high prices for pictures that he turned out with remarkable speed.

William Keith (1839-1911) was a disciple of Hill's, and like him was brought to America from England as a boy.

Thomas Moran (1837-1926), also English-born, began his career as an illustrator in Philadelphia. He returned to England when he was twenty-five and was much stimulated by his first acquaintance with the paintings of Turner. Still, he was determined to be an American painter. Another to accompany a government exploration party, he found his subjects in the canyons of the Yellowstone and Colorado rivers. He painted them as dramatically as he could, and perhaps cannot be taken to task for having failed to capture the awesome beauty of these natural wonders. Paintings of both subjects were purchased by Congress (and now belong to Washington's Smithsonian Institution) for ten thousand dollars each. The excitement they generated contributed to the foundation of the national parks system.

George Inness was a wildly uneven painter whose work remains maddeningly divided between heavy pretension and poetic realization. Historically he marks the end of the native American landscape school as the first American painter who responded wholeheartedly to contact with the Frenchmen at Barbizon. He produced in the second half of his career a hybrid in which he consciously tried to harmonize the philosophical ideals of the first Hudson River generation with his personal struggle to ally himself with a religion. As a technician, he tried to present American landscape in the broad, coloristic terms of the rebel Frenchmen—including not only the men of Barbizon but the grand old rebel, Delacroix, as

well. At the end of his eccentric and emotional but determined course, Inness even produced some semi-impressionistic pictures.

Inness was born in Newburgh, New York, in 1825, but grew up in New Jersey, where his father, a prosperous merchant, had retired. The boy was epileptic (and failed in school as a result), and Inness in fact lived his long life—he died in 1894 at the age of sixty-nine—as a semi-invalid. He could not take long sketching trips in the wilds, but he could travel to Rome and Paris. His Europeanization, thus cultivated, had been seeded when, at nineteen, he studied for a while with Régis Gignoux (1816-1882). Gignoux, a student of the French Academician Delaroche, painted in America from 1840 to 1870, capitalizing on landscapes that in France were accepted as examples of exotic Americanism because of their subjects, and in America were accepted as prestigious examples of French traditionalism. Inness always insisted on discounting any influence that Gignoux had on him, maintaining that in spite of this early contact he was self-taught, but it is difficult to believe that a nervous, impressionable, unschooled youth of nineteen could not have been permanently affected by this association.

In 1847 (he was twenty-two), Inness went to Rome. He went again in 1850, and in 1854. Now twenty-nine, he was accompanied by a wife who was his mainstay (they had a large family, including a daughter whom he saddled with the given names "Rosa" and "Bonher"). They went to Paris and, living on the Left Bank, Inness received the impact of the established romantic revolution represented by the aging Delacroix, and of the revolution taking place in the woods around Barbizon. Gignoux's example, if only by contrast, had prepared him for both.

Returning to America, he was torn by aesthetic confusions as an artist and religious confusions as an individual.

After shifting churches several times, he became a Sweden-borgian, and although nature continued to be for him a manifestation of the Divine, he turned the Divine inward: always certain that he was a genius by the will and the gift of God, he regarded his art as a personal fulfillment rather than as a medium for the transmission of a message, as the earlier Hudson River painters had done. This is the essential difference that makes Inness an artist who believed in art for art's sake and for the artist's sake, presaging the twentieth century.

Although he was elected a member, Inness inevitably quarreled with the National Academy, where there were members who questioned his divinity, and in 1859 he began residence at Medfield, a village twenty miles from Boston, to cultivate the Boston instead of the New York market. He was forty-five in 1870 when he went for another four years abroad, living mostly in Rome and Paris.

On his return he set himself up in Montclair, New Jersey, and his star rose along with the new appreciation of the Barbizon school. Inness is really two painters—the late Hudson River painter that he was before the age of fifty, and the semi-Barbizon painter that he became after that. Altogether he painted about fifteen hundred pictures. He is possibly underrated in his first phase—*The Delaware Water Gap* (New York, Middendorf Collection), painted in 1857 when he was thirty-two, is a true gem of Hudson River painting—and he certainly remains, as a matter of critical habit, overrated in his second. In spite of his occasional successes in his late years, he is often a heavy-handed painter of dense, airless landscapes that, neither French nor American, reveal nothing much more than the limitations of an imagination that was more active than effective. If this heretical evaluation escapes strenuous objections from readers of this book, it could mean that Inness's inflated reputation is on the wane.

AMERICAN GENRE PAINTERS

In 1834 when Washington Allston saw some genre studies by William Sidney Mount, a youngster who had recently been elected to the National Academy, he was sufficiently interested to suggest that the author should study the paintings of Ostade and Jan Steen. Allston, the sage and the dean of American painters, trained in England and dedicated to the grand tradition, was more alert and more generous than his colleagues when he took a serious interest in these efforts by a young man whose recognition by the Academy had come through his more conventional efforts in history painting and portraiture. But even Washington Allston could not imagine a school of American genre home-born, home-grown, and self-sustaining. Mount conceived it. He found patrons, later on, who wanted to send him to Europe, but he was never interested in going there and never made the trip. Why travel? He was delightfully happy in rural Long Island, where he found the subjects he liked best in the course of his daily life as a gregarious bachelor.

Mount's birth year, 1807, shows that American genre painting was born between the first and second crops of American landscape. (Mount was eleven years younger than Asher B. Durand, nineteen years older than Frederic E. Church.) He was born to conviviality, since his father ran a

tavern in Setauket and his grandfather another in the nearby village of Stony Brook. An uncle, Micah Hawkins, found time to combine theatrical avocations with a grocery business and is credited with the invention of the blackface minstrel show. One of Mount's brothers was a musician and dancing master. Two others, Henry Smith Mount (1802-1841) and Shepard Alonzo Mount (1804-1868), were painters of sorts. Shepard Alonzo was a self-taught portraitist, and Henry Smith was a sign painter—but of such skill that he was elected an associate member of the National Academy, signs being, in the early nineteenth century, part fine and part commercial art.

Mount was seventeen when he was apprenticed to his brother Henry in New York. The National Academy opened its first school two years later, and he went to classes there. By 1832, when he was twenty-five, William Sidney Mount was elected an Academy member, on the basis of his religious-historical paintings and his routine portraits. Portraiture, however, bored him.

Whether New York bored him or irritated him, he returned to Stony Brook in 1836 (he was twenty-nine) to recuperate from an illness, and found the vicinity too good to leave again. He died thirty-two years later, in 1868, at his brother's house in Setauket, where he had been born.

Mount must have been a most engaging fellow. He was sincere in his belief that the life around him was worth painting for its own sake without sentimentalizing or heightening, but he was not obstreperous about the idea. For sketching excursions to the farms in the vicinity he rigged up a traveling horse-and-wagon studio at about the same time that Daubigny rigged up his floating studio to paint the gentle riverbanks of the Ile de France. When he needed models, his friends and neighbors served. In a meticulous technique he painted them sharing good moments of life in a world where

everything was sparklingly fresh. (He had no interest in romantic decay or picturesque disorder.) There is little drama in his pictures, but much warmth. Everything is simple and lucid, unquestioning, and now and then a bit too obvious. But even when the obviousness is obtrusive, even when the subjects seem trite because, over the years, other artists have worn them threadbare—even then, one need only remember that Mount once commented that Adam and Eve were foresighted when they left the Garden of Eden, since life had so many better things to offer. He found them on rural Long Island.

Mount was an amateur musician and invented an instrument describable as a reduced violin. There were fewer parts than Stradivarius would have approved of, but the instrument was easier to make, and Mount thought that the tone was just as good as any. He called it the Yankee Fiddle, or Cradle of Harmony. As a performer he was in demand at dances and community functions.

Mount painted country bumpkins moon-eyed with love, naughty boys engaged in harmless pranks or playing hooky from school, old cronies engaged in rustic concourse, and various other subjects that to today's taste are, in today's vernacular, corny. His contemporaries did not complain about triteness, but they objected to the lack of gentility. Mount did not care. And it is beginning to be apparent that beneath his ordinary subject matter there is a discernment of values that are comparatively esoteric even today. His picturesque settings, honestly set forth, are appreciative of the innate architectural quality of nineteenth-century carpentry, taken for granted by his contemporaries, adulated by ours.

At another level of perception Mount was fascinated by the American Negro, and if his picture of slavery is too idyllic —like the rest of his actors, Mount's Negroes are always happy—he recognized the physical beauty of Negro types

and was sympathetic to special racial sensitivities. On this score he could have made a splash in Europe if he had wished. Engravings from his pictures of Negro life were immediately successful in Paris, where they were in tune with the romantic interest in exoticism, but Mount made no effort to capitalize on the foreign market. He was content and fulfilled at home.

George Caleb Bingham led two careers simultaneously: he was a painter and a politician. Like Rubens's (although here any comparison between the two men must end), his contrasting activities were connected by an appropriate thread. Rubens, the princely artist, performed princely missions at international courts. Bingham the backwoodsman painted raucous backwoods subjects and stumped for his candidates (and for his own candidacies) as a flamboyant orator in a territory not long wrested from the wilderness.

Bingham was not born to the backwoods. He came to life in 1811 as the second son of a prosperous, even wealthy, tobacco grower on a plantation in Augusta County, Virginia. Eight years later his father lost everything after injudiciously guaranteeing the notes of a friend. He took his family (there were six children now and two more were born later) to Franklin, Missouri, just west of St. Louis, a brand-new town and the largest settlement between St. Louis and the west coast. There he quickly recouped his fortunes, but when he died, only four years later, the estate was mismanaged, and soon there was nothing for his family to live on.

Bingham the future artist was twelve years old when his father died. His mother tried to make ends meet as the mistress of a girls' school, the usual recourse of a destitute gentlewoman who could read and write (she was even possessed of a small library of English classics), but the project

did not flourish. In 1827, members of the community of
Franklin helped her acquire a farm, which her teen-age sons
could help cultivate. The harassed woman has come down
in most accounts as a hard taskmaster.

Little is known about young Caleb in the years most im-
portant to his decision to make painting his career. It is
thought that he was tutored by a man named Jesse Green,
who doubled as cabinetmaker and Methodist minister near
the town of Arrow Rock. The same combination of profes-
sions distinguished the Reverend Justinian Williams of
Boonville, and it was probably he who took Caleb on as an
apprentice for a year or two about 1827/28. In spite of con-
fusions between one account and another (including Bing-
ham's own) as to just what he was doing, and where, at just
what time, it seems safe to say that in his early twenties he
combined cabinetmaking, sign painting, the reading of law,
and perhaps a little preaching.

Choosing from this complexity of interests, he was en-
couraged enough by his attempts at portraiture to set himself
up in that profession in 1833, probably at Arrow Rock. He
had seen no painting except the few family pictures brought
to the frontier by the most prosperous settlers, but taught
himself a sharp, uncompromising, naïve style that marks him
in this early period as a first-class American primitive. Only
by hindsight, however, is this early work connectible with his
late flowering as a genre painter of great skill and originality.

He was an ambitious and energetic young man, already
setting his sights on the cities, with St. Louis as a beginning.
He became engaged to a young woman of good family, from
Boonville, Missouri, named Elizabeth Hutchison, and in
1836, when she was seventeen and he twenty-five, they mar-
ried. She bore him three children before she died twelve
years later in Arrow Rock. Bingham racked up a total of
three marriages: his second wife, Eliza Thomas of Columbia,

whom he married in 1849 just a year and three days after Elizabeth's death, died a lunatic in the asylum at Fulton, Missouri, in 1876. Less than two years later, aged sixty-seven, he married Mrs. Martha Livingston Lykins of Kansas City, with whom he enjoyed the last thirteen months of his life. He died suddenly in 1879.

Bingham at that time was professor of art at the University of Missouri, having been appointed when the School of Art was introduced in 1877. His political activities were too numerous for listing; some idea of their extent is suggested by the facts that in 1862 he was appointed state treasurer, a position he held until 1865, and that in 1874 he was president of the Kansas City Board of Police Commissioners. His political connections brought him a steady stream of portrait commissions. His portraits are sometimes superb, sometimes deplorable.

Bingham was late in finding himself as a genre painter, and before long managed to debauch his talent, so that his career as probably the finest American artist in that field stretched over only ten years or so, from about 1845, when he was thirty-four, through 1855. His political interests began before he turned thirty, and his sketches at political meetings, made for the fun of it, were the genesis of later paintings of county elections and campaigns including the stump speakers, the puzzled yokels, the horseplay, the top-hatted bosses, the Tom Sawyers watching the adults, and such incidentals as the occasional citizens besotted with the free whisky distributed by candidates at the polling places. But his great paintings show the life of the river. His finest of all, *Fur Traders Descending the Missouri* (Metropolitan Museum), showing an old man, a boy, and a raccoon in a dugout, floating against a misty background of island foliage and gentle sky, goes beyond the specific definition of time and place that must usually be accepted as a limitation inherent

in even the best genre painting, and becomes a lyrical, generalized expression of rough men and gentle nature in harmony.

Bingham's genre painting was a conscious, and fortunate, effort to capitalize on the eastern states' interest in the picturesque West. His scenes became best-sellers as engravings on the basis of their subjects rather than the distinction of his style—a style marked by sobriety (even in his raucous subjects), precision, and almost classical balance. He was a studio painter, synthesizing largely from memory scenes of river life that he had known as an adolescent. And he was self-taught—with less than three months' formal training in his craft in Philadelphia between March and early June, 1838.

Bingham's current eminence began during the 1930's when the American regional painters rediscovered the Middle West and propounded the life of that region as the solid core of American strength, investing it with a falsely gawky, homespun, frontier quality that, as observed by the youthful Bingham, had been genuine. Bingham's resuscitation survived the debacle suffered by regional painting during the 1940's, for he had also been discovered as a kind of backwoods Poussin, a master of the balanced disposition of figures in landscape or within architecturally bounded space—even though Poussin's boundaries were defined by classical temples and Bingham's by raw wood store fronts. The identification of virtues between these two artists is an exaggeration of Bingham's stature, but only an exaggeration, not a total falsification.

Shortly after his first success as a genre painter, Bingham also made his first success in politics. He was elected in 1848, when he was thirty-seven, to represent Saline County in the state legislature. He managed somehow to paint several pictures a year, to see them through as engravings and market them, to travel as far as New York and New Orleans (and

intermediate points), and at the same time to be an active politician who threw his weight into the antislavery movement. By 1856 his sights as an artist had gone beyond the Atlantic, and he took a year off from politics to polish himself as a painter. He was forty-five.

He landed at Le Havre, went immediately to Paris, and headed directly for the Louvre. Disappointed, he left for Germany within a month. Bingham, like several other mid-nineteenth-century American artists, went to Paris expecting to find it the cradle of inspiration inherited from the past, but instead was confused by the city's tempo and appalled by its morals. And like others, he took refuge in Düsseldorf, where he found what he wanted. But what he wanted, alas, turned out to be his ruination as well, symbolized by *Jolly Flatboatmen in Port* (St. Louis, City Art Museum), a second variation on an early success. The picture, slick and complicated, looks as if a native Düsseldorfer had painted it from a verbal description supplied by an American tourist who, in turn, remembered not the flatboatmen themselves but was recalling, not very accurately, Bingham's first telling of the story. Nothing in the picture rings true.

Bingham stayed in Düsseldorf until the end of 1858, returned to America in January, 1859, and plunged into a wildly crowded schedule of portrait painting, politics, and official business with art committees. This was his life for the twenty years that remained to him—a full life, spent shuttling back and forth between Missouri and Washington. But his life as a major American artist (at least as we see his work today) had ended.

Richard Caton Woodville (1825-1856), who might have become America's best genre painter, died before his thirty-first birthday. His death has been called suicide, but nothing

we know of his life prepares us for such an end. On the other hand, we know very little, really, about his personality. We know that he had money, talent, and love—or at least a wife and a mistress. Legend has given him a roistering youth, but even if this were known to be true, thirty is still an early age to have tired of life so desperately.

Woodville's father was a prosperous merchant in Baltimore, where the family held a good social position. Creditable drawings done in Woodville's boyhood are extant, but his family was not responsive to the idea of art as a career. Records show that he was enrolled as a medical student at the University of Maryland when he was seventeen, but other evidence shows that he must have spent as much time drawing as doctoring. A scrapbook kept by one of his friends, Dr. Stedman R. Tilghman, has preserved sketches Woodville did of the inmates of an almshouse and some very lively impressions of his professors lecturing, as well as some careful portrait drawings that look as if this young American had discovered Ingres—an impossibility. Tilghman was one of several of Woodville's contemporaries who have left us comments on his good looks, his wit, and his attractive manner.

Woodville's firsthand acquaintance with paintings came largely through the collection of Robert Gilmor in Baltimore, which included examples of Dutch genre paintings. From the first, Woodville seems to have been most interested in such subject matter. It is not certain just how long he remained a medical student, but by the time he was twenty he had learned enough about painting to have a picture accepted in the National Academy. Earlier that year—1845— he had secretly married the daughter of a prominent doctor. His family forgave the escapade and, impressed by his introduction to the Academy (or despairing of leading him into channels more respectable than a painter's career), sent the young couple to Düsseldorf.

Woodville became a technically expert painter in the Düsseldorf tradition of miniaturistic detail, with the difference that he never sacrificed the sensuousness of pigment to the tight, glossy, surface favored by the Germans. He is closer to his seventeenth-century models than he is to their other nineteenth-century descendants. Never much interested in exhibiting in Europe, he sent his paintings home, where they were enthusiastically received. Twice he came back to Baltimore, where he sketched American subjects for development in Europe, which was more compatible to his chosen mode of life—whatever it was—than Baltimore or New York could have been. In addition, there was a complication in his personal relationships as far as Baltimore was concerned. When he was twenty-five, Woodville deserted his wife for a half-German, half-Russian art student named Antoinette Schnitzler, whom he later married. By 1851, he and Antoinette had left Germany. They set themselves up in Paris, and thereafter lived in France and England. He died in London in 1856 of an overdose of morphine. His death certificate, recently discovered, was issued after a post-mortem examination and describes the death as accidental, the drug having been "medicinally taken."

Woodville is the best draftsman of all American genre painters, and his color is both rich and fresh. Somewhat in the manner of a director in the theater, he was skillful in the selection and combination of expressive attitudes for the performers who enact his scenes. He made a serious, and generally successful, effort to invest each character in his little dramas with an appropriate individual response to the situation. His shortcoming is that he himself seems to have had no particular response, sympathetic or otherwise, to the stories he tells, and thus leaves us with none, although we admire the taste and clarity of the telling. What we know of Woodville's life indicates that he lived it fully. Yet Woodville the artist seems curiously shut off from experience.

Eastman Johnson (1824-1906) was born seventeen years after William Sidney Mount, the father of American genre painting, and twelve years before Winslow Homer. He lived for eighty-two years, and to a large degree he followed Mount's lead while to a lesser degree in a few pictures he approached Homer's stature. But in neither case was the degree sufficient to make Johnson, today, except in a very few pictures, anything better than a disappointing painter.

He was born in rural Maine, but he was not a country boy. His prosperous, wellborn father was a successful politician with influential friends in Boston and Washington. After brief study with a Boston lithographer, he set himself up as a portraitist, sponsored by his father's friends. He was an established, virtually self-taught professional at eighteen. But wisely and modestly he limited himself to the medium of black and white crayon.

To learn to use color, he left, at the age of twenty-five, for Düsseldorf. Unlike most of his student compatriots, he was disappointed in the city. After Boston and Washington it seemed drab, and he complained that the women were homely. He went to The Hague, where he spent more than three years, and then to Paris. This city he was prepared for, loved, and was ready to make good use of. He entered the studio of Couture, Manet's master. But his mother's illness called him back to America. He had been in Europe six years.

Equipped now with a professional technique that he employed with facility, he painted sentimental genre scenes with success. In 1859, aged thirty-five, he made a national sensation with *Negro Life in the South*—which was rechristened, by popular acclaim, *Old Kentucky Home* (New-York Historical Society)—showing the happy condition of slavery. It is a remarkably blind picture considering its date; its insipidity makes "Uncle Tom's Cabin" resemble something by Aeschylus. But its success enabled Johnson to set himself up in a New York studio, where, during the Civil War, he

painted cheerful scenes of wounded soldiers, devoted nurses, and the like. A master of the cliché, he was naturally popular with a mass public.

These judgments, perhaps overharsh, seem refuted by some of Johnson's work in the 1870's, when he spent summers on Nantucket Island and in his native Maine and painted figures in the countryside with a richness and breadth that suddenly reveal his ability to control objective effects of light. These pictures tie him to Winslow Homer. Here and there, in an interior, he even suggests the great American master, Thomas Eakins. But the final comment on Eastman Johnson is that his best paintings were sketches for projects that he visualized in large format, highly finished. They were not found attractive by patrons. Neither Johnson nor his clients understood the nature of his potential.

ECCENTRICS AND INTELLECTUALS

The antipodes of the creative temperament are inspired eccentricity and scholarly intellectualism (romanticism and classicism, revolt and conformism, personalism and universalism), which, of course, are brought into balance by most painters, no matter on which side their art tends to be weighted. Mid-nineteenth-century America produced its share of both eccentric and intellectual artists, but the share

was not large, since the extremes in art can flourish concurrently only when a long and continuously productive tradition stimulates one and supports the other. America in the mid-nineteenth century did not offer such a tradition, but some eccentrics were generated by the unquenchable effervescence that is the root of creative expression at any time anywhere, and some intellectual painters expressed American efforts to direct this energy into accustomed European channels. This chapter (and very nearly this book) concludes with notes on a few of these antipodal artists—and on Winslow Homer.

John Quidor (1801-1881) was a contemporary of the earliest Hudson River landscapists and American genre painters—artists, in both cases, whose American subject matter brought them great popularity. But Quidor's pictures illustrating American legend and folklore failed to catch on. This is difficult to understand, since he found so much of his material in Washington Irving's popular stories. The usual explanation, by hindsight, is that Quidor did not seem to the public to be a skilled artist. He painted with eccentric freedom at a time when polished surface and precise detail were standards of technical excellence.

Quidor is represented by record with only forty-five paintings, and of these only thirty have been located today. Their special flavor combines rollicking humor with an undefinable yet inescapable undercurrent of the sinister, great comic verve with latent morbidity. One feels that Quidor must have been a bizarre personality, perhaps unstable, but this is sheerly an impression, unless the spotty, incomplete record of his life is some kind of substantiation.

He is known to have been born in Tappan, New York. His father is thought to have been a teacher. When he was

ten, the family moved to New York City. Later he was apprenticed to John Wesley Jarvis, the portrait painter (not an iota of his teacher's influence is apparent in Quidor's work), and in 1827 was listed as a portraitist. During his thirties and again in his fifties and sixties he produced the gusty narrative pictures, violent beneath their comedy, for which he is admired. During the interval of his forties, however, he turned out a series of curiously ill-drawn large religious compositions approximating the manner of Benjamin West. They might represent an effort to attract the public, or possibly a personal crisis of some kind. Neither explanation seems quite satisfactory.

Quidor no doubt supported himself as a sign and banner painter. When he was seventy, or shortly before, he moved to his daughter's home in Jersey City, and there spent the last years of his life, dying at eighty. If he painted during this final decade, the pictures are either lost or have not been recognized.

The meager known outline of Quidor's life is usually padded out with some appropriate but altogether unsubstantiated anecdotes. He remains unknown as a man and isolated as a painter in the history of American art.

William Rimmer (1816-1879) was one of the seven children of an extreme eccentric, even, by the time of his death, a madman, who believed that he was the lost Dauphin. Rimmer himself was eccentric, if never to the point of madness, and believed that his father had indeed been the Dauphin, and that hence he, Rimmer the artist, was the rightful king of France.

"Rimmer the artist" is an incomplete description of a man who at one time or another during his life was a typesetter, a soapmaker, a cobbler, and a physician of sorts. As a

doctor, as in his other professions, he was self-taught. He read medicine, and made independent dissection of cadavers; after practicing for some years he was accepted in a medical society that gave him a dubious diploma. As a doctor he was a failure: he somehow did not inspire confidence in his patients.

Rimmer was born in England, but his father brought him to America when he was two. When he was ten, the family moved to Boston from Nova Scotia, living in poverty while the father (a cobbler) fed the children on stories of wild romance in order to prepare them for their eventual reception into their rightful royal position.

Rimmer was primarily a sculptor. He painted little, and all but in secret; what painting remains is, for the most part, in very bad condition. But he was a brilliant anatomical draftsman. He had no use for the gracefulness of the female nude. His males, drawn as if flayed, assume every attitude of anguish and violence. All, somewhat disturbingly, are without genitalia; Rimmer's eccentricities included this inconsistent bit of modesty. The drawings were widely used as models, and Rimmer, for all his wildness, was respected in Boston as an art lecturer. He supported himself by teaching young ladies—refusing male students and, as well, avoiding the company of other artists.

Even under these limitations, his school in Boston built for him a reputation as a teacher, and he was offered the good position of director of the art school of Cooper Union in New York. He accepted it, moved to New York, quarreled with the board (he refused to follow the school's policy of teaching commercial art), and returned to Boston. He remained poor until the end of his life, always involved in wild business schemes and the development of inventions that never worked—thus concluding his life much as it had begun in the slums of Boston when his father had, among other

experiments, tried his hand at silk-worm culture and electrical gadgetry.

Rimmer's paintings perhaps had allegorical meanings for him; that he left no keys makes them pure fantasies. His *Flight and Pursuit* (Boston, Museum of Fine Arts) may well be the eeriest painting in American art. A dark-skinned man rushes with demonic energy through a Moorish palace while, in one of a series of receding bays, a cloaked figure in the same violent attitude echoes him, and an unexplained pronged shadow enters the picture on his heels—descriptive of no recognizable object, but surely connected with the second title Rimmer gave the picture—*On the Horns of the Altar.*

Martin Johnson Heade (1819-1904) abandoned his headquarters in New York, a city he had never cared much for, and settled in St. Augustine, Florida, in 1881, when he was sixty-two years old. When he died at eighty-five he was forgotten, although he had continued to supply an inconspicuous market with landscapes and flower paintings. He was rediscovered, with enthusiasm, in the 1940's, as an artist connectible with Audubon, the Hudson River School, American still-life painting, and surrealism. With these ties, both pre- and post-mortem, obviously he cannot be pigeonholed.

Heade was borne in Lumberville, Pennsylvania, to one of those farm families that during the nineteenth century became prosperous landed gentry. His father gave him a couple of years in Italy during his teens, but the experience left no mark on him as an artist. Back home, he painted semi-Hudson River landscapes, depending as much on imagination as on actual scenes. When he was forty he met a Reverend J. C. Fletcher, an amateur naturalist who had been to Brazil, and in 1863-64 the two men went to that country together.

Heade, who as a boy had been fascinated by humming-birds and had taught them to drink water from his hand, planned a book that in this special area would have paralleled Audubon's "Birds of America." Like Audubon he took his studies to London for reproduction, but when he was dissatisfied with the proofs he abandoned the project. His paintings of these vivid little creatures show them placed rather artificially, as if in the display cases of a natural-history museum, against backdrops of foliage, flowers, and landscape.

Between 1866 and 1881 Heade's nominal headquarters were in New York, but he was always traveling, and at one time or another he went across most of the United States, making further trips to South and Central America as well. His flower paintings, often of exotic specimens, show blooms against luxuriant backgrounds or lying on rich stuffs. His romanticized landscapes—a few seascapes are the best of these —have a transfixed, rather sinister quality that accounts for the grafting-on of surrealist associations.

Heade's interest in South America brought him the friendship of Frederic E. Church (seven years his junior), who scolded him for leaving New York. But Heade, an unusual fellow, was not much interested in being at the center of things. He seems to have been one of those happy people who are more interested in doing what they want to do than in attracting attention to what they produce.

William Page (1811-1885), while following what sound like *retardataire* ideals, was one of the most original of American artists. He is also all but a lost one: his works have darkened to such an extent that only a few are left to represent him.

Born in Albany of an eccentric father, Page was brought with his family to New York when he was nine, and by the

time ne was eleven was winning drawing prizes. At fourteen he was taken into the law office of Frederick dePeyster, who, as a member of the board of the National Academy, took some of Page's drawings to its president, Colonel Trumbull. Trumbull, engaged in ossifying the institution, advised Page to stick to the law where he might make some money, but Page entered the Academy classes anyway. He managed also to make a stab at preparation for the ministry, which was effective only in convincing him that he could no longer accept Christian doctrine.

From the first, Page's interest in painting combined a revival of the past with the application of a dozen or so theories including the neoclassical belief that painting should refer for its model to sculpture rather than to life, and some less tangible Swedenborgian principles. Probably through Samuel F. B. Morse he became interested in Washington Allston's out-of-fashion veneration for the rich color and grand composition of the Venetians, and through Allston he found Titian as a final model.

Working at portraits and historical subjects in Rochester, Albany, and Northampton, Page supported himself until, at twenty-two, perhaps even earlier, he married a pretty girl named Lavinia Twibill, the daughter of an actor, and set up a studio in New York. He was elected to the Academy on the strength of a successful picture of Lavinia and their baby, but was not very successful in selling his work. In an effort to change his luck on Allston's home ground, he moved to Boston in 1843—the year of Allston's death—and stayed into 1847. Divorcing Lavinia when she became pregnant after an encounter with an anonymous stranger, he married another pretty girl. In Boston he acquired a reputation with the local intellectuals as a fine talker on the subject of art, but still sold very little, and returned to New York.

For twenty years he had dreamed of Europe, and at last,

in 1850, armed with commissions to copy paintings by Titian, he went to Italy. He copied the Titians, darkened varnish and all, under the delusion that Titian had painted them thus. He also turned out historical and allegorical pictures of his own, in the same darkened manner. In a second marital disaster his wife left him, eloping with a lover, was returned to him by the police, but eluded him again. (After a series of amorous adventures, she married Peter B. Sweeny, the notorious lawyer to Boss Tweed.) For his third wife, he chose an older and plainer woman, making his selection during the divorce proceedings.

In spite of his erratic history, Page was always held in great respect by such figures as Robert and Elizabeth Barrett Browning, his friends in Rome, and the whole coterie of Boston thinkers. His nudes in the manner of Titian were bothersome to a prudish America, but he was eloquent in their defense. In 1871, when he was sixty, he served a term as president of the National Academy, which he had always worked to reform. His technical experiments have cost us much of his work, but such of his paintings as have not deteriorated to the point of unrecognizability have a gravity, a sobriety, and also a sensitive warmth (this is most true of his portraits) that set them apart in his time and establish him as one of the most admirable of American artists.

William Morris Hunt (1824-1879) was a tragically defeated painter and a strong force in the re-Europeanization of American taste in the latter nineteenth century. An intellectual and something of an aristocrat, he would probably have been happier as a patron and critic of art than as a creator.

Hunt was born in Brattleboro, Vermont, to a prominent family. (His father was a Congressman, and his brother,

Richard Morris Hunt, became a pre-eminent architect in the eclectic Beaux-Arts style, the Grand Hall of the Metropolitan Museum being among his designs.) He attended Harvard and also had painting lessons from a family friend. His widowed mother thought him too delicate to return to college after his junior year and moved with her children to Europe. Hunt found Düsseldorf wanting, and went on to Paris to study under Couture. He also discovered Barbizon and made the acquaintance of Millet, whose broad, rather soft technique triumphed over Couture's as the basis of his style, perhaps to its detriment.

When he returned to the United States after eleven years (in 1855), Hunt saw himself as a missionary for the elevation of American taste to French standards, with the Barbizon painters—then the radical young group—at the top of his list. Settling first in Newport and then in Boston, he made converts, as their teacher, of such wellborn intellectuals as John La Farge and Henry and William James.

As a painter, Hunt held every promise but achieved almost nothing. He was one of those artists whose intelligence, taste, and dedication are always apparent but never fulfilled: he lacked the catalytic spark, whatever it is, that can turn a man like Courbet, a man of only moderate intelligence and faulty taste, into a master painter. Nor did Hunt attain adequate mastery at a purely technical level. His potential and his defeat were summarized in two murals commissioned in 1875 and executed in 1878 for the state capitol of New York at Albany. The sketches, now scattered around in a number of American museums, are promisingly inspired with ideal grace and poetic elevation. But the murals themselves—allegories of day and night, symbolizing civilization routing ignorance—deteriorated so rapidly that they were soon indecipherable.

Hunt at least did not live to see this final defeat. Never robust, and always suffering under knowledge of his own

limitations as an artist, he executed the murals under the double pressure of an urgent schedule and self-doubt. He collapsed after their completion, and died a few months later, apparently a suicide.

John La Farge was an American gentleman who, in spite of talent, erudition, and an adventurous spirit, missed several boats that might have carried him to a position as an important nineteenth-century artist. The balance was wrong somewhere. The erudition, and possibly the gentlemanliness of which it was a part, countered the adventurousness during the century of all centuries when adventurousness was prerequisite for creation in the arts.

La Farge was born in New York in 1835, but as an adopted Bostoner he was a member of the intellectual circle that included Henry and William James and Henry Adams, whose struggles to reconcile American and European culture took them no further, in the field of painting, than a reverence for art-historical idealism while it was being demolished by the painters who amounted to anything in France. Where with luck he might have found his direction through the forces that were to birth impressionism, La Farge was trapped in the literary quagmire of Pre-Raphaelite sensibility, and instead of becoming part of the new century he followed both the academic-Renaissance tradition, which had been embalmed long since, and the neomedieval revivalism that mistook an understanding of the past for an adventure in the present.

La Farge's father had been a Napoleonic officer and his mother's father had fled France during the Terror. He first studied under his grandfather, Binsse de Saint-Victor, a miniaturist. The family cherished its French tradition, and although he was not yet certain that he wanted to be a painter, La Farge was sent to Paris when he was twenty-one to study

under Thomas Couture, that maddening academician who combined the stuffiest reverence for dessicated academic formulas and regulations with the production, now and then, of a portrait so richly painted of a subject so directly observed that one forgives him everything. In an occasional portrait La Farge shows that, like Manet, he understood and could adopt the best that Couture had to offer, but unlike Manet he accepted the bad with the good.

The narrowest miss of all for La Farge was that he did not know Manet, who was still frequenting Couture's studio at this time, and that he left France before the scandal of 1863 (the Salon des Refusés) that made Manet the center of a controversy that would surely have awakened the young American. As a very young man with a provincial's exaggerated respect for the Academy, La Farge did not remain long enough in France to learn to ask the questions that finally discredited outworn standards. He returned instead to an America that, for all the humanistic awareness of intellectuals like the Jameses and Henry Adams, was still busy catching up with an aspect of European intellectualism that was moribund. Henry Adams later wrote of how much he owed John La Farge, saying that he had "sat at his feet since 1872" admiring "a mind complex enough to contrast against the commonplaces of American uniformity . . . a mind opaline with infinite shades and refractions of light." La Farge affected readers and audiences the same way in his writing, lecturing, and teaching, but it was still a matter of catching up.

The architect H. H. Richardson recognized that La Farge's combination of conscientiously applied talent and scholarly reverence for the past should make him ideal as a muralist for his, Richardson's, neo-Romanesque architecture, and invited him to decorate the interior of Trinity Church in Boston. This La Farge did with great success. From that time (1876) on he executed numerous murals and designed

stained glass that was admirable in its rejection of the debased pictorial style then in vogue and its return to the principles of medieval pattern and craftsmanship—although still cursed with the taint of the second hand. As a muralist he combined a determined naturalism with the knowledgeable application of tried-and-true compositional recipes that had filtered down from the Renaissance through the academies. One respects his murals as the best of their kind by an American, but that is about the extent of it.

And yet all this time there was a second La Farge, the La Farge of personal sensibilities expressed in intimate and poetic terms. In small paintings done for his own pleasure, La Farge suggests Corot, Manet, Fantin-Latour, and even, in a special context, Gauguin. It is never quite fair to use a set of established artists as yardsticks for judging the merit of another, but these comparisons are unavoidable when an artist's work, like La Farge's, seems to struggle for release in precisely those directions. When his most ambitious work is forgotten and his charming sketches and small paintings are seen as a group, La Farge might be a young artist on the point of release into greatness.

In 1886 he went to Japan, and in 1890 made his famous journey to the South Seas in the company of Henry Adams—an unlikely visitor to those exotic spots, whom one imagines impeccably attired for tea while surrounded by the half-naked natives. La Farge's paintings and watercolors of the islanders and the landscape, while habitually admired, are usually not much more than well-delineated records of types and customs. But here and there—in a mountain that turns purple, a sea that goes red, or in an exaggeratedly brilliant flower patterned against unnaturally green foliage—La Farge hints at Gauguin in more than the coincidence of subject matter.

La Farge and Adams returned from the South Seas in 1891 by way of Paris, where they saw an exhibition of painting by Gauguin, who had just left France for his first journey

to Tahiti. La Farge—who was already fifty-five—was not impressed. Gauguin remained for him only "that crazy Frenchman" who had traipsed off a bit late for an adventure that La Farge had already concluded. La Farge's tragedy was that all his life he remained a sensible Bostonian who, for all his intelligence, somehow always traveled looking backward.

He died in 1910 at the age of seventy-five.

The concurrent schools of nineteenth-century American painting—native landscape and native genre—were fused and ennobled by a New Englander, Winslow Homer. Born in 1836, he was a long generation younger than the founders of those schools—say, Cole, Durand, and Mount. When he died in 1910, he had created independently an American expression that fufilled the American promise and, at the same time, paralleled, without imitating, first the realist and then the impressionist revolutions in France. But it must always be remembered about Winslow Homer that his greatness did not consist in his bringing American painting into line with French innovations, including impressionism (as a group of younger men began doing during his lifetime). His greatness lay in the independence of expressions that were generated by the force of his own time and place.

Insistence on this point is not a matter of chauvinism. The point is important simply because Homer's art is too frequently reduced in stature by the effort to see him as a second Courbet or a second Monet. He was neither: he was a first Winslow Homer.

He was born in Boston of a family with a long, sound, middle-class history. His boyhood talent for drawing indicated a practical career as a lithographer-illustrator, and when he was nineteen he was apprenticed to the most successful lithographer in Boston, John H. Bufford. He completed this

stint and celebrated his twenty-first birthday by setting out
as a free-lance illustrator. Two years later he moved to New
York, and although he studied briefly here and there he was
proud, the rest of his life, of having had no master after
"taking my nose off the lithographic stone."

At this time the most widespread medium for printing
illustrations in American magazines and papers was the wood-
block, and for seventeen years Homer combined popular
subjects with the kind of assignment that today would go to
the best news photographers. He covered Lincoln's inaugura-
tion in 1861. The next year and up into 1865 he covered
various Civil War campaigns, making trips to the front. He
was thirty years old in 1866 when he exhibited his first
major oil, *Prisoners from the Front* (Metropolitan Museum)
at the National Academy. Today the picture looks expert but
a little too much like an illustration. It carried, at the time,
a great emotional appeal with its dignified confrontation of a
Yankee officer, trim, neat, and assured, and his ragged but
proud Confederate counterpart. Realistic, devoid of senti-
mentalism (Homer never painted a sentimental picture all
his life, although most of his subjects were of a kind habitu-
ally treated sentimentally by his contemporaries), deliberately
objective on the surface, *Prisoners from the Front* was, for
the public at that time, expressive of contrasting ideals that
should never have come into tragic conflict.

Late the same year, Homer went to France, and in 1867
he had the pleasure of seeing *Prisoners from the Front* well
received by French critics at the Paris exposition. He had
already begun to find himself as a painter of figures in rural
landscape—usually children or young people playing games
or doing farm chores. Upon his return he gave more and
more time to painting, making trips from his New York base
to the White Mountains and the Adirondacks, and to Glouces-
ter, Massachusetts. Finally in 1875, thirty-nine years old, he

did his last work for Harper's Weekly, which had commissioned most of his important illustrations.

At a time when Americans still regarded polished detail as the first proof of a painter's skill, Homer was working in broad-planed, simplified forms. The critics fussed about his lack of finish (and continued to do so throughout his career), but at the same time they recognized his force. He was usually well received critically in the exhibitions, and was popular with the public as well, but he sold very little even though he could be called famous. He had been efficient and vigorous in the prosecution of his career as an illustrator and was never intimidated by anybody or anything, but he was by nature a solitary, and now he withdrew more and more from other people and became a rather prickly character. He could turn a biting, contemptuous phrase with almost pathological cruelty. He never married (his relatives supplied biographers with the standard legend about an early disappointment in love) and was always distrustful of women although he painted young girls tenderly. Sometimes in his caustic isolation he is a little remindful of Degas, his contemporary within a few years of birth and death, although he had neither the close family ties that enriched and complicated Degas's life nor, of course, the mundane spectacle of the most sophisticated capital in the world that made Degas a constant spectator in a vast theater.

Homer withdrew instead to the rugged coast at Prouts Neck, Maine. The dividing point of his life came when he was forty-five: in the spring of 1881 he went to Tynemouth, on the North Sea coast of England, and for most of two years lived and worked in solitude. Upon his return he abandoned New York and settled at Prouts Neck, making a trip nearly every year to points that ranged from Quebec to Bermuda.

In Maine he found his subjects for the pictures that are usually most admired. The New England fishermen—and their wives, sturdy figures standing on the rocks against the

waves, with the wind whipping their skirts—became for Homer the heroes of man's struggle with the elements. The sea in its fearful power, breaking gray and green against the rocks, is a force at once all-fertile and indifferent that nourishes and destroys. Around the brilliantly sunlit southern islands, the water becomes bright-colored and sparkling, but even in these seas Homer found his theme repeated. In *The Gulf Stream* (Metropolitan Museum), a shipwrecked sailor floating alone in a dismasted sloop awaits his end in helpless resignation.

Homer discovered watercolor in his late thirties and brought the medium to its climax in southern subjects, where his fluid, transparent notations make him the first modern watercolorist in America and one of the first anywhere. In some of these southern studies, the quickest and sketchiest, he is most nearly an impressionist by French definition. But his true relationship with the French is not in the technical devices of suggestion and semiscientific optical sparkle. He shared the impressionists' basic concept of light as a bathing and enveloping medium, but he never abandoned the concept of form as a succession of planes defined by firm outlines. Monet's prismatic disintegration would have been totally disharmonious with Homer's Americanism, which made the last unequivocal statement of faith in the young strength of the new continent. It was a faith that had become eroded during Homer's young manhood. His paintings are thus more like memories of a faith than its proclamation, but they summarize, nevertheless, a heritage.

Homer was only eight years older than Thomas Eakins of Philadelphia, and for this not very good reason the two painters are usually paired historically as the two great American realists. Actually, Eakins belonged to a new America, an urban America that Homer had rejected in middle age when he settled in Prouts Neck. For that reason, Homer concludes this chapter of this book, and Eakins begins the final one.

EAKINS AND
CEZANNE

Thomas Eakins of Philadelphia and Paul Cézanne of Aix-en-Provence were contemporaries within a few years of their births and deaths, and there was a time, between 1866 and 1870, when as young men they might have joggled one another, as strangers, on a crowded street in Paris, or perhaps one day in the Louvre. Later in life, Eakins was aware of Cézanne as an artist. Cézanne, surely, never even heard Eakins's name. Their greatness is comparable in degree but utterly contrasting in historical context. Eakins was one of the great traditional realists of any time or place, while Cézanne was the most revolutionary force in art since Giotto.

In spite of the vast difference in the nature of their achievements, they had much in common. Both began as admirers of French Salon stars whose pedantic exercises they later recognized to be unrelated to their standards as mature painters. Both were led toward self-discovery by seventeenth-century Spaniards. Both suffered rejection on the double

basis of provincial and fashionable taste in art. And, as old men, both received belated recognition. Both insisted that the visible world is the only valid point of departure for a work of art, while declaring with equal emphasis that they did not want to imitate but to "re-create" it. The great difference between them was that Eakins was giving consummate expression in his century to a tradition of humanistic realism that had remained unbroken, no matter how varied, for six hundred years, while Cézanne was shattering it. It is this contrast between two forms of greatness, antithetical yet coexistent, that makes possible the combination of Eakins and Cézanne as subjects for a chapter concluding the nineteenth-century—a combination unlike any offered by any other century unless the fifteenth, with its medieval Van Eyck and its Renaissance Masaccio, is a distant parallel.

Thomas Eakins of Philadelphia, probably the greatest American painter and certainly one of the greatest nineteenth-century painters on any acceptable international list, was in his fifty-eighth year when he was finally elected an associate of the National Academy of Design. In the self-portrait he painted as the required "diploma" work, he does not appear especially jubilant over the bestowal of this honor, one of a series of rather shamefaced recognitions that were to come to him during the remaining fourteen years of his life. There is nothing triumphant in the face he painted. It is a worn, tired face, the mouth tense and drawn down at the corners, the brows knitted less with an effect of concentration than with one of habitual distress, but the eyes piercingly alert. It is the face of a man who as he entered old age was totally absorbed in what he was saying as an artist, and who had discovered that there were not many people interested in listening.

Eakins and Cézanne

As a supreme realist, Eakins appeared heavy and vulgar to a public that thought of art, and culture in general, largely in terms of graceful sentimentality and pretty idealism. Today he seems to us to have recorded his fellow Americans with a perception that was often as tender as it was vigorous, and to have preserved for us the essence of an American life that, indeed, he did not idealize—because it seemed to him beautiful beyond any need for idealization. Thus Eakins occupies a classical position in the history of nineteenth-century thought and art—that of the great man who saw too clearly in terms of the present to be acceptable to a public accustomed to thinking of greatness and beauty as prerogatives of the past, which therefore should be imitated.

And yet Eakins was not a modernist by standards that today have reversed the situation. (We now have a public accustomed to thinking that great art exists only as a revolution against the past, which therefore must be rejected.) In 1866, at the age of twenty-two, he was studying in Paris, where nascent impressionism, in the early work of Manet, was a roaring scandal. He seems to have been indifferent to what was going on—even unaware of it, although he was alert and investigative by disposition. During Eakins's young manhood, impressionism fought its battles; during his middle age, it won its decisive victories; during the last years of his life, cubism and fauvism virtually changed the very definition of art. But throughout his life, Eakins stayed on course as a "scientific realist," a term applied to him (which he accepted), although it is incomplete because it fails to indicate the warmth of spirit that suffuses his art.

Even so, the term is accurate as far as it goes, and the fact that it cannot be applied to any other major painter of the time is proof of the high degree of isolation of the art of this man who, paradoxically, loved the life around him and dedicated himself to recording it.

To whom can Eakins be compared, even among the realists who shared his half of the century? To Courbet? No; despite his credo of realism and his nominally common subjects, Courbet loved opulence and theatrical effects as dearly as any Salon painter. These effects Eakins detested. To Daumier? No, because this great humanitarian employed realism to probe a sociopolitical system that held no interest for Eakins. To Winslow Homer, who, as another American, might be closest? Not quite, since Homer, for all his attention to the American scene, was more interested in discovering picturesqueness in the commonplace than in showing that the heart of life exists in everyday things. None of these men—not Courbet, because he lacked true sensitivity to any personality other than his own, and not Daumier or Homer, simply because they were not portraitists—left anything comparable to Eakins's characterizations of his contemporaries as individuals. His portraits, which in the end constitute his most impressive work, are a triumphant expression of the noblest ideal of his century, although certainly Eakins had no such ideal, no such program, in mind when he painted them.

It was the ideal of the average individual as an independent, responsible unit in society, living within a code of law and morals determined by himself and other individuals as a mass, yet remaining a free man within that mass. Even Daumier, who had a vast love for people that included full recognition of their foibles, never presented them to us as individuals but only as generic types. Eakins, even when confronted by a set of features utterly undistinguished, always managed to explore the character of the individual who lived behind them while reproducing those features with surface exactitude.

This skill came to Eakins not quite by accident; it was a secondary aspect of what he thought of as his main interest in art, his scientific realism. Portrait painting was a way of

making a living; a lesser spirit would have been content to compromise with necessity by subjecting his talent to the creation of effigies that aimed to please—a compromise so nearly universal in the field of portraiture that it led John Singer Sargent, the most fashionable practitioner of his and Eakins's day, to comment that it was "a pimp's profession." But Eakins, apparently without setting himself a moral obligation, was temperamentally incapable of flattery. It is not surprising that some of the plain-faced people whom he painted with such unyielding truth were dissatisfied with the results and rejected their portraits, even though their posthumous (if undeserved) reward for commissioning them in the first place is that they have been immortalized; by comparison, most of Sargent's immortalizations now look like costume studies posed by mannequins. Some of Eakins's sitters, on the other hand, committed a form of posthumous suicide by paying for a portrait they hated and then burning it.

Before saying much more about Eakins, we had better make some distinction between the terms "naturalism" and "realism," since both are applied to his art. In painting, the line between the two has never been well defined and they are often used interchangeably. But naturalism is a term specifically connected with the nineteenth century. More applicable to literature than to painting, naturalism signified an extreme of realism based on the methods of writers like Zola, who believed that the writer (or painter) could be and should be scientifically objective and precise in his description of life. Naturalism was not only anti-idealistic (it tended, pendulum fashion, to give more attention to the sordid than to the beautiful); it also tried to avoid all value judgments—something that is simply impossible for any writer or artist, since he cannot be an automaton.

Realism is less extreme. It may be anti-idealistic, since it regards the description of any facet of life as legitimate mate-

rial for the artist, but it is also interpretative. If the realist does not idealize, he at least admits that he responds. And by responding, he interprets according to his temperament.

In view of these definitions, hazy though they are, the description of Eakins as a scientific realist is quite accurate, if limited. His passion for anatomy and perspective as the bases for representation was indeed scientific and objective. But anatomy for him was also, and primarily, a way of understanding the human body, which he loved as the most beautiful of all natural objects. And perspective was a means of distilling from nature the essence of a world that delighted him. His art can be called naturalistic only in relative terms, only in comparison with the swooning romanticism that distorted the natural appearance of objects in the service of an extremely personal vision. Eakins was a realist in the most profound sense—a sane, practical, and reflective man who found that the mere fact of the world's existence was so wonderful in itself that he asked no greater satisfaction than to observe the world and to explore its structure.

This love of the world as one vast and glorious reality that could be explored, explained, and given its deepest meaning by discovering the physical principles that animated it, was at the heart of the nineteenth century's joy in science. It was also at the heart of Eakins's original interest in painting, so much so that at one time he hesitated between science and art as a profession. Where things are in perfect balance, a very small weight may be decisive on one side or the other; Eakins's final choice of art may quite possibly have come about because his father, Benjamin Eakins, was a writing master who taught penmanship to young Philadelphia gentlefolk at a time when fine calligraphy, if not exactly thought of as an art, was cultivated and respected in very much the same way as drawing. There was a close bond between Thomas and his father; he liked to sign pictures in which his father appeared (including one in the collection of Mr. and Mrs. Paul

Mellon showing father and son hunting reedbirds in the marshes on the Cohansie River, across the Delaware from Philadelphia), *Benjamin Eakins Filius Pinxit*.

Thomas, who was later to have three sisters, was born on July 25, 1844, the first child in this middle-class Scotch-Irish American family. When he was two years old, the family moved to a house at 1729 Mount Vernon Street, where he lived the rest of his life. However inconsequential in itself, the fact of this static residence is somehow an appropriate symbol of the solidity and continuity of an art that developed with such power in a single direction, during a time when restiveness, experiment, and various aesthetic detours and excursions were typical of the lives of artists elsewhere. It is always surprising to remember that Eakins was almost an exact contemporary of Renoir, that he was only five years younger than Cézanne, and only nine years older than Van Gogh.

If the relation of vital statistics to the sequence of aesthetic revolutions meant anything, we would have to say that Eakins lagged a generation, maybe two generations, behind the greatest of his European contemporaries. But Eakins's insensibility to the revolutionary sequence is evidence enough that American culture was not then of a character (let us not say "was too far behind") to nourish these revolutions even if they had been imported as they occurred. It was a culture that had produced so few artists it could call truly its own that it still needed the kind of painter Eakins was. He was one of those whose strength lies in their revelation of ways of thinking and feeling that are born and bred into them by their time and place, as opposed to the clairvoyants or prophets whose strength is that they speak in the strange tongues of genius.

In Eakins's America, technical conservatism was not only a valid means of expression but the only valid one for an indigenously expressive art. The adoption of im-

pressionist techniques at that stage of the game, not to mention post-impressionist ones, would have been a kind of anachronism-in-advance. Eakins's trouble with the public and his patrons came not because he painted in a way that people in general did not understand (this was the impressionists' trouble in France), but because he painted in a way that they understood perfectly. There was no question as to what he was saying or how he was saying it; he was speaking in clear (and beautiful) language about familiar truths, but for this very reason he offended people who had become accustomed to the idea that the painter's function was to speak in the debased rhetoric of the Salon, which confused truth with sentimental clichés. The impressionists had to fight this same battle, but their manner of assault differed in accord with their terrain, which was Paris instead of Philadelphia, New York, or Boston.

And yet in spite of their contrasting surfaces—the impressionists with their broken, sparkling color and their forms so frequently eroded by effects of light and air, and Eakins with his firm definition and, sometimes, the brown shadowy depths abominated by his French contemporaries—Eakins and the impressionists were close kin. Both painted a bourgeois world that put its faith in mundane, practical values. In the hands of the academicians these values, disguised as idealism, bred some of the most flatly prosaic and banal art of all time. But the great realists of the century, with the impressionists as their consummation in France and Eakins as their sole indisputably great man in America, embraced the everyday world and loved it for the way it looked, felt, tasted, sounded, and smelled. They found it worth loving in spite of all the confusion and ordinariness because, if you knew how to hunt it out, there was something firm and wonderful in daily life that made all the trivialities and accidents worth while.

In France, where artistic revolutions had been following one another not only by generations but by split generations, the new technical vocabulary of impressionism was a natural accompaniment to a new way of revealing the world. Not only in color, but in the ways of putting a picture together, the impressionists went beyond anything that an American could then absorb without becoming, as Mary Cassatt eventually became, an adopted citizen of a foreign culture.

All that has changed; we are accustomed now to an internationalism in art that jumps the Atlantic, in both directions, as one experimental movement succeeds another. Eakins preceded a generation of painters who began to take up the slack, but he seems less to have resisted foreign influences than to have been simply impervious to them.

Eakins belonged to the last generation of American artists for whom a truly indigenous expression was possible, except in the limited terms of folk art in the hinterlands. The country's increasing international power and international involvement, culminating in World War I, so changed its character that for an artist to be American in the way that Eakins was American became impossible. His death on June 25, 1916, less than ten months before our entry into the war, was a coincidence of timing that is almost symbolic. After 1918, American*ism*—and the last syllable is the important one—could only be a form of isolationism, an artificial and reactionary attitude toward painting that had its temporary victory and final defeat in the regionalist art of the 1930's, at the same time that a group of American politicians, the isolationists, were trying to make a walled island of the United States.

But Eakins had come into his young manhood with the Civil War; the decisive years of his development as an artist were the decades of the nineteenth century that brought this country truly of age, that determined its character as some-

thing more than a hybrid, part pioneer and part, if vestigially, colonial. During Eakins's best years—the years of early maturity, when an artist's direction is set for him—European manners in art were still regarded as imported refinements that artists might aspire to, but this aspiration was a denial of more spontaneous and hence more specifically American ways of expression.

The impressionists, sharing with Eakins a faith in the commonplace as a natural source of inspiration, would certainly have recognized their kinship with him if they could have known him. They would surely have recognized his stature, and just as surely his contrasting Americanness—his solidity, his trust in factual clarity. Any provincial flavor in his conservative technique was inherent in the true expression of a culture that had not yet questioned itself at base, and hence did not stimulate its artists to question the efficacy of traditional art forms.

For an aristocratic and Europeanized intellectual such as Henry James (Eakins's exact contemporary), the European-American contrast seemed a cultural hiatus in fashions and manners that was anguishing to someone who loved both worlds. But Eakins, never a fashionable man and by James's standards not even a well-educated one, could remain undivided. Lately we have come, almost without realizing it, to equate the importance of any nineteenth-century artist with the degree to which he was a prophet or a forebear of modernism. But Eakins's strength lies in the fact that he was not a prophet and not even interested in following the latest thing. Prophecy and fashion, which in the art of painting mean experiment and embellishment, went against the grain of Eakins's vision of a world so inexhaustibly beautiful and meaningful from day to day that a painter needed only (to use Eakins's own word) "re-create" what he saw to fulfill his function as interpreter.

As a sturdy young boy, Eakins had loved the rural coun-
tryside around Philadelphia, where he boated, fished, and
hunted. He attended Central High School, an institution that
was, and is, notable in the Philadelphia public-school system
for educating the brightest boys at a level several hefty
notches above that of the average high school. He was an
exceptional student there, strongest in mathematics and sci-
ence. He was also good at art, at a time when art was taught
by rule and not regarded as a form of laissez faire for self-
expression. Mechanical drawing and perspective, which of
course are forms of geometry, were as important or more
important than sketching. No artist since the Renaissance,
when its rules were being formulated, has been more inter-
ested in pure perspective than Eakins was. Some of his pre-
liminary perspective studies for paintings have an analytical
clarity that makes them appealing to contemporary eyes as
independent works of abstract art.

Without these early analytical and scientific associations,
art would probably not have interested Eakins as a profes-
sion, and his first enthusiasm for his tentative choice was a
bit dampened at the Pennsylvania Academy of the Fine Arts
in Philadelphia, which he entered in 1861 when he was
seventeen. The introductory year, standard in art schools at
the time, consisted almost entirely of drawing from plaster
casts of antique sculptures, a meticulous discipline teaching
a few principles that any gifted student can pick up quickly.

Drawing from casts has discouraged many talents, stulti-
fied others, and delayed the development of virtually all who
have been subjected to it. At best, it inculcates an ideal of
anemic grace in its substitution of the smooth, blank forms of
inaccurate casts for the vitally idealized originals of antiquity.
This warped introduction to classical art may explain why
Eakins during all his life never came to an understanding of
it. Although he revered the Parthenon figures, he thought

they were "undoubtedly modeled from life," a misconception of their reference to life as a source. He said that "nature is just as varied and just as beautiful in our day as she was in the time of Phidias," and also that there could be no objection to idealization as long as one "understands what it is that he is idealizing." This last, of course, was the point, but by every evidence of his work, Eakins continued to think of idealization as a form of watering down, as indeed it was in the hands of his contemporaries.

The hours and days of waste and boredom in the cast-drawing classes were punctuated at the Academy by occasional life classes. Although the nude body was regarded as little more than a living cast that could be shifted into a few standard poses, Eakins's earliest drawings from life are full of weight, structure, and a potential for movement. The human body had already become for him the most wonderful thing in the world—not an evocation of sensuous delights or a symbol of fecundity, as it became for Renoir in those same years; and not a rather curious, even unlovely, object that somehow could take on and reveal the social and psychological status of an individual, as it became for Degas; and not even the most fluid and adjustable compositional element available to an artist, as it had been for centuries to any number of painters. For Eakins, the body was an organism so wonderfully articulated and interdependent in all its parts that nothing could equal its beauty as the one greatest single object in the whole of creation.

This was a scientist's recognition of fact as the truest miracle, the most fascinating mystery of all because it can be explained, and because its fascination increases as the mystery is unraveled. During his years as an art student, Eakins supplemented the Academy classes with courses in anatomy and dissection, which included witnessing operations, at the Jefferson Medical College. He even considered becoming a surgeon.

After following this divided course for five years, he made his final decision in 1866 and went to Paris to study at the Ecole des Beaux-Arts, where all drawing and painting was based on the nude. In many ways this is the most contradictory period, or the only contradictory period, in his life. His master was Jean Léon Gérôme, a superb technician but an artist who now seems as stuffy and artificial a painter as any the Salon produced. Yet, in spite of Eakins's abomination of affectation, he admired not only Gérôme but some other Salon painters who would seem unlikely to appeal to him. He did reject, significantly, painters like Bouguereau, whose female nudes, while impeccably drawn, were so candy-tinted and coy that even a young American excited by his first study in Paris could not fail to recognize them as unrelated to the reality that he had already investigated by dissection.

What seems most curious, at first, is that Eakins showed no sign of interest in Courbet and Manet, although he must have read and talked to other students about the scandals in the air. If he saw the exhibitions held by these painters in 1867, in sheds they erected outside the grounds of the Exposition Universelle after they were rejected by the Salon jury, he did not mention them in his letters home. He did write enthusiastically about the exhibitions of machinery (the division, in fact, in which that exposition made its greatest contribution).

Possibly Courbet and Manet, if he knew them at all, seemed to the young Eakins a manifestation of art for art's sake—art as opposed to science—for which he had no use, while the machines held for him the interest that he found in drawing and painting the nude—the interest of construction, of parts joined in interdependence, moving with or against one another in perfect logic. The fact that Courbet's nudes were a glorification of flesh rather than structure, and that Manet's were a glorification of paint as something with

its own existence and its own reason for being, could have concealed from a provincial young man the more important fact that these two artists had rejected a threadbare idealism for an immediate reference to the life around them.

It is difficult to find anything in Eakins's art that he could have learned from Gérôme, except that the studios supplied him with nude models in quantity. (When the students stripped and wrestled, he said, he learned even more.) His true teachers in Europe were Velázquez and Ribera in the Spanish museums. He compared them with Gérôme and discovered that he had been overrating this little man. In the objectivity of Velázquez and the forceful realism of Ribera he found his own nature verified. He spent six months in Spain, returning to Philadelphia in the summer of 1870, and never left America again.

From this point on, the temptation is always to recount the story of Eakins's rejections and defeats, and the even more discouraging story of public indifference to his work. But for a while, at least, this was only one side of the story. It is true that his realism ran counter to the taste for prettiness and sentiment that had been inculcated into the members of society who commissioned portraits, as well as into the artists who served them and hence made up the juries for most exhibitions. However, in the late 1870's Eakins was recognized by a group of younger artists as a forerunner of their "New Movement," a loosely organized revolt against the conservatism of the National Academy. He was able to sell very little, virtually nothing, but his technical proficiency was never questioned (although its goals were never understood), and in 1882 he was appointed director of the Pennsylvania Academy's art school, where he had volunteered to take over the life classes in 1876.

Eakins was a superb teacher, and was recognized as one. The casts went into the dustbin; the course was based on the

study of the nude; classes in dissection were introduced; and the painting courses were revolutionized. Painting had been approached as a kind of tinting of careful drawings. Eakins insisted on the identification of drawing with painting, of color with form, which in the context of American art education at that time was as innovational as Cézanne's more complicated and radical experiments in applying the same general idea.

Under these circumstances, Eakins might have achieved real success before the end of his lifetime, as the impressionists did in France. But in 1886, when he was forty-two, a bitterly decisive professional disaster occurred. About half the Academy students were women, and a growing uneasiness as to the morality of their working from nude models had created some opposition to Eakins's program. The crisis came when he insisted that male models pose in the women's classes without the usual loincloth. He refused to compromise on this point, and the directors of the Academy accepted his resignation.

Eakins's insistence may seem almost fanatic, especially since so many of the women students were doing little more than marking time in studying a genteel avocation. But anyone who has drawn from life knows that the loincloth is bothersome, not because it modestly conceals what it does, but because it interrupts the flow of line and the feeling of total structure of the body. It is true that Eakins was far from objective in his love of the nude; nudity was a passion with him, and if he could have he would probably have liked to go through life naked. He once managed a brief canter thus, on horseback. But as far as the art classes were concerned, he might have argued with total impersonality that to draw a nude with the loincloth was like drawing an engine partially swathed. His obduracy was also a matter of principle: he would teach as he pleased, or he would not teach at all.

This debacle occurred in the second year after Eakins's marriage—a late one, at the age of forty—to Susan Hannah Macdowell. (His first fiancée, Katherine Crowell, the sister of a boyhood friend who later married the eldest of Eakins's three sisters, had died five years earlier.) Mrs. Eakins, who had been his pupil, was also a painter, and in the hard times that followed, the marriage was a solace. In spite of the loyalty of former students, Eakins fell increasingly into obscurity. The loss of his position as a teacher was more than a financial blow; it largely negated his position as an influential artist. The social and moral bases of the disagreement verified a suspicious attitude toward Eakins that had been recurrent in a conservative community, and left him in the position of a rebel and nonconformist. (Ten years earlier his most ambitious figure composition, showing Dr. Samuel David Gross performing an operation in his clinic, had been refused for exhibition at the Centennial Exposition as being too "indelicate" for a mixed public. Eakins finally got it into the medical display, and sold it for two hundred dollars. It is now in the Jefferson Medical College, Philadelphia.)

To add to his difficulties, the times began to catch up with him. By the 1890's, impressionism, triumphant in Europe, was seeping into America as the new movement for the kind of young artist who formerly had turned to Eakins. Whistler, combining the appeal of delicate sentiment with a colorful personality and an easily assimilated modernism— all antithetical to Eakins's art—became the idol of the social intellectuals.

But Sargent, all flash and high style, was king. When he came to Philadelphia as a lion, a hostess asked if there was anybody special he would like to see. There was only one man: Eakins.

His hostess did not even recognize the name.

Paul Cézanne was the same age within a year or two as Monet and Renoir. He was younger by nine years than impressionism's patriarchal figure, Pissarro, who was his mentor insofar as he found one among fellow painters. He was five years older than Thomas Eakins. He was separated by some six centuries from Giotto, who had initiated the revolutionary concepts of space and reality that, perfected in the Renaissance, had remained the foundation of Western painting in spite of all variations and refinements until Cézanne initiated the revolution called modern art.

Awkward, "feeble in life," as he said, and divided between shyness and belligerence, he seemed an unlikely prospect for a revolutionary genius. But his radical shift of emphasis in the painter's means of expression from realism to abstraction made his achievement so revolutionary that, like Giotto's, it was only half understood during his lifetime even by those of his colleagues who admired and tried to imitate it. For that matter, there is not much reason to believe that Cézanne himself suspected the explosive potential of his innovations.

Cézanne painted during a half century when space could still be thought of as it was in the Renaissance. Nineteenth-century painters, like Renaissance painters, represented space as a measurable entity with our planet as a module. But Cézanne lived, also, into a time when this reassuring concept was questioned and then destroyed, when space and time themselves were shattered to become relative values indefinable in the old terms. Twentieth-century painters, along with scientists, rejected the old definitions.

Cézanne belonged to both worlds. In his most famous single statement he looked at the past and said that he wanted to "make of impressionism something solid and durable like the art of the museums." He did just that, but his giving of coherence to impressionist technique, which had become

somewhat loose and scrambled, was not a retroactive reform. In the process of "solidifying" impressionism he brought the representation of form into a new area and set a boundary line that separated the art of the museums from a twentieth-century art that was antitraditional. In belonging to these two worlds he paralleled the revolutionary position of Giotto, who can be seen equally as the medieval climacteric and as the first Renaissance painter. In the same way, Cézanne is identifiable both with tradition ever since Giotto ("the art of the museums") and with its rejection.

Cézanne was born on January 19, 1839, in Aix-en-Provence, the son of a banker who had made a fortune as a hat manufacturer. He was forty-seven years old in 1886 when his father died at the age of eighty-eight, and during all those years he had been dependent on the rich old man and conscious of his father's disappointment in an only son who as a painter had attracted attention of a kind that could have been gratifying only to a comedian; who, instead of marrying and assuming a position of importance in Aix, where the family had lived since 1700, had formed an unacceptable liaison, produced an illegitimate son, and isolated himself from the community; and who, roaming the countryside in his rough clothes, could have been taken for a surly, bearded peasant if the painting equipment he carried had not identified him as the local eccentric.

Until his early twenties, Cézanne gave some promise that eventually he would settle down to the life of a respectable professional man in the provinces. His boyhood and youth were normal enough in spite of his interest in art and literature. Of the two, literature interested him most. When Cézanne was thirteen he met a schoolmate a year younger than he, a boy named Emile Zola who was living in Aix with his widowed mother. Cézanne, the sturdier of the two, took to defending his new friend when he was baited as a "Pari-

sian." But Zola was the one who even then had a good idea of what he wanted to do and how he was going to go about doing it. He was going to conquer Paris as a writer.

In the boyhood they shared, Zola and Cézanne ranged the country around Aix and probably tried together to climb Mont Sainte-Victoire, the mountain near Aix that later became for Cézanne a motif to be studied and restudied and a symbol of the enduring wonder of a world that he always regarded as a miracle, "the spectacle that God the Father spreads before our eyes." We are so accustomed to thinking of Cézanne in terms of formal analysis that it is difficult to think of him as the man who said, "How can anyone look at nature without thinking of its author? The artist should consider the world as his catechism; he should submit himself to it without a struggle."

Victor Hugo, then at the apex of his fame, was the boys' literary idol; they also discovered Alfred de Musset, and tried their hands at writing poetry. After Zola, at eighteen, went to Paris, Cézanne sent him some of his efforts. By this time—1858—he was attending law school at his father's insistence, but was also attending painting and drawing classes as he had been doing since 1856 or earlier in such schools as Aix offered. These were not impressive, but their part in Cézanne's early development must not be discounted. At the local Ecole des Beaux-Arts he studied drawing under Joseph Marc Gibert, a conventional pedant, and for years (up to 1870) he was influenced by Emile Loubon, a Provençal painter whose protégés included Monticelli.*

Nobody, including Cézanne himself, seems to have been

* Adolphe Joseph Thomas Monticelli (1824-1886) developed a personal style in which Watteau's *fêtes galantes* were reinterpreted in a dense mosaic of thick dabs of paint. He had only a moderate success during his lifetime but his technique left its mark on that of other painters, Vincent van Gogh among them, and in his best paintings he created with heavy shadows and golden lights a visionary, poetic world.

profoundly impressed by his promise as an art student in Aix, but, missing Zola's companionship, Cézanne began to think of joining him in Paris and devoting himself to art. It took him three years to reach a decision, but in April, 1861, twenty-two years old, he left law school and left Aix to join his best friend. His father, naturally, was not pleased, but had yielded to the supplications of Cézanne's mother and sister, who always served as arbiters in the conflicts between father and son.

This first Paris venture was a failure. Zola was still a friend, but Zola the young man of the Paris streets and cafés was no longer Zola the boy of the Provençal countryside, while Cézanne, in the city, became a displaced person. He was a tall, gangling fellow (this always comes as a surprise; something about his self-portraits, which we think of first rather than photographs, suggests a short, heavy, solid man) who, in his unease, affected rude country ways and dressed in rough country clothes. He attended the Académie Suisse, probably as preparation for candidacy as an entrant in the Ecole des Beaux-Arts. His ferocious obsession with his work, among other students who were making the most of the traditional bohemian indulgences expected of young artists, made him a freak, and his work itself—figure drawings blocked out with almost savage strength—satisfied neither the standard of fluid grace nor that of classical precision, the poles of academic acceptability. He had no facility. He also admired, still, all the wrong men—or those who seem the wrong men today, such men as Meissonier and Cabanel, the gods of the Salon, although his genius, struggling for release, had nothing to do with the banal perfection of their exercises.

In retrospect we can discover in Cézanne's drawings from this period the germ of his later preoccupation with form as a kind of living geometry, but he was groping toward something that he himself could not understand, and had not

even tried to define. After five months in Paris—disappointed that he saw so little of Zola, hating city life, and the butt of the studio jokesters—he decided that he had neither the talent nor the temperament to be an artist, and returned to Aix to enter his father's banking business.

If his father was relieved, this relief was short-lived. Cézanne re-enrolled in a local art school, and after a year and a month—in November, 1862—he went back to Paris.

This time, Paris was not entirely foreign to him, and he had assimilated his discovery, in the Louvre and in books, of the first great painters who influenced him—Caravaggio and the seventeenth-century Spaniards, masters whose strong definition of volumes, combined with a fervent emotional response to the world as a visual spectacle, were continued by Cézanne in his maturity. It is true that after he found his own way he did not paint volumes as the self-contained entities seen by Caravaggio and Ribera; it is true also that he saw the world in its intimate aspects rather than as the spectacular manifestation that appealed to the seventeenth-century realists. But the brotherhood was there all the same in the mutual recognition of what Cézanne called "sensation" —the impact of the visible world on the artist's senses—as the only legitimate point of departure, and of the re-creation of natural forms as the painter's only means of expression.

A few months after Cézanne's second arrival in Paris, the godhood of his Salon heroes was questioned by the Salon des Refusés, and although Cézanne was not yet much attracted to the central figure of this scandal, Manet, he had grown to the point where he understood two of the men whose art had produced Manet's—Courbet and Delacroix. Delacroix died that year—1863—and the great memorial retrospective of 1864 impressed Cézanne deeply.

He began painting now in a way that combined the thick, rich, heavily impastoed surface of Courbet (the paint

frequently applied with the palette knife), the somber darks and dramatic lights of the seventeenth-century Spaniards, and his own curious response to the romantic adventure as intellectualized by Delacroix. The still lifes and portraits of this period (with friends and relatives as models) are fulfillments of the strong, blocky drawings from the nude done at the Académie Suisse—vehement, almost aggressive, declarations of physical structure described in uncompromising planes— already protocubist. He began inventing, also, erotic fantasies that would yield rich veins for post-mortem mining by psychiatrists—scenes of rape, of gentlemen fully clothed (including top hats) regarding naked courtesans writhing on their beds, and great, cumbersome, heavy-buttocked bodies intertwined in a not altogether harmonious combination of architectural composition and a repressed schoolboy's sexual dreams.

Leading a life divided between Aix, where he felt at home although he was increasingly regarded there as a freak, and Paris, where he never managed to feel at home, Cézanne began to know the young impressionists, and met the patriarch Pissarro. Pissarro recognized something so strong in Cézanne's work that its awkwardness could be taken seriously as a symptom of his potential. Cézanne's promise differed from Monet's or Renoir's. He was slow to accept impressionism in general. Even in its nascent stages it forecast an ultimate dissolution of form antithetical to the basic emotional premise of Cézanne's response to art and to the world.

And so he struggled along, groping, stimulated, sighting somewhere a goal. Like any young artist—he was now in his late twenties—he submitted regularly to the Salon. He was regularly refused. His friend Zola had added art criticism to his other journalistic activities and had become the standard-bearer for Manet. He dedicated his novel "La Confession de Claude" to Cézanne and their mutual boyhood friend, Bap-

tistin Baille, and in 1866 dedicated his "Mon Salon" to
Cézanne in a letter that said, "You are my whole youth."
Cézanne's letter of 1866 to Count Nieuwerkerke, the Super-
intendent of Fine Arts, protesting Salon policy, is phrased
with a journalistic flair that suggests Zola's doctoring, but
"Mon Salon" of the same year suggests just as strongly that
the unknown painter was contributing to the brilliant young
writer's ideas about art. As an art critic, Zola was not much
interested in aesthetic theory, but he relished acting as self-
appointed attorney for the defense of the rebels who were
being mistreated by the Academy. He saw painting first as a
sociological manifestation, almost as an illustration to aspects
of the society that he began to dissect in 1871 with the first
of the twenty novels in his series "Les Rougon-Macquart."
Cézanne's struggles were even then supplying the raw mate-
rial for another of them, "L'Oeuvre," that would not appear
until 1886.

Cézanne was thirty years old in 1869 when he met a
young model, Hortense Fiquet. Their liaison and later mar-
riage endured for the rest of his life, but from the first pre-
sented complications. It could be taken for granted that the
union would be intolerable to Cézanne's father, and the
couple began a program of concealment that lasted for nine
years. When the War of 1870 broke out, Cézanne's father,
who had bought him a substitute conscript, expected his son
to return to Aix. This Cézanne did, spending the war period
there and at L'Estaque, where he established Hortense. It
was an important year for him as an artist. Isolated from his
acquaintances, he mulled over advice he remembered from
Pissarro and began painting in lighter, smaller touches of the
brush, clarifying his color and experimenting with landscape.

In 1872, when Cézanne moved with Hortense and their
newborn son for a two-year stay in Pontoise (where he worked
with Pissarro) and nearby Auvers, he was still an artist of

promise in Pissarro's judgment but only beginning to be acceptable as a colleague to the rest of the circle. They were not at all keen on including him when the first impressionist exhibition of 1874 was organized, but Pissarro insisted. Cézanne exhibited *A Modern Olympia,* one of his erotic fantasies, showing a well-dressed gentleman (possibly intended to represent Cézanne himself) seated on a couch in an elaborate interior—suggestive of a seraglio—while a Negro servant lifts drapery from a vast white bed where an oddly swollen courtesan is curled up. In context with his later work, it of course can be read as prophetic in certain passages, as can anything Cézanne painted in these early years, but if we could look at it without the advantage of hindsight surely it would strike us as a most curious picture altogether. Rid of all associations and standing by itself as an isolated work by an anonymous painter, it might be thought of as a parody on the romantic Orientalism of the first half of the century. Painted freely, with a kind of sinuous awkwardness, it is difficult to imagine as the work of the same artist whose *House of the Hanged Man, Auvers* was in the same exhibition. (Both paintings are now in the Louvre.)

House of the Hanged Man, Auvers is a masterpiece of French landscape painting—at once sober and filled with life, organized with the firmness, variety, and balance of Poussin's classical tradition, yet filled with the light and air, and instinct with the love of the natural countryside, that the Barbizon men had taught the impressionists. It is Cézanne's impressionist masterpiece, but if it is a document of his debt to impressionism as a source, it also isolates him from the other impressionists in its concentration on solid formal structure.

Cézanne came in for his full share of the catcalls that greeted the exhibition, and this could have been the reason for his refusal to exhibit in the second group show two years

later. But whatever the public reception of his pictures, he was now taken seriously by the handful of other painters and dealers or collectors and the critic or two who had confidence in the impressionists. In the third impressionist show (1877) he exhibited sixteen paintings but never exhibited with that group again. As for the Salon, he had outgrown his respect for its idols, and after his sixth successive rejection in 1869 had submitted nothing until 1876. Now in 1878 he began submitting regularly again and, again regularly, was refused. By a fluke he was included once in 1882. Each jury member was allowed to admit one work by a student without its being put to a vote, and Antoine Guillemet, by calling Cézanne his student, which of course Cézanne was not, took advantage of this privilege. The picture attracted no attention, favorable or otherwise.

Cézanne increasingly gained the respect and friendship of the impressionists even while refusing to exhibit with them. His stubbornness in this regard might be explained by his continued difficulties with his father. Salon acceptance would indicate to the solid citizen of Aix that his painter son had achieved some degree of professional status, while the revilements that continued to greet the impressionist exhibitions could only confirm the unhappy idea that Cézanne was an incompetent artist and eccentric personality. The relationship between father and son exploded one day in 1878 when the father opened a letter (from Chocquet) addressed to Cézanne and found in it a reference to Hortense and her son Paul—by that time six years old. In the ensuing quarrel the old man used his strongest weapon—money—and told Cézanne to get rid of these two dependents. Cézanne in his confusion adopted the unconvincing strategy of denying everything, to which his father answered that a bachelor should be able to live on less than Cézanne's allowance had been, and cut it in half.

Zola, whose "L'Assommoir" had just made a huge success, came to Cézanne's aid with both money and good counsel. For nearly a year he supported Hortense and Paul, who were established in Marseilles, where Cézanne could make frequent visits from Aix or L'Estaque, and he also advised Cézanne to avoid a complete break with his father. His mother, always sympathetic, acted as go-between, and the two families limped along, for eight years, toward an understanding. In the spring of 1886, Cézanne, now forty-seven, married Hortense with his father's consent, after some seventeen years of liaison. His father died six months later, and Cézanne at last came into full estate as a wealthy citizen of Aix.

Cézanne's interest in marrying Hortense after so long a time seems to have been entirely a matter of his wanting to legitimize their son. Hortense, both before and after the marriage, is an oddly wooden figure when we try to connect her with Cézanne's life or to give her a life of her own. She is described as having been good looking when young, and a lively talker, but she never becomes more than an effigy. Cézanne's paintings of her might be of any other person, male or female, who was willing to sit for the tiring sessions that he demanded of a model. He presents her as less alive than his apples and vases. Nobody seems to have liked her very much; she was unflatteringly referred to by Cézanne's friends, and yet she does not materialize even as an unlikable person. The probability is that Cézanne, like many people who are obsessed early with erotic visions similar to his, did not mature as an ardent sexualist. He seems to have had no other women, but his interest in Hortense waned long before their marriage. She spent as much time as possible in Paris, apparently contributing nothing—either desirable or undesirable—to Cézanne's life, which with the marriage and the inheritance took on a stable pattern.

But these stabilizing events coincided with a bitter one

—Cézanne's permanent break with Zola under the most wounding circumstances. In that year, 1886, Zola published "L'Oeuvre," the novel in which he explored the lives of painters as part of the Parisian social complex. The hero, Claude Lantier, was presented as an aborted genius whose inability to achieve the goals he had set himself drove him to suicide. Lantier and his rejection of—and by—conventional society combine elements recognizable in the personality of Cézanne and the career of Manet. But in spite of Zola's former championship of Manet and his lifelong friendship with Cézanne, the portrait of Lantier is more pitying than admiring. With Manet's death in 1883, Zola had cooled in his support of the impressionists. He had never really understood what they were getting at, and the nearer they got to it, the more he reacted with disapproval. Glutted with his own success, he began to make the conventional equation between success and merit.

Cézanne was still unknown to the general public; hence Claude Lantier was generally identified only with Manet. But Cézanne recognized the picture of himself as a failure, a man unable to finish anything. He wrote Zola a letter thanking him for a copy of the book, a letter remarkable for its restraint but one that should have been anguishing to Zola in its obvious hurt. The two men never met again, even when Zola made a visit to Aix ten years later, in 1896. In that year Zola wrote an article in which he not only intimated but said outright that Cézanne was an "aborted genius," and also made an open reversal of his support of the impressionists, admitting that it was their independent spirit, rather than their principles, that he had admired. Zola seems to come off badly in all this, but it could be argued that he was admirable in confessing what he believed to have been a mistake; and it should be remembered also that the next year he made his most courageous stand as the defender of Dreyfus.

In effect, Cézanne's marriage and his break with Zola conclude his personal biography, although he lived another twenty years. Few artists seem so removed, as artists, from the events of their personal lives as does Cézanne, a removal that widens steadily after his youth. If Hortense Fiquet somehow never comes to life for us as a personality, Cézanne himself becomes, in spite of everything, less a human being than an abstract force represented by his paintings. This has led to (or is the result of) exaggerated analyses of his art as an art of pure calculation, although he always insisted that "sensation" ("feeling" might be a better word) is the nourishing root of all art.

Yet it is natural that we should think first of Cézanne's art as structural rather than emotionally expressive, since its structural aspects were its innovational ones. The idea that certain colors—generally, the cool ones, with blue as their key—tend to suggest distance, to recede, while those at the other pole of the spectrum—red, yellow, and orange—tend to advance, was not new. But what had been, for centuries, a secondary consideration in the use of color was enlarged by Cézanne as a major premise that form could be expressed by planes of color rather than by the centuries-old device of imitative light and shadow.

Where impressionism had split color into the hues of the spectrum and, in the process, had dissolved form into an airy mist, Cézanne re-established the solidity of natural objects by thinking of color something in the way a sculptor thinks of his medium. He tried to abandon all usual ideas of photographic description, to make the various elements of his pictures—the mountains, foliage, sky, and houses of a landscape, or the bottles, plates, tablecloths, and fruits of a still life—structurally independent of photographic values. In the usual run of realistic still lifes any object can be excised, probably marring the balance of the arrangement, but

at worst merely leaving a hole neatly silhouetted in the canvas. In a still life by Cézanne, no such excision is possible. Form is not self-contained; all form is interrelated in a structure that would sag or collapse with the removal of any part, just as a roof would sag or collapse with the removal of one of its essential skeletal beams.

In creating these structures, Cézanne rejected the limitations of conventional perspective. One object may seem to be seen from above, another from straight on. Planes tilt or flatten without regard for the laws of vision. Asiduous analyses of his compositions have been made from this multiperspectival approach, but such analysis is only an effort to force Cézanne's revolution into some kind of concordance with conventional optics. Cézanne's methods were revolutionary not because he created a new system, but because he regarded each painting as a new problem that could be solved only by finding means to satisfy the demands peculiar to it.

Cubism, which, by a standard description, "shatters all form and then reassembles it in new relationships," had its genesis in Cézanne, but to think of Cézanne only as protocubist is a convenient blindness. Like hundreds of artists, he saw forms as variations on the simplest geometrical units, and said so, but this was an elementary aspect of a tremendously complicated vision. Like all great artists, Cézanne found the formal means to express his responses to the world, and like a handful of them, his means were so revolutionary as to shift the course of art.

Not much of this was understood during Cézanne's lifetime (and most of it is confusing enough today), but by the end of his life he was revered by a group of young artists who sensed, even if they could not entirely explain, his greatness. In 1895, when Cézanne was fifty-six years old, Pissarro, Monet, and Renoir argued the dealer Ambroise Vollard into holding a Cézanne show. There were some favorable, if not

very perceptive, critiques. Five years later, Maurice Denis painted his *Homage to Cézanne* in the tradition of Fantin-Latour's pictorial homage to Manet—although Denis and Cézanne had never met. Exhibited in the Salon of 1901, it was purchased by André Gide and is now in the Musée d'Art Moderne in Paris.

Cézanne's defensive mistrust of people began to soften. The young artists who sought him out as pilgrims, after the turn of the century, were welcomed in Aix by a kindly, aging man. In 1904 he was given an entire room in the Salon d'Automne. He exhibited in that Salon the next year, also, and although the popular critic Camille Mauclair could still describe him as "a worthy old man who paints for pleasure in the provinces" whose work was "an artistic joke," Cézanne had become the patriarch of a new avant-garde. On October 15, 1906, he was caught in a storm while painting in the fields. He died a week later, not quite three months before his sixty-eighth birthday.

Among his impressionist friends, Renoir and Monet, men his own age, were still alive and painting, while Degas, older, was alive but nearly blind. During his lifetime Van Gogh, Seurat, and Gauguin, now grouped with him as "post-impressionists," had been born and had died. The year before his death, fauvism had come to term in the early work of Matisse; the year after, Picasso, inspired by Cézanne, began the seminal experiments of cubism—all of which means that the nineteenth and twentieth centuries were coexistent in the persons of living representatives. But the change between these two centuries was particularly violent, and Cézanne is the one artist who belongs fully to both. Dying as the centuries divided, he had been richly nourished by tradition, but had become the most powerful single source of inspiration for the break from tradition called modern art.